P9-AQX-233

DANGEROUS
RHYTHMS

ALSO BY T. J. ENGLISH

The Corporation

Where the Bodies Were Buried

Whitey's Payback

The Savage City

Havana Nocturne

Paddy Whacked

Born to Kill

The Westies

DANGEROUS RHYTHMS

JAZZ AND THE UNDERWORLD

T. J. English

wm

WILLIAM MORROW

An Imprint of HarperCollins*Publishers*

DANGEROUS RHYTHMS. Copyright © 2022 by T. J. English. All rights reserved. Printed in the United States of America. No part of this book may be used or reproduced in any manner whatsoever without written permission except in the case of brief quotations embodied in critical articles and reviews. For information, address HarperCollins Publishers, 195 Broadway, New York, NY 10007.

HarperCollins books may be purchased for educational, business, or sales promotional use. For information, please email the Special Markets Department at SPsales@harpercollins.com.

FIRST EDITION

Designed by Nancy Singer

Library of Congress Cataloging-in-Publication Data

Names: English, T. J., 1957- author.
Title: Dangerous rhythms : jazz and the underworld / T. J. English.
Description: First edition. | New York : William Morrow, an imprint of HarperCollins Publishers, 2022. | Includes bibliographical references and index. | Summary: "From T.J. English, the New York Times bestselling author of Havana Nocturne, comes the epic, scintillating narrative of the interconnected worlds of jazz and organized crime in 20th century America"— Provided by publisher.
Identifiers: LCCN 2021060831 (print) | LCCN 2021060832 (ebook) | ISBN 9780063031418 (hardcover) | ISBN 9780063031425 (trade paperback) | ISBN 9780063031432 (ebook)
Subjects: LCSH: Jazz—Social aspects—United States—History—20th century. | Jazz—History and criticism. | Music and crime. | Organized crime—United States—History—20th century.
Classification: LCC ML3918.J39 E65 2022 (print) | LCC ML3918.J39 (ebook) | DDC 306.4/84250973—dc23/eng/20220315
LC record available at https://lccn.loc.gov/2021060831
LC ebook record available at https://lccn.loc.gov/2021060832

ISBN 978-0-06-303141-8

22 23 24 25 26 LSC 10 9 8 7 6 5 4 3 2 1

To all the musicians and jazz club impresarios
who kept the music alive during
the Great Pandemic of 2020–22.

In the primitive world, where people live closer to the earth and much nearer to the stars, every inner and outer act combines to form the single harmony, life. Not just the tribal lore then, but every movement of life becomes a part of their education. They do not, as many civilized people do, neglect the truth of the physical for the sake of the mind . . . The earth is right under their feet. The stars are never far away. The strength of the surest dream is the strength of the primitive world.

—Langston Hughes, *The Big Sea*

It's got guts and it don't make you slobber.

—a Chicago gangster explaining his love for jazz

CONTENTS

INTRO

There is a reason that "Strange Fruit" still stands as the seminal jazz song. Written by Abel Meeropol in 1937 and sung so memorably by Billie Holiday two years later, it beckons from the great beyond, elliptical and haunting. The song is both a ballad and a primal scream, an aching tone poem that carries with it the deep, heart-wrenching emotionalism of the blues, as well as the lucid, steely observationalism of someone who has been a witness to history. In form and content, it is a brutal diagnosis of the human condition in B-flat minor. That this song speaks for jazz at the core of its being is no accident. It is a circumstance so sacred that any discerning listener of "Strange Fruit" can hear—and feel—the alchemy of lyrics, poetry, melody, and soulfulness that, through the artistry of Lady Day, rankled the conscience of America and set a new course for what has become this country's most durable art form.

"Strange Fruit" finds its power in the perverse metaphoric imagery of "Black bodies swinging in the southern breeze, strange fruit hanging from the poplar trees . . ." Blood on the leaves, blood at the root.

It is a song about lynching.

And it is a song about America.

It is generally agreed that jazz as a new musical art form began to take shape in the early years of the twentieth century. It is not generally commented upon that jazz, in its origins, was a response to the horror and reality of lynching in America. But consider this: From 1882 to

1912, in the thirty years leading up to the onset of jazz, there were 2,329 instances of lynching of Black people in the United States (according to statistics of the Tuskegee Institute). Many believe this number is low, given that the documentation of lynching was suppressed for generations.

During this period, a reign of terror was unleashed upon African Americans. Each act of lynching was designed to have a ripple effect beyond the individual person whose life was taken. The perpetrators meant to send a message to the entire Black community. Ritualistic, methodical, perverse in nature—the killings were designed to extinguish both body and soul.

They were also designed to traumatize the living by sending a chill through the hearts of Negroes that would be internalized and passed down from generation to generation.

Very few Black families in the American South and beyond were not touched in some way by lynching. If it was not a family member, a relative, or a friend who was murdered, it was someone in the community who was perhaps only a few steps removed. Of those many instances of lynching during the late nineteenth and early twentieth centuries, each act contributed to the overall effect of violent intimidation. Sometimes the process involved male genitals being severed and ears cut off and kept as trophies or mementos. Sometimes the killings were secretive or clandestine, but just as often they were conducted as public spectacles. Women and children gathered to observe the torture and hanging of a victim. The atmosphere at these events was festive, convivial, with white people gathering to affirm that despite the eradication of slavery as a legal institution, the dictates of white supremacy in the antebellum South would live on.

The fact that these spectacles were sometimes carried out with the acquiescence of legal authorities—politicians, local lawmen, Christian church leaders—undermined the confidence of Negroes in their own country. Lynching was designed to enforce the view that for Black folks

in America, a sense of inferiority and terror was their rightful inheritance.

For the would-be inventors of jazz, this was the contemporary state of affairs. Black folks who sought to make music, to partake in a tradition that had flourished on the plantations and elsewhere for generations, did so with the knowledge that they were creating their sounds within a social context that was malignant and hostile.

The instruments were not new. String instruments, various types of horns, the piano, and drums had been around for decades or, in some cases, centuries. But what these early musicians were attempting to do with these instruments was almost beyond calculation.

It is difficult—perhaps even impossible—for people today to grasp the full immensity of what was taking place. The early formations of jazz—the rhythm patterns, melodic phrasings, and occasionally aggressive syncopation—were revolutionary. It has been commented upon that the creation of jazz was an attempt to codify an entirely new language. But it was more than that: Jazz was an attempt to rearrange the molecular structure of the universe, to obliterate recent history and replace it with expressions of joy, inventiveness, and grace. This new music was nothing less than an attempt to achieve salvation through the tonal reordering of time and space. The music was an affirmation of the human spirit, a declaration of the present tense. As the writer Stanley Crouch wrote, "Nothing says 'I want to live' as much as jazz."

It is a quirk of history that around the same time that jazz was first taking shape, organized crime in America was also in its incubation stage. Organized crime, as opposed to random street crime or crimes of passion, was rooted in the economic system of the country. Almost from the beginning, there existed in the United States a belief among some that capitalism was a shell game that involved the exploitation of labor, using violence if necessary. American citizens in the early part of the twentieth century were having to face the truth, only recently documented, that the country's wealth had been created, in part, through

the institution of slavery and the eradication of indigenous populations and the appropriation of their land. This was the home of the free and the land of the brave, a historical narrative written in blood. The criminal underworld, which became the domain of organized crime, was designed to be a parallel universe to the upperworld, both in its philosophical imperatives and its methods.

By now it is a familiar story: Successive waves of immigration filled out the ranks of organized crime. At the street level, Irish, Italian, Jewish, and other immigrant groups defined the terms of the underworld, but they did not create the system under which it operated. This was created by the white, Anglo-Saxon, Protestant (WASP) elite—the bank owners, land barons, early industrialists, and manipulators of capital who set the tone for a new century. The dye had been cast, and now the tapestry would be woven.

From the onset, social gathering places such as the saloon and, much later, the nightclub became places for the people to meet. It became commonplace for the financiers and owners of these establishments to be people with one foot, or perhaps both feet, in the underworld. Night people like to socialize and do business with other night people, and from the beginning music played a role as a facilitator of these interactions. As jazz evolved in the early decades of the century, moving from plantations and the streets into the saloons and clubs, it moved from the background into the foreground. Jazz was not music that had been carefully fostered in conservatories or academies. It was the music of the people. And the fact that it flourished mostly at night and became associated with vice—bordellos, gambling, drinking, and artful carousing—only added to its charm.

Many white people, from recent European immigrants to native-born Americans, were as enthused by this new music as were African Americans. The idea that jazz could cross over and become a viable source of commerce became a gleam in the eye of gangsters from sea to shining sea.

The intermingling of jazz and the underworld was there from the

beginning—if not musically, certainly as a business enterprise. And it wasn't always about the profit motive. Many gangsters of all ethnicities were drawn to jazz because they loved its energy and its rhythms. They sought to make this music part of their lives by owning the clubs where jazz was played, or by hanging out there, creating an atmosphere that contributed to and became interchangeable with the structural aspects of ragtime, Dixieland, swing, and bebop.

Jazz was eviscerated by white cultural commentators in its first decade of existence. It was thought of as "jig music." And then there was the fact that it was played most commonly in places of ill repute—bordellos and clubs owned and run by Sicilian immigrants. These clubs were often located in vice districts made possible by political bosses who were Irish, another ethnic group often denigrated by the WASP ruling class. To top it all off, as the music developed and became more of a commercial venture, the agents and managers who became important brokers for the musicians were often Jewish, the newest target of bigotry and vilification to arrive on these shores.

The fact that jazz was attacked in the newspapers, with quotes from cultural arbiters, music critics, some politicians, and toadies in law enforcement, usually stemmed from the music's roots in the underworld. Jazz was viewed as being morally suspect. That Negro musicians—in some cases, the sons and daughters of former slaves—were fraternizing with known criminals from the immigrant class was viewed as an unholy alliance. The question was posed: Unless the musicians themselves are of low character, why on earth would they be partnering with men who are ruthless, violent, and hostile to the God-fearing values of polite society (meaning white society)?

The answer to this question was simple: The average Black musician had less to fear from an Italian mafioso inside a club than he did from the average white cracker out on the street. The early twentieth-century musician had less to fear from a gangster than he did from a policeman. For people in the jazz world, the bordello and the honky-tonk were a source of refuge from a society where, among other threats

and indignities, lynching was an ongoing nightmare, and had been for generations.

This book is an attempt to chart a narrative course through the history of both jazz and the underworld, focusing on the interactions between the musicians and the mob. As a criminal phenomenon, the mob, as organized crime became known, involved more than just the gangsters. In the case of its association with jazz, it also involved club owners, managers, business agents, record company representatives, and more. It involved people within the system—political bosses, elected representatives, and cops—who were "on the take," in one manner or another, so as to facilitate the relationship.

The mob's involvement in the music business is a broad and far-reaching saga. For much of the twentieth century, jazz *was* the music business in America; there was no other. There had never been a musical phenomenon in the country like jazz. In later decades, rock and roll, rap, and hip-hop surpassed jazz in commercial popularity and cultural relevance, but for seventy years or so, jazz constituted close to 80 percent of record sales and dominated the airwaves through live radio broadcasts. Furthermore, it was the music Americans wanted to hear when they went out for a night on the town.

In crucial ways, the mob used the popularity of jazz in the 1920s, 1930s, and 1940s as a way to stretch its muscles and expand to cities and small towns all around the country. There was a time when most jazz clubs in cities like New York, Chicago, New Orleans, and Kansas City were "mobbed up." Throughout the century, this model spread to other cities on the coasts (especially in Los Angeles) and in the Midwest (St. Louis, Detroit, Denver, and others). In the Nevada desert, an entire city was founded on the relationship between jazz and the underworld (Las Vegas), and the model was transported beyond the boundaries of the United States to Havana, Cuba, in an audacious attempt by the mob to go international. The relationship between jazz and the underworld became a method by which the mob franchised and created beachheads in various localities. Through all this, the music developed

and evolved according to commercial trends, technological advances, and the artistry of the musicians.

Whether or not this relationship was good for the music or the musicians is a topic of debate. In 1989, on the popular television entertainment program *The Tonight Show with Johnny Carson*, African American bandleader Lionel Hampton made this provocative statement: "History has proven that nobody was better for Black jazz musicians than Al Capone. His nightclubs alone employed hundreds." Hampton was a political conservative, a member of the Republican Party and a prominent supporter of Ronald Reagan. He was also a businessman, the proprietor of a band that hired and fired musicians on a regular basis. To Hampton, the relationship between the gangster and the musician was to be judged as the fulfillment of a capitalist pact. The mobster hired musicians, which was good for the musicians. End of story. But it is not that simple.

From the beginning, the relationship was based on a kind of plantation mentality. The musician was an employee for hire, not unlike the waitresses, busboys, and doormen who worked at the club. By its very nature, this was unfair to the musician. Patrons were drawn to a nightclub not because of the hired help, they were there because of the artistic talents of the musicians. Various musicians' unions in different cities did try to establish work rules and basic pay standards, but more often than not, mob-controlled clubs ignored these regulations. They could get away with it because they exerted undue influence over the political and municipal system under which the clubs operated. Through corruption—payoffs to politicians, cops, and city officials that "greased the wheel"—a mob-affiliated club owner guaranteed that things went his way.

This universe of corruption was the context under which the musicians and the mob entered into their working relationship. Whether or not it was good for the musicians is most fairly assessed through the prism of history. Over the years, things changed. By the 1960s and 1970s, with the civil rights struggle redefining the racial dynamics of

the country, Black musicians could view their relationship with white mobsters differently than they did back in the 1920s and 1930s. The plantation system was exposed for what it was. Despite the comments of a conservative bandleader like Lionel Hampton, for most musicians of color, the relationship between the mob and the music lost its appeal.

Of course, not all jazz musicians were Black. From the beginning, musicians of all ethnicities were drawn to the music. This presented unique challenges for some, especially, as noted in these pages, Italian American jazz musicians. Most notably singers, these artists sometimes found themselves having to navigate their ethnic proximity to the mafia, who, as a subset of the mob, were active participants in the history of jazz almost from the beginning.

This saga is loaded with illuminating anecdotes and a startling cast of characters. On the musical side: Jelly Roll Morton, Fats Waller, Duke Ellington, Cab Calloway, Louis Prima, and many others. On the underworld side: Al Capone, Owney Madden, Legs Diamond, Mickey Cohen, and Bugsy Siegel, to name a few. The story also includes notorious club owners and talent managers like Morris Levy, Jules Podell, and Joe Glaser, men who walked a line between the two realms.

In the first half of the book, the dominant figure is Louis Armstrong, a founding father of jazz. Armstrong pioneered a new sound on the horn and also embodied the spirit of jazz with a stage persona that was joyous and infectious. He was one of the first true stars of jazz and therefore had to navigate the business side of the music, which brought him deeper and deeper into the orbit of the underworld.

The primary figure in the second half of the book is Frank Sinatra. Through his immense talent and what J. Edgar Hoover, director of the Federal Bureau of Investigation (FBI), described as his "hoodlum complex," the singer melded the worlds of music and organized crime in ways that were unprecedented.

Armstrong and Sinatra were shining lights in a constellation of planets and stars, circling around larger spheres of power while dodging

the occasional asteroid. As jazz unfolded throughout the twentieth century, the participants of this saga communed among celestial bodies, but they also wallowed in what the great pianist Mary Lou Williams referred to as "the muck and the mud" of the jazz business.

To jazz purists everywhere, a word about my use of the term "jazz" throughout this book. Some might take exception that a book about jazz includes the likes of Bing Crosby or Joe E. Lewis or, for that matter, Frank Sinatra, whom many probably view as primarily a singer of pop tunes. I could defer here to saxophonist Lester Young, musical genius, hipster, the epitome of a jazzman, who in 1956 said to journalist Nat Hentoff, "If I could put together exactly the kind of band I wanted, the singer would be Frank Sinatra. Really, my man is Frank Sinatra."

In establishing a jazz singer's bona fides, there is no higher praise. Even so, for the purposes of this book, it must be acknowledged that there was a time before the mass proliferation of records, cassettes, CDs, and streaming when American music was not nearly as categorized as it would later become. In the first half of the century, American music was American music. Yes, everyone knew that jazz was a specific musical style unto itself, but it existed as part of the whole. Popular singers like Crosby, Ella Fitzgerald, Sinatra, and even Armstrong freely moved between pop and jazz tunes with little commentary or criticism from critics or the public.

Over the years, a cultural contretemps developed over the definition of what constitutes jazz. Was it exclusively music rooted in blues and swing, or did it, by its very nature, allow for flights of improvisation or borrowings from classical music or music of other cultures?

This book addresses that subject only tangentially; it is not the central motif of this story. I am not writing here as much about jazz the music, as I am jazz the business and cultural phenomenon. Throughout the century, the culture of jazz was infused with all kinds of music and musicians who did not fit a present-day purist's definition of jazz. This book addresses aspects of the business—the nightclubs, management

relationships, dealings with agents and record companies, the relation-ship between musicians and mobsters as human beings—that became the foundation for all that came later.

In the United States, music as a potentially lucrative target for un-derworld exploitation started with the business of jazz.

It could be argued that this is not a book about jazz at all. It is a book about the American story, and the ways in which jazz became such an important compositional element of the narrative. You cannot under-stand America without knowing the history of jazz—or the mob.

Taken together, they are part of the country's origin story, symphon-ically intertwined, like an orchestral extravaganza by Ellington, with harmonic complexity, rich tonal shadings, dissonance, syncopation, and all the other elements that make a piece of music resonate in the imag-ination and remain timeless. Through the striving of numerous musi-cians, club owners, record label executives, and gangsters chronicled in this book, the contrapuntal groove between jazz and the underworld emerges as the heartbeat—and the backbeat—to the American Dream.

PART ONE

MAJOR
CHORD

1

SHADOW OF THE DEMIMONDE

At the age of fourteen, Louis Armstrong of New Orleans was a potent combination of streetwise youth and naïve back-alley urchin with a song in his heart. Already, young Louis had survived the Waif's Home for Boys, an orphanage for wayward children of color, where he'd been sent for firing a .38 caliber pistol into the sky on New Year's Eve, 1913. He meant no harm, but possession of the weapon—his stepfather's—was a violation of the penal codes, so off he went. Louis made the most of the Waif's Home. It was there, in the school band, that he began to play the cornet in earnest. With a determination and discipline that had heretofore not been present in his life, he learned to hit the high notes and hold it there; he perfected his embouchure; and under the tutelage of a serious instructor, he began to develop a voice on the horn—his own voice—that he would perfect in the years ahead. By the time Louis returned to New Orleans after eighteen months at the Waif's Home, he was ready to reconfigure his existence in the city, on the planet, and in this universe through the performance and power of music.

And what music it was! In the last decade, roughly from the turn of the twentieth century, New Orleans had been in the throes of a musical revolution. Few had seen it coming, though in retrospect it was a development that almost seemed preordained. Given the city's unique

cultural inheritance under French, then Spanish, and then American rule, a melting pot of musical flavors had been bubbling for some time. Like the churning waters of the Gulf as the tides enter the mouth of the mighty Mississippi, music in New Orleans was a confluence of rhythms. It wasn't so much a melding of styles as it was the intermingling of powerful forces, a commingling of sources whose collective flow was irrefutable.

It came from the plantations.

Legendary bassist Pops Foster, whose mother was part Cherokee, was born and raised on a plantation near the town of McCall, in Ascension Parish, in south Louisiana. It was on the McCall plantation, in the early years of the new century, that Pops and other children of former slaves began playing a new kind of music on instruments that were often homemade. Pops Foster's first bass was made by his brother, Willie.

[Willie] put a two-by-four through the hollow of a flour barrel and nailed it on. We used some kind of wood for a bridge and carved some tuning pegs to stick on the two-by-four. Down on the two-by-four we bounded some nails in to tie the strings to. We couldn't afford regular strings so we used twine. It had three strings: we'd twist three pieces of twine together for the lowest, then two, then one for the highest. For two or three days we'd rub the twine with wax and rosin before we'd put them on the bass. The first bow was a bent stick with sewing machine thread tied on it. After a while we got a regular bow without any hair on it. For hair we caught a neighbor's horse and cut the hair off his tail, but it didn't work, and we went back to the sewing machine thread. My daddy made us use the bow on it, no plucking.

Pops learned to play the bass using this homemade instrument. Later, his uncle bought him a used cello for $1.50. Pops and his siblings practiced around the plantation. Sometimes they were hired to play at lawn parties and fish frys. In the fields, they played quadrilles, polkas,

rags, lancers, and classical variations they'd heard emanating from the boss man's phonograph. Eventually, friends and fellow musicians came from New Orleans full of excitement about what they were hearing there. Some brought back techniques, sounds, melodies, and musical flights of fancy that were incorporated into what was being played in the fields. A generation was intoxicated; clearly, New Orleans was *the place*. Budding musicians—including Pops Foster—became part of the flow to the big city in search of musical nirvana.

It came from the funeral parades.

New Orleans was known for its many social clubs and associations, some of which had bands that played at community affairs and, most notably, funeral processions that passed through the city's streets on a regular basis. These bands were often exuberant, even during solemn occasions such as a funeral. They emphasized brass instruments—cornets, clarinets, saxophones, trombones, and tubas—which could be played while walking; and percussion, which became the primary purview of "the second line," funeral followers who were not part of the immediate family. Quite often the music on these occasions was semi-improvisational. The players would take a well-known song—say, "When the Saints Go Marching In" (which was itself a melding of popular Negro spirituals)—and take it through endless variations to sustain the tune throughout the course of the procession.

The funeral parades were serious musical displays, and many musicians—especially those who were canny showmen as well as brilliant players—emerged as stars. Cornet player Buddy Bolden, most notably, lit up the sky with his virtuosity and became the first great jazz legend in New Orleans. Young Louis Armstrong first saw and heard Buddy Bolden play at Funky Butt Hall, and like so many others, he was enraptured by the spirit of the music in ways that altered the trajectory of his life.

It came from the bordellos.

Prostitution had existed in New Orleans almost from the beginning. The cultural tradition of fancy bordellos was brought to the region by

the French, who established the convention of a madam, or matron, who presided over the establishment. The best houses had a well-appointed foyer with lace curtains, Oriental carpets, mirrors, and furniture imported from Europe. Here pimps, johns, and ladies of the evening met, drank champagne, and smoked fine cigars while awaiting the main event in a room upstairs or down the hall. New Orleans had dozens of high-class bordellos, and they all had solo piano players—or sometimes a player piano—and occasionally a singer. The style of the day was a jaunty form of music known as ragtime, and it would formulate one of the major tributaries that led to the creation of modern jazz.

In the bordellos, the pianists were known as "professors," and many would become musical deities in their own right. Ferdinand Joseph LaMothe, better known as Jelly Roll Morton, did well for himself as Professor Jelly Roll playing at some of the best sporting houses in town. It was here, expanding on the parameters of ragtime, that Morton learned about music and about life.

Those years I worked for all the houses, even Emma Johnson's Circus House, where the guests got everything from soup to nuts. They did a lot of uncultured things there that probably couldn't be mentioned, and the irony part of it, they always picked the youngest and most beautiful girls to do them right before the eyes of everybody . . . A screen was put up between me and the tricks they were doing for the guests, but I cut a slit in the screen, as I had come to be a sport now myself and wanted to see what everybody else was seeing.

It came from Africa.

On Sundays in what was once known as Congo Square (now part of Louis Armstrong Park), Blacks gathered to play the drums, chant, sing, and dance. These gatherings involved a near direct transference of rhythm patterns and dance movements from Africa, where rhythmic music has always been as much a spiritual undertaking as a social one.

This tradition of drum circles in Congo Square continued throughout much of the nineteenth century, right up until the birth of jazz as the city's popular musical form. The renowned Creole reed player Sidney Bechet, born in New Orleans in 1897, eventually found fame and a livelihood on a world stage, but he never forgot his roots.

> My grandfather, that's about the furthest I can remember back. Sundays when the slaves would meet—that was their free day—he beat out rhythms on the drums in the square—Congo Square they called it . . . He was a musician. No one had to explain notes or feeling or rhythms to him. It was all there inside him, something he was always sure of.

Congo Square was a place of profound cultural expression, and it was also where, on the other days of the week, slave trading took place. Thus, in New Orleans, music and slave commerce were inexorably intertwined; the ground on which the roots of jazz found fertile soil was also a locale of capitalist exploitation and sorrow. Eventually, this bitter reality would become the emotional foundation of the blues, another musical form whose folkloric impetus comes from the African continent.

The kind of vocal blues made famous by Ma Rainey, Bessie Smith, and many others was not indigenous to New Orleans; the blues singing tradition mostly came from the Delta. But the harmonic and emotional content of this music became the soulful core of jazz in the Crescent City. In later years, when people made note of a certain New Orleans sound or New Orleans style of jazz, they were, knowingly or not, referring directly to those elements of the blues that found their way into the bloodstream of the new music.

Little Louis

Back o' Town was a Black slum neighborhood in the city renowned for its legacy of poor sanitation and municipal neglect. During the city's

periodic epidemics of yellow fever throughout the nineteenth century, Back o' Town was hit hard. In such a densely populated area, the disease spread easily, and many people became feverish; unable to hold down food, they succumbed to diarrhea and nausea. Quickly, they wasted away and died a horrible death. (From dust they came and to dust they returned.) This tradition of pestilence and institutional dereliction of duty in what passed for city services continued into the new century. Local inhabitants were proud of their neighborhood, which was as commercially active as any Black neighborhood in the city. But inhabitants often found themselves on the losing end of battles with rats, stray dogs, cockroaches, water bugs, and assorted vermin drawn by horse manure and other effluvia that piled up in the streets. The other problem was flooding. Located between the Mississippi River and Lake Pontchartrain, Back o' Town was frequently underwater due to poor drainage.

It was in this neighborhood that Louis Armstrong, born August 4, 1901, was first introduced to the world. As a child, he accepted the good with the bad. The physical environment of Back o' Town was a mess, but this was also a vibrant red light district teeming with humanity.

Little Louis, as he was known to his family and friends, had a hungry curiosity and an open heart almost from the beginning. As a kid, Armstrong was compelled to navigate an environment that was rambunctious and sometimes threatening. James Alley, the little street where Armstrong's home was located, ran through a part of the neighborhood known as the Battlefield. In a memoir published in 1954, Armstrong remembered:

[They called it the Battlefield] because the toughest characters in town used to live there and would shoot and fight so much. In that one block between Gravier and Perdido Streets more people were crowded than you ever saw in your life. There were church people, gamblers, hustlers, cheap pimps, thieves, prostitutes and lots of children. There were bars, honky-tonks and

saloons, and lots of women walking the streets for tricks to take
to their "pads," as they called their rooms . . . [My mother] told
me that the night I was born there was a great big shooting
scrape in the Alley, and the two guys killed each other.

Little Louis's parents split when he was a child; there is no record
that they were ever married. The future jazz legend was raised in Back o'
Town primarily by his grandmother. He later moved in with his mother,
whom he worshipped to the point that he was ridiculed as a "momma's
boy" by other kids in the neighborhood. This led to a fistfight, which
Armstrong claims to have won, but he would later admit he was not
a fighter by nature. He was a fun-loving kid with a big smile who was
popular with the many streetwalkers, pimps, and working-class citizens
who populated his neighborhood.

In the middle of the fifth grade, Armstrong dropped out of school.
His mother hardly noticed. When she wasn't working as a domestic for
a white family in the Garden District, she was turning tricks with men
she brought home. Louis and his sister referred to these men euphemis-
tically as "stepfathers." "All I had to do was turn my back and a new
'pappy' would appear," Armstrong wrote in his memoir, *Satchmo: My
Life in New Orleans* (published in 1954). "Some of them were fine guys,
but others were low lives." Young Louis took to the streets and got by
on charm and sincerity. He got a job selling newspapers in the neighbor-
hood and fell in with an older crowd of boys.

When we were not selling newspapers we shot dice for pennies
or played a little coon can or blackjack. I got to be a pretty
slick player and I could hold my own with the other kids. Some
nights I would come home with my pockets loaded with pen-
nies, nickels, dimes, and even quarters. Mother, sister, and I
would have enough money to go shopping. Now and then I
even bought mother a new dress, and occasionally I got myself
a pair of short pants in one of the shops on Rampart Street.

Little Louis soaked up the sights and sounds of the city. He sought out the music, which was prevalent in the saloons and honky-tonks, which, technically, he was prohibited from entering due to his age. But the music often spilled out into the street, and Armstrong saw the effect it had on people. Before he'd ever even touched a cornet, he was drawn to the sound of that instrument and paid careful attention to the great players he heard: Bolden, Bunk Johnson, and especially Joe "King" Oliver, who would one day become a significant mentor to the aspiring young musician.

At the time, Armstrong could not afford any kind of instrument, much less a cornet. But he and his closest friends had been bit by the bug, so they formed an impromptu vocal quartet that strolled the streets singing harmonies and songs for spare change. Armstrong and his friends didn't know it, but they were engaged in an early twentieth-century version of an American tradition that would continue, in updated forms, for the next hundred years. Whether it be doo-wop singers harmonizing on a street corner in the Bronx or rappers spitting out lyrics in a park in South Central L.A., it was an organic way for new vocal traditions to take shape and give birth to entirely new musical forms.

We began by walking down Rampart Street between Perdido and Gravier. The lead singer and the tenor walked together in front followed by the baritone and the bass [Armstrong was a tenor]. Singing at random we wandered through the streets until someone called to us to sing a few songs. Afterwards we would pass our hats and at the end of the night we would divvy up. Most of the time we would draw down a nice little taste. Then I would make a bee line for home and dump my share into mama's lap.

In the honky-tonks and saloons, Armstrong noticed something right away: The best musicians—Joe Oliver, for example—played in the clubs that were frequented by a certain breed of clientele. The term

used back then to describe the gamblers, pimps, and "players" of distinction was "sporting men"; later generations would refer to this breed as "gangsters." They had a certain style, and they had power. In fact, many of them seemed to own the very honky-tonks where the best musicians plied their trade. Armstrong was too young to fully comprehend the stratified layers of this world, but he sensed instinctively that succeeding in this adult realm of music involved learning the lay of the land. It was a task he would spend nearly the rest of his life seeking to master.

By the time he returned from the Waif's Home for Boys, Armstrong had set his sights on a life in music. Thanks to his time at the orphanage, he could play the cornet with the skills of an adult, and he had begun to develop talents as a performer. People loved to watch this young kid play his horn. By the age of fourteen, he had established a reputation locally as a musical prodigy.

One night, a friend named "Cocaine" Buddy Martin told him about a gig at a local honky-tonk in the city's red light district. "The boss man's name is Andrew Pons," said Cocaine Buddy. "He is one of the biggest operators in the red light district, and he ain't scared of nobody. He wants a good cornet player . . . All you have to do is put on your long pants and play the blues for the whores that hustle all night. They come in with a big stack of money in their stockings for their pimps. When you play the blues they will call you sweet names and buy you drinks and give you tips."

It all sounded good to Little Louis. He went to work at Andrew Pons's honky-tonk and established a following there.

Armstrong was with Pons late one night closing up the honky-tonk when he noticed a gaggle of rough-looking characters across the street. The men were Black, and they seemed to be looking in the direction of Pons's saloon with hostile intent.

Louis knew that Pons was enmeshed in some kind of dispute with a rival businessman in the district named Joe Segretto. Rumor had it that Segretto was affiliated with the Matranga family. Everybody in New Orleans knew about the Matrangas. On the street, their name was often

whispered. The mafia had been entrenched in New Orleans for decades, and the Matrangas were the premier mafia faction in the city. They were respected in some quarters, feared in others. There had been many murders attributed to mafia wars in the city. Even Little Louis, who had been away at the Waif's Home in recent years, knew that you did not want to be on the wrong side of the Matrangas. If you were running a honky-tonk or dancehall in the district, it was not unlikely that you would have to deal with the mafia. Andrew Pons knew this, but he refused to go along.

Armstrong noticed one of the men across the street raise his arm and—*bang*. He fired off a shot in the direction of Andrew Pons and Armstrong. Louis felt the bullet whiz past his head, and he froze.

"Well I'll be goddamned," said Pons, as the men across the street fired more shots, "those Black bastards are shooting at me."

Pons whipped out a revolver and returned fire. The other gunmen ran, and Pons chased after them, a volley of shots back and forth ringing out into the dark night.

Armstrong had not moved. A flock of bystanders ran up to him and asked, "Were you hit? Are you hurt?"

Turning his head slightly to look at the concerned citizens, Louis said nothing. Then he fainted.

> I thought the first shot had hit me . . . When I came to I could still hear the shots coming from Howard and Perdido and the cries of the colored boys. They were no match for [Pons]: he was shooting well and he wounded each of them. When he stopped shooting he walked back to his saloon raging mad and swearing to himself.

Louis had not been hit. He went home that night, happy to be alive. As he noted in his memoir, "I continued to work in [Pons's] honky-tonk, but I was always on the alert, thinking something would jump off any minute."

To Armstrong, the incident became a cautionary tale. It had not escaped his notice that the gunmen were Black, likely hired shooters for the Matranga family. This was disturbing, the mafia contracting out jobs to local hoodlums. Somehow, to Louis, this seemed unfair. How were you supposed to know who your enemies were if you couldn't tell by the color of their skin? Among other things, this suggested to Little Louis that the world was a more complicated place than he had imagined. And also more dangerous. He very easily could have died. "It was days before I got over the shock," he noted.

From this point onward, Armstrong realized there was something he would need if he were to have the long career in jazz about which he dreamed.

Protection.

Kingdom of Jass

It wasn't until 1917 that the word "jazz" entered the nomenclature of the city of New Orleans through the local press, and even then it was initially spelled "jass" in the newspapers. By then, this style of music had been cooking for at least two decades. No one had been able to assign a name to this ongoing musical fermentation because it was in such a vibrant state of transformation. Fans of the music weren't sure if what they heard one week was related to what they had heard the week before. The music was building upon itself, adding new chord changes, patterns of syncopation, instrumentation (the trumpet hadn't even entered the picture yet), accents, and shadings on a near daily basis. For a phenomenon like this to take place, with musicians regularly listening to and influencing one another, a certain locality to exhibit the music and somehow turn it into a viable commercial venture was required. Thus was born a district so notorious that many, to this day, refer to it as the most legendary red light district that ever was.

Storyville, as the district became known, was not designed specifically to showcase this new musical form that was rising from the gutters

to emanate from street corners, parks, basements, rooftops, and honky-tonks. That, as it turned out, was a happy accident. The district was created primarily as a way to contain and control vice in the city. The most ubiquitous endeavor in this regard was prostitution.

By the late nineteenth century, whorehouses of many levels and varieties were commonplace in New Orleans, and they were spread throughout the city. This created problems for the city's businessmen and promoters. Wrote Al Rose in *Storyville, New Orleans*, his definitive history of the district: "The financial stability and social welfare of the city were seriously threatened by the wide dispersal of harlotry. Specifically, real estate values were seriously disrupted by the unpredictability of the 'moral' development of neighborhoods. A man might purchase a home for his family on a quiet street today and find himself neighbor to a brothel tomorrow."

Not everyone in the city liked the idea of a centralized vice district. The tight sixteen-block radius that comprised Storyville had, in fact, been created as a compromise with reformers, who would have preferred to see prostitution completely outlawed in the city. But the world's oldest profession was so deeply entrenched in New Orleans, such a significant aspect of the city's history and culture, that it was an irrefutable fact of life. The man who led the charge to stamp out prostitution and other forms of vice was an alderman named Sidney Story. As a compromise, Story was the one who put forth the ordinance in 1897 that led to the creation of a district. He did so reluctantly as a means to, as he put it, "lessen the blight" of vice throughout the city. For his troubles, his detractors forever after referred to the district as "Storyville." Much to Story's consternation, the name stuck.

Along with everything else, the alderman hated jazz, which he saw as a musical component of the city's criminal underworld.

The district, located in the northern reaches of the French Quarter, was already home to many honky-tonks, dancehalls, and bordellos. The creation of Storyville did not involve constructing new buildings or altering the city landscape in any way. What was new was that, within the

district, prostitution was now allowed. The de facto legalization of this previously illegal practice inevitably gave rise to new levels of permissiveness in the area. Gambling parlors and drug dens became commonplace, and the district's honky-tonks and saloons became the central breeding ground for a new class of criminal hustler in the city.

For such an environment to thrive, organization was required. No one was yet using the term "organized crime," but everyone understood that for a district such as Storyville to reach its maximum commercial potential, it needed a potentate, or boss, who could bestow power, secure the necessary city licenses to run a business in the area, and settle disputes. There were few people who had the kind of skills and reputation to serve in this capacity. The man who eventually filled the role was Thomas Charles Anderson.

Anderson was born on November 22, 1858, and raised in the neighborhood known as the Irish Channel. He was the son of Irish and Scottish immigrants, and his beginnings were humble. Born in harsh poverty, from early on in life he showed a proclivity toward social interaction as a means of advancement. His first known job, as a preteen, was selling copies of the *Daily Picayune* newspaper on street corners. This was the same job through which Little Louis Armstrong set out into the social universe. These two men, Anderson and Armstrong, born in poverty in separate parts of the city, would come to play an essential role in setting a course for the relationship between jazz and the underworld—not only in New Orleans, but, by extension, all around the United States.

Anderson was ambitious: By the time he was a teenager, he had advanced to serving as an errand boy for the brothels in his neighborhood. These were not the grandiose bordellos of Storyville and the French Quarter but rather chippie joints patronized primarily by Irish immigrants who had been lured to New Orleans to dig the city's system of levees and canals. The women who worked in these establishments required opium and cocaine to smooth the edges of their day; young Tom Anderson made regular runs to the local pharmacy to obtain these

items, both of which could be legally purchased at the time in specified doses.

As a hustler on the make, Anderson rubbed elbows with some shady characters, but he also cultivated a parallel existence. He knew Irish cops whom he met in front of the city's main courthouse while peddling newspapers. They liked the young kid with his mop of reddish-brown hair and sociable manner, especially when he played a role in the arrest and conviction of a local thief. Having witnessed an act of petty thievery on Basin Street, Anderson pointed out the thief's hiding place for the cops and even agreed to testify in court. He received a small financial reward for his services but, more important, established himself as a friend of the system.

By the late nineteenth century, Anderson had begun his legitimate career path as a bookkeeper for an oil company. But a young man with his drive and ambition was not destined to serve as a mere employee for someone else. Together with a partner, he became the proprietor of his own small oil company, which sold everything from salad oil to axel grease and whose motto was "The Only Independent Oil Company Not Controlled by Trusts or Monopolies."

By now Anderson was a man about town. He greased his hair and parted it in the middle, and he sported a luxurious handlebar mustache, which was de rigueur among the city's sporting men. He married early (at age twenty-two), had a child, and then lost his wife to typhoid fever. Now a widower, he put his child in an orphanage and began what would become a lifelong pursuit: the seduction and conquest of some of the city's most renowned madams.

The manner by which Anderson elevated himself to become boss of the city's underworld was a classic tale. It was a pattern that would play out in many U.S. cities in the early twentieth century. In some ways, it is the story of the mob itself: how organized crime evolved to become such a force in modern urban America.

The use of the term "mob boss" is believed to have originated in

New York City, in the infamous Five Points district, but it was based on a phenomenon that was unfolding in a number of American cities. It all started with what became known on the street as a "mob primary."

An aspiring political leader would stand on a soapbox or overturned milk crate and orate about the events of the day. Eventually, if all went well, he would attract a following that would become the basis for his running as an alderman or other candidate for public office. This person was often a saloonkeeper who was willing to offer a free drink, a sandwich, a cellar mattress on which to sleep, or all of the above, in exchange for the pledge of a vote. The type of person to most benefit from this sort of handout was usually a rough character—a bum, a homeless person, a thief, or a gangster. Thus, the mob boss, or mobster, became the leader of a less than savory constituency that was, nonetheless, powerful enough to sway local elections.

The arrangement worked both ways. By aligning himself with a rising and powerful mob boss, the street hoodlum was now also a mobster. He was "connected," part of a system in which he now had a vested interest. Ostensibly, he would now have the kind of protection, or "juice," that was necessary for him to operate a vice business, such as a house of prostitution, gambling den, burglary ring, or any manner of quasi-criminal enterprise popular throughout the underworld.

This symbiotic connection between the upperworld of politics and business and the underworld of vice and crime would become the foundation for organized crime in America. It also became the nexus of interests that launched the career of Tom Anderson.

In 1892, Anderson opened a restaurant and bar strategically situated at 12 Rampart Street, at the entrance to what would soon be known as Storyville. The place was called Anderson's, and it would become a structure as familiar as any in Storyville. Located directly across from the Rampart Street train station, the bar was literally the first thing a person saw when they disembarked, and Anderson's became known as "the gateway to Storyville." It was the first saloon/cabaret in

the United States to be illuminated by electric lights. With more than one hundred light bulbs in the ceiling, plus an electric lighted sign outside, Anderson's was a monument to Thomas Edison and a promise of things to come: vice and politics arm in arm under the brilliant, man-made radiance of American ingenuity.

For Big Tom, the bar was the culmination of all the relationships and alliances he had cultivated as a street hustler, businessman, and backroom politician. The bar was an immediate success. Anderson's sold plenty of beer, rye, and whiskey, and it became a central gathering place for the mob in New Orleans. Pimps, mafiosi, off-duty cops, political figures, and others who walked the fine line between the upperworld and the underworld became its favored clientele. And then there was the music. According to Sidney Bechet:

> [Anderson] had practically everything there, card rooms, bar, a hop room—and he had music. Sometimes you'd hear accordion, guitar, mandolin, sometimes bass, maybe a violin; other times you'd hear someone singing there. It wasn't a whorehouse but you'd hear *whorehouse* music there.

Over the following decade, Tom Anderson's influence and base of power continued to grow. He acquired a financial interest in a lavish bordello at 172 Customhouse (Iberville) Street operated by one of the most renowned madams in town, Josie Arlington. It was rumored that they were lovers. Anderson opened two more saloons, one called Anderson's Annex (later renamed the Arlington Annex in honor of Josie), and the Astoria Club, on South Rampart Street in the city's Negro section, soon to be known as Black Storyville. If all this wasn't enough, in 1904, after Storyville had been in existence for seven years, Anderson was elected a representative of the Fourth Ward in the state legislature. He became a ranking member of the Ways and Means Committee and a member of the Committee on City Affairs. In the Fourth Ward, which

included Storyville, his power was ubiquitous. Many began referring to Storyville as "Anderson County."

Big Tom was no absentee landlord. He loved to socialize, and his establishments became important showcases for "jass," or jazz, in its crucial period of incubation as a national art form.

By 1910, there were more than sixty honky-tonks, dancehalls, or private clubs that showcased live music in the district. The musicians were almost exclusively Black, but the clientele was mixed race. From the beginning, jazz became identified as race-mixing music, an unusual development, perhaps unprecedented, where Blacks and whites came together to celebrate what was an authentically African American form of expression. The clubs were all owned by white men. And the type of men who owned the clubs were often associated with vice—prostitution, gambling, opium and cocaine, unfettered drinking, and whatever else could be used to help turn a profit.

The music, and what it represented, was not loved by everyone. In polite society—meaning white society—jazz was sometimes characterized as a threat. An editorial in the *Times-Picayune*, dated June 17, 1917, was unequivocal in its disdain.

Why is the jass music, and, therefore, the jass band? As well ask why is the dime novel or the grease-dripping doughnut. All are manifestation of a low streak in man's tastes that has not yet come out in civilization's wash. Indeed, one might go further, and say that jass music is the indecent story syncopated and counterpointed. Like the improper anecdote, also, in its youth, it was listened to behind closed doors and drawn curtains, but, like all vice, it grew bolder until it dared decent surroundings, and there was tolerated because of its oddity . . . It behooves us to be last to accept this atrocity in polite society, and where it has crept in we should make it a point of civic honor to suppress it. Its musical value is nil, and its possibilities of harm are great.

The naysayers could do little to impede the popularity of the music. The more polite society sought to stigmatize the culture of jazz, the more popular it became among people looking for that rare item: an authentic experience that was not being dictated to them by government fiat, the church pulpit, a judge's bench, or some other mechanism of social control. To those who loved the music, jazz was real. For others, it represented that most American of prospects: a business opportunity.

Jelly Roll Blues

In 1910, Tom Anderson opened a new bordello adjacent to Arlington's Annex; it was run by Hilma Burt, one of the district's more ambitious madams. According to master pianist Jelly Roll Morton, "Hilma Burt's was on the corner of Customhouse and Basin Street, next door to Tom Anderson's Saloon—Tom Anderson was the king of the district and ran the Louisiana legislature, and Hilma Burt was supposed to be his old lady."

Burt was indeed Anderson's "old lady" (mistress)—one of many, perhaps, but enough of a main squeeze that he outfitted her with one of the swankiest bordellos on Basin Street. Noted Morton:

> Hers was no doubt one of the best paying places in the city and I thought I had a very bad night when I made under a hundred dollars. Very often a man would come into the house and hand you a twenty- or forty- or a fifty-dollar note, just like a match. Beer sold for a dollar a bottle. Wine from five to ten . . . Wine flowed much more than water—the kind of wine I'm speaking about I don't mean sauterne or nothing like that, I mean champagne, such as Cliquot and Mumm's Extra Dry . . . I'm telling you this tenderloin district was like something that nobody ever seen before or since.

Born on October 20, 1890, as Ferdinand LaMothe, Jelly Roll Morton came from Creole stock. He claimed to have a French lineage in

New Orleans going back four decades, but Morton had the reputation of being a fabulist. He didn't need to embellish: According to the public record, and those who knew Morton, his life and personality were the stuff of legend. In 1938, when the musical anthropologist Alan Lomax tracked down and interviewed a mostly forgotten Jelly Roll Morton about his life and career for the U.S. Library of Congress, Morton claimed to have invented jazz. It was a provocative statement that stirred up much resentment and led many to view the pianist as an egoist, but the fact is that Morton, as much as anyone, could lay claim to such a bold assertion.

Aside from his musical contributions as the first composer of recognizable tunes that became some of the most prominent early jazz standards ("King Porter Stomp," "Doctor Jazz," "Original Jelly Roll Blues," to name a few), Jelly Roll cut quite a figure. Though he was slight in stature—reed thin, like a bantamweight boxer—Morton made sure he was noticed when he entered a room. He wore embroidered ties, tailored suits (he claimed to own dozens of them), a diamond-encrusted cravat, and a silk hanky in his breast pocket. His complexion was café au lait, on the lighter side, which made him employable in many of the whorehouses where dark-skinned musicians were not allowed. He conked his hair or slicked it back in the upwardly mobile Negro style of the day. Embedded in his front tooth was a half-carat diamond that sparkled every time he smiled. His teeth were otherwise scraggly and sharp, like a ferret's. When Jelly Roll entered an establishment, he had the look of an elegant wharf rat.

At the same time he was emerging on the scene as a brilliant musical force, Morton staked his claim among the city's sporting men. The nickname Jelly Roll came from his supposed popularity with women, "Jelly Roll" being a slang term for "vagina." (The more accurate street translation might be "pussy.") Said Johnny St. Cyr, one of the district's most popular banjo/guitar players, "Jelly lived a pretty fast life. In fact, most of those fellows round the district did. They were all half-way pimps anyway."

In his memoir, Morton freely concedes that he was a pimp. In the district, a pimp was known as a "P.I." Jazz pianists, apparently, were prone to a life as procurers, as they could keep an eye on their stable of girls while playing at a bordello. Equal to Morton's reputation as a P.I. was his notoriety as a pool hustler and a gambler. Paul Barbarin, a New Orleans drummer, said that Morton was "mostly a gambler . . . He'd lose maybe four or five hundred dollars" a night, and that proved to be his "downfall—easy come, easy go." Danny Barker, renowned musician and chronicler of early New Orleans jazz, noted that Morton "took on the lifestyle of the notorious night people of the underworld." Pianist Earl "Fatha" Hines, who got to know Jelly Roll later in Chicago, said that in the early days of jazz, "you had to act bad whether you were bad or not," meaning you had to carry yourself like a gangster. "Jelly Roll Morton found that out long before I did," said Hines, "and that's why he carried a gun and talked loud."

Morton was not the only musician to carry a pistol; many did. But unlike most others, his was not solely for protection against robbers and ruffians. Once, during a rehearsal with his band, Morton became frustrated when his trombonist, Zue Robertson, refused to play the melody of one of his tunes the way he wanted it. After trying to convince Robertson through verbal means, Morton chose another way. He took a large pistol from his pocket and placed it on top of the piano. On the next take, Robertson played the melody note for note as Jelly Roll wanted it.

Morton's persona as a hoodlum and pimp was unusual: The story of jazz and the underworld is most often a case of gangsters and mobsters influencing the business of jazz from above as club owners, managers, record label owners, et cetera. Morton's personal proclivities suggest another aspect: hoodlums who rose from the streets to become practitioners of the music.

In his historic interviews with Alan Lomax (later adapted into the book *Mister Jelly Roll*), Morton describes his introduction to jazz in New Orleans in a way suggesting that gangsterism—and the violence associated with it—was part of the equation from the start. According to

Morton, the jazz parades, in particular, sometimes devolved into armed combat, which he describes as if they were something out of Herbert Asbury's *Gangs of New York*:

> It's a funny thing that the second line marched at the head of the parade, but that's the way it had to be in New Orleans. They were our protection. You see, whenever a parade would go to another district the enemy would be waiting at the dividing line. If the parade crossed the line, it meant a fight, a terrible fight. The first day I marched a fellow was cut, must have been a hundred times. Blood was gushing out of him same as from one of the gushers in Yellowstone Park, but he never did stop fighting . . . And about that time the broomsticks and brick-bats would start to fly, the razors would come into play and the seven shooters—which was a little bit of a .22 that shot seven times—would begin popping . . . Sometimes it would require a couple of ambulances to come around and pick up the people that was maybe cut or shot occasionally.

Morton understood that to play jazz in the streets, the bordellos, and the clubs was not for sissies. Between the late-night clientele in the district who might be drunk or stoned, and the volatile nature of race mixing in clubs and bordellos where the patrons were white and the performers were Black, the possibilities of "misunderstandings" and/or confrontations were ever present.

Even so, Jelly Roll Morton insisted on going his own way. Other musicians sometimes preferred playing in clubs that were "connected"— that is, mobbed up or owned by underworld figures. To some, these clubs were safer; they were protected. But Morton didn't see it that way. Later in life, he complained about being "robbed of three million dollars" by mobster club owners, as well as agents, managers, and other vultures. For this reason, he preferred to remain independent. Which also had its drawbacks.

In the mid-1910s, Morton left New Orleans and ventured out on a tour that took him to the West Coast, from Los Angeles to Tacoma to Seattle and Vancouver, British Columbia. Serving as one of jazz's first unofficial ambassadors, he spread the gospel far and wide. Eventually, he wound up in Washington D.C., where he opened a club of his own called the Jungle Inn. The co-owner of the club was a woman named Cordelia, and Morton's wife, Mabel, worked behind the bar. There was one night that Mabel would never forget:

This Cordelia, she never would back up Ferd [short for "Ferdinand," that is, Jelly Roll]. He had put a cover charge on the Jungle Inn to keep the riff-raff and the roughnecks out of the place, but she would let them come in anyhow even when they wouldn't take their hats off . . . One night one of those riff-raff got to acting rowdy and Ferd called him out. The fellow then used some bad language. Ferd slapped him. Then he sat down at the piano and began to play and the fellow slipped up behind him and stabbed him. Stabbed him the first time in the head and, when Ferd turned, he stabbed him just above the heart. Then Ferd grabbed him and they went down.

I was back of the bar mixing a Pink Lady when I heard the scuffle. When I came out from behind the bar I couldn't hardly tell which was which, they were so covered with blood. The blood was just gushing out of Ferd like out of a stuck beef. I took the heavy glass ashtray and I struck this young man hard as I could in the head. Then we pulled Ferd away—Ferd was on top by then—and Ferd grabbed an iron pipe and was going to kill him, but Cordelia grabbed Ferd and the fellow got away.

The assailant escaped and was never charged. Morton was rushed to the hospital. He survived the injuries, but, according to Mabel, there were physical repercussions that lasted a lifetime.

It is possible—likely, even—that if the Jungle Inn had been a mob club, an encounter like the assault on Morton never would have happened. There would have been bouncers on hand—though in many cases public knowledge that a club was connected and/or protected by the mob was enough to keep it safe. Morton had long preferred to not be under the thumb of "the syndicate," or any other controlling interest that might rip him off. In terms of security, this meant flying without a net. He learned the hard way: a sneak attack from a maniac with a long blade. Go your own way at your own risk.

"Blow that Quail!"

Louis Armstrong did not need to be told that the honky-tonks that were connected were the honky-tonks where you wanted to be. He learned this from King Oliver, whom he worshipped. Oliver was twenty years older than Armstrong. In many ways, the veteran cornetist and bandleader was both a mentor and father figure to the young musician. "I never stop loving Joe Oliver," said Armstrong. "He was always ready to come to my rescue when I needed someone to tell me about life and its little intricate things and help me out of difficult situations."

Oliver had a big, bald head that he often topped with a bowler hat. He could be formal and stern, but he had a playing style on the horn that was raw and spontaneous. His genius was arranging his playing in such a way that it melded in interesting ways with others in the band. As a composer and arranger, Oliver created musical configurations that gave new meaning to jazz. His band, which he co-led with trombonist Kid Ory, was at the vanguard of the new music.

Armstrong would come to watch King Oliver play nearly every night at Pete Lala's, one of the most renowned jazz venues in Storyville. Clarence Williams, a pianist born in Plaquemine, Louisiana, who was part of the deluge of musicians who had arrived in New Orleans around the turn of the century, remembered Lala's as the center of the universe:

Round about 4 A.M., the girls would get through work and meet their P.I.'s—that's what we called pimps—at the wine rooms. Pete Lala's was the headquarters, the place where all the bands would come when they got off work, and where the girls would come to meet their main man. It was a place where they would come to drink and play and have breakfast and then go home to bed.

Armstrong also remembered Lala's:

These pimps and hustlers, et cetera, would spend most of their time at [Lala's] until their girls would finish turning tricks in their cribs . . . They would meet them and check up on the night's take . . . Lots of prostitutes lived in different sections of the city and would come down to Storyville just like they had a job . . . There were different shifts for them . . . Sometimes two prostitutes would share the rent in the same crib together . . . One would work in the day and the other would beat out that night shift . . . And business was so good in those days with the fleet sailors and the crews from those big ships that come in the Mississippi River from all over the world—kept them very, very busy.

Everyone knew that Pete Lala's was a mob-connected club. The owner was Peter Ciaccio, a Sicilian immigrant, which was confusing because there were two other clubs in the district owned by men named Lala, including Big 25, another popular club with a business license issued to John T. Lala. All of these localities were part of a group of clubs owned and operated by Italians. Rightly or wrongly, clubs in the district owned by Italians were believed to be mafia-connected. King Oliver didn't even need to tell Little Louis that these clubs were the place to be. The connected clubs were, ostensibly, the most reliable when it came to their dealings with the musicians.

Armstrong knew this partly from experience. One of the first places he held a steady gig was at Matranga's, which was located in Black Storyville.

Matranga's was nothing like Pete Lala's, which was cavernous and well appointed. Matranga's was a barrelhouse saloon that had been in existence since at least the late 1880s. Its clientele was primarily Black though the ownership was Sicilian—a common arrangement in New Orleans at the time. Being a Matranga, the owner of the club, Henry Matranga, was "a man of respect." Remembered Armstrong, "Henry Matranga was sharp as a tack and a playboy in his own right. He treated everybody fine, and the colored people who patronized his tonk loved him very much."

Armstrong knew that Matranga's was a mafia club. Using King Oliver's example as his guide, he not only tolerated the fact that the club was connected, he preferred it. In his memoir, he gave an example of why. One night at Matranga's, a fight broke out that was quelled by the club's bouncer, who went by the name of Slippers. It was Slippers, as Armstrong remembered it, who got him the gig at Matranga's in the first place. Slippers may have been a hulking thug, but he loved jazz.

[He] liked my way of playing so much that he himself suggested to Henry Matranga that I replace the cornet player who had just left. He was a pretty good man, and Matranga was a little in doubt about my ability to hold the job down. When I opened up, Slippers was in my corner cheering me on. "Listen to that kid," he said to Matranga. "Just listen to that little son-of-a-bitch play that quail!" That is what Slippers called my cornet . . . Sometimes when we would really start going to town while Slippers was out in the gambling room in the back, he would run out on the dance floor saying: "Just listen to that little son-of-a-bitch blow that quail." Then he would look at me. "Boy, if you keep on like that, you're gonna be the best quail blower in the world. Mark my words."

The night a fight broke out, Slippers was in fine form. To Armstrong, it was further example of why a jazz musician was better off in a mob-controlled club.

That night, a ditchdigger from one of the levee work camps came into the place and gambled away all of his earnings in the back gambling room. Slippers had his eye on the guy from the moment he entered. The guy became angry upon losing, as gamblers sometimes do; he vented his frustration in the bar area by threatening to rob everyone in the place. Slippers tried to reason with the fellow: "Shut your mouth, friend, or you'll be out of here on your back side." The guy quieted down, but after a few minutes he was at it again, claiming that the house was running a crooked game. So Slippers grabbed the guy by the scruff of his neck and led him aggressively toward the door.

The guy had a gun, a large .45, which he pulled out and fired wildly in the direction of Slippers.

Through all of this, Louis Armstrong and his band were playing some down-home barrelhouse blues—until the shots rang out. Color drained from the face of Boogus, the piano player, while Garbee, the drummer, started to stammer, "Wha, wha, wha . . . what was that?"

"Nothing," said Louis, trying to act nonchalant, though he also was terrified.

Slippers pulled out his pistol and fired back; he winged the ditchdigger in the leg. The guy went down. Slippers walked over and relieved the man of his gun, then continued what he started by tossing the man out onto the sidewalk. A horse-drawn ambulance arrived and the troublemaker was carted off to the hospital. Said Armstrong, "Around four o'clock the gals started piling in from their night's work. They bought us drinks, and we started those good old blues." In some honky-tonks, a shooting was a startling event that would lead, at least, to the club closing for the night. Not at Matranga's.

To Armstrong, it was a mutually beneficial alliance: "One thing I always admired about those bad men when I was a youngster in New Orleans is that they all liked good music."

Being aficionados of jazz was one thing, but even more significant was the role men like Henry Matranga could play in making it possible for Armstrong to function in an unjust world.

One night when Armstrong wasn't even scheduled to perform at Matranga's, he stopped in for a beer.

> The tonk was not running, but the saloon was open and some of the old-timers were standing around the bar running their mouths. I just said hello to Matranga when Captain Jackson, the meanest guy on the police force, walked in. "Everybody line up," he said. "We are looking for some stick-up guys who just held up a man on Rampart Street." We tried to explain that we were innocent, but he told his men to lock us up and take us to the Parish Prison only a block away. There I was trapped, and I had to send a message to Maryann: "Going to jail. Try and find somebody to get me out."

Louis spent the night in jail, and then, miraculously and without explanation, he was released.

> While I was in the prison yard I did not realize that Matranga had contacted his lawyer to have us all let out on parole. I did not even have to appear in court. It was part of a system that always worked in those days. Whenever a crowd of fellows were rounded up in a raid on a gambling house or saloon, the proprietor knew how to "spring" them, that is, get them out of jail.

Armstrong now had a protector in New Orleans; that protector was the mafia.

2

SICILIAN MESSAGE

The history of organized crime in America, much like the history of jazz, is part fact and part mythology. Popular culture has had a lot to do with this: Sensationalized accounts (yellow journalism and, later, the tabloids), dime store novels, radio in its heyday, movies, television, comic books, graphic novels, alleged memoirs, and countless "true crime" accounts have put forth a discernible narrative. American movies, in particular, with their melding of true-life characters and fictionalized story lines, make it possible for the average citizen to believe that he or she has knowledge of the subject. Most everyone has heard of Al Capone, Lucky Luciano, or Meyer Lansky. Those names are as familiar as Louis Armstrong, Jelly Roll Morton, and Duke Ellington. The gangster narrative is a cherished trope in the rags-to-riches fantasy that lies at the heart of the American Dream.

Since pop culture is as much devoted to creating myths as it is to preserving historical reality, Americans sometimes embrace what they want to believe over what is verifiably true. In the case of the history of organized crime, there is a belief among many that it all started with the mafia. Others contend that Irish refugees fleeing the Potato Famine of 1845–55 laid down the template for organized crime. No doubt, waves of immigration—primarily Irish, Italian, and Jewish—shaped the development of mobsterism in late nineteenth- and early twentieth-century

America. But the economic framework on which these dynamics would be exerted, and the philosophical core of U.S. capitalism (which has always involved the use of "influence," power, ruthlessness, and violence), was in place long before mass immigration to the United States began.

In New Orleans, corruption and the plundering of municipal funds had been a feature of the underworld going back to French and Spanish governments that had previously ruled the city. The Louisiana Purchase, it is said, was itself a bit of a swindle. Rich people and people who were connected could get away with crime. Sometimes they could get away with murder.

The template that most historians cite as the system that made organized crime possible was Tammany Hall, in New York. Tammany, nicknamed "the Tiger," was a business association that sponsored candidates for public office and delivered votes on election day. It often did so through the use of fraud and violence. Tammany derived its power through proceeds generated in the underworld, primarily gambling money and, in later years, profits from the sale of illegal booze during Prohibition.

The common perception is that Tammany Hall was created by Irish immigrants. It wasn't. It was created in Philadelphia by WASP businessmen in the years immediately following the American Revolution as a social, fraternal, and benevolent organization. The idea was that men with money and influence would use that influence to control a city's political, business, and economic fortunes. It would determine who would advance and who would not. (Hint: WASP businessmen would advance, all others would not—unless they were selected by the organization to do so.) Tammany Hall was a system of power and influence that—once generations of hungry and ambitious Irish, Italian, and Jewish immigrants had risen through its ranks and seized control (primarily in New York)—would, by example, fundamentally reshape the nature of urban America.

The phenomenon of Tammany Hall was replicated in other U.S. cities. In New Orleans, it was called "the Ring," a consortium of business

and political interests based on connections of which Tom Anderson from the Fourth Ward and Storyville was a shining example.

As the American underworld took shape in the late nineteenth century, the mafia was certainly a factor, but it was not the progenitor. The idea of money as the elixir that would grease the wheel of urban advancement was baked into the system long before the first wave of Irish, Italian, and Jewish immigrants came ashore. Municipal corruption, graft, boodling, illegal gambling and prostitution proceeds, street-level extortion, and gangsterism were a consequence of men and women maneuvering for power, clawing and scratching to gain a foothold and advance in society.

The social universe was the arena in which this narrative would find its arc. A place for businessmen, politicians, and gangsters to come together and hatch their schemes had become a requirement of urban life. Sometimes these places were part and parcel of those schemes. Honky-tonks, saloons, and dancehalls (in the early twentieth century the term "nightclub" was not yet in fashion) were sometimes financed with money from illegal gambling, extortion, and other criminal activities. That money was also used to pay the musicians who were, through the emerging phenomenon of jazz, an increasingly vital aspect of city life.

In New Orleans, this development had a distinct flavor. The musicians were primarily a mix of Blacks of all hues and Creoles like Jelly Roll Morton, Sidney Bechet, and others. The impresarios of this world—the men who owned the clubs and paid for the entertainment—were a mixed bunch, but by the early decades of the new century they came to be dominated by a particular ethnic group with a penchant for exquisite cuisine; finery in style and presentation; a high standard of craftmanship; an artistic aesthetic that ranged from the bourgeois appeal of opera to the earthiness of brothel culture; and a criminal tradition going back to the Old Country that sometimes involved extortion, intimidation, kidnapping, dismemberment, and murder.

Sicilians had been coming to the state of Louisiana in significant

numbers since at least the 1870s. Political turmoil in Sicily had created a permanent migration class, mostly peasants fleeing domestic persecution for a better life on the American continent. With New Orleans serving as the third largest seaport in the United States, Louisiana was a natural destination. The climate, which had been so onerous for an earlier generation of Irish immigrants, was familiar to immigrants from Sicily. It was hot and languid, with long stretches of sweltering sunshine, but this was not new for the Italians who came by ship from across the sea. Many new immigrants found agricultural work in rural Louisiana, especially in the cane fields, and in New Orleans, with a thriving merchant culture of cobblers, tailors, and haberdashers. Newly arrived Italians distinguished themselves as players in the local economy.

Almost immediately, there was the issue of the Sicilian Black Hand, a tradition of extortion that came from the Old Country and found particular notoriety in the local press. Newspapers like the New Orleans *Mascot*, the *Daily Picayune*, and others couldn't get enough of this secret society. Coverage of the Black Hand, which was a real phenomenon in the city's Italian immigrant community, veered toward the sensational. There were Black Hand murders, with notes left on dead bodies and threats that were occasionally pinned on storefronts and sent through the mail to merchants and shopkeepers demanding a payment, or "tribute," to do business in the area. Coverage in the press openly referred to Italians as "dagos," and the operative signifier was "swarthy" and "secretive," terms designed to identify Italians as outsiders, no matter how far they might have advanced in the commercial realm.

As long as the Black Hand remained a fringe culture representative of Italians preying on other Italians, the city's white, post-European citizenry viewed it as a kind of blood sport, or entertainment for the masses. By the 1880s, as Sicilians in the city's enclave of Little Palermo branched out into New Orleans at large, a slightly different phenomenon began to take shape. The Black Hand became old news, and a more insidious kind of criminal subculture rooted in intimidation and violence made inroads into the city's mainstream corridors of power. This

fraternity of crime would have a profound effect on the way Sicilian immigrants saw themselves in relation to the rest of American society, especially those who were, in many ways, closest to them in the cultural and economic pecking order—recently freed African American slaves and their offspring.

Il Stuppagghieri

The version of the mafia that developed in New Orleans, much like its predecessors in Sicily, was not simply a criminal organization. It was rather a workingman's organization, albeit one whose leaders did not hesitate to commit crimes. As Italian immigrants in the city and state made inroads into areas of commerce such as produce import/export and, most important, along the waterfront as stevedores, longshoremen, and union activists, the mafia came looking for a taste. Often, mafia groups were a veiled continuation of traditions first begun "on the other side," in Sicily, which was certainly the case with the *Stuppagghieri* (sometimes spelled *Stoppaglieri*), an influential mafia faction that made its presence felt in New Orleans in the late nineteenth and early twentieth centuries.

The boss of the *Stuppagghieri* was Salvatore Matranga, scion of the Matranga family, who first immigrated to New Orleans in the 1850s. This was the same Matranga family that would, decades later, hire the young Louis Armstrong to play at their popular honky-tonk in Black Storyville, thus initiating the century-long relationship between jazz and the underworld.

Salvatore Matranga came from the town of Monreale, in the province of Palermo, where the *Stuppagghieri* had been created in the 1830s. Matranga's many sons and cousins, all of whom followed Salvatore to New Orleans in dribs and drabs, formed the ruling council of a sophisticated and insidious secret society. By 1880, they were believed to have hundreds of members divided into small groups of at least ten members, or *saldati*, each with a leader, or *capodecina*, at its head. Activity of the

capos was coordinated by a trio of group leaders (eventually known as underbosses) who answered to and advised *il padrone*, the boss.

There was, at the time, no national Five Family structure or anything like that. Mafia families in the United States, of which the Matrangas were one of the first and most influential, did have associates in other cities (primarily among Sicilian communities in New York and Chicago), but they functioned mostly within their own jurisdictions. The *Stuppagghieri* was based in the Vieux Carré (the French Quarter) and the adjoining neighborhood of Faubourg Marigny, otherwise known as Little Palermo.

The Matrangas and the *Stuppagghieri* were not alone. There were other mafia factions in the city vying for control. In fact, the primary reason non-Italian citizens in New Orleans knew that the mafia existed was because of interfactional killings that were reported in one of the city's many newspapers.

From the mid- to late 1880s, the city had its first mafia war, between the Matranga family and another well-represented faction known as the Provenzanos. This war had its roots among the city's dockworkers, which were a major source of employment for Italian immigrants and a source of plunder for the mafia.

The Provenzano clan was associated with the *Giardinieri*, another mafia faction from the town of Monreale, in Palermo. The rivalry between the *Giardinieri* and *Stuppagghieri* ran deep, with the former, in Sicily, representing the traditional, established mafia and the latter representing a more rebellious, antiestablishment movement within the mafia. Back in the Old Country, the differences were political, territorial, and lethal. In New Orleans, they tended to revolve around economic issues, with political undercurrents having to do with the Matranga family's strong ties to "the Ring." With economic interests in bars and restaurants in the Fourth Ward, *Il Stuppagghieri*, not *Il Giardinieri*, had their fingers in the city's nightlife.

Charles and Antonio Matranga, the oldest sons of Salvatore, the *padrone*, were the primary point men in the family's rivalry with the

Provenzanos. The war frequently resulted in violence, such as on the night in October 1888 when Giuseppe Matranga, cousin to Charles and Antonio, was found dead of gunshot wounds. His corpse was fished out of the Mississippi River near the docks. Giuseppe, father of five children, earned a modest living as an oysterman and seemed to have little or no involvement with his cousins' *Stuppagghieri* organization.

Charles Matranga was the family's underboss on the docks. Known by his Sicilian longshoreman employees as "Millionaire Charlie," Matranga saw his family's ongoing rivalry with the Provenzanos as an existential threat. After the death of Giuseppe, the innocent oysterman, Charles Matranga sought to infiltrate the Provenzanos through the use of informants and snitches. It was an effective strategy, but it sowed the seeds of paranoia and mistrust within the New Orleans mafia that would lead, in two short years, to a crescendo of gangland violence in the city.

On the night of May 5, 1890, a Matranga family work crew unloaded cargo from an 847-ton steamer ship moored at the river docks on the uptown edge of the Vieux Carré. In the wee hours, after finishing their work, the stevedores climbed into a horse-drawn wagon illuminated by lanterns and headed back toward their homes in and around the district. There were half a dozen men, including the driver. Among them was Antonio Matranga, foreman of the work crew and an underboss in the *Stuppagghieri*. The men drank wine and sang songs as the wagon ambled along Decatur Street near the French Market. Men were dropped off at their homes, and eventually there were only three men left in the wagon—Matranga and two others. The wagon came upon the intersection of Claiborne Avenue and Esplanade, a broad avenue. It was there, in the near darkness, that a crew of hitmen emerged and opened fire with rifles and a shotgun.

Antonio Matranga had his leg blown apart. The other two men in the wagon were also injured, though not as seriously as Matranga, who would lose his leg and spend the next month in the hospital.

Everyone in town knew what this ambush was all about. Only recently the Matrangas had successfully outbid the Provenzanos in a

highly lucrative contract negotiation with the city's major produce importers. The Provenzanos were letting it be known how they felt about this.

The Matrangas held a series of secret meetings to plot their revenge. Salvatore Matranga, the *padrone*, was especially incensed because he believed that the city's popular chief of police, an Irishman named David Hennessy, had sided with the Provenzanos in their waterfront rivalry with the Matrangas. Hennessy had recently launched a highly touted investigation of the mafia in New Orleans, suggesting publicly that his investigation could lead to the deportation of certain notorious Sicilians in the city, including Salvatore Matranga. In their war with the Provenzanos, the Matrangas may have been swayed by the old Sicilian bromide attributed decades later to New Orleans mafia boss Carlos Marcello. Discussing his problems with the Kennedy brothers, JFK and RFK, Marcello is alleged to have said words to this effect: "If you cut the tail off a dog, it continues to bark. You want to silence the dog, you need to cut off its head." This was Marcello suggesting to cohorts that the mafia not bother with their nemesis, RFK, the attorney general, but instead kill JFK, the top dog.

To redress their grievances with the Provenzanos, the Matrangas may have felt a similar strategy was required: Why cut the tail off the dog? Why not go for the head, which, in this case, was represented by Chief David Hennessy?

A strapping man, thirty-two years of age, with a handlebar mustache and a public reputation for rectitude, Hennessy was a legend in his own time. The city's mafiosi felt that his reputation was mostly a charade, that Hennessy was on the payroll of the *Giardinieri* and that he spent much of his free time at a bordello called the Red Lantern, of which he owned a piece. The Matrangas felt that Hennessy was a dirty cop who, for more than a decade, had been promoting himself as an anti-mafia crusader, all the while getting his beak wet at the hands of their mafia rivals.

On a dark, foggy night in October 1890, just five months after the

ambush of the Matranga work crew on Esplanade, Chief Hennessy was out by himself on a street corner in the Vieux Carré. A series of gunshots rang out. It was dark, and no one got a good look at the assailants, but the shooters had been close enough to hit Hennessy with multiple gunshots. Hennessy's deputy had been nearby at the time; he arrived on the scene to find the chief lying in the street, barely able to breathe. The deputy asked, "Chief, who did this to you? Who shot you?"

Hennessy's final word, according to the deputy, was "Dagos." He identified his killers as mafiosi shortly before being rushed to the hospital, where he died the next day.

Rope Around the Neck

For the death of David Hennessy, there would be hell to pay. To the citizens of New Orleans, the chief had always been presented as an incorruptible figure. People in the know knew otherwise. In American life, both urban and rural, there had evolved the proclivity of fantasy presentations in the press and through popular storytelling (dime store novels and comic books). The truth often lay buried beneath the surface, known only to the politicians, municipal reporters, businessmen, madams, prostitutes, and other denizens of the underworld, where all of the above sometimes intermingled and shared "ya ya," as gossip was called in the parlance of Creole Louisiana. The public trafficked in legend and misinformation because it made it easier for leaders to manipulate public opinion.

In the wake of Hennessy's assassination, the lie that trafficked best in the general population was the claim that the mafia in New Orleans was out of control and needed to be stopped; that all Sicilians were suspect; that, furthermore, Italians were a lower breed of human to begin with, not white, not fully American, not capable of mixing with the WASP citizenry.

Mayor Joseph A. Shakespeare expressed the common anti-Italian prejudice, complaining that New Orleans had become home to "the

worst classes of Europe: Southern Italians and Sicilians . . . the most idle, vicious, and worthless people among us." He claimed that they were "filthy in their persons and homes" and blamed them for the spread of disease, concluding that they were "without courage, honor, truth, pride, religion, or any quality that goes to make a good citizen."

Within hours of Chief Hennessy's death, Mayor Shakespeare told the police to "scour the whole neighborhood [of Little Palermo], arrest every Italian you come across." Within twenty-four hours, forty-five people were arrested, and as many as two hundred and fifty Italians were rounded up. Nineteen men were ultimately charged with the murder of Hennessy or as accessories after the fact and held without bail in the Parish Prison. These included Charles Matranga, who turned himself in and was charged with plotting the murder.

The legal proceedings were to be divided into two trials. Four months after Hennessy's murder, in mid-February 1891, the first trial took place involving nine defendants, including Matranga.

After one month of deliberations, the mafia boss and another man were found not guilty by directed verdict, as no evidence had been presented against them. The jury declared four other defendants not guilty and asked the judge to declare a mistrial of three others, as they could not agree on a verdict. Meanwhile, all nine men, though victorious, were returned to the adjoining Parish Prison—a move that would prove fatal for most of them.

Outside, the crowd was irate. That night, an emergency meeting was called, led by a consortium of businessmen that declared themselves the "Vigilance Committee." A crowd gathered at the intersections of Canal, St. Charles, and Royal Streets, near the statue of Henry Clay, a prominent leader of the Whig Party and an inspiration for the nascent Know Nothing anti-immigrant movement. William Stirling Parkerson, a leader of the Regulators, a vigilante squad, stood before the crowd and announced, "People of New Orleans . . . when courts fail, the people must act. What protection or assurance of protection is there left us, when the very head of the police department—our chief of police—is

assassinated, in our midst, by the Mafia Society, and his assassins again turned loose on the community?"

The crowd roared. The decision had already been made. A mob of more than two hundred and fifty men stormed the nearby Parish Prison. The guards were no match for the rabble, many of whom were armed with clubs and guns. The crowd easily broke through the prison gates and went looking for their prey.

The vigilantes had a list: Charles Matranga was not on that list. His life was spared, a telling indicator, perhaps, of the Matranga family's abiding influence on the street.

The victims were all Italians, and all were unarmed. Few of these men were shown to be members of the mafia; one was a cobbler who had the misfortune of owning a shop across the street from where Hennessy was murdered. Others were common laborers and merchants whose primary reason for being a suspect was their Italian ancestry.

Three of the Italians were found hiding in the women's prison. They were beaten and blasted with shotguns. Six others were shot in the prison yard, some in the face, some in the back, then their bodies were dragged out in front of the prison. Two men were still alive; they were also dragged out in front of the prison along with the dead bodies.

The crowd was now in the thousands, white men baying for blood. The two men who were alive were strung up and hanged with a rope around the neck. One man was hanged from a tree, the other from a lamppost at the corner of Tremé and St. Anne Streets. Various people in the crowd riddled the hanging bodies with bullets.

The bodies were left hanging in the breeze. The nine other dead bodies were lined up in front of the prison so that a steady parade of onlookers, including women and children, could walk by and gawk at the deceased Italians. Said Parkerson, the leader of the vigilantes, "Of course, it is not a courageous thing to attack a man who is not armed . . . But we looked upon these men as so many reptiles . . . This was a great emergency, greater than has ever happened in New York, Cincinnati,

or Chicago . . . Hennessy's killing struck at the very root of American institutions. The intimidation of the Mafia and the corruption of our juries are to be met only with strong measures. I recognize no power above the people."

Mayor Shakespeare accepted kudos from far and wide; it was an event that attracted mostly favorable attention around the United States and even the world. Asked by a newspaper reporter about the position of the mafia in New Orleans after the lynching, the mayor was boastful. "They are quiet, quieter than they have been for years. The lesson taught them at the Parish Prison has had a most excellent effect, and I do not anticipate we will have any more trouble with them." And then, in one of the more irrelevant and wrongheaded statements in the city's history, the mayor added, "You may announce that the reign of the mafia in New Orleans is over."

For the city's African American population, the lynching in February 1891 must have seemed a strange and unusual occurrence. Black people in the city of New Orleans, the state of Louisiana, and in the entire South knew all about lynching. Since the Reconstruction era, there was hardly a Black family in the South that had not been directly touched in some way by white terrorism. In Louisiana, in particular, lynching had become institutionalized. White supremacist organizations like the KKK and the White League strung up Black folks in the town square, then mutilated the bodies and lit them on fire. Rarely was anyone ever prosecuted for lynching. In fact, whites in the criminal justice system—sheriffs and judges—were sometimes members of the organizations that perpetrated the violence.

There were occasionally instances of non-Black people being lynched. There are a few documented instances of Irish immigrant laborers having been lynched in the South in the 1850s. In Los Angeles, in 1871, an estimated seventeen to twenty Chinese immigrants were hanged by a mob of five hundred people in what is remembered as "the Chinese massacre." In the not too distant future, lynching of Mexican

nationals would become common in a number of U.S. states. But in 1891, in the city of New Orleans, the wholesale lynching of what were legally considered to be "white people" was a rare occurrence.

And the killings at Parish Prison were not a one-off. Over the next decade, there were at least seven other documented instances of Sicilians being lynched by white mobs in the state of Louisiana. The killings in New Orleans had started a trend, with Italians and Italian Americans on the receiving end of a particularly violent and perverse mode of American racism.

It was at this same time, as the earliest inklings of jazz were beginning to take shape, that African American musicians found themselves interacting with Sicilian club owners in the city. The musicians—and, for that matter, Black people in general—now had reason to view their Sicilian counterparts in a slightly different light. Sicilian immigrants—especially those who were seen as having any association, real or imagined, with the mafia—were susceptible to a kind of bigotry and racism that African Americans knew all too well. In a sense, they now had a shared experience, however temporal, as "niggers." There may well have resulted a kind of kindred understanding, perhaps empathy or solidarity, that laid the groundwork for a mutually conducive working relationship. Having been on the receiving end of the rope, Sicilians and Blacks had reason to understand one another, or at least to have a shared understanding of who the enemy was, or could be, and how their identities as outsiders made them ideal habitués of what would become an underworld culture of honky-tonks, bordellos, gambling parlors, and nightclubs, where jazz was soon to become the music of the downtrodden, the hipster, and those with a taste for the cutting edge.

White Jazz

Sicilians in New Orleans were not exclusively nightclub operators or mafiosi; they were also musicians. From the beginning, there were a number of white musicians in the city, though in the streets, at the

funeral parades, and in the honky-tonks it was clear that "jass," or jazz, was something singular and historically profound: an expression of African American culture that was undeniably infectious, even for white folks—or, at least, a certain type of white person who could accept the possibility of African American artistry as something worth celebrating.

Some Sicilian musicians from New Orleans would go on to find fame and fortune, none more so than Louis Prima, who was born December 7, 1910, in the neighborhood of Little Palermo. As a trumpet player, singer, and entertainer, Prima would become a jazz legend. His roots in New Orleans were a classic byproduct of his Italian American heritage in the city at a time when jazz was inspiring levels of excitement that bordered on pandemonium.

Prima's parentage on both sides was Sicilian. His father, Anthony, was born in New Orleans in 1887, just four years before the Parish Prison lynching, at a time when anti-Italian bigotry in the city had been given full agency among the city's white gentry. In 1906, at the age of nineteen, Anthony married Angelina Caravalla in St. Ann's Catholic Church. Anthony worked for a soda pop delivery company. Angelina was the daughter of a barber. She had show business pretentions, and from the beginning she encouraged her three children to take part in music and entertainment. Louis, the second oldest son, was first given a violin to learn, which he soon ditched in favor of the trumpet, an instrument that was being made desirable—and famous—by his musical hero, Louis Armstrong.

Like most Italian New Orleanians with a taste for jazz, the Primas rubbed shoulders with the city's African American population in ways that other white citizens did not. Angelina regularly took part—in blackface—in a celebration that paid homage to the King of the Zulus, an honorary figurehead of the city's Mardi Gras.

Minstrelsy was a form of American entertainment that went back decades. Some of the earliest influences on jazz, from ragtime to Negro spirituals, first found expression in minstrel shows, a form of entertainment that later gave way to vaudeville. White people blackening

their faces to play African American characters in skits and plays was a common element of the show. These performances were often meant to disparage and lampoon Black folks and plantation life, but not always. Angelina Prima's participation in the Zulu parade was meant as a tribute, and it was undertaken with reverence. More than most immigrants of European extraction, Sicilians acknowledged and respected Black culture. Some might argue that it had to do with Sicilian roots in North Africa as descendants of the Moors. For whatever reasons, some Sicilians identified with Black folks and even resembled people of African descent in hair type, skin color, and facial features. Louis Prima, who had kinky black hair and spoke in the manner of a New Orleans Black man (modeled, he would admit, on Louis Armstrong), was denied jobs early in his career in clubs because booking agents thought he was Black.

Sicilians and Blacks in New Orleans banded together in honky-tonks like Matranga's, Joe Zegretto's, Pete Lala's, Lala's 25 Club, Eddie Graciele's, Dante's Lodge, and other Sicilian-owned clubs. It was a relationship that would continue, in various permutations, throughout the history of jazz.

The most renowned Sicilian jazz musician of his day was Dominic James "Nick" LaRocca. Born April 11, 1889, he was raised in the Irish Channel, the same hardscrabble neighborhood as Tom Anderson, the boss of Storyville. LaRocca's Sicilian-born father had come to New Orleans as a cornet player, but he didn't want his son Nick having anything to do with the dubious prospect of a career in music. LaRocca began working as a laborer in New Orleans when he was a teenager, but before long, as jazz emerged as a cultural phenomenon, Nick was bitten by the bug. He bought a used cornet and, without his father's knowledge, in 1908 he formed a band comprised mostly of Italian American youngsters. LaRocca's band was strictly a ragtime combination, like most New Orleans bands at the time. But as young Nick began to compose his own music, he incorporated elements that appealed to him, including

military parade band music as pioneered by John Philip Sousa, and even opera.

From the beginning, LaRocca showed a proclivity—both as a composer and bandleader—toward spirited interaction between the musicians. More than anything, this is what excited budding young musicians about jazz. You could play ahead of the beat, or slightly behind the beat. You could riff off the melody and work out musical ideas during extended solos. You could engage fellow bandmates in a kind of call-and-response, a musical dialogue between instruments that was unlike anything ever presented to listeners in the form of public entertainment.

LaRocca wasn't the greatest horn player, but he distinguished himself as someone with a strong lip; he could play for long stretches during funeral marches and parades. This landed him a job playing with Papa Jack Laine's band. As a bandleader, Laine was noteworthy for defying segregation laws by hiring light-skinned African American musicians and calling them Cuban or Mexican.

By 1916, New Orleans musicians were in demand in other cities, especially Chicago, where jazz was on fire. As a last-minute replacement, Nick LaRocca was offered an opportunity to play cornet in a band led by drummer Johnny Stein in Chicago. He took the gig; the rest, as they say, is history. The band would become known as the Original Dixieland Jass Band, and it became the first band to make commercially issued jazz recordings for a record label. By then, Stein had left the band and LaRocca took over as leader.

The term "Dixieland" was controversial from the start. Some felt it was meant to connote "white," as the Original Dixieland Jass Band was an all-white group. It was no accident that an all-white band was the first to be paid to record the music. The Victor Talking Machine Company, which recorded LaRocca's band on February 26, 1917, had been looking for an all-white band to record. It was complicated enough that jazz was perceived to be "Negro music" without having to sell the

idea to white consumers that they should patronize Black musicians. Racism in America was about white supremacy, but it was also a commercial construct. The Original Dixieland Jass Band solved this problem. They were not exactly original, borrowing as they did from Buddy Bolden, King Oliver, Louis Armstrong, and other New Orleans masters of African descent, but they played with enthusiasm and creativity. In "Livery Stable Blues," their first recorded hit tune, the musicians approximated the sounds of farm animals braying and communicating with one another. The song was a sensation, as was "Tiger Rag," the first jazz composition—along with songs composed by Jelly Roll Morton—to become standards played by aspiring bands around the country.

Being white and one of the form's first bona fide recording stars did not insulate Nick LaRocca from the underworld side of the jazz life. On the contrary: Because LaRocca was Sicilian, as were the majority of players in his band, this may have implied a relationship that was or was not there. While in New York recording with the Victor Talking Machine Company, the Original Dixieland Jass Band booked gigs at Reisenweber's, a dance club and restaurant. The establishment was known for fierce competition between bands. One night, a rival band of LaRocca's group was startled to find that, right before they were scheduled to take the stage, their instruments had been vandalized—drums slashed and horns mangled. Though it was never proven to be the case, it was believed by some that LaRocca and his Sicilian bandmates had friends in the mafia who were looking out for them.

Even before that, in Chicago, LaRocca learned that his Italian heritage might put him in an unusual position with the club owners and hangers-on in the jazz world.

LaRocca and his Original Dixieland Jass Band were playing a club called Casino Gardens on the North Side. The club was the headquarters of a robbery gang led by an Irish mobster named Mickey Collins. Every afternoon, the gang's members showed up with bags of stolen loot, which they divvied up at the club.

Whenever LaRocca and his band members showed up, the gang-

sters had a good laugh. The musicians, all of whom hailed originally from New Orleans, wore threadbare coats that were poorly suited to the frigid winter conditions in Chicago. An Italian member of Collins's crew took a liking to LaRocca. As Nick hung up his coat, the gangster asked, "Why you wear a flimsy coat like that? Why don't you get yourself a decent winter coat?" LaRocca explained that most of the money he made from the gig he sent home to his mother in New Orleans. Said the hood, "Meet me at Sears Roebuck tomorrow afternoon and I'll buy you one."

The next day, LaRocca went to Sears. The gangster wasn't there, but the clerk seemed to be expecting the young musician. He helped LaRocca try on different coats until he found one he liked. LaRocca was told by the clerk, "Very good, sir. I'll hold this one for you."

Later that night, after his gig at Casino Gardens, LaRocca went to get his old coat and discovered that it had been slashed to ribbons. Before he could even react, he turned around and there was the Italian gangster with the coat he had picked out that afternoon at Sears Roebuck. The gangster presented LaRocca with the coat as a gift.

LaRocca was no dummy; he knew that accepting a gift from a mobster was a dubious proposition. He accepted the coat, but he also started carrying an automatic handgun in his coat pocket, leading bandmates to tag the cornet player with a new nickname: Nick the Gunman.

Not long after that, LaRocca began dating a statuesque blonde who, unbeknownst to him, was also the girlfriend of Joe Bova, leader of the South Side Gang, a rival of Mickey Collins's North Side crew. One night at Casino Gardens, Bova paid an unexpected visit to the club and confronted LaRocca. "Stop fraternizing with my lady-friend," he said, "or somebody is likely to find a waterlogged cornet player floating in the Chicago River."

LaRocca was shaken by the threat. A few moments later, the musician was approached by Mickey Collins, who said, "I saw you talking to Joe Bova. What's that punk doing in here?"

Collins listened carefully while LaRocca explained the situation. Not long after that, Bova was snatched from the back of the club and taken to an office, where he was confronted by Collins and the Italian underling who gave LaRocca the new coat. According to LaRocca, Collins and the Italian beat Bova to a pulp and then pinned him to the wall by his ears, using long hatpins.

LaRocca, however, stopped dating the blonde. After leaving Chicago, he went on to bigger and better things, namely recording the first hit jazz record of the twentieth century. But from that point onward he was well aware of the potentially perilous relationships a musician could form with a mobster, including those who did you favors or called you their friend.

Farewell to Storyville

On October 9, 1917, eight months after the Original Dixieland Jass Band recorded the first jazz record, Storyville was no more. This startling turn of events was the result of a groundswell that had given rise to the American Temperance Society, a movement that would, in two short years, result in passage of the Eighteenth Amendment and the beginning of Prohibition. In the minds of reformers, the worlds of vice, jazz, and booze had become inexorably intertwined.

Officially, the primary culprit in the eradication of Storyville was the U.S. Navy. With the United States officially entering the First World War in April 1917, the War Department, along with the secretary of the navy, became concerned about prostitution in port cities like New Orleans serving as a temptation for soldiers on shore leave. The navy secretary personally undertook an investigation of Storyville, interviewing the likes of Tom Anderson and other impresarios of the district. On behalf of the navy, the secretary declared that in his view Storyville was in violation of a decree issued earlier that year by the War Department making it illegal for a prostitution business to exist within

five miles of a military installation. The secretary demanded that Storyville be shut down. Within months, all houses of prostitution within the district were put out of business, which meant, parenthetically, that Storyville no longer had a reason to exist.

Some called it the Triumph of Virtue, but in fact, prostitution in New Orleans did not come to an end. Bordellos continued to exist, now spread around the city as they had been before Storyville ever came into existence. What did come to an end was the concept of a vice district where prostitution was the lure for an entertainment scene that included a multitude of jazz venues all within a few blocks of one another. The French Quarter, to a degree, would pick up where Storyville left off and become a nexus point for jazz in the city, but the closing of Storyville had a powerful psychological and symbolic effect. Thus began an era when many of the best jazz musicians left New Orleans, a movement that would continue over the next decade.

In many ways, the transformation had already begun. Since at least the turn of the century, steam- and paddleboats leaving from the port of New Orleans and heading up the Mississippi River had become a popular leisure activity for people from the southern and midwestern states. A big attraction on these excursions was riverboat gambling and also jazz bands, which had become de rigueur on the boats.

In the year 1918, none other than Louis Armstrong was hired to play on a boat known as the *Sydney*, which was part of the Streckfus Steamboat Line. Satchmo, as Armstrong was now commonly known, had been playing cornet in Kid Ory's band when he was approached by Fate Marable, a piano player whose acclaimed band had been playing the Streckfus Line for more than a decade. Marable offered Armstrong a slot in his band. Having never been outside of Louisiana, Armstrong, still only seventeen years of age, jumped at the opportunity.

The steamboats are remembered in the lore of jazz history for having brought the music "up stream." Armstrong wrote about it in his memoir, noting that in Jim Crow America, white folks in places like

St. Louis and Davenport, Iowa, were seeing all-Negro bands for the first time in their lives:

> The ofays were not used to seeing colored boys blowing horns and making fine music for them to dance by. At first we ran into some ugly experiences while we were on the bandstand, and we had to listen to plenty of nasty remarks. But most of us were from the South anyway. We were used to that kind of jive, and we would keep on swinging as though nothing had happened. Before the evening was over they loved us.

One thing that Armstrong noticed, in many of the cities where the riverboats docked for the night, was that jazz in one form or another had already arrived. The New Orleans musicians may have been the most sophisticated and accomplished at the new music, but it seemed as though the seeds of jazz as a new art form had found fertile soil in a number of localities along the Mississippi River and its many tributaries. Also in many of these towns and cities—and, for that matter, on riverboats like the *Sydney* and others—the music attracted its share of riff-raff. Gamblers, hustlers, pimps, and prostitutes circulated around the jazz universe like bees to a hive. Rightly or wrongly, the music continued to be viewed as a form of entertainment for shady characters.

This reality would have repercussions for the development of the music, but even more significantly it would have a profound impact on the business of jazz.

As of yet, jazz was hardly a business at all. Recording the music for phonograph records, even with the success of the Original Dixieland Jass Band, was in its infancy. Few bands or musicians were known well enough to sell records or draw an audience that would pay an admission fee. Jazz was still mostly street music—the mellifluous conjuring of honky-tonks, whorehouses, and steamboats. But these sounds could not be denied. It wasn't just that jazz was infectious; it certainly was that. It was also something more. Jazz was a cultural expression that helped

to define America as a place of diversity and possibilities. It represented the creation of something spontaneous and wondrous. In this freshly tilled soil, the seeds had taken root; jazz was spreading, and wherever it spread, it took on the dimensions of a potentially lucrative commercial venture.

There were the musicians, and there were the money changers—club owners, managers, agents, and promoters. Which meant there were many points of entry for businessmen hustlers and their underworld associates.

It appeared that jazz was on the cusp of sprouting like a ripe fruit tree, with branches that reached around the United States. Inevitably, in the many localities where the fruit flourished, the mob was there looking to harvest the bounty and savor the juice.

3

KANSAS CITY STOMP

By the 1920s, the phonograph player had been around for decades, but not many people owned one. The Original Dixieland Jass Band and a few other New Orleans bands had been recorded, but to be aware of this fact you had to be either wealthy or have access to drinking parlors or private clubs where phonograph players were put on display, as if they were novelty items from another galaxy. It was common for classical music or symphonies to be recorded and sold as discs, but most felt that jazz was beneath the commercial requirements of this new technology. The thinking was that if you were a fan of this music, you likely did not have the money to purchase a disc, much less an actual phonograph player. Jazz was the music of the proletariat; it had not yet been formulated into something that could be monetized on a mass scale.

As the music spread, however, the desire to hear this new confection was becoming a genuine phenomenon. In social gathering places, on riverboats and in saloons—and, increasingly, in theaters and concert halls—the music stoked the imagination and brought rhythm to the feet of those who were open to its charms. Jazz began taking shape in many cities and towns, but where it urgently and most emphatically become institutionalized was in cities that had a native population and social philosophy that was predisposed to give the people what they desired. It also helped to have a commercial and political structure that

was conducive to the idea of vice and the underworld as a legitimate social construct. Cities that had evolved around the concept of a political machine, which, as in New Orleans, was open to the codification of good times and chicanery as a fact of life—this is where the new music was most likely to gain traction.

People's response to the music itself was one thing, but to turn jazz into a commercial venture seemed to require a specific district where the music could flourish. A vice district. In this regard, Kansas City, Missouri, which had only recently emerged from being a cow town to being an actual city, was ahead of the game.

If Storyville had Tom Anderson, who had the vision—and the political skills—to create the proper environment for jazz, Kansas City had Thomas Joseph "T. J." Pendergast. These two men had many things in common besides the fact that they were both named Tom. Both were of Irish descent and Democratic Party political bosses at a time when being a political boss made you, locally speaking, as powerful as any dictator. Anderson had maximum control in Storyville, until a power larger than himself usurped his authority and rendered him and the district over which he presided a historical afterthought. Tom Pendergast's reign was more deeply rooted.

In 1911, Tom inherited the organization known as the Pendergast machine from his older brother Jim, a former factory worker who became a Democratic Party committeeman from the city's First Ward. Jim was also proprietor of the American House, a multipurpose saloon that featured gambling tables in the back and rooms upstairs for quick, commercially transacted assignations. Tom Pendergast served an apprenticeship as doorman and bouncer at the popular saloon.

By the turn of the century, a number of U.S. cities had seen the rise of political machines. In big cities like New York, Chicago, and Philadelphia—and even smaller cities like Albany (New York), Boston, and Jersey City (New Jersey)—political organizations that revolved around working people, immigrants, and the poor would become a staple of urban life. Tammany Hall in New York set the standard. An

elaborate system for delivering jobs, city services, and power to "the lit-
tle man" in exchange for electoral support helped to grease the wheels
of progress and underwrite a period of accelerated industrialization.

In Kansas City, the political machine run by one Pendergast (Jim)
and then another (Tom) was sometimes referred to as "Little Tammany,"
but in many ways the Pendergast machine was, for half a century, the
most stalwart of them all. The organization became a symbol of be-
nevolence for those it serviced. The only way the machine could exist
is if it delivered, and deliver it did with basic needs like coal for heat
during the winters, holiday turkeys, a roof over the head, food, a job. By
the time Tom Pendergast took over the organization after his brother's
sudden death, the machine would be credited with transforming a one-
time midwestern cow pasture into one of the most energetic cities in
America—and, almost by accident, give birth to one of the most storied
jazz eras to ever exist.

Born July 22, 1872, in Saint Joseph, Missouri, Pendergast's ances-
tors were Potato Famine immigrants who hailed from County Tipperary,
in the Irish midlands. As a child, Pendergast was raised in a section
of Kansas City known as West Bottoms, an industrial area in the First
Ward that would become the home base for the machine.

By the 1920s, Kansas City was an emerging industrial hub, with
stockyards and slaughterhouses. The city had transitioned from a waste-
land to being thought of as the most significant crossroads of what were
known as "the Territories"—Texas, Oklahoma, Kansas, Missouri, Iowa,
Indiana, Michigan, Arkansas, and Louisiana. The city's reputation
was based in large part on Pendergast, whose power was far reaching.
Locally, City Hall became known as "the House of Pendergast." The
state capital in Jefferson City was referred to as "Uncle Tom's Cabin."
Harry S. Truman, who was handpicked by Boss Tom to run for the U.S.
Senate and eventually became the thirty-third president of the United
States, was sarcastically known as "the senator from Pendergast." The
boss was unapologetic about his power: "I'm not bragging when I say I

run the show in Kansas City. I am the boss. If I were a Republican, they would call me a leader."

Voter fraud was common in local elections. Ghost voting and stuffing the ballot box were common tactics of the machine, as was voter intimidation. Election day was often violent in Kansas City, which resulted in a relationship between the political apparatus and men of violence that sometimes reasserted itself during labor disputes, municipal contract negotiations, or whenever it was needed. Through force and guile, Pendergast reigned supreme. Built like a football player, with a big head and magnetic smile, he was earthy and blunt. He was a local chieftain who laughed, cried, and seemed to genuinely care about the lives of his constituents. He could be kindly and sentimental but was also a tough-as-nails, gravelly voiced brute who mangled the English language and wasn't afraid to get rough with anyone he felt deserved it.

In a newspaper interview, Pendergast once explained how he handled two underlings who questioned an order: "One of them hesitated, said he didn't know anything about it. Well, I slapped him with an open hand. The other tried to protest. I hit him with my fist and knocked him through the glass door."

Pendergast didn't have to get rough very often. There was a reason that throughout the Territories, Kansas City was known as "Tom's Town."

The biggest single boon to the machine occurred on January 16, 1919, with passage of the Eighteenth Amendment, which, once it went into effect one year later, inaugurated the long, bloody era known as Prohibition. The Volstead Act—a series of laws and regulations that sought to eliminate the manufacture, distribution, and consumption of alcohol in the United States—became the law of the land. Thus began the most robust era in the history of organized crime. It was also a time when the new music became elevated to an exalted cultural status, so much so that a young author named F. Scott Fitzgerald in 1922 published a collection of short stories titled *Tales of the Jazz Age*. From that point onward, both Fitzgerald and the Jazz Age were on their way.

The Pendergast machine was well positioned to make the most of new restrictions on booze. For one thing, the boss was the owner of the T. J. Pendergast Wholesale Liquor Company, the largest liquor distributor in the state. Shortly after the Volstead Act was passed by the U.S. Congress, Pendergast sued the federal government on the grounds that Prohibition was unconstitutional. He lost the lawsuit and later that year made a show of liquidating his liquor company by turning it into a soft-drink dealership. It didn't matter. Kansas City would become known as "the wettest city in the Territories," and no one doubted that the man who made the booze flow was T. J. Pendergast.

Built on a stratified system of aldermen, ward bosses, precinct captains, and block captains, the machine could determine how the booze was stored and distributed; it could bring the product to the people. The machine also had near total control over the police department, with its many members of Irish descent, to make sure that things ran smoothly. In the entire run of Prohibition, from 1920 to 1933, not a single felony conviction for violation of the Volstead Act was ever imposed in Tom's Town.

Last but not least in the consortium of players who would become essential brokers during the era were the gangsters.

Among other things, the imposition of Prohibition gave rise to an idea, one that would alter America in ways few could have imagined. As it turned out, people didn't want only to be able to consume alcohol as they saw fit; they wanted a place that set the proper mood for engaging in what was now an illegal activity. An entire generation of Americans crossed over to the dark side by knowingly and willingly breaking the law. And they were determined to have a good time doing it.

This intertwining of the worlds of alcohol, hoodlums, and all forms of vice was certainly not new. New Orleans had seen the rise and fall of its legendary vice district before Prohibition was ever instituted. The underworld is where a person went to taste the hoary fruits of the devil. It just so happened that in Kansas City, as jazz was asserting itself as the new music for people with adventurous spirits, reformers and the United

States government created a scenario that would unwittingly lay the groundwork for a staggering new epoch of crime, vice, and music.

Pendergast was the boss, but a coterie of characters emerged as leading lights of the era. In the African American community, few were better connected than Felix H. Payne, a popular nightclub owner, community leader, sporting man, and silver-tongued orator who would become one of the city's leading public figures during the Pendergast years.

A flashy dresser with spats, a silk scarf in his breast pocket, hair conked and slicked back, Payne was often seen at the Jefferson Hotel, where Boss Tom maintained the office of the Jackson County Democratic Club, until it later moved to a small, unassuming brick building at 1908 Main Street. Payne was possibly the machine's most influential Negro. He would eventually buy a piece of the Kansas City Monarchs in the Negro Baseball League and, in 1928, began publishing the *Kansas City American*, an African American weekly newspaper that was a robust supporter of Pendergast and his Democratic Party machine.

Few were as capable as Payne when it came to delivering "the colored vote" on election day. Ensuring he had the influence to guarantee a certain percentage of voters, Payne established a reputation in the city's premier Black neighborhood as a deliverer of good times. He owned numerous nightclubs in what became known as the 18th and Vine jazz district, most notably the Sunset Cafe, a popular honky-tonk at 12th and Highland. Whiskey and beer flowed freely at the Sunset, but one of the biggest draws was the man who worked behind the bar: Kansas City–born blues singer Big Joe Turner.

While serving drinks or making change, Turner might break into a chorus of "Morning Glory" backed by the boogie-woogie revelry of Pete Johnson, the house pianist. Turner became the patron saint of blues and jazz singers in the city and would go on to become a giant figure in the history of American folk music.

Along with the Sunset, Payne was the proprietor of the Eastside Musicians Club, a notorious gambling parlor where patrons could bet

the daily number on a huge policy wheel that was spun each day by the ward boss.

Payne's partner, the man who served as manager at the Sunset and other clubs, was Piney Brown (not to be confused with Walter "Piney" Brown, a well-known Kansas City blues singer who emerged on the scene a generation later). Whereas Payne projected the air of an aristocrat, Piney Brown was a country Negro known to be an irascible ladies' man and degenerate gambler. His legend in town was best expressed by Joe Turner who, after Brown died prematurely in the late 1920s, immortalized the club manager in "Piney Brown Blues":

> *I dreamed last night I was standing on*
> *18th and Vine*
> *I shook hands with Piney Brown, and I could*
> *hardly keep from crying.*

Brown first established his managerial bona fides at another Felix Payne–owned establishment, the Subway Club, located in a basement at 1516 18th Street. Saxophonist Eddie Barefield, a sideman in Kansas City who regularly played at the Subway Club, remembered Brown as being generous to a fault. "I don't think he made any money off the Subway, because he gave away too much . . . You could go down there any night and get juiced and eat and do whatever you wanted to do. If you came there as a musician, it never cost you anything."

It was at the Sunset, with Felix Payne as his overlord, that Piney Brown hosted some of the hottest late-night jam sessions in the city. Musicians wound up at the Sunset because they knew they would be taken care of. "Piney was the patron saint of all musicians. He used to take care of them," recalled Barefield. "In fact, he was like a father to me . . . Most all the playing and jamming happened at Piney's place. He didn't care how much it cost . . . If you needed money to pay rent, he would give it to you and take you out and buy you booze. He was a man you could depend on for something if you needed it."

The saxophonist was talking about Piney Brown, but he could easily have been talking about Boss Tom or the Pendergast organization in general. You could depend on it if you needed it: The machine philosophy was based on doing favors for those who identified themselves as being one of its constituents. In that sense, musicians were like everyone else in the city. You pledged your support to the machine, and it was incumbent upon the machine to deliver. Those who delivered with sincerity and benevolence, from Felix Payne and Piney Brown all the way up to Boss Tom, were revered by those they served.

It was an arrangement that enemies of the machine could never quite understand. The *Kansas City Star*, the city's preeminent daily newspaper, routinely characterized the machine as dictatorial and corrupt. Why would anyone pledge fealty to an organization that tacitly condoned sin and vice as a money-making proposition; that skimmed money from municipal projects, the money then going into the pockets of ward bosses; that demanded fealty on election day using techniques that included coercion bordering on thuggery?

The answer was not complicated: In times of need, it sometimes seemed that the only person you could depend on was the ward boss, the local committeeman, the block captain, or the machine-affiliated saloon owner in your district—who treated you, not as a freeloader and an imposition, but as a friend and a human being.

The Sin Business

In 1926, Tom Pendergast established an alliance in Kansas City that would have a profound impact on the city's burgeoning population of musicians. Though this alliance did not directly involve the musicians, it did involve two spheres of influence that would ultimately shape their destinies: the machine and the underworld.

It was perhaps inevitable that Pendergast would join forces with mafioso Johnny Lazia. A suave and sophisticated gangster with wire-rimmed spectacles and a tasteful assortment of suits tailored in Little

Italy, Lazia seemed more like a bank president or legitimate captain of industry than a hoodlum. Officially, he was a paid organizer for the North End Democratic Club, which is how he and Pendergast became bosom buddies. As personalities, their temperaments were opposite, Pendergast the gregarious ruffian, Lazia the circumspect operator. But as businessmen, they were two peas in a pod.

Lazia was born John Francis Lazio (the spelling was later changed for reasons unknown) on September 22, 1896, in Brooklyn, New York, to Sicilian immigrant parents.* The Lazia family moved to Kansas City when John was a child and settled in a cold-water flat at 406 Campbell Street. The city had become something of a mecca for Italian immigrants. Some had moved north from New Orleans in the years following the infamous Parish Prison lynching, a seminal event in the social trajectory of Italians in America. Blatant racism had contributed to an insular mentality among the sons and daughters of Italy. In Kansas City, Italians settled in the North End, an immigrant neighborhood where Italian was spoken in the street more often than English.

The North End was Kansas City's Little Italy. For Italian immigrants who sought to get ahead in life, the inherent insularity of the community was a double-edged sword. For young Johnny Lazia, it was initially advantageous. At the age of sixteen, through a family connection he landed a job as a law clerk with a downtown law firm. Lazia was a good student, and his family had every reason to believe that their son was on the road to a reputable life. Lazia may have been a lawyer of some type had he not fallen in with the darker influences of his neighborhood.

* Someday someone will do a study on all the twentieth-century gangsters who were born in Brooklyn and branched out across the United States to lend their particular accent and flavor to the country's criminal diaspora: Johnny Torrio and Al Capone in Chicago, Mickey Cohen in Los Angeles, Benjamin Siegel in Las Vegas, Lazio in Kansas City, and many other lesser known individuals. Brooklyn, possibly, can lay claim to being the premier spawning ground and/or finishing school for the largest number of American gangsters.

Ironically, he would become a man of stature and influence in Kansas City, just not in the way his parents imagined.

The Black Hand was prominent in Kansas City, just as it had been in New Orleans in the late nineteenth and early twentieth centuries. When assessing the prevalence of this criminal society in U.S. cities, factoring in bias and racism is essential. Yes, *La Mano Nera* did exist. The organization was known to leave threatening notes and other evidence of its crimes, and its existence was an open secret in Little Italy. But the phenomenon was such an irresistible source of sensationalism for the local press that it was hard to assess its true threat to the average Italian American citizen.

Mostly, it was a threat to the community's business and power structure. In 1911, Joseph Raimo, a Kansas City policeman—originally born in Naples—received a note from the Black Hand that was published in a Kansas City newspaper. Officer Raimo, thirty-four years old, had played a role in the investigation of a woman shop owner in the North End who was brutally murdered. The killing was believed to have been an act of reprisal by the Black Hand.

The note was delivered to Raimo at his home. In Italian, it read: "Mr. Raimo, Traitor, the others want money and you know it and this notice brings you death. Beware!! Last notice!" A dripping dagger and black cross, symbols of the Black Hand, were scrawled on the page.

One week later, Raimo was gunned down while walking on a city street. His funeral at Holy Rosary Catholic Church on Missouri Avenue in the North End was one of the most widely attended services to ever take place in the neighborhood. Still, many naysayers, including the acting Italian consular general in the state of Missouri, contended that there was no such thing as a secret Italian criminal society. In the press, the consul general offered $1,000 to anyone who could prove the existence of the mafia.

There is no evidence to suggest that Johnny Lazia, at the age of sixteen, was a member of the mafia. But there is little doubt that the

existence of the Black Hand, a mysterious and violent cult, had a corrosive effect on young males in the neighborhood. Though he was gainfully employed with a decent job as a law clerk, Lazia succumbed to the temptations of his generation and fell in with a group of hoodlums. Armed robbery became their specialty. It is not known how many jobs pulled off by this teenage band of gangsters were successful, but it is known that on an afternoon in 1916, Lazia and a couple of his cohorts robbed a saloon and engaged in a shootout with local police. Lazia was the only person captured. He kept his mouth shut and took the fall, receiving a sentence of twelve years for armed robbery. In 1917, just nine months after having been sentenced, the lieutenant governor of Missouri paroled Lazia on the condition that he join the U.S. Army. Lazia took the deal and was released from prison. He ignored the conditions of his parole and never joined the army; instead, he returned to Kansas City and went to work for the political machine of Tom Pendergast.

By the early 1920s, Lazia was known as an up-and-coming power in the city's mafia, but you wouldn't know it by his rap sheet. After his youthful stint in prison, he would never again be charged with a violent street crime. At a time when Kansas City would rise to be the city with the sixth most homicides in the United States, with many of the killings an extension of organized crime activities, Lazia was a master at insulating himself from prosecution. Undoubtedly, Lazia played a role in ordering a number of these murders. He was to become the most powerful bootlegger in the city—friend, confidant, and business partner of Al Capone in Chicago—but he was also a master at keeping his hands clean.

Along with the illegal booze business, which made Lazia a millionaire many times over in a relatively short period of time, he became renowned for something else that would define Kansas City during the 1920s and 1930s.

With all of the country's major locomotive lines running through the city, and the burgeoning popularity of the motorcar, Kansas City

was a central stop for businessmen traveling across the United States. Pendergast and the city's overseers had envisioned as much and set about establishing the city as a sex and gambling mecca. As in New Orleans with Storyville, the idea was to create a vice district that would facilitate the city's sin trade. Booze was the main attraction, but gambling, sex, and narcotics were not far behind.

Wrote a visitor from New York, "If you want excitement with roulette, cards, dice, the races, or a dozen other forms of chance ask a patrolman on the Kansas City streets. He'll guide you. It's perfectly open. You just walk in."

As for sex, wrote Edward Morrow of the *Omaha World Herald*, "If you want to see some sin, forget Paris and go to Kansas City."

Commissioner Harry J. Anslinger of the Federal Bureau of Narcotics declared that Tom's Town was the "drug distribution center of the Midwest." Anslinger's agents staged raids in Kansas City, but they almost always came up empty because Lazia or Pendergast were tipped off ahead of time.

Commercial sex was plentiful—not just prostitution, from cathouses to upscale bordellos, but also a variety of so-called "bawdy houses" where striptease and full-frontal nudity were on display. Most of these clubs were located in and around downtown. Among the most well known were the Blue Goose, the Winnie Winkle, the Oriental, and the Jubilesta. By far the most notorious was the Chesterfield Club, located downtown at 320 E. 9th Street, where the waitresses wore only see-through cellophane aprons that revealed their pubic hair to have been shaved into the pips of playing cards: diamonds, spades, hearts, and clubs. When patrons left a tip, they folded the bill and placed it at the edge of the table; the waitresses were trained to squat down oh-so-delicately and pick up the money with their vaginas.

Occasionally, the kinkiness turned dark. In his biography of saxophone legend Charlie Parker, *Kansas City Lightning*, author Stanley Crouch described the goings-on at the Antlers Club, located in the neighborhood of West Bottoms, birthplace of Tom Pendergast. Saturday

nights at the Antlers included private sex shows that some described as "freak shows." Writes Crouch:

> The shows, also known to the musicians as "smokers," generally involved sex acts presented in an almost vaudeville style, with the band performing musical backgrounds for different kinds of erotic exhibitions. Men in dresses were seen performing oral sex on other men or being mounted by men after being lubricated in a slow, sexual preamble. Women had sex with other women. Some puffed cigars with their vaginas; others had sex with animals.

The bacchanalia both public and private fueled the drinking and gambling. It was all highly profitable for those in control. Pendergast's take reportedly was $20 million annually from gambling, with another $12 million from prostitution and narcotics. And that doesn't even include money from the booze rackets, which was possibly more than all of the above combined.

Lazia may well have raked in even more, as he was the day-to-day overseer of these criminal operations and the first to calculate proceeds, which he divided up along with representatives from the Pendergast machine.

Jazz was an essential element of it all. Most of the gambling parlors and strip clubs and private sex shows had live bands. Pendergast himself, known to be a family man and churchgoer, was not a patron of the clubs or the music, but many of the mobsters were jazz lovers who owned clubs, which they used to launder their criminal proceeds. Big Joe Lusco, a mafia rival of Lazia's, owned Dante's Inferno, an iconic nightclub on Independence Avenue. Not to be outdone, in the late 1920s Lazia opened the Cuban Gardens, a restaurant, nightclub, and casino located alongside a dog-racing track owned by Boss Tom.

The Cuban Gardens was a dream come true for the mafiosi. In August 1927, like a lot of prominent gangsters of his generation, Lazia

had made a trip to Havana, Cuba. He was smitten. There is a photo of the young gangster at Sloppy Joe's, the preeminent tourist bar in Havana, along with his wife, Marie, and Charlie "Mad Dog" Gargotta, his second-in-command. At the time, the mob was using the island to smuggle molasses into the United States for the manufacture of bootleg rum, and it was rumored that leading lights of the underworld on the East Coast had established a cozy relationship with the Cuban government that would, decades later, lead to the mob establishing an offshore criminal paradise in Havana.

Along with the business opportunities he explored, Lazia bore witness to some spectacular Afro-Cuban music at a nightclub located inside Havana's Oriental Park Racetrack. Almost immediately upon his return home, the mobster started plans to re-create this scene in the heartland of the United States.

Conceived as an upscale supper club—something that did not yet exist in Kansas City on this scale—Cuban Gardens was built from scratch. One of the investors was a longtime business associate with Pendergast's Jackson County Democratic Club. During the construction of Lazia's nightclub in Clay County, north of the city line, the mobster complained that "the fix over here in this county is too high." Payments to the local sheriff, prosecutor, and other county officials was normally part of doing business.

Along with the club's large bandstand and dance floor, it had all the trappings of a 1920s Havana-style casino. Dice, roulette, and blackjack were the primary games of chance. As part of the club's fine-dining mandate, Lazia brought in a chef who specialized in something that Kansas City, a meat-and-potatoes kind of town, had never experienced before: Cuban cuisine.

When the club opened in late 1928, it came under scrutiny from the Ministerial Alliance of Liberty, a local anti-vice watchdog organization. The county sheriff made a series of raids and claimed, much to his disappointment, that he had found no evidence of gambling. Like many who entered the place, he admitted that seeing the fashionably attired

men and women in evening wear dancing to "The Chant of the Jungle" and other Latin-inflected musical standards was a charming sight.

The Cuban Gardens was Kansas City's version of reaching for the stars, a staple of Prohibition-era nightlife at its most grandiose, when the flow of profits from illegal booze created a mentality that anything was possible.

In reality, the club was the beginning of Lazia's downfall. Cuban Gardens wound up costing the mobster in ways more than financial, as it created a paper trail that would ultimately be used to indict and convict him on tax-evasion charges.

For the city's jazz musicians, the club was a godsend. Cuban Gardens booked only large orchestras that played dance music and Latin jazz, and it paid top dollar.

Given the club's high-level financial and ownership roots in the underworld, there was an aura of menace to the place. Outside the club, armed guards sat in a small building at the entrance to the parking lot, sizing up arrivals and allowing admittance only to those who were authorized. Once inside the club, security personnel dressed in formal evening clothes did not hide the fact that they too were armed. This sinister mood sometimes enveloped the musicians who played the club.

By now, Kansas City musicians were used to playing at clubs run by mobsters. They had learned how to navigate this reality without getting themselves killed, but the nuances could be treacherous. In October 1930, Andy Kirk's Clouds of Joy—one of the city's most prestigious big bands—was booked to play an ongoing residency. Mary Lou Williams, who played piano in Andy Kirk's orchestra, remembered an occasion when the Clouds of Joy had an unfortunate run-in with one of Lazia's henchmen who managed the club.

Andy was playing tuba, and the band was conducted by our singer, Billy Massey. Billy was a man not easily scared, and one day [at the club] he ran off his mouth to the boss. The hood concluded he was crazy, which was not far wrong, and told the

band to pack up and leave—but fast. The rest of the guys were too nice, he said, for him to think about killing Billy.

In this instance, the musicians got off easy. They were fired but lived to see another day. Given the high demand at the time for bands of all varieties, Andy Kirk's Clouds of Joy was immediately booked at the Pla-Mor Ballroom, another prestigious Kansas City venue controlled by the mob.

Vice Music

The 18th and Vine district, east of downtown in the city's Black section, was sufficiently renowned that it had been immortalized by bluesman/bartender Joe Turner, who dreamed—and sang—about a street encounter with the ghost of Piney Brown. The district, no doubt, stoked the dreams of innumerable jazz hounds from coast to coast. Located between the streets of 18th and 12th, from Vine Street over to Paseo, dozens of nightclubs were packed into this tight radius of twelve blocks. The neighborhood included the Black musicians' union building, the offices of two competing Black-owned newspapers, barber shops, clothing and shoe stores, diners, ice cream shops, and a level of streetlife, day and night, that rivaled Bronzeville in Chicago and Harlem in Manhattan. At night, the district gave way to drinking, gambling, prostitution, and music, mostly a mix of jazz, blues, and swing.

William "Count" Basie, born in Red Bank, New Jersey, was twenty-one years old when he first came to Kansas City. At the time, he was playing piano for a touring burlesque revue, and when he got to Kansas City, he could hardly believe what he encountered:

Oh my, marvelous town. Clubs, clubs, clubs, clubs, clubs, clubs, clubs. As a matter of fact, I thought that was all Kansas City was made up of was clubs . . . I mean, the cats just played. They played all day and tomorrow morning they went home

and went to bed. The next day, the same thing. We'd go to one job we played on, then go jamming until seven, eight in the morning . . . At that time, it was blazing. I mean, everything was happening there, it was beautiful. Wonderful trumpet players, and clarinet players, and banjo players. You could hear the blues coming from any window or door. And it was the most remarkable thing I ever heard.

A few years later, Count Basie returned to Kansas City to assume the role of piano player for the Bennie Moten orchestra, the most renowned band in town.

"I found Kaycee to be a heavenly city," said pianist Mary Lou Williams, who migrated to Kansas City from Pittsburgh after hearing stories about the great music being played there.

Now, at that time, Kansas City was under Tom Pendergast's control. Most of the night spots were run by politicians and hoodlums, and the town was wide open for drinking, gambling and pretty much every form of vice. Naturally, work was plentiful for musicians, though some of the employers were tough people . . . Of course, we didn't have any closing hours in those spots. We could play all morning and half through the day if we wished to, and in fact we often did. The music was so good that I seldom got to bed before midday.

Born May 8, 1910, Williams was an elegant piano player, but she could also get down and dirty. She remembered going on a club crawl one night with a handful of musicians, including Jack Teagarden, a brawny, white trombone player and vocalist from Texas who worshipped Louis Armstrong. (He also had a thing for Mary Lou and proposed to her twice.) They wound up at a club that was decorated to resemble the inside of a penitentiary, with bars on the windows and waiters in striped

jumpsuits like convicts on a chain gang. "In these weird surroundings," said Williams, "I got up and played for the boys, and Jack got up and sang some blues."

Just as the town was wide open in terms of vice, the district encouraged an attitude of liberation toward the music. Certainly, ragtime, the blues, and traditional New Orleans jazz were prominently on display, but these influences on the Kansas City sound were singular. "The bands in the Midwest had a more flexible style," noted clarinetist Garvin Bushell. "They also had done more with saxophones in Kansas City." Lester Young, Ben Webster, Budd Johnson, Eddie Barefield, and, later in the 1930s and 1940s, Charlie Parker emerged from the firmament as virtuoso musicians, bringing the saxophone to the forefront of the music. It all started at 18th and Vine.

Both the machine and the mob made their presence felt. Tom Pendergast, though not a purveyor of the clubs or the music, was beloved, as he was believed to be "a friend of the Negro" and the man who made it all happen. The person who served as Pendergast's face in the district was Felix Payne, the ward boss, gambler, and newspaper publisher.

In January 1929, while the jazz scene in Kansas City was at its peak, city dwellers woke up to the following headline: "FELIX PAYNE KIDNAPPED." The newspaper was the Kansas City Call, a rival of Payne's newspaper, the American. Whereas Payne's paper extolled the virtues of mafioso Johnny Lazia as a legitimate businessman and contributor to the district, the Call was no friend of the machine, and it loved to tweak Payne. This particular story was juicy. Payne had been abducted by "racketeers" as he eased his Packard into the garage behind his home at 26th Street and Woodland Avenue. He was blindfolded, hustled into a waiting car, and driven to a warehouse. He was robbed of $800 in cash, $3,000 in cashier's checks, and forced to strip down to his underwear. The kidnappers eventually released Payne. He wandered nearly naked through the city's Central Industrial District until he came

to a flagman's shanty, where he telephoned someone at a gambling club on 12th Street; they came and picked him up.

Payne claimed that it was all a misunderstanding among friends. Most of his anger was directed at his bête noir, the *Call*, for its salacious coverage of the event. In an open letter to the publisher, Payne wrote: "I was making or earning dimes in Missouri, blacking boots, hopping bells, carrying dishes, shooting craps, promoting clubs, saloons, shows, prize fights, baseball teams, carnivals, amusement parks, barber shops, poolhalls, and railroad excursions when you were playing lemon pool and running down wild women to bring to Kansas City."

The kidnapping of Payne sent a chill through the district, and many of the musicians started carrying guns.

Eddie Durham, who played guitar for the Moten orchestra, remembered, "Everybody in Bennie Moten's band had guns . . . The reed section all had automatics, and the voice section all had revolvers . . . I had a .45." Count Basie had never seen so many weapons. "Everybody carried a gun," he said, including "machine guns." Some band members wore bulletproof vests. The Count may have been only slightly exaggerating when he claimed that patrons would "shoot at each other, and if you played a song they didn't like, they'd shoot you too."

The interplay between the musicians and the hoodlums was sometimes complicated. In later years, in oral histories of the era, some musicians spoke of the hoodlums with affection and nostalgia. Alto saxophonist Buster Smith, who was a mentor to Charlie Parker, spoke for many when he said, "All of them big clubs were [run by] them big gangsters, and they were a musician's best friend. They give you a job and something to eat. And work regular. We didn't know nothing about their business, they didn't know nothing about ours, all they want us to do is play the music and keep the crowd happy."

Eddie Durham eventually moved beyond the Moten band and, through his pioneering virtuosity on the electric guitar, played with all the Kansas City bands. He found the influence of the mobsters to be almost comforting.

I played at one place . . . a mobster come in with his big white hat on and his four bodyguards. The boss come in and said, "All right, Johnny, check the hardware." These guys would take a machine gun . . . all the guns, lay 'em on the piano . . . They had it pretty well controlled. Only thing was . . . one particular night, some fight started. Not between the gangs, something else. I left [the club], jumped out the window and went home about one o'clock. Come three o'clock, knocking on the wood . . . was the triggerman. "Come on, he wants you back there." Got in the car. Felt good . . . nothing's going to happen to you. I got a friend . . . Those guys paid you double for anything you ever done in Kansas City. They never owed a musician a nickel. The gangster always protected; they would always treat everybody right. If you touched a musician or one of the girls, you'd go out on your head. Nobody ever harassed musicians.

The man Durham worked for was Ellis Burton, who, like Felix Payne and Piney Brown, served as a go-between with the Black musicians, the mobsters, and the machine. Burton owned the Yellow Front Saloon, a notoriously tough honky-tonk. He was short, round, and dark-skinned. Though he rarely smiled, he was, according to Sammy Price—a Delta blues piano player originally from Texas—practically "a godfather to the musicians." Remembered Price,

I'd had a problem in Kansas City with a police officer. The guy was interfering with me, you know, that thing where a guy just don't like your looks. So I told Ellis about it. Ellis sent for the man. This man was a policeman and everybody shivered when you called his name . . . Ellis Burton never looked a man in the eye. He always had his hat down so that he's looking at your lips and nose, and you can't see his eyes. He said to this man, "If you interfere with Sammy Price anymore, forget those favors that I used to do for you." And the guy left me alone.

The mob controlled law enforcement, and it also had great influence with the criminal justice system. As in New Orleans, where the Matranga family got Louis Armstrong and other musicians out of jail through payoffs to judges, Kansas City was, if anything, even more corrupt in this regard.

"They would raid us occasionally," remembered Booker Washington, a popular trumpet player, "but no sooner do they take the people down, there was always a bond waiting for them to get out . . . Burton had his connections . . . I stayed downtown for about ten minutes, come on back, start all over again . . . He had a strong hold politically to even operate that place."

It's not hard to see why the musicians idealized the mobsters. The underworld provided opportunities for the jazzmen in Kansas City unlike anything outside the big cities of Chicago and New York, where similar music scenes were flourishing, with a similar symbiosis between the musicians and mobsters.

The Devil and Bennie Moten

Since the early 1920s, the best and most firmly established band in town was the Bennie Moten orchestra. Moten was a local product, Kansas City born and raised, and he came to epitomize the 18th and Vine era because of his musical prowess and also his affiliation to the Pendergast machine. He remained a force in the jazz world until he died, tragically and unexpectedly, at the age of forty, during a tonsillectomy operation gone wrong.

Among other things, Moten and his band were the first Kansas City group to record a 78 record, which they did under the auspices of OKeh Records, Inc. Record sales were minimal in the early 1920s, but a number of Moten's recordings by OKeh and later Victor (formerly the Victor Talking Machine Company) became treasured by musicians and other serious jazz aficionados, as they were the first examples of the Kansas City sound to be immortalized on discs.

Moten became known for pioneering what was called "riffing,"

playing a series of chords and repeating it over and over to an orgiastic crescendo. Moten himself might riff on the piano, or someone else in the band would apply a similar technique.

Over the years, the Moten band acquired many of the best musicians in town. Moten was known to have pilfered the cream of Walter Page's Blue Devils, a ferocious band out of Oklahoma City that regularly toured the Territories and became legendary as the preeminent force in the informal, late-night showdowns, known as "Battle of the Bands," which took place in Kansas City and elsewhere around the country. The great Count Basie played piano with the Blue Devils, until he was lured to Kansas City by Moten. After Moten's death, the cream of his band became the nucleus of the Count Basie Orchestra.

In the mid-1920s, Moten incorporated into his band tenor saxman Lester Young, Walter Page, Oran "Hot Lips" Page (no relation to Walter), the sublime vocalist Jimmy Rushing ("Mister Five by Five"), and Basie. Moten was able to offer these men certain amenities that were beyond the scope of the Blue Devils. There was the district, a steady source of employment, and Moten paid better—he had a recording contract and a touring schedule that was as robust as any band west of the Mississippi. Furthermore, he played a style of music that was exciting to the best young musicians.

Moten had another advantage: He was in tight with Boss Tom.

"Bennie was a businessman first and last," said trumpet player Hot Lips Page, one of the original members of the Blue Devils. "He had a lot of connections out there, and he was a very good friend of Pendergast . . . Through contacts of this kind, he was able to control all of the good jobs and choice locations in and around Kansas City. In his day, you might say he was stronger than MCA."

Moten always dressed sharp. On a weekly basis, he was seen coming in and out of Pendergast headquarters at 1908 Main Street. Bennie was on a first-name basis with the boss, who saw the bandleader as the kind of dependable, upwardly mobile Negro who was a shining example of what the machine could produce.

The source of this relationship—in fact, the source of Moten's power in general—was his role as a founding member of the Black musicians' union. Officially known as Musicians' Protective Union Local 627, and on the street as the Colored Musicians' Union, the organization started in 1917 with twenty-five members. By the late 1920s it was one of the largest musicians' unions in the United States, with over three hundred card-carrying members.

Though Moten was never the actual president of Local 627, to the musicians in the district he might as well have been. He ran Paseo Hall, a large performance venue owned by the union that was located at the bustling corner of 15th Street and Paseo. When the hall opened in 1924, it booked mostly white acts. Moten saw the hall as an ideal venue for Black bands and a Black, dance-oriented clientele. The eight-piece Moten band played there on Thursday and Friday nights, and Moten rented the hall out for $50 on other nights.

Among other things, Bennie was a tireless self-promoter. In 1928 and 1929, the Bennie Moten orchestra toured the big cities—Chicago, New York, and Philadelphia—as an ambassador for the Kansas City sound. In the annals of jazz history, the sleek pianist, composer, and bandleader did more to establish Kansas City as a beacon of jazz than any other musician.

In Tom's Town, Moten walked a fine line between being a sugar daddy to the musicians and a flunky for the machine. To work as a musician in town, an instrumentalist needed Kansas City's version of a cabaret card. The man to see about securing a card was Bennie Moten. Among musicians, there were many stories about cats who had their cards suspended, or revoked, or could never get one because of one perceived violation or another—or simply because they didn't have an "in" with the right people. Getting a cabaret card was not easy; it involved complete and total capitulation to the Pendergast machine.

Many trade unions in Kansas City and surrounding Jackson County were beholden to Pendergast in this way. Generally speaking, the ma-

chine put forth and elected city officials who were pro-union and would protect their interests. For musicians and the venues that employed them, this was a determining factor in how much they would be required to pay in taxes and local fees, and as a buffer against zoning ordinances or rules that might make it prohibitive for a nightclub to exist in the first place. These were the sort of municipal and business realities by which a friend in high places could make or break a musician or nightclub owner's prospects for making a living.

To secure this sort of advantage, there was a trade-off. To become a member of Local 627 and receive a cabaret card—which made it possible for a musician to work—it was understood that on election day you would vote the Pendergast ticket, straight down the line. It was imperative that the machine could count on Local 627 for a certain number of guaranteed votes in local and state elections. The musicians' union was not unique in this regard. This was how patronage worked in Kansas City and other urban centers where political machines did their business. The machine took care of its constituents in exchange for a guaranteed electoral tally on voting day.

A musician could complain, noting to his or her shop steward—or anyone else who would listen—that this was not a very democratic system. Few complained. In Kansas City, you accepted life as it was, not how you wished it to be. The town was booming with employment opportunities for musicians and club owners in a way that outpaced most other cities. Nonetheless, it came at a price. Working within the parameters of the era, to gain access to employment you bartered away a piece of your soul. You traded away your right to vote in exchange for the right to work, all of which was controlled by a higher power. In this sort of arrangement, your freedom—as a citizen and a human being— was limited and controlled by outside forces. For better or for worse, that cabaret card was your pound of flesh. To function as a musician in Kansas City, you were owned by Boss Tom and the Pendergast machine. This also meant that you were owned by the mob.

Rim Shot

In the 1930s, with the Great Depression having taken hold throughout the United States, Tom's Town continued to thrive. While the stock market crash of October 1929 and a general economic malaise over the next decade hit the music business hard (the sale of phonograph players tanked, and the recording of music virtually came to a halt), you wouldn't know it if you were out for a night on the town in Kansas City. If anything, with dwindling economic opportunities overall, the nightclubs in Kansas City became even more of a bonding mechanism between the mobsters and the musicians.

There were signposts, however, that the Pendergast era might be heading toward a reckoning. The incident that seemed to augur rough days ahead was what became known as the Union Station Massacre, still remembered as a seminal event in the city's history.

On the morning of June 17, 1933, at the city's architecturally majestic and always busy centralized train station, Frank "Jelly" Nash, a notorious criminal and prison escapee, was being transported by the FBI from Hot Springs, Arkansas, where he'd been captured, to Leavenworth prison in Kansas. It was the intention of the seven-man law enforcement entourage transporting Nash to put him in a car outside Union Station, where they would drive the final leg of the trip to Leavenworth.

Nash had friends in the underworld, including a few who intended to use his transfer in Kansas City as an opportunity to spring Nash from custody. Three men, including the notorious outlaw Pretty Boy Floyd, had been hired for the job.

As Nash was being led outside the station to the waiting vehicle, the gunmen opened fire. There was a ferocious shootout. Before it was all over, four lawmen—two local cops and two federal agents—and Nash were killed in the melee. The gunmen all got away but were eventually captured while hiding out in Kansas City.

The carnage was shocking, even in Tom's Town, which had expe-

rienced more than its share of gangland mayhem during the years of Prohibition. Four cops shot dead in broad daylight, with women and children and other innocent bystanders forced to duck for cover. In the later investigation of the crime, it was revealed that John Lazia had played a role in providing refuge for one of the gunmen while he hid out in town. This led to a higher than usual level of public scrutiny of Lazia and his many political connections, including his cozy relationship with Pendergast.

The massacre turned the tide of public sentiment against the city's dark matrix of underworld alliances. If Lazia had not yet figured out that the glory days were over, he did eight months later, on Valentine's Day, 1934, when he was found guilty of tax evasion. His ownership of the Cuban Gardens nightclub raised some questions: Who paid for its construction? How was it financed? How much income did it generate? These became central topics of discussion at Lazia's trial, where he was found guilty and sentenced to twelve months in prison. While awaiting appeal, he was out on bail.

Lazia's problems made him vulnerable, and in the underworld, being vulnerable is like having a disease. Nobody comes around; you lose your juice. And sometimes you lose your life.

That summer, Lazia and his wife, Marie, were in the back seat of a car as it pulled up to the curb in front of the stately Park Central Apartments, on Armour Boulevard, where they lived. Lazia got out first and was helping his wife out when, like a tap dancer working the boards, the incessant rhythm of a Thompson submachine gun lit up the neighborhood, followed by the dull thud of two shotgun blasts. Lazia had the presence of mind to push his wife back into the car and tell the driver, "Get her out of here," thereby saving Marie's life.

It was believed that Lazia was shot by mob rivals who sensed that he was weak and no longer the monumental figure he had once been.

The mafia boss languished in the hospital for a couple of days, and then he died. According to his personal physician, who was standing

at his bedside when he passed, his final words were: "I don't know why they did it. I'm a friend to everybody. If anything happens, notify Tom Pendergast, my best friend, and tell him I love him."

T. J. Pendergast was going to need the love. In 1937, with his health beginning to show signs of wear and tear, he was indicted by the same IRS office that took down Lazia. Pendergast, a lifelong gambler who bet on the horse races nearly every day of his adult life, had neglected to pay his taxes or fully account for his income. Not only that, losses at the track had cost Pendergast so much that he illegally transferred proceeds from a government project to cover his gambling debts. In 1939, the unthinkable came to pass: Boss Tom was indicted, convicted, and sent away to prison on tax-evasion charges. He served his time, was released, and then died shortly thereafter.

Through all of this, Kansas City's Jazz Age soared. The word most often used to describe the scene was "joy." Jazz, as expressed, expanded, and expounded upon in Kansas City, was a historical force of nature, but it could not survive the fall of the machine. With the murder of Lazia and the shaming of Pendergast, the entire concept of the wide-open town was called into question. New rules were set, reform ordinances passed and enforced. This particular example of unbridled musical expression was over, but beyond Kansas City, in other places across the land where jazz was being played, the party was just getting started.

4

DISFIGURATION

In 1922, Louis Armstrong was summoned to Chicago by the musical mentor he most admired: King Oliver. It came in the form of a telegram informing him that his services were required immediately as second cornet in the Creole Jazz Band, led by Oliver. It had been a long time coming. Armstrong had more or less reached a plateau in New Orleans. He was thought of as quite possibly the best horn player in town, but since he had no real interest in fronting his own band, he was a perennial sideman. Also, for Armstrong, the New Orleans underworld had begun to lose its charm.

In his memoir, Louis wrote about Black Benny Williams, a local drummer in a brass band who was also a hoodlum. For a time, Armstrong looked up to Black Benny and was enamored of his hoodlum ways: Benny was six foot six, with a prominent scar, and he'd served a number of stints in prison. Wrote Armstrong: "He would not bother anyone, but God help the guy who tried to put anything over on him . . . Not scared of anyone and so great on his bass drum, a good heart—he was my star." But near the end of *Satchmo*, Armstrong relates an anecdote about how—returning from a riverboat cruise, his pockets flush with cash—he was at a bar with Black Benny and a few others. "Since you're so rich, why don't you buy me a drink," said Benny to Armstrong. The young jazzman threw a twenty-dollar bill down on the bar to cover

drinks for everyone. Black Benny snatched the twenty off the bar and put it in his pocket. Right there, Louis knew that things had changed.

> I smiled all over my face. What else could I do? Benny wanted the money and that was that. Besides I was so fond of Benny that it did not matter anyway. I do believe, however, if he had not strong armed the money out of me I would have given him lots more, I had been thinking about it on the train coming home from St. Louis. But since Benny did it the hard way I gave the idea up. I sort of felt he should have treated me like a man.

Armstrong could see that in his hometown, to men like Black Benny and others, he would always be Little Louis, the plump, compliant kid who played the blues in honky-tonks. After receiving the telegram from King Oliver, he was on a train to Chicago within a matter of days.

For the country's young jazz musicians, the arrival of Armstrong in Chicago was a seismic event not unlike the eruption of Mount Vesuvius in 79 A.D., which was the result of many foreshocks, with occasional rumblings, until the force of its power rose up and spilled over for all to see. Said one musician, "The news spread like wildfire. It wasn't that Louis' name was then known, but the musicians were aware of the fact that a young trumpet player had just arrived from New Orleans and was playing with Oliver."

Armstrong arrived at Lincoln Gardens, a large dancehall on the city's South Side, in a worn tuxedo bursting at the seams. The tuxedo was required attire to play in King Oliver's Creole Jazz Band. Louis had put on weight since getting married a year earlier to a woman who liked to cook. Cornetist Rex Stewart, one of many young musicians transformed by hearing Armstrong, noted: "What he carried with him was the aroma of red beans and rice . . . He conveyed this to the world by the insouciant challenge of his loping walk, the cap on his head tilted at an angle, which meant back home: 'Look out! I'm a bad cat—don't mess with me.'"

By now, Armstrong knew he was gifted, but he remained solicitous of those who took the time to nurture his talents, none more so than King Oliver. On his very first night at Lincoln Gardens, the young cornetist stuck to his role as backup to Oliver's lead. "I did not solo until the evening was almost over," he wrote in his memoir. "I did not try to go ahead of Papa Joe because I felt that any glory that came to me must go to him."

As the set wound down, patrons near the stage shouted out, "Let the youngster blow!"

Oliver nodded approvingly for Armstrong to step forward and let it rip. The audience roared their approval.

Over the next two years, Lincoln Gardens became the hottest venue in a city where new nightclubs and speakeasies sprouted up almost on a weekly basis. Audiences were discovering Armstrong, to ecstatic effect, but even more significant was the impact it had on other musicians.

Eddie Condon, a white guitar player, born and raised in Chicago, turned out to see this young horn player whom everyone was talking about. In his memoir, *We Called It Music*, Condon described arriving at Lincoln Gardens:

> As the door opened the trumpets, King and Louis, one or both, soared above everything else. The whole joint was rocking. Tables, chairs, walls, people, moved with the rhythm. It was dark, smoky, gin-smelling. People in the balcony leaned over and their drinks spilled on the customers below . . . Oliver and Louis would roll on and on, piling up choruses, with the rhythm section building the beat until the whole thing got inside your head and blew your brains out.

Condon wasn't the only one. In jazz biographies and histories it is often noted that groups of musical neophytes made regular pilgrimages to Lincoln Gardens. Bix Beiderbecke, Benny Goodman, and other future legends of the music reveled in the unprecedented skill and

exuberance of the young horn player from New Orleans, who nightly at Lincoln Gardens was engaging in a musical version of the Sermon on the Mount.

Through it all, Louis remained loyal—some might say under the thrall of his mentor. Armstrong was not the kind of person to rock the boat by demanding more pay or higher billing. At the time, he didn't require much. All he wanted to do was play music, which was the dominant philosophy of nearly all the young jazz cats flooding to Chicago. In many ways, the Windy City was now the hottest spot in the country. Many New Orleans musicians had moved there: Jelly Roll Morton, Sidney Bechet, Wingy Manone, Kid Ory, Freddie Keppard, along with Oliver and Armstrong. When jazz aficionados talked about "the Chicago jazz style," they were usually referring to those "cats from New Orleans" who brought their sound north to capitalize on the opportunities to be found in the big town.

Given Armstrong's sincere love and affection for Oliver, imagine how disappointed he must have been when he learned, two years into his residency with the Creole Jazz Band, that he was being ripped off by the boss? He learned about it from Lil Hardin, the band's piano player, who was also now his wife. (Louis had divorced his first wife and married Lil in 1924.) Lil learned about Oliver's thievery from Johnny Dodds, the band's sax player, who discovered that Oliver was skimming the sidemen's salaries, collecting $95 for each player and paying them only seventy-five. When Dodds confronted Oliver about it, he denied it and refused to show his bandmates the royalty checks he was receiving from Lincoln Gardens management. Except for Armstrong and Lil, everyone in the band quit.

Armstrong's love for his mentor was vast, but it did have its limits. He was stunned when his wife told him that Oliver had said, "As long as Little Louis is with me, he can't hurt me."

To Armstrong, his boss's comment reminded him of Black Benny back in New Orleans snatching that twenty-dollar bill off the counter. Could it be possible that Papa Joe was jealous of his talents and fearful

of being left in the dust by the younger player? His wife told him, "As much as you idolize him, daddy, you must leave him immediately. Because King Oliver and his ego and wounded vanities . . . may hurt your pride."

Louis did the unthinkable: He left King Oliver's band. The feelings of anger and betrayal built up in Armstrong until he thought he might be developing an ulcer; he vowed that he would never again be played for a sucker. And so Little Louis sought out something that was familiar to him, a network of support that had worked for him back home in New Orleans. Once again, he took refuge in the cool embrace of the mob.

Papa Joe

Armstrong's many biographers, assuming the role of armchair psychoanalyst, have noted that the trumpet master, having grown up without a father, spent much of his adult life seeking out father figures. King Oliver had served that role for a while. Now it was time for a new adult male in his life, someone who could provide guidance in the world of jazz and entertainment, certainly, but also serve as protector for a young Black man in a hostile world. Louis tended to wear his heart on his sleeve; he needed someone he could trust.

Joe Glaser was no paragon of virtue, but he fit the bill as a mentor and protector for Armstrong. They began a relationship in 1925, with Armstrong going to work at the Sunset Cafe at 315 E. 35th Street, in Bronzeville, a lively club managed by Glaser. Twenty-eight years old at the time (he was born in 1896), Glaser came from the world of professional boxing, where he'd been making a living as a scout and manager for various fighters. It was there that he first met a rising bootlegger and gangster who, at the time, went by the name of Al Brown. Soon everyone knew him by his real name: Al Capone.

Glaser and Capone had an affinity for one another that was based on business. As he cultivated connections in the underworld, Glaser received advanced word on which boxing matches were fixed. He could

sometimes predict outcomes to the exact round when a mob-controlled fighter would "take a dive." This information was invaluable to people like Capone—and others—who routinely bet large sums on the fights. Capone may have noticed that Glaser, a salty character with a gravelly voice who did not seem to fear anyone, was especially conversant with African Americans. Capone's admiration for Glaser manifested itself in the young gangster asking Joe to manage a couple of his South Side Black-and-Tans (racially integrated clubs), the Sunset Cafe and also the Dreamland Ballroom. Glaser also took on the job of managing a number of whorehouses and speakeasies for Capone, part of the gangster's growing South Side bootlegging empire.

Glaser was a hustler at a time when a young man on the make could perform miracles.

He was an Ashkenazi Jew, with an ancestral lineage traceable from the former Russian-mandated Jewish ghetto known as the Pale of Settlement. Many Ashkenazim settled in Chicago, and in later years some of these men became hoodlums, businessmen, and attorneys for prominent underworld figures in Chicago and beyond. One of these men was Jules Stein, who would front $100,000 for Glaser to found Associated Booking Corporation, his booking agency for Black musicians. Glaser also did business with fellow Ashkenazi Sidney Korshak, an entertainment lawyer, who, together with Stein, would found MCA, the biggest and most powerful entertainment conglomerate in the world.

In 1925, Glaser was still "making his bones." Like many gangster/businessmen, he sometimes found himself entangled with the law. That year, he was indicted on bootlegging charges, and he also became enmeshed in a massive conspiracy case that involved payoffs made by the underworld to Chicago policemen. Now that he was a member of the Capone organization, he was provided with legal representation, and the charges were squashed.

Glaser didn't know that much about jazz. At the Sunset Cafe, when he first hired Armstrong, it was to serve as sideman for the Carroll Dickerson band, but it soon became apparent that the kid trumpet

player from New Orleans was the real draw. Glaser fired Dickerson and changed the name of the band to Louis Armstrong and His Sunset Stompers.

"Something you need to know about me," Glaser told his new employee. "I've got a terrible temper, and I always keep my word."

Armstrong took to Glaser right away, referring to him as Papa Joe, even though there was only a three-year age difference between them. His affection for Glaser was derived in part from his feelings about Jews that he developed as a boy in New Orleans.

For a time at the age of seven, Louis worked for the Karnofskys, a family of Jewish peddlers from Lithuania. He ran errands for the Karnofskys and never forgot how they took him under their wing, feeding him traditional Jewish dishes and introducing him to Yiddish phrases. Years later, he wrote, "They were always warm and kind to me, which was very noticeable to me—just a kid who could use a little word of kindness."

Among other things that he would never forget about the Karnofskys: They lent him the money to buy his very first cornet.

Glaser could see that among musicians Armstrong was revered. Years later he told an interviewer, "All the young musicians in town would come to hear Louis—Benny Goodman, Muggsy Spanier, and the rest. I used to let them in free. Hell, they were kids and never had any money."

Glaser was proud of the Sunset's status as a Black-and-Tan, and he had a proprietary attitude toward Armstrong and the other Black musicians he employed.

The Sunset had the cream of the Black-and-Tan shows, and there wasn't a big name in colored show business that didn't work for me at one time or another. I spent more money on my shows than the Cotton Club. Why, I once hired a band out of Columbus, Ohio—Sammy Stewart—for thirty-six hundred a week. But Sammy was a bad boy. He would've been one of the

biggest names in the business today if he didn't go wrong. Hell, Cab Calloway started for me at thirty-five a week while his sister Blanche was making two or three hundred. Ethel Waters, the Nicholas Brothers, and everybody else you could mention worked for me.

So thrilled was Papa Joe with Armstrong's drawing power at the Sunset that he decided to give the rising young star top billing. This decision was met with resistance from his mostly silent business partner, Al Capone.

Capone was not yet the overlord of the Chicago underworld, though he was one of the city's most ambitious bootleggers, and he was getting more powerful every day. Shortly before Armstrong took up residency at Joe Glaser's Sunset Cafe, on November 10, 1924, Capone was the beneficiary of one of the most notorious gangland murders in the city's history. Dean O'Banion, boss of the North Side gang—a powerful bootlegging consortium—was murdered in his flower shop on a bright, sunny morning. A former choirboy and singing waiter, O'Banion was popular with his underlings. It has never been proven that Capone ordered the hit, but the elimination of the most significant Irish mobster in town had unburdened Al of a powerful rival. There was no looking back now; Capone was poised to take over the illegal beer and liquor trade in all of Chicago.

The kind of business relationship that Joe Glaser had with Capone did not involve discussing murders or underworld strategy. Glaser was not part of Capone's gang, but he was part of his business activities, which were made possible by the activities of the gangsters. The club was partly financed with money from Capone's criminal rackets. Big Al himself frequently stopped by the Sunset, as he did with the half dozen or so other clubs of which he owned a piece.

Louis Armstrong frequently spotted Capone at the club. He later described the gangster as "a nice little cute fat boy—young—like some pro-

fessor who had just come out of college to teach or something." There's little doubt that Armstrong knew for whom he was working; given his views on working at clubs owned by mobsters, which he had developed back home in New Orleans, he likely took a certain amount of pride in being associated with the underworld's rising star. He may have been in awe of Capone, but the man to whom he gave his allegiance was Joe Glaser. "I always admired Mister Glaser from the first day I started working for him. He just impressed me different than the other bosses I've worked for. He seemed to understand colored people so much."

With Armstrong packing the club, Glaser made the decision to not only give Louis Armstrong and His Sunset Stompers top billing on the marquee but to put Armstrong's name in lights alongside the bold claim: "The World's Greatest Trumpeter."

Capone didn't get it. He'd heard Armstrong play and thought he was fantastic, but as far as he knew the kid didn't have the fame to justify the hype. He sent a gangster emissary to the club to tell Glaser to alter the marquee accordingly.

Armstrong never forgot Papa Joe's response. Years later, he wrote:

When one of Capone's Boys told Joe Glaser that he must take the name of Louis Satchmo Armstrong down from the Marquee LIGHTS because this is a small world and very few people— "know Louis Armstrong" and his greatness, Mr. Glaser still standing at the door of the Sunset Cafe (Chicago) sharp as a tack TACK—"29" years old, THREE "YEARS" older than ME at that time. When this ugly Gangster told Mr. Glaser that he must take the name of ARMSTRONG down off of the Marquee and it was an "order from Al Capone" Mr. Glaser looked this cat straight in the face, and told him these words—I think that Louis Armstrong is the world's greatest and this is my place and I defy anybody to take his name down from there. And that was that.

Armstrong had found the protector he desired. And in the months and years ahead, there wasn't a serious jazz fan alive who wouldn't recognize the name of Louis Armstrong.

The Gangster as Jazz Lover

Would the culture of jazz have captured the zeitgeist in the way that it did were it not for the phenomenon of Prohibition?

Musically, jazz was a force to be reckoned with from the earliest years of the new century; that train had left the station before Prohibition ever existed. As an art form, the genesis of jazz bore no relation to the historical circumstances of the 1920s. On the other hand, the reality of Prohibition created a framework for the music that would otherwise not have existed. And it wasn't just that new venues created by the people's desire to imbibe were ready-made for jazz combos and dangerous rhythms. There was something about the Roaring Twenties itself—the clandestine social interactions, the pushing of racial boundaries, the hoodlums, the musicians—that turned jazz from a subculture into a telling representation of the national psyche. The music was daring, seemingly spontaneous, rhythmic, torrid, sensual, and a little bit naughty. It took you places you needed to be and left you there, all grown up, independent of spirit, ready for anything.

Prohibition gave rise to an elaborate ecosystem for the music: Speakeasies, or "blind pigs," became the place for trios and quartets, nightclubs for larger bands with floor shows, and dancehalls and theaters for big orchestras and "Battle of the Bands," raucous affairs where multiple bands faced off against one another in a show of musical supremacy.

In the underworld, the illegal liquor and beer created a stratified criminal structure that, in some ways, remains intact one hundred years later. Sophisticated distribution networks brought the product into the country, as is the case today with illegal narcotics. Scotch, Irish whiskey, and other spirits from Europe and Canada were prized commodities, as was rum from the Caribbean. Beer was usually manufactured illegally in

U.S. cities. Bourbon and rye were conjured up in remote country stills. The manufacture, distribution, and sale of the product was facilitated by corruption at all levels of municipal government, business, and law enforcement. Criminals who had once scuffled for income from gambling, prostitution, thievery, and whatnot now found themselves in a position to deliver a sought-after product while paying no tariffs or taxes to the government. It was almost too good to be true.

For the gangsters, the big drawback was competition. Bootlegging was simply too potentially profitable to pass up. Every criminal in town became part of a liquor manufacturing and/or distribution cartel. It was a violent business. Hijacking of rival booze trucks was common and often deadly. Unlike Kansas City, where things ran relatively smoothly thanks to the ubiquitous power of the Pendergast machine, in Chicago and much of surrounding Cook County there was no unifying element. The county was under the domain of at least seven major cartels.

Gangland murders were frequent, with outrageous shootings in the streets and back alleys of the city. Some of this was simply a product of the times: American capitalism at its most rough-and-tumble. And some of it was carefully orchestrated by one man who had designs on the entire kingdom of vice.

Born January 17, 1899, the son of immigrant parents from Naples, Italy, Alphonse Gabriel Capone took a wrong turn early in life. The Brooklyn where he was born and raised was in the middle of a waterfront gang war, with Irish and Italian gangs vying for control of the commercial docks. As a teenager, Capone was muscular and physically capable in a world where violent confrontations were a frequent occurrence. Johnny Torrio, an older and wiser Brooklyn gangster, saw the value in Capone's muscle. He put the young hood to work as a bodyguard and as a bouncer at the Harvard Inn, a saloon and dancehall partly owned by Torrio.

It was at the Harvard Inn that Al got into a tussle that would lead to his being given the nickname "Scarface." While letting a young couple into the club, Capone supposedly said to the female, "Honey, you have a

nice ass and I mean that as a compliment." The woman's companion—her brother—pulled out a knife and attacked Capone, slicing him on the side of the face. The wound healed nicely but left a scar and a moniker that no one would dare use in Capone's presence.

At the age of nineteen, Al married Mae Coughlin, an Irish Catholic girl from St. Mary Star of the Sea parish in the neighborhood of Carroll Gardens, Brooklyn. In short order, Mae gave birth to their son, Albert Francis Capone, whom they called Sonny. Capone made a stab at a legitimate life, working in the city of Baltimore as an accountant for a family friend. His employer was pleased with young Al's performance. Capone might have settled into a simple working-class life were it not for the onset of Prohibition. By then, Torrio, his underworld mentor, had moved to Chicago and staked his claim as an up-and-coming bootlegger in the Windy City. He summoned his former protégé, telling him there were riches to be made in the business of illegal booze. The city was wide open.

Al packed up his wife and son and made the move from Baltimore to the Windy City. Beginning with his arrival in town, the young hustler projected an image of toughness and violence. His boss, Torrio, was the opposite, a cerebral gangster in the model of Johnny Lazia in Kansas City. Torrio benefited from having Capone serve as his Doberman pincher, a role Al undertook with glee. He was arrested a couple of times on assault charges but was always quickly back on the street thanks to Torrio's political connections.

By the time of the murder of Irish mobster Dean O'Banion in his flower shop, through a series of gangland convulsions and murders Capone had emerged as Torrio's second-in-command. Within the next few months, he would be the undisputed champ. The incident that opened the floodgates was an attempt on his life by what was left of O'Banion's North Side gang. In front of the Hawthorne Inn in Cicero—which Capone had recently turned into his headquarters—three North Siders opened up with Thompson submachine guns (Tommy guns) on Capone's car one afternoon, riddling it with bullets. Capone's driver was

wounded, but two bodyguards ducked for cover and were unharmed. Big Al wasn't even in the car; he'd gone into the restaurant at the Hawthorne Inn for a moment and missed the shooting entirely.

Twelve days later, in Chicago, the same hit team went after Torrio. They opened up on the mafia boss outside his house at 7011 Clyde Avenue, in the Jackson Park section of the South Side. Two gunmen armed with automatic pistols and shotguns opened fire on Torrio, hitting him five times in the jaw, right arm, abdomen, and chest. Somehow, the forty-four-year-old gang boss survived. Weeks after the shooting, he summoned Capone to his hospital room and told him that he was going into retirement. He turned his entire operation over to Al.

It was a moment for which Capone had been waiting, and he seized upon his ascension to the throne with enthusiasm, waging war simultaneously with all of his rivals. This period, from 1925 to 1929, was possibly the most violent of the Prohibition era, when the presence of gangsters in the city became a sign of the times. Author Herbert Asbury described it in his 1940 masterpiece *The Gem of the Prairie* (later retitled *The Gangs of Chicago*):

> Chicago seemed to be filled with gangsters—gangsters slaughtering one another, two hundred and fifteen in four years; gangsters being killed by the police, one hundred and sixty in the same length of time; gangsters shooting up saloons for amusement; gangsters throwing bombs, called "pineapples"; gangsters improving their marksmanship on machine-gun ranges in sparsely settled neighborhoods; gangsters speeding in big automobiles, ignoring traffic laws; gangsters strutting in the Loop, holstered pistols scarcely concealed; gangsters giving orders to the police, to judges, to prosecutors, all sworn to uphold the law; gangsters calling on their friends and protectors at City Hall and the County Court House; gangsters dining in expensive restaurants and cafes; tuxedoed gangsters at the opera and the theater, their mink-coated, Paris-owned wives or sweethearts on

their arms; gangsters entertaining politicians and city officials at "Belshazzar feasts," some of which cost twenty-five thousand dollars; gangsters giving parties at which the guests playfully doused each other with champagne at twenty-five dollars a bottle, popping a thousand corks in a single evening; gangsters armed with shotguns, rifles, and machine-guns, convoying beer trucks; gangsters everywhere—except jail.

Through it all, Capone cut quite a figure. He seemed to revel in the notoriety he received at ball games, theaters, and coming in and out of police stations and courthouses, where he sometimes stopped to give the reporters a juicy quote.

His taste for jazz was, by most accounts, legitimate, though his first love was opera. At home, he listened to phonograph records of Verdi and Enrico Caruso, and though his formal education ended at the sixth grade, he often read the libretto of operas at home before taking in the actual performance at the opera house. Opera not only represented culture but, more important, it was Capone's way of connecting with his Italian heritage, a way to show that he wasn't just a "dago," a "wop," or any of the other insults he had heard all his life.

If opera appealed to Capone's Italian side, his love of jazz was a manifestation of his American side. The music made him smile and tap his feet. As he made the rounds at his many nightclubs around Chicago and neighboring Cicero, he made a point of tipping the musicians. In later years, many musicians remembered how he would shake their hand or straighten their tie and leave behind a twenty-dollar bill. These encounters were usually pleasant, but not always. Clarinetist Johnny Dodds once did not know a song that the gang boss requested. According to Dodds, Capone pulled out a hundred-dollar bill, tore it in half, and stuck one half in Dodd's breast pocket and the other in his own pocket. Said Capone, "Nigger, you better learn it for next time."

Other musicians found Capone's presence in a club to be unnerving, whether he was friendly with them or not. Anyone who read the

newspapers or listened to the radio knew that Capone was Public Enemy Number One. Other gangsters were trying to kill him. It was not unreasonable to surmise that if Capone was in the house, the possibility of mayhem was greatly increased.

Even so, if Capone liked you it could be profitable for a musician, not only with bookings at his various nightclubs, but also the many private parties and events he hosted or attended. One man who found this out—famously—was Thomas "Fats" Waller.

As one of the biggest stars in jazz in the 1920s, Fats Waller was in high demand. Based in New York City, where he'd been born and raised, Waller played multiple instruments, but he was especially renowned for his innovations on the piano. He practically invented the Harlem stride style, which was rhythmic and jaunty and, when Fats played it, sounded as if multiple pianos were playing at once. Waller was also a brilliant composer who had written the scores for a number of musical revues on Broadway. On top of all that, he was perhaps most famous as a highly entertaining performer. When Fats Waller tickled the ivories and sang any one of his many hit songs—"Ain't Misbehavin'," "Honeysuckle Rose," or "Lenox Avenue Blues"—he mugged and smiled as if he were high on alcohol or cocaine (he sometimes was), told risqué stories, and unleashed a bevy of jokes and entertainment tricks from his early days in Black vaudeville.

In 1926, Waller was playing a gig in Chicago at the Hotel Sherman, located not far from Capone's headquarters in Cicero. One night Capone came in with two or three bodyguards. It was clear that Al was dazzled by Waller. He slapped Fats on the back and left an exorbitant tip. A few nights later, the entertainer was finishing up his last set when a couple of the men he had seen before with Capone came into the place. One of them walked up to Waller, pressed a gun to his abdomen, and said, "Don't make a scene. Just come with us and everything will be okay."

Fats did as he was told. He was put in the back seat of a car and driven into Cicero, which was a short ride from the Sherman Hotel.

The hoods remained silent. The car pulled up in front of the Haw-
thorne Inn. Being an out-of-towner, Fats might not have known the
significance of this place as the headquarters of Al Capone, but he soon
understood. Once inside, the men led Waller to a piano in a private
party room, where many of the most renowned hoodlums from in and
around Chicago were in attendance for a birthday party for Big Al.
Waller's presence was meant to be both a birthday gift and a surprise.
When Capone saw the piano player, he was ecstatic.

In Waller's retelling of this story over the years, he entertained Ca-
pone and his men for the next three nights. Staying in a room at the
Hawthorne Inn, he rose in the afternoon, ate a big meal, and performed
late into the night and the following morning. By the time he left, Ca-
pone had stuffed his pockets with cash—$3,000, claimed Fats, which
today would total over $40,000.

Fats left Chicago and returned to New York with a great story to
tell. Not only had he emerged unscathed from his encounter with some
notorious gangsters, he had come through it all with a pocket full of
dough. Not all entertainers were as lucky as Fats.

The Chicago Way

Joe E. Lewis, born Joseph Klewan in New York City, had been perform-
ing at Green Mill Gardens (the name was later changed to the Green
Mill Cocktail Lounge) in Uptown, in Chicago, for a solid year. A mod-
estly talented jazz crooner, Lewis was nonetheless a superb entertainer;
he told jokes between songs, and sometimes, in the grand vaudeville
tradition, the jokes *were* the songs. The audiences were so good for
Lewis at Green Mill that the club's manager, Danny Cohen, had agreed
to pay him $650 a week, more than the club had paid any act to date.

Green Mill had been around since 1910. Its name was inspired by
the world renowned Parisian burlesque club Moulin Rouge (French for
"red mill"). Since the early years of Prohibition, the club had become
one of the city's favorite speakeasies. Al Capone was one of the club's

owners, and he made sure the booze flowed at Green Mill with no inter-ference from cops or city officials. The club was so well connected that cops were known to duck inside for a drink every now and then; they knew that the inner sanctum of Green Mill was a safe zone for coppers on the take.

In October 1927, Lewis approached Cohen, the manager, to tell him that he was not going to renew his contract with the club. He'd been offered a better deal at a brand-new club called the New Rendez-vous, located downtown in the Loop.

Lewis knew that this was not likely to go over well with Cohen or the rest of the club's management. Though only twenty-five years old, Lewis knew a thing or two about show business and the mob. He'd got-ten his start in Easton, Pennsylvania, as lead singer with a group called the Honey Boy Jazz Band. Joe filled in one night for the band's regular singer, who was stricken with laryngitis. Part of the act involved Lewis appearing in blackface, which was common at the time. He had an okay voice and sang his heart out, though few paid much attention, as it was January 16, 1920, the night Prohibition was to go into effect exactly at midnight.

In the following years, Lewis improved as a singer and came up with an act of his own. He was handsome and had impeccable comic timing. He made fun of himself and roasted patrons in the audience. His signa-ture song was "Macushla," a sentimental Irish ballad made famous by the tenor John McCormack. Joe used to laugh about it: At Green Mill, he was a Jew singing an Irish song to a room full of Italians.

One of his biggest fans was Capone himself. Big Al, always with an entourage of bodyguards, stopped into the club almost every week. A booth at the end of the bar was reserved for Capone and his party. The bodyguards could see both entryways from that vantage point, and Capone could see the stage, where Joe E. Lewis entertained the house with jazz ballads and yucks in the old vaudeville style.

One thing Lewis knew about mob joints like Green Mill was that they took a proprietary interest in their employees. Lewis was friendly

with Capone, and he knew Capone's underling "Machine Gun" Jack McGurn, whose birth name was Vincenzo Antonio Gibaldi. These men were mafiosi, and one thing about mafiosi or any other kind of mobsters: They called the shots. That's how it was.

Lewis liked Capone, but he wasn't too sure about McGurn. He'd once dated a woman who had also dated McGurn, and Joe always felt that this put him on shaky ground with the hoodlum. It's not that Lewis was afraid. He was a tough Jew, born in poverty in a tenement house on Jefferson and Cherry Street in New York City. His father died when he was twelve years old. At sixteen, he lied his way into the army and served for a year in the First World War. Lewis may have been a singer and a jokester, but he was no wimp. He was certain that he could take care of himself and do what he wanted.

When he told Danny Cohen that he would not be renewing his contract, it did not go well. "You ungrateful punk," said Cohen. "You were a two-bit comic on the Levee when I picked you up and gave you a break. Who made you master of ceremonies? Who upped you to six hundred fifty a week? I *made* you—and this is how you pay me back?"

"Danny," said Lewis. "I appreciate everything you've done. But the decision has been made. I'm giving you three more weeks, then I move on."

"You give me three weeks? No, you don't give me nothing. You're through right now."

It was not how Lewis wanted it to go, but it was already a done deal. Not only was the New Rendezvous giving him $1,000 a week, they were also giving him a percentage of the door, which was unheard of in those days. It was a deal that Lewis could not pass up.

Lewis was then residing at the Commonwealth Hotel, on West Diversey Parkway, walking distance from the New Rendezvous on North Clark Street. The day after his showdown with Cohen at Green Mill, he arrived outside his building and there stood a well-dressed young man, Sicilian-born, with the kind of manly good looks that often appealed to the ladies. It was Jack McGurn.

"Hiya, Joe," said McGurn.

"Hello, Jack," responded Lewis. "What brings you here?"

McGurn was not a man to be trifled with. He'd started out as a middleweight boxer, but his career took a sudden turn in 1923 when his stepfather was murdered by the Black Hand. McGurn, at the age of twenty, set aside his boxing pursuits to seek out the three men who were known to have killed his stepfather. Systematically, one by one, Jack McGurn murdered each assassin. Not long after that, he went to work for Capone and was thought to be a wizard with the Tommy gun, hence his nickname.

McGurn said to Lewis, "I heard you had some beef with Danny."

Joe shrugged. "No beef. My contract's up, and I've decided not to renew."

"Well," said the gangster, "we're renewing."

"We?"

"Now Joe, you know I got a piece of the joint."

"Yeah," said Joe, "but you don't own a piece of me. I start at the Rendezvous on November 2."

Said McGurn, "You'll never live to see it open." The gangster said the words quietly, as true tough guys usually do. No shouting, no scare tactics.

Lewis replied, "I'll reserve a table for you." He turned and walked away. This was the way he'd learned to handle sticky situations. Smooth. Never lose your cool. But he was, at that moment, terrified. Machine Gun Jack didn't need to raise his voice to strike fear in the hearts of men; he did it with his actions, and by reputation.

A couple of weeks went by. In nightclub circles and the underworld, word had gotten around that Joe E. Lewis had been given the order: Return to Green Mill, renew your contract, or you are going to be killed. Lewis could hardly sleep at night, but he followed his regular routine. A week before opening night, he was at the New Rendezvous for a rehearsal. Into the club came a police captain whom Lewis knew to be a regular at Green Mill. The captain told Lewis that he should

take a vacation in Dubuque, Iowa, far from Chicago. "Give McGurn time to cool down," said the captain.

"I open November 2, Captain. I'm not going anywhere."

The captain seemed more upset than Lewis. "Joe, you can't buck the mob. They made you, and they can break you."

Indignantly, Lewis answered, "I'm not a hoodlum. I'm an entertainer."

Certainly, these words were true. In his business, Joe E. Lewis was friendly with mobsters, but that didn't make him a criminal.

The captain tried to explain it: "You're a piece of property. Their property. And a valuable piece at that. You can fill a club. That's no small thing."

Lewis said nothing. He felt trapped. He was at a crossroads. It was the same crossroads that confronted jazz musicians from New Orleans to Kansas City to Chicago. If hoodlums owned the clubs where you performed, if they controlled your ability to practice your art and make a living, did that mean they owned you?

Lewis did not think of himself as a slave; he was offended by the concept. He said to the cop, "You can't beat the odds by ducking them. I open here at New Rendezvous on Wednesday."

On Sunday, an ad appeared in the local newspapers:

The New Rendezvous announces its opening, November 2!

The most elaborate and snappy girl revue ever attempted!
Joe Lewis, America's greatest cafe entertainer!
And twelve (12) unadorned daughters of Eve!

Lewis appeared at the club, and the night was a smash. The place was packed from Wednesday through the weekend. Machine Gun Jack McGurn never did make an appearance. Lewis sang his jazz ballads and told some jokes, just like he had at Green Mill. Just in case, he had a loaded .22 pistol tucked inside his suit coat as he performed.

A week went by and nothing happened. Lewis received no threats. He was almost giddy with relief. Machine Gun Jack McGurn, it seemed, was all bark and no bite.

A few nights later, Lewis was getting ready to retire for the night in his room at the Commonwealth. He pulled back the top sheet on his bed, and the phone rang. He answered, "Hello."

"Don't open the door." It was a man's voice, with a heavy Italian accent.

"Who is this?"

"Don't open the door—for nobody."

Lewis heard the person hang up. That was it.

He was unnerved by the call but not overly so. That night, he tossed and turned but eventually fell asleep. He wasn't even sure what time it was when he was awakened by a knock at the door. His first thought was: *Housekeeping.* Still in his pajamas and half asleep, he rolled out of bed, walked over, and unlocked the door.

Three men walked into the room. Lewis didn't recognize any of them, but one of them was a nineteen-year-old hoodlum named Sam "Momo" Giancana, a punk kid making his bones. Years later, Giancana would be one of the biggest mobsters in Chicago.

One of the hoodlums said, "Just one favor, Joe. Don't yell." And then they were on him.

Decades later, the assault was described in the book *The Joker Is Wild: The Story of Joe E. Lewis*, a biography of Lewis written by newsman Art Cohen:

[The lead gangster] drew a .45 revolver. One of his helpers pulled out a .38 and moved behind Joe. Joe braced himself for a bullet. It did not come. A horrendous blow hit him from behind. He turned and he fell and saw the man with the .38 raising his arm to clout him again. The third assailant was unsheathing a hunting knife. Pain coiled around his brain, tighter, tighter, and sank its fangs deeper and deeper . . . The knifeman

went to work. He punched the blade into Joe's left jaw as far as he could, ripped his face open from ear to throat, and went on cleaving impassively, like a butcher.

Lewis was left unconscious on the floor. When he came to, he wasn't sure how long he'd been lying there.

His first reaction was an impression that he was drowning. He was lying on the floor, his face immersed in a pool of blood. He remained in a state of shock for several seconds . . . With tortured effort, he slowly turned his head. In the full-length mirror of the closet door he saw the horrifying image of a man, his left jaw hanging loose in a great raw flap, the splintered bones and slashed muscle exposed.

Somehow, Lewis was able to reach the phone and press the button for the front desk. He wasn't able to say anything, but the desk clerk got the message that something was wrong.

They found the entertainer in a pool of his own blood. He was rushed to Columbus Memorial Hospital, three blocks away. Miraculously, Lewis survived the attack, but it would be many months before he was able to speak. His vocal cords were cut, and he had a major concussion. The loss of blood alone might have killed him had he not been hurried into emergency surgery.

Later that afternoon, the attack on Lewis was headline fodder in all the newspapers. In the weeks, months, and years ahead, the story became something more—a cautionary tale repeated by jazz musicians and other entertainers throughout the country for generations to come.

In many cities—New Orleans, Kansas City, Chicago, New York—the nightclubs were owned by mobsters. What had happened to Lewis could have happened almost anywhere, to any performer who found him- or herself on the wrong side of the mob's wishes. Joe E. Lewis was merely the poor sap who found out the hard way. It was a professional

hazard, one that many musicians secretly—and not so secretly—had begun to dread.

Lewis kept his mouth shut. To police investigators, he wouldn't even confirm that he'd been threatened by Jack McGurn, much less that McGurn was likely behind the attack. His recovery took nearly two full years, and even then, Lewis emerged more as a stand-up comic than a singer. His vocal cords never fully healed.

Momo's Delight

As recounted in *The Joker Is Wild*, the city's premier gangster boss felt bad about the attack on the persnickety nightclub entertainer. Capone maintained a patriarchal relationship with his minions, be they Black or white. Perhaps he was reminded of his own encounters with a blade that had left him facially scarred for life. Technically, Jack McGurn was his underling, and the attack had not been cleared with the boss. There is no evidence to suggest that Capone ever sanctioned or disciplined McGurn, but he did seek to make amends with Lewis by offering him $10,000 in cash. Lewis turned down the money.

In later years, Lewis became almost a mascot of the mob. He did not stop working in mob-controlled nightclubs. In fact, he worked at most of them in a career that stretched from Chicago to New York to Los Angeles and Las Vegas and lasted into the 1960s.

For half a century, it was not publicly known who the actual assailants were in the attack on Lewis. In 1992, a book published by Sam "Momo" Giancana's brother, Chuck, told the tale (the gangster Giancana was deceased by the time the book was published, murdered in his Chicago home in 1975).

According to Chuck Giancana, on a night in May 1949, he and his brother, Sam, were at Chuck's wedding reception, held at a Chicago nightclub. The entertainment, as arranged by Sam, was Joe E. Lewis. That night, Sam told Chuck the story of how he and two others did a job for Jack McGurn. Gleefully, Sam Giancana recalled for Chuck how,

back in the day, they took care of Lewis. "Shit, we cut his fuckin' throat from stem to stern . . . His goddamned tongue was hangin' by a string out of his mouth when we got done with him. It's a wonder the guy lived, let alone that he can sing."

Twenty-two years after the attack, and here was Joe E. Lewis warbling tunes and telling jokes at the Giancana family event.

Sam Giancana grinned at the memory. "One thing we didn't count on was how other entertainers would react . . . The story spread like wildfire . . . There isn't a star alive now who would turn us down, especially Joe E. Lewis. He wouldn't turn me down for nothin'. He'll fuckin' croon his heart out all night if I tell him to."

The entertainer and the mobster: In the 1920s, jazz musicians found themselves at the center of this conundrum. As hired talent, you worked for the boys. This put you at their mercy. Sure, you could resist, try to stand up for yourself. But then you might just wind up like Joe E. Lewis, cut within a millimeter of your life, spending the rest of your career as a compliant slave.

5

BIRTH OF THE HIPSTER

The Plantation Café was a flashy Black-and-Tan located kitty corner from the Sunset Cafe, at 35th and Calumet, in Chicago. Both of these establishments were owned by a consortium that included Al Capone and Joe Glaser, who seemed to have a monopoly on this particular South Side intersection. While Louis Armstrong was making a name for himself at the Sunset, King Oliver became the regular weekend band at the Plantation. According to legend, Oliver sent a note to Armstrong, his former protégé, that read: "Close those windows or I'll blow you off 35th street." It was meant to be a good-natured warning, but jazz could be an intensely competitive business.

In late 1926, two and a half years after it opened, the Plantation was bombed by persons unknown. No one was seriously injured or killed, but the club incurred considerable damage and had to be closed; it never did reopen. A few months later, another Capone club—the recently renovated Café de Paris—was also bombed. The supposition was that Capone's rivals were emboldened by a series of federal raids conducted by the Bureau of Prohibition. The raids were part of a larger campaign by President Calvin Coolidge to shut down the notorious nightclubs of Chicago. Capone saw the onslaught as being unfair, and he said so in a series of courthouse commentaries to newspaper reporters, who quoted him with relish:

"I've been spending the best years of my life as a public benefactor.
I've given people the light pleasures, shown them a good time, and all
I get is abuse . . ."

"When I sell liquor, they call it bootlegging. When my patrons
serve it on silver trays on Lake Shore Drive, they call it hospitality . . ."

"They talk about me not being legitimate. Nobody's on the legit,
you know that and so do they. Nobody's really on the legit when it
comes down to cases."

On the South Side, the nightclubs were suffering. Partly this was
because of "the hip flask ruling" by which federal judge Adam C. Cliffe
dealt a major blow to nightclub owners throughout the city. Up until
then, some clubs had successfully defied Prohibition by claiming that
they could not be held liable if patrons were drinking alcohol from a
hip flask that they had brought onto the premises. The theory, not yet
legally tested, was that if a person was in the club drinking from a flask,
there was no way prosecutors could prove that the booze, discovered
and then confiscated on the premises, had been sold to them by the
club.

The popularity of the hip flask turned out to be an example of how
the lingo of the Prohibition era became the lingo of jazz. Among pa-
trons in a club, if a person asked, "Are you hip?" they were asking if the
person was carrying booze on them. Jazz musicians and their followers
took the term and turned it into an existential statement. "Are you
hip?" was a broader question about a person's state of awareness. To be
hip meant that you were in the know. And to be a hipster usually meant
that you were a lover of jazz.

In December 1926, a consortium of legitimate club owners from the
Loop not affiliated with the mob tested the hip flask arrests in court.
A lawyer for the club owners argued before the state supreme court
that just because people came into a club with flasks from which they
were drinking alcohol did not mean the club was responsible and could
be shut down—as they had been by federal agents. Judge Cliffe ruled
against the club owners by declaring that the Volstead Act outlawed not

just public places that actually sold illegal alcoholic beverages but also "places where people carrying liquor congregate."

It was a serious blow to the city's nightclubs and therefore the many musicians who depended on the clubs to make a living. Thus began a period of club closures, with musicians leaving Chicago to find work in other localities.

He Who Diggeth the Digger

Milton "Mezz" Mezzrow was a clarinetist and sax player born and raised in Chicago whose primary mission in life was to play his way deeper and deeper into the emotional core of the African American experience. Or, as Mezzrow put it, as a musician he desired to "absorb the Negro idiom." This was complicated by the fact that Mezzrow was white and Jewish. This did not dissuade the man. On the contrary, not only did he become a skilled practitioner of the New Orleans style, which fit his definition of "hip" or "authentic" jazz, but he became the embodiment of what writer Norman Mailer would later describe, in a famous 1957 essay, as "the White Negro." From early in his life, Mezz crossed color lines and became a "traitor" to his own race, a journey he chronicled in *Really the Blues*, one of the liveliest jazz memoirs ever published. "They were my kind of people," wrote Mezzrow. "And I was going to learn their music and play it the rest of my days. I was going to be a musician, a Negro musician, hipping the world about the blues the way only Negroes can. I didn't know how the hell I was going to do it, but I was straight on what I had to do."

In retrospect, Mezzrow's views were built on a set of presumptions about Black folks that today seem antiquated. Fetishizing the Black experience would become a cottage industry in the United States, and the culture of jazz was a contributing factor. And yet, in a way, Mezzrow was rebelling against racial constraints faced by all jazz musicians, Black and white.

The most well-financed nightclubs were segregated—the audiences

were 90 percent white, either because that was the club's policy (Jim Crow) or because the average citizen of color could not afford the admission price. The clubs on the South Side owned by Capone were different. Capone, though no race pioneer, took pride in the fact that his clubs were Black-and-Tan. This likely was because the mob boss understood that the roots of jazz—or at least the venues where jazz was played—involved an intermingling of Italians and Blacks. From the beginning, jazz was race-mixing music, and selling it to the public as such was part of its appeal.

Mezzrow, as a student of the music and of Black culture, was hyper attuned to the idea of white musicians diluting jazz, either though laziness or ignorance, or as a sop to commercialization. He felt that it was a white musician's obligation to not only understand where the music came from but to embody its principles as a musician and as a human being.

Playing in clubs that were owned and operated by white gangsters was, according to Mezzrow, regrettably part of the devil's deal that made the music possible. "Our whole jazz music was, in a way, practically the theme song of the underworld because, thanks to Prohibition, about the only places we could play like we wanted were illegal dives."

Mezzrow's relationship with the hoodlums could best be described as love/hate. The great pianist Earl Hines remembered Mezz as one of the few musicians who ever stood up to Capone.

> Only [musician] I ever heard of who had a run-in with Mr. Big of the syndicates [Capone] was Mezz Mezzrow, who was working at a night spot in suburban Burnham. It seems Al's younger brother, Mitzi, went for one of the good-looking entertainers with Mezz's outfit, and Scarface ordered her fired. Mezz argued back while a half dozen of Al's henchmen stood around laughing at the nerve of this musician arguing with Mr. Six-Shooter. Finally, Al started laughing too and said, "The kid's got plenty of guts."

Having your career as a musician tied to the underworld meant that you were inexorably tethered to not only the activities of gangsters like Capone but also the whims of the Bureau of Prohibition. In 1927, as many of Chicago's clubs were being padlocked for liquor violations, Mezzrow, like many musicians, sought work elsewhere. In Mezzrow's case, he headed for Detroit, where he had connections. The move was meant to be temporary. The jazz musician's life was largely a vagabond life—you sought out gigs wherever they were. This meant traveling to different cities and then returning to the home base to count the pennies and lick your wounds.

If Mezzrow thought that by taking a break from Chi-Town he would be escaping the clutches of the gangsters, he was in for a surprise.

One of the most powerful bootlegging gangs in the United States was based in Detroit. The newspapers referred to this group as the Purple Gang. It was primarily a Jewish gang led by the Bernstein brothers, Abe, Joe, Raymond, and Izzy.

The Purple Gang derived its strength from the fact that Detroit was located close to the Canadian border and well situated to import illegal shipments of booze from a number of locations in the Great Lakes. Up until the mid 1920s, the border was porous, with numerous bootlegging operations bringing in booze by way of Windsor, Ontario. The Purple Gang took over this trade through a campaign of violence that was alarming even to Al Capone. As a gangster, Capone's usual technique was to stamp out any and all competition, but he made an accommodation with the Bernstein brothers that allowed them to control—and profit from—the flow of illegal liquor in the Great Lakes area.

Mezzrow learned about the Purple Gang as soon as he arrived in Detroit. His first regular gig was at a club called Luigi's, which was managed by Louis the Wop.

Many notable musicians on tour stopped in to jam at Luigi's—including the Dorsey brothers, Tommy and Jimmy. The place was a veritable social club for Detroit-area musicians and gangsters. Wrote Mezzrow, "Soon I found myself hanging out with them. They were

mostly gamblers and big spenders, flashy good-natured Jews, dressed in loud checked suits and open-necked sports shirts. At first I took them to be businessmen and we had some fine times together."

Eventually, the leader of the group, whom Mezzrow describes in his memoir as Sam "Trombanick" (a pseudonym), asked the musician if he'd like to come back to their apartment at the Charlotte Hotel to play some poker. Mezzrow joined the men. It was there at the hotel in Detroit that Mezzrow would try opium for the first time and develop an addiction that would hold him in its grip for more than a decade.

Narcotics was becoming a highly profitable racket for those in the underworld who were willing to take the risk. Eventually, members of the Purple Gang would be indicted and convicted on heroin-, opium-, and cocaine-smuggling charges. In some ways, smuggling dope was easier than smuggling booze, which was shipped in bulky crates and barrels, and in bottles that sometimes shattered while being transferred from one place to another. Dope shipments were manageable in size and easy to offload. Not many gangsters were yet peddling the product, so there was not likely to be hijackings and aggressively violent competition.

The biggest problem for dope peddlers was that, as of the mid-1920s, there was not yet much of a market for opium or heroin. That would change as gangsters like those in the Purple Gang introduced the product into the nightclub scene, especially among a group they figured would be an easy sell: musicians.

Mezzrow was an enthusiastic marijuana user, as were many jazz musicians. Smoking the plant was not yet illegal in most states and would not be until the 1930s. Mezzrow would soon become known as one of the most reliable weed sellers in the jazz world, a "gage hound" with the best product (which he purchased from a Mexican supplier on Chicago's South Side). As someone who was often on the lookout for the cutting-edge experience, Mezz was aware of the harder drugs like opium and heroin, but their use was not yet common among jazz musicians.

While drinking some high-quality gin and playing a round of "knock

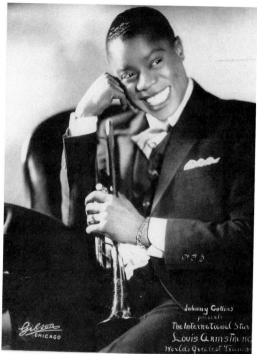

A young Louis Armstrong.
(Hogan Jazz Archive,
Tulane University)

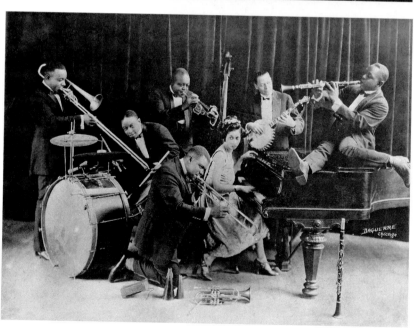

King Oliver and his Creole Jazz Band, with Oliver on cornet (standing, in center), and Armstrong on one knee with trombone, an instrument he rarely played.
(Hogan Jazz Archive, Tulane University)

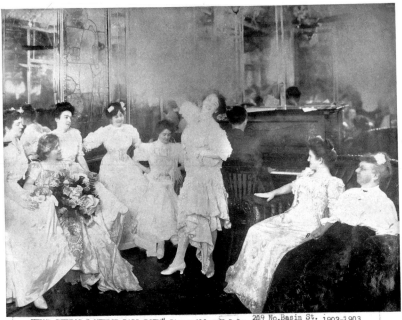

HILMA BURT'S "MIRROR BALL ROOM" Storyville, N.O.La. 229 No.Basin St. 1902-1903

Hilma Burt's bordello in Storyville, New Orleans, on
Basin Street, with Jelly Roll Morton on piano.

(Louisiana State Museum Jazz Collection)

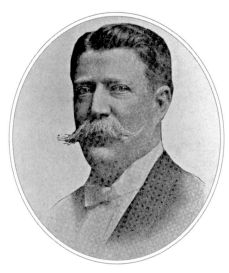

Tom Anderson, political boss of
Storyville and proprietor of one of its
most famous honky-tonks.

(Hogan Jazz Archive, Tulane University)

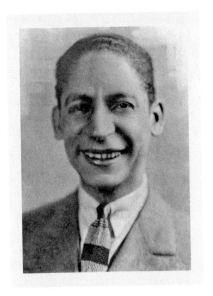

"Professor" Jelly Roll Morton.

(Wikimedia Commons)

The lynching of eleven Sicilians in March 1891 was a key event in the development of the American mafia.
(Frank Leslie's Illustrated Newspaper/Historic New Orleans Collection)

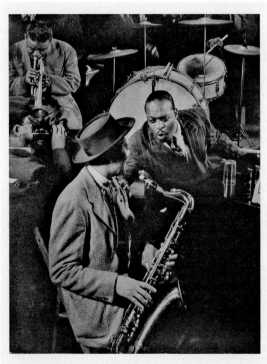

Lester Young (on tenor sax) and Count Basie (on piano) were among those who revolutionized jazz in Kansas City during and after the Pendergast era.
(Gjon Mili/The LIFE Picture Collection/Shutterstock)

Kansas City's Thomas
"T. J." Pendergast, political
boss and kingmaker.
*(Kansas City Public Library,
Missouri Valley Collection)*

Mafioso John Lazia (second from
right) opened Cuban Gardens,
Kansas City's most luxurious
nightclub, after a visit to Havana
in the late 1920s.
(Terence O'Malley Collection)

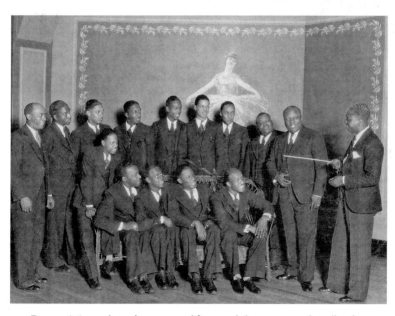

Bennie Moten (standing, second from right), prominent bandleader,
high-ranking official in Musicians Local 627, and a major player in the
Pendergast machine—and therefore the mob—in Kansas City.
(LaBudde Special Collections, UMKC University Libraries)

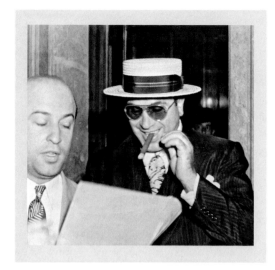

Alphonse "Al" Capone was a major impresario of jazz in the 1920s. He owned a piece of many nightclubs, including the Sunset Cafe in Chicago (which later became the Grand Terrace), Club Plantation, Friar's Inn, Green Mill, and the Cotton Club in Cicero, which was managed by his brother Ralph.
(Library of Congress)

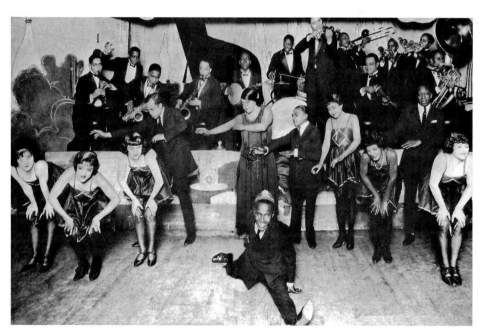

Carroll Dickerson's Sunset Syncopated Orchestra at the Sunset Cafe, 1924.
(Wikimedia Commons)

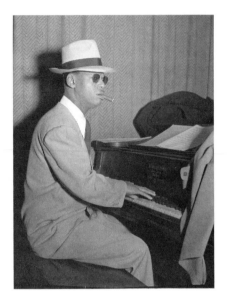

Earl "Fatha" Hines is believed to be the first great modern jazz piano player. He enjoyed a twelve-year run at the Grand Terrace, a club co-owned by Capone and other gangsters.
(Library of Congress, William P. Gottlieb Collection)

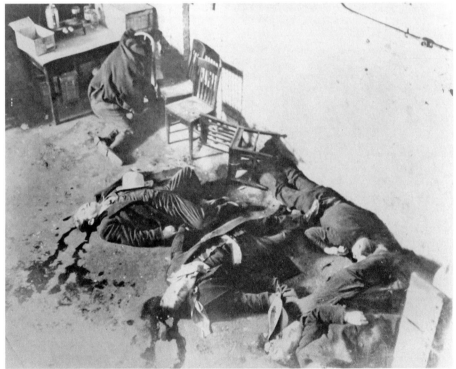

When the St. Valentine's Day Massacre occurred, on February 14, 1929, Hines wondered whether he was in business with mass murderers. Like many musicians, he adhered to the rule of the three monkeys: Hear no evil, see no evil, speak no evil.
(Library of Congress)

Joe E. Lewis.
(Getty Images)

Jack McGurn.
(Chicago History Museum/Getty)

Green Mill opened on North Broadway in Uptown Chicago in 1907. In the mid-1920s, it became part of Al Capone's portfolio of speakeasies. The club is still in existence today.
(T. J. English)

When popular singer/comic Joe E. Lewis switched from Green Mill to a different venue, the mob sought revenge. On orders from Machine Gun Jack McGurn, Lewis was brutally attacked. His throat was slit and his face cut. For years afterward, Lewis was a mascot of the mob.
(Wikimedia Commons)

Thomas "Fats" Waller was arguably the most entertaining performer of the Jazz Age. He was also a brilliant composer who wrote the music for numerous Broadway shows, including *Hot Chocolates*.
(*Library of Congress*)

Mobster Arnold Rothstein was known both in the underworld and the press as "the Brain" and "the Big Bankroll." He launched the careers of many who would become New York's most notorious racketeers, including Legs Diamond, Charlie Luciano, and Meyer Lansky. Rothstein also provided the financing for *Hot Chocolates* and other Broadway shows.
(*Library of Congress*)

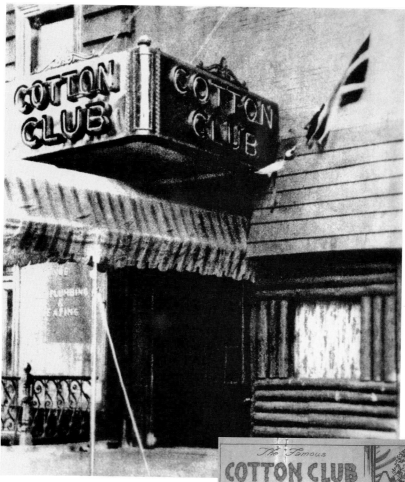

The Cotton Club opened in Harlem in 1923. The owner was Owney Madden, who had only recently been released from prison after serving an eight-year term for homicide. The performers and staff at the club were mostly African American, but Blacks were not allowed in as patrons.

(Getty Images)

The club's promotional slogan, "The Aristocrat of Harlem," appeared on programs, menus, and advertisements.

(Author's Collection)

Duke Ellington's orchestra was the house band at the Cotton Club, where it presented some of the most sophisticated jazz ever performed on a stage.

(Smithsonian National Museum of African American History and Culture Collection)

To be a showgirl at the Cotton Club was nearly as prestigious as being a musician. Some, like Lena Horne, rose from the chorus line to become stars.

(Getty Images)

Owney Madden.
(Garland County Historical Society)

Dutch Schultz.
(Library of Congress)

When Dutch Schultz was murdered in October 1935, there was a seismic shift in the American underworld. For some musicians and show people (most notably Louis Armstrong), it was a relief, as Schultz had meddled in the music business like few others.
(Getty Images)

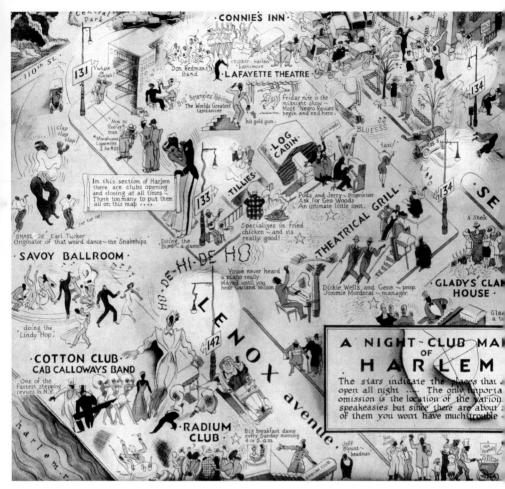

Jack "Legs"
Diamond (with
cigarette) was
a big fan of
nightclubs and
speakeasies.
(Getty Images)

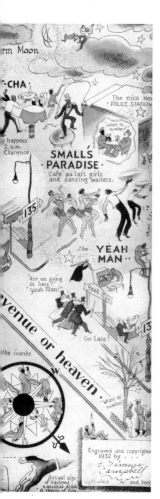

From the early 1920s until the mid-1930s, Harlem was the jazz capital of the universe.
(*Library of Congress*)

If you look closely, you can see the marquee for the Hotsy Totsy Club in Manhattan, the popular second-floor speakeasy owned by Legs Diamond, which showcased live music and, occasionally, dead patrons.
(*Getty Images*)

Sonny Greer, a drummer in Duke Ellington's orchestra, had
a fondness for gangsters. Whenever he wanted a cash tip,
he moved his drum set near the gangsters' table and played
the song "My Buddy."
(Library of Congress, William P. Gottlieb Collection)

When Lena Horne sought
to leave the Cotton Club for
greener pastures, she was told
by the club's manager, "Nobody
leaves the Cotton Club until
we say so."
(Getty Images)

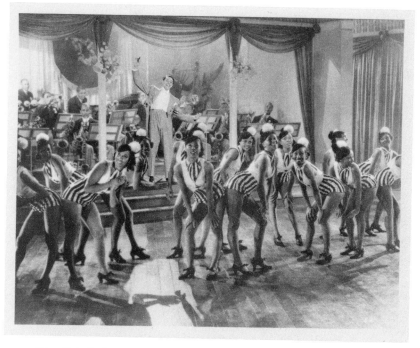

The Cab Calloway Orchestra followed Duke Ellington as the house band at the Cotton Club. Calloway's shows were, if anything, even more elaborate and grandiose than the Duke's.

(Smithsonian National Museum of African American History and Culture Collection)

In 1946, horn player Mezz Mezzrow, with co-writer Bernard Wolfe, published *Really the Blues*, an exposé on gangsters and drugs in the jazz world from the 1920s through the 1940s.

(Library of Congress, William P. Gottlieb Collection)

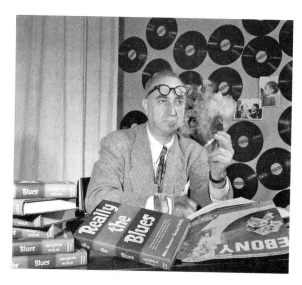

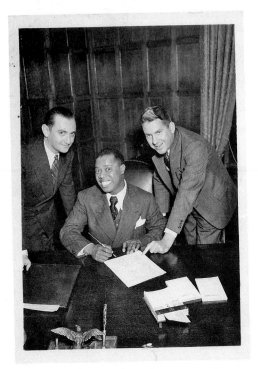

Louis Armstrong found himself caught between mob-affiliated managers. He resolved the dispute by signing a joint agreement with his manager, Joe Glaser (left), and Tommy Rockwell, handling promotion.
(Louis Armstrong House Museum)

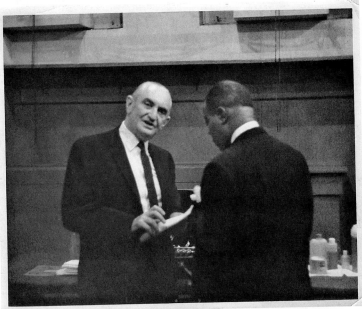

Joe Glaser began his career as a hoodlum in the Capone organization. Some surmise that, throughout his long reign as arguably the most significant manager in jazz, he never did shake his gangster ways.
(Louis Armstrong House Museum)

rummy," Mezzrow noticed the "businessmen" disappearing one by one into a bedroom, then returning half stoned out of their minds.

"What the hell's going on in there?" asked the jazzman.

"Send him in here and let him find out for himself," somebody yelled from the bedroom.

Mezzrow rose from the card table and walked into the bedroom:

The smell in that room was enough to knock you out. It was sort of sweet, with a punch in it, heavy as an insomniac's eyelids, so thick and solid it was like a brick wall built all around you. It made my smeller tingle, got me scared and excited me too, put me on edge—it promised a rare jam-up kick, some once-in-a-lifetime thrill.

One of the gangsters said, "Come over here and lay down your head on my chest, and I'll let you smoke something that'll make you throw your muggles [marijuana] in the ashcan."

Mezz took a hit off the pipe, and that was it.

Goddamn if I didn't live through it. Man, I even liked it. Before I finished one pill a heatwave heaved up out of my stomach and spread all through me, right down to my toes, the most intense and pleasant sensation I have ever felt in all my life . . . I glowed all over, like the sun was planted in my breadbasket. Man, I was sent, and I didn't want to come back.

Mezz was hooked—not immediately, but the seed had been planted. He would be one of the initial test cases in the mob's efforts to introduce hard drugs into the jazz world—an initiative that would continue to unfold over the next half a century, leading to the premature demise of some of the greatest jazz musicians who ever lived.

Eventually, Mezzrow made his way back to Chicago, and then on to many of the locales where jazz would take hold—New York, Paris,

Amsterdam. That day in Detroit lingered in his memory like a dream. Who were those guys?

> Years later, when I was living in New York, I finally found out who all my hophead friends were. One day I saw Sam Tromba-nick's mug staring at me from the front page of a Manhattan paper—he was one of the leaders of the Purple Gang and he had just been bumped off. That Purple Gang must have included in its membership the whole goddamned population of Detroit. After that, one by one, I saw the kissers of most all those good-natured sporty guys in the papers, including [the one] who gave me my initiation to hop—they all got theirs sooner or later.

Before long, dope would be all the rage among a certain strata of jazz musician from Detroit to Chicago, New York to Los Angeles, and back again. Often, their suppliers would be from among the gangster underlings who serviced the clubs—underbosses, errand runners, and Good Time Charleys who served as a lifeline, or death knell, between the musicians and the mob.

Three Monkeys

Things were looking up in 1927 when William "Big Bill" Thompson, a Republican, was elected mayor of Chicago for the third time. He'd pre-viously served two terms, from 1915 to 1923, and now was at it again. The people knew what they were getting: a corrupt public official who seemed to have formed some kind of "arrangement" with Al Capone. He was elected with Capone's support, which manifested itself during what became known as "the pineapple primary," so called because se-lected polling places were firebombed with hand grenades (pineapples) as a way of intimidating those who might vote against Thompson. Such was the nature of democracy in gangland Chicago.

The day he was sworn in, Thompson announced that he would

bring law and order back to the city. What that meant was that the mayor was counting on Capone to put a lid on things. In exchange, Big Bill allowed Big Al to reopen many of his nightclubs, Prohibition be damned.

Despite attempts on his life by other gangsters and pressures from Prohibition agents and prosecutors, Capone, along with his associates, remained a highly visible presence at the clubs. Trumpeter Marty Marsala, Italian American, Chicago born and raised, remembered a typical encounter: "At one place we worked, Capone would come in with about seven or eight guys. They closed the doors as soon as he came in. Nobody would come in or out. Then he gets a couple hundred-dollar bills changed and passes them around to the entertainers and waiters. His bodyguards did the passing. We got five or ten bucks just for playing his favorite numbers, sentimental things."

Eddie Condon, the erstwhile guitarist, remembered a night at the Friars Inn, one of the city's most notorious gangster hangout spots, when a group of hoods showed up. In his memoir, Condon wrote:

> The other customers left and the doors were closed; the band played and hoods drank. One of them noticed Jim Lannigan's bass fiddle. The bulge on its underside caught the light and made an attractive target. The hood kept looking at it, measuring the distance and cocking one eye. Finally he took out a revolver and fired. The bullet hit the fiddle on the seam and the whole back opened up. The band kept on playing; the hood asked Jim how much the fiddle cost and stripped off enough from his roll to have it repaired . . . In all of the joints the bands kept on playing no matter what happened, though sometimes the drummer would hold his bass drum over his head to keep it from getting smashed.

The hoodlums all liked jazz. One of them told Condon, "It's got guts and it don't make you slobber."

For Capone, jazz was not all fun and games. Throughout the land, big-name mobsters in cities large and small opened nightclubs. It became something of a competition. Capone had the Sunset, Green Mill, the Plantation, the Cotton Club, and others, but in December 1928 he opened what would be his crown jewel, the Grand Terrace Cafe on South Parkway and 50th Street.

The club's official owner was Ed Fox, who was also co-owner, along with Glaser and Capone, of the Sunset Cafe. At the Grand Terrace, Fox was determined to showcase the most elaborate floor shows, complete with scantily clad dancers, backed by the best band in town. For this, Fox turned to bandleader and pianist extraordinaire Earl "Fatha" Hines.

Hines's band had been playing at the Plantation when it was shut down. For the pianist, who was nearly as big a star in town as Louis Armstrong, the residency at the Grand Terrace was the culmination of his time in the city. Shows at the club were broadcast live on national radio. At 10:30 P.M., the shows went out over the airwaves on station WMAQ to the eastern United States. At 11:30 P.M., on station WENR, a second identical set was broadcast live to the western part of the country. This was the era in which a type of music known as "Chicago style" became familiar to jazz lovers from coast to coast.

In the hands of Fatha Hines, Chicago style was a dazzling combination of hot jazz from New Orleans, the blues, and a virtuosic style of playing known as stride piano, keeping time with the left hand by jumping between bass notes and chords. Hines had what some called a "trumpet style" on the piano; he often defied time and played torrid passages with two hands before returning to the melody. Hines was the first truly modern jazz pianist.

Like Satchmo, he was also an entertaining performer: tall, with elegant hands and a big, toothpaste smile that he flashed often. He sometimes grunted and moaned while playing. An impressive composer and bandleader who brought together some of the best musicians in town,

he was also smooth enough to emcee the radio broadcasts of the show from his seat at the piano.

Born and raised in Duquesne, Pennsylvania, twelve miles outside of Pittsburgh, Hines arrived in Chicago in 1925 at the age of twenty-one. Having played at the Sunset with Armstrong, he knew the protocol at clubs that were known to be "mobbed up." The gangsters explained it:

> They told us no harm would come to us so long as we did what we were supposed to do and let them handle what they were supposed to do. It was a case of the three monkeys: See no evil, hear no evil, speak no evil.

Sometimes, while hanging out at the club, the young pianist heard the mobsters making "arrangements" regarding shipments of beer and other matters relevant to their business. These discussions went in one ear and out the other. A detective at the club once asked Hines, "What were your friends talking about back there?"

"How would I know?" said the pianist.

"Well you were sitting right there next to them."

"I sit next to people on the El and on the bus; it's none of my business what they're talking about."

At first, Hines admired the gangsters. Like many of the musicians, he thought of Capone and the others as modern-day Robin Hoods who were delivering to the people a product they desired. Not only that, they used the proceeds from booze to help make the good times roll.

After Hines and his orchestra had been at the Grand Terrace a few months, business was booming. The club's owner, Ed Fox, sent Hines downtown to pick out a brand-new piano. "I saw this beautiful, white Bechstein standing there," remembered Hines. "I played it, and it sounded as good as it looked."

The store's owner doubted that Hines had the money or authorization to order the piano. The owner called Ed Fox, who told him, "Yes,

let him have whatever he wants." Hines thought he had died and gone to heaven. "It made a big difference to me, because a good piano makes me feel like playing and inspires me."

Others associated with Hines's band were also tickled by working in the gangsters' clubs. Quinn Wilson, a bassist who wrote arrangements for Hines's orchestra, thought that having the hoodlums around added pleasure to the gig. "They always liked to play, and those guys were funny," said Wilson. "One night, Earl went to sleep while he was eating at the dining table in the kitchen. His cigar was on the ashtray and it had gone out, so one of them put tabasco sauce on the end. When Earl woke up, put it in his mouth, he got the taste of tabasco. Boy, you talk about guys being playful!"

Not all antics were so good natured. Which is why, as Hines remembered, nearly everyone came to the club armed: "I was heading for the kitchen one night and this guy went pounding past and another guy came up behind me and told me to stand still and rested a pistol on my shoulder and aimed at the first guy and would have fired if the kitchen door hadn't swung shut in time. Some of the waiters even had pistols."

A musician never knew when a gangster might come asking for a favor. Early one evening, while a group of racketeers were having a meeting in the club, Hines was in the kitchen when, suddenly, one of the goons rushed in and dropped a package in his lap. "The heat's on!" the hood shouted and continued running out the back of the club.

Hines hung on to the package. "I opened it later and found there was twelve thousand dollars in the package. I counted it and hid it, because I knew I'd have to have it when they asked for it."

A week later, the hoodlum came into the club and asked Hines, "You got that stuff?" The pianist had the money—all twelve grand. As a gratuity, the hood peeled off five hundred and gave it to Hines.

With working conditions like these, some musicians might have cracked under the pressure, but not Fatha Hines. "They were exciting times," he said, "and I think some of the excitement got into the music."

And yet, slowly, over time, Hines's feelings about the gangsters began to evolve. One event that shocked the bandleader—and everyone else in the nation—was the St. Valentine's Day Massacre, which occurred on the morning of February 14, 1929. In a warehouse at Dickens and Clark Streets, in the neighborhood of Lincoln Park, seven people (five members of the North Side gang and two affiliates) were lined up against a wall by triggermen disguised in police uniforms. The resultant slaughter was gruesome. "I was in a music store a block away when the [massacre] occurred," said Hines. "There were so many cops in the area right afterwards I thought some celebrity was visiting."

A photo of the crime scene was leaked to one of the newspapers—the victims' bodies mangled and saturated with blood. No one doubted that Capone was somehow behind this horrible act of mayhem. Scarface took the opportunity to leave Chicago on an extended vacation in Miami; he was away from the Grand Terrace and his other clubs until later that fall.

For Hines, the rampant bloodshed gave him pause. Were his business partners mass murderers? Things that Hines had once found charming, he no longer did—such as, for instance, the fact that when he traveled, including on the road during bookings in other cities, Capone assigned two armed bodyguards to be at his side everywhere he went. At first, Hines interpreted this as a gesture of benevolence, but then he realized that Capone hadn't assigned the bodyguards until the club was packed and generating revenue. Insisting on bodyguards, he realized, was a case of the gangster/businessman protecting his asset, not an act of kindness.

Hines remained at the Grand Terrace for twelve years, until it closed in 1940. Generally, he remained true to the principle of the three monkeys. Whatever misgivings he had about partnering with killers he kept to himself. Until, later in the 1940s, he gave an interview to *Ebony* magazine. Hines believed that when he was talking with a staff writer from *Ebony*, his comments were off the record. Not only were they printed in the magazine, they appeared under his byline, along with the headline:

"How Gangsters Ran the Band Business." The article detailed names, including Al Capone and his brother Ralph, orchestras, and nightclubs involved in gangland control of the entertainment business.

When Hines saw the article, complete with photos, he was shocked. He met with an editor from the magazine in a New York City club and angrily grabbed him by his coat lapel. "I'm afraid to go back to Chicago now. But I'll tell you one thing—if any of these hoodlums ever catches me and asks me about the story, I'm going to break my motherfucking finger pointing at *Ebony's* office."

Later in life, after most of the gangsters were dead and gone, Hines reminisced about his years at the Grand Terrace and other mob-controlled clubs. His memories were filled with wonder and excitement, yet they were also bittersweet. In one recorded interview for an oral history project, he noted, "There's not a single big name of the show world—Duke Ellington, Cab Calloway, Louis Armstrong—who haven't at one time or another had contact with the syndicates." He became quiet, then added, "The racketeers owned me too."

Satchmo and Muggles

Throughout the late 1920s, Louis Armstrong bounced back and forth between Chicago and New York City. In his first foray to New York, in 1925, he played in the orchestra of Fletcher Henderson, one of the two or three most popular bands in the country. This meeting of two great talents did not go well. Armstrong found Henderson's musical arrangements and style to be too rigid for his tastes. Rarely was he afforded opportunities to solo or shine. Once his contract was up, he left the Henderson band and returned to the Windy City.

In the late 1920s, the reputation of jazz rose in the culture. Considering that only a decade and a half earlier the music was rarely heard outside the honky-tonks of New Orleans, it was significant to hear jazz described by composer George Gershwin as "the only musical idiom in existence that could aptly express America." Aaron Copland, soon

to emerge as America's leading classical composer, felt the same way. He had already written two large-scale concert pieces influenced by jazz, and he saw big things for the music, predicting that someday jazz might become "the substance not only of the American composer's fox trots and Charlestons, but his lullabies and nocturnes. He may express through it not always gaiety but love, tragedy, remorse."

Cultural stature was one thing, but for the businessmen and gangsters who functioned as impresarios of the music, jazz was still ad hoc. There were few individual stars, though Louis Armstrong, not yet thirty years old, was certainly one of them.

One person who recognized Armstrong's value was Tommy Rockwell, a young, ambitious producer with OKeh Records. Rockwell had recorded Armstrong before in two landmark sessions known as the Hot Five and Hot Seven recordings. He had been courting the young trumpeter ever since.

Technically, Louis didn't have a manager. His wife, Lil, had assumed the role ever since Louis left King Oliver's band. She deserved credit for many of his biggest successes: Lil taught Armstrong how to dress and present himself to the public. She also encouraged him to stand up for himself with club owners. But by 1929, Armstrong and Lil Hardin had drifted apart. Rockwell saw an opening.

If it was up to Armstrong, the man he would have preferred to have as manager was Papa Joe Glaser. But the former manager at the Sunset Cafe, who insisted on putting Armstrong's name on the marquee as "The World's Greatest Trumpeter," was currently indisposed. In January 1927, Glaser was convicted of running a "disorderly house"—a whorehouse—one of many he managed for Al Capone. He was fined $100. Glaser appealed the conviction, but it turned out the pimping charge was just the tip of the iceberg.

Six months to the day after that conviction, Glaser was charged with statutory rape. Glaser had violated the underworld rule about not getting high on your own supply. He was charged with having sex with a fourteen-year-old girl. To a friend, Glaser explained, "She wore make-up

and seemed to be in her twenties. In fact, it was her mother who pointed her out to me and encouraged my interest in her."

In February 1928, Glaser went on trial for rape. The proceedings lasted one day. Glaser was found guilty. The *Chicago Defender*, the city's most prominent Black newspaper, put his sentencing on page one: "Found guilty of attacking Delores Morgan Wheeler (white), a 14-year-old schoolgirl, Joseph G. Glaser (white), was sentenced to ten years by Judge Harry B. Miller."

Glaser appealed this conviction. Somehow, it was determined that the only way to overturn the guilty verdict was for him to marry the victim, which he did.

Six weeks later, before the ink had dried on these legal negotiations, Glaser was busted again. Once again it was an underage girl, Virginia Sherman, a seventeen-year-old he encountered at the Plantation nightclub. Glaser convinced the girl and a friend of hers to come back to his apartment. When he attacked Sherman, the friend ran into the street and flagged down a policeman. She led the cop back to Glaser's place, where the club owner was arrested.

By now, Glaser was enough of a fellow traveler of the Capone mob to utilize his friends in high places to get the charges quashed, as he had for previous bootlegging and bribery charges. The man who usually showed up in these situations was Sidney Korshak, the young attorney and up-and-coming fixer for the Capone syndicate. Whether Korshak handled Glaser's case is not known, but what is known is that the charges were dropped. Years later, Ernie Anderson, a publicist who worked for Glaser and Armstrong, looked into the matter and was told that "all the court records . . . had been 'lost or stolen.'"

Less than a year later, Glaser was legally entangled once again, this time with a young woman and a paternity suit. Even with the mob running interference for him, Glaser's career was hopelessly mired in scandal.

Tommy Rockwell recognized an opening when he saw one. He was no Joe Glaser, with the Capone affiliations and underworld pedigree, but he was, if anything, better connected in the music business.

In the years since he and Armstrong first met, Rockwell had become associated with some of the biggest names in jazz, including Bing Crosby. Like many men on the business side of jazz, Rockwell was hardnosed. Born in Oshkosh, Wisconsin, he had been orphaned at a young age and raised by his grandmother. He dropped out of school and enlisted in the service while underage and served in the First World War. After the war, he worked at Columbia Records before becoming a general manager with OKeh.

Rockwell knew little about music; some say he was actually tone deaf. But he understood the business, and he could play hardball with the best of them. Rumors had it that he was "connected" with New York City's version of Al Capone, bootlegger Dutch Schultz, who had begun underwriting Broadway musical productions. In the past, Armstrong had expressed to Rockwell that it was his dream to one day perform in a Broadway show. Rockwell sent a telegram to Armstrong assuring him that if he returned to New York City, the recording director could get him a gig on the Great White Way.

With his entire band of nine musicians spread over four cars, Armstrong drove from Chicago to New York. Rockwell proved true to his word. He got Armstrong a job with the Carroll Dickerson band playing the music for an all-Black musical revue called *Hot Chocolates*. In the show, Armstrong got to play—and sing—"Ain't Misbehavin'," the hit song written by Fats Waller.

The revue opened at the Hudson Theater on Broadway, where it was performed twice daily, once as a matinee and once in the evening. Then, after those shows, the entire band rushed to Connie's Inn, a popular nightclub/speakeasy in Harlem, where the entire score was performed yet again. It was a whirlwind schedule that required stamina, and Armstrong was the star. In May, he signed a one-year management contract with Tommy Rockwell.

Hot Chocolates ran for nearly one year. After its run, Connie Immerman, owner of Connie's Inn, fired the Dickerson band—including Armstrong. It was a shock to the trumpet star.

By now, both he and his new manager knew that Louis should no longer be playing as a sideman; he should have his own band, under his own name. Furthermore, Rockwell felt that Armstrong should take to the road and give the rest of America a taste of what he could do.

In the fall of 1930, Rockwell booked Armstrong to headline at a club in Los Angeles. Louis had never been to California, and he was excited by the prospect.

The Cotton Club was located in Culver City, not far from the MGM studios lot. The club was believed to be mobbed up, since liquor was openly sold on the premises, and gambling was common in a back room day and night. A member of the house band at the Cotton Club noted that Frank Sebastian, the club's proprietor, was "the big man in Culver City, [with connections] in the police department. The police all came in there and ate for free, you know."

Mostly, Armstrong used the club's house band, which included Lionel Hampton, a young vibraphonist who would go on to great things. The band was billed as "Louis Armstrong and His Sebastian New Cotton Club Orchestra."

For most Californians, the band's residency at the club was their first opportunity to hear Louis Armstrong live. With the aid of the movie business, jazz had moved west. Movie stars turned out to see the young trumpet master. He was achieving new levels of notoriety, and then disaster struck—in the form of a long, lean marijuana cigarette.

Armstrong had smoked weed at least since the mid-1920s. Lyricist and manager Charlie Carpenter claimed to have been with Armstrong outside the Savoy Ballroom in Chicago the first time he smoked. A joint was handed to him by a white musician who said, "I got a new cigarette, man. It makes you feel good."

Armstrong was reluctant to try it, until the musician mentioned that he had been sick with pneumonia and felt that smoking the plant had helped him heal. Louis gave it a try; it was love at first puff. He later explained to an acquaintance that "it makes you feel good, man. It

relaxes you, makes you forget all the bad things that happen to a Negro. It makes you feel wanted, and when you're with another tea smoker it makes you feel a special kinship."

Jazz musicians had multitudinous names for cannabis: "muggles," "tea," "gage," "muta," "bush," "reefer," "hemp," "hay," "grefa," and so forth. A marijuana smoker was known as a "viper." To "tighten somebody's wig" meant to get them high. Once Mezz Mezzrow emerged as a primary dealer among jazz musicians (he was Armstrong's dealer of choice), his product became known as "the Mezz," as in "Ah man, this is really the Mezz." A particularly fat joint was called a "Mezzroll."

In many states where jazz was played, marijuana was not yet illegal. Mezzrow wrote how he and Armstrong used to "roll our cigarettes right out in the open and light up like you would a Camel or a Chesterfield." However, earlier in 1930, the U.S. government had created the Federal Bureau of Narcotics (FBN) and undertaken a vigorous anti-marijuana campaign. As a result, many states had passed local statues declaring the manufacture, sale, or use of marijuana to be a felony. The fact that California was one of those states may not have been known by Armstrong. Not that it would have mattered. He was accustomed to getting high before, in between, and after sets. And so, on the night of November 14, 1930, when he stepped out into the parking lot to smoke some reefer with friends between sets, he was startled when plainclothes detectives from the Los Angeles Police Department arrived on the scene, confiscated his joint, and told him he was under arrest.

They allowed the bandleader to finish his second set before taking him downtown to be booked on narcotics charges. He spent the night in jail.

Frank Sebastian saw to it that his star headliner was released the next day.

Armstrong still had four months to go on his contract with the club. In terms of his current booking, it was a minor inconvenience, though news of the arrest did appear in the pages of *Variety*, where it was noted

that the charge against the musician was "a felony punishable by not less than six months and no more than six years in the penitentiary."

Since his days in Black Storyville, Armstrong was accustomed to having mobsters take care of arrests related to one club or another. But this was slightly more complicated. Armstrong was forced to turn to an agent and manager he knew from Chicago—Johnny Collins. Though not as established as Tommy Rockwell, Armstrong's manager back in New York, Collins happened to be there when Armstrong needed him most (he was living in L.A. at the time). The Chicago-based hustler stepped in and helped set up a plea deal. Armstrong pleaded guilty to the charges and was given a sentence of thirty-nine days in jail, of which he served nine. Upon having the sentence suspended so that he could go back to Chicago, Judge William Tell Aggeler cautioned Armstrong, "So leave [marijuana] alone. Don't deal in it at all. If you have a nice home and a good wife, and you are getting along all right, don't be cultivating evil habits."

As a side effect of this legal odyssey, Armstrong now had two managers—though not all of the parties involved were aware of this fact. Armstrong's contract with Tommy Rockwell had lapsed the previous September. Armstrong believed the fact that he and Rockwell had not renewed their deal meant that the OKeh representative was no longer his manager. In L.A., Armstrong signed a deal with Collins, who now believed that he was manager of the hottest jazz musician in America. Collins immediately arranged a series of bookings back in Chicago, to be completed once the trumpeter was finished with his run at the Cotton Club.

Weed bust aside, Armstrong's time in Los Angeles was a success. He was relieved to have dodged a bullet, legally speaking. Once again, having business representatives with mob connections had proven to have great value. His new manager was already paying dividends.

Satchmo had no idea as he flew back to Chicago that he was jumping from the frying pan into the fire.

Management Wars

To people who knew Johnny Collins, he was thought of as a hustler and
hood. Even Armstrong referred to him as a "gangster." Collins was short
and overweight, with a pencil-thin mustache and thinning hair slicked
back. He looked like something that might have slithered out from un-
der a rock. His business practices were also shady, and some wondered
how it was possible that a bottom-feeder like Collins was representing
Louis Armstrong. Budd Johnson, one of Armstrong's sidemen, believed
that Collins had "tricked" him into signing a management contract. In
truth, Armstrong was fascinated by men like Collins—quasi-tough guys
who were not likely to back down in a negotiation with other quasi-
tough guys.

Back in Chicago, Collins booked Armstrong at the Showboat,
a popular gathering place for bookies and bootleggers. Now that the
trumpeter was being paid at a scale better than most, he had no trou-
ble putting together a band of local musicians. The residency at the
Showboat was going well until one night in April, when three hoods
showed up and told Armstrong he was still under the management of
Tommy Rockwell in New York. Armstrong called for security. Later, he
recalled, "The gangsters started a fight . . . right in front of where I was
standing . . . One of the gangsters took a chair and hit a woman over the
head with it, and the chair crumpled up in pieces. Some of the pieces
hit my horn."

Not long after that, these same gangsters confronted Johnny Col-
lins at the Showboat. They demanded that he give them $6,000 or they
were going to "burn off" his mustache. Collins had the men arrested.
On April 25, the *Defender* ran a story stating that three men had been
arrested for trying to extort money from Armstrong. The men denied
the extortion charge and claimed they were "only trying to get him to
change managers."

These incidents, no doubt, made it clear to Armstrong that he had

a management dispute on his hands. If he had any doubts about that, the point was brought home one night following his gig at the Showboat. According to Armstrong, a "big, bad-ass hood" named Frankie Foster paid him a visit backstage. Foster was "muscle," a freelance hitman who did jobs in both Chicago and New York for whomever paid him. In no uncertain terms, the hitman told Armstrong that he had a gig the following night in New York City.

"What gig?" asked Armstrong.

"Connie's Inn."

"Who set this up?"

"Your manager, Mr. Rockwell."

At first, Armstrong was more annoyed than frightened. He was still upset with Connie Immerman and his brother for having fired him and his band after the closing of *Hot Chocolates*. It was his intention to never again work for the Immermans.

Armstrong told Frankie Foster, "Look, I'm booked here at the Showboat for another week. I can't be in New York for no show at Connie's Inn."

Foster pulled out a revolver and cocked it.

"Jesus, it look like a cannon and sound like death," Armstrong recalled. "So I look down at that steel and say, 'Weeellll, maybe I do open in New York tomorrow.'"

Foster led the trumpeter to a pay phone in the hallway; he dialed a number and handed the receiver to Armstrong. On the line was Connie Immerman, owner of Connie's Inn.

"So when you gonna open here?" Immerman asked.

Looking straight at Foster, Armstrong replied, "Tomorrow A.M."

Armstrong never did go to New York to play at Connie's Inn. Instead, he had Johnny Collins file a lawsuit on his behalf against Tommy Rockwell and the Immerman brothers, charging that they were "conspiring and confederating to interfere with, hinder or prevent the plaintiff in the exercise of his vocation."

Disgusted by the whole turn of events, Armstrong considered shutting down and not playing for anybody, but he had to make a living.

The lawsuit turned out to be problematic. Lawyers for the Immermans produced a contract, signed by Armstrong and executed the previous July, before the trumpeter went to Los Angeles to play at the Cotton Club. The contract specified that Armstrong had agreed to play at Connie's Inn. Lawyers for Armstrong countered that the trumpeter assumed that once his business relationship with Rockwell had lapsed, he was no longer bound by that contract. Not everyone agreed. Rockwell and the Immermans filed a grievance with the American Federation of Musicians (AFM), claiming that the musician was in violation of a contract that he signed. The federation agreed with Rockwell and the Immermans and sent Armstrong a telegram that read:

T.G. ROCKWELL HAS SUBMITTED CONTRACTS CALLING FOR YOUR SERVICES AT CONNIES INN AND DEMANDS THAT YOU IMMEDIATELY START TO FULFILL SAME STOP YOU WILL MAKE ARRANGEMENTS TO DO SO OR SUBMIT REASONS WHY YOU SHOULD NOT BE HELD IN VIOLATION OF SAID CONTRACTS.

Armstrong was miffed. Not only was he being asked to "eat shit" and play for a club owner who had fired him, the contract with Connie's Inn had him being paid only $250 a week, less than half what he had been making at the Cotton Club.

Things heated up: Armstrong's lawyers added the AFM to their lawsuit. The union responded by terminating Armstrong's membership, which, technically, meant that he could no longer be booked at clubs in the United States.

Meanwhile, Armstrong was now understandably concerned that he had angered certain New York gangsters. Frankie Foster, who had shown up in his dressing room to threaten him with a cocked gun, was not only

a representative of Tommy Rockwell and the Immerman brothers. He was a representative of Dutch Schultz, who was a primary financier of Connie's Inn. This wasn't just a war between managers; it was a case of Armstrong being on the wrong side of the mob. Even if he didn't have the example, four years earlier, of Joe E. Lewis getting his face slashed and vocal cords cut, he knew the dangers. "It's no trouble at all for a Gangster to pull the Trigger," he once wrote, "especially when they have you Cornered and you Disobey them."

There were two things he needed to do: One was to get out of town, to go on the lam. He had Collins set up a European tour. The AFM couldn't mess with him while he was overseas; he could still make a living while waiting for his legal situation to be settled and his union membership reinstated.

The other situation was management. Armstrong had come to the conclusion that both Rockwell and Collins were "small time hoods." The problem was not that they were hoods; it was that they were small time.

Armstrong often remembered—and quoted—the words of Slippers, the hoodlum and bouncer at Matranga's in Black Storyville where he got his start. Said Slippers: "Be sure and get yourself a white man that will put his hand on your shoulder and say, 'This is my nigger.'"

Substitute the word "gangster" for "white man" and it is clear where Armstrong stood on this issue. As a manager, he needed someone who was tough but also someone he could trust.

All roads seemed to be leading back toward Papa Joe Glaser.

6

FRIENDS IN DARK PLACES

The Hotsy Totsy Club was not the fanciest speakeasy in Manhattan, but it was one of the most popular. That's the way it was in New York City's most desirable borough, where, in the year 1929, Police Commissioner Grover Whalen estimated there were approximately thirty-two thousand speakeasies, more than the sum total for many states. Manhattan was a citadel of booze, and if you wanted to be part of the "in" crowd, you whispered a secret password to a doorman and were ushered into an exclusive, red-velvet denizen of delight, with a tuxedoed quartet playing "hot jazz" and flappers dancing the foxtrot, the Lindy Hop, or the Charleston.

What made the Hotsy Totsy Club fashionable was that it was partly owned by Jack Diamond, who in recent years had become something of a gangster celebrity in the Big Town. Newspaper editors liked the way Diamond's nickname—"Legs"—fit into a headline. Diamond was a freelance bootlegger in New York who had, in recent months, begun to take on the Combine, a consortium of New York's biggest suppliers of illegal booze. The Combine had been formulated to forestall the kind of gangland mayhem that had resulted in Chicago with the rise of Capone. Mostly, it worked. That is, until Legs Diamond and his relatively small gang, which included his brother, Eddie, started hijacking alcohol delivery trucks—at gunpoint—in the New York area. This was especially

aggravating because Legs Diamond, an Irish American hood originally from Philadelphia, had been mentored by some of the Combine's most renowned bosses. Now the student had turned on his teachers, which put him in a precarious position in the New York underworld.

Even so, Legs circulated openly in the city. Part of the gangster's legend was that he was a habitué of nightclubs. Some contend that his nickname came from his abilities on the dance floor, where he some-times danced with his wife, Alice, whom he married in 1926, but more often with his mistress, a Ziegfeld Follies showgirl who went by the name of Kiki Roberts (her real name was Marion Strasmick). This tryst between the gangster and the showgirl was a big reason that Diamond was often in newspaper gossip columns, including those written by Wal-ter Winchell, America's dean of entertainment columnists.

Winchell knew all about Diamond from his days hanging out at Lindy's, the famous Times Square restaurant that was a popular night spot for Broadway show people, newspapermen, and gangsters. Winchell had become friendly with Arnold Rothstein, whose nickname "the Brain" was an indication of his role in the Combine. Rothstein was that rare item, a successful gambler who had parlayed his winnings over the years—believed to be in the multimillions—into a vast criminal port-folio. Among other things, Rothstein had in 1924 masterminded the largest heroin-smuggling shipment ever in the United States. With the aid of corrupt New York police officers, Rothstein smuggled dope from Europe into the country, where it was stored in a warehouse in lower Manhattan across from a police precinct.

At the time, Legs Diamond, in his midtwenties, was working for Rothstein as a bodyguard, as was another soon-to-be-famous New York gangster, Charles "Lucky" Luciano. Rothstein cut both Diamond and Luciano in on his heroin operation. In fact, it was Diamond who made a trip to Germany to make sure the dope shipment was good to go. It was the Philly mick's first trip outside the United States.

At Lindy's, Legs was often seen at Rothstein's table, which was a good place to be seen. Rothstein was a legend. He thought of himself as

a businessman, not a gangster, and he cultivated relationships with some of the city's most famous power brokers, including Walter Winchell.

Another famous face at Lindy's was Al Jolson, the Jewish actor and singer who, in 1927, starred in *The Jazz Singer*, the first talking picture. With tunes like "Toot Toot Tootsie (Goodbye)" and Irving Berlin's "Blue Skies," the movie's score barely qualified as jazz, but it was an indication of how popular the music had become that producers saw it as commercially advantageous to use the word "jazz" in the title.

Even before *The Jazz Singer*, Jolson was a stage star who made a name for himself by appearing in blackface, a holdover from minstrel days. One of Jolson's biggest fans was Winchell, who never tired of seeing the entertainer sing "Mammy" and "Swanee" in his stage show on Broadway.

After Jolson's show one night, Winchell visited the entertainer backstage. After making small talk, Jolson confided to the columnist that he had a big problem. He explained that Legs Diamond was trying to "put the bite on me" for $50,000. "He says if I don't come through with the dough, he's gonna hurt me real bad."

"That son-of-a-bitch," said Winchell. "Does he have your marker? Do you owe him?"

"No," said Jolson, "I swear. He says it's for protection, but I don't need that kind of protection."

Gangsters extorting money from entertainers—most notably musicians—had become an all-too-common trope of the era. Jazz musicians even had a slang name for this type of person, a "tush-hog."

"Don't worry," said Winchell, "I'll take care of it."

That night at Lindy's, Winchell used the phone booth to call another person he knew from his efforts as a power broker—Frank Costello, who was one of the Combine's rising stars. Costello's real name was Francesco Castiglia, from Naples, Italy. The newsman didn't mince words: "Hello, Frank, this is Winchell. Listen, Legs Diamond is putting the muscle on my friend Al Jolson for fifty big ones. I know Legs is a punk, but Jolson is scared. Is there anything we can do about this?"

Costello took care of the problem. It was the kind of favor that occasionally transpired between a powerful journalist and a gangster boss; Winchell understood that this favor was to be repaid somewhere down the line.

Meanwhile, Legs continued to make enemies. He did not hide the fact that the Hotsy Totsy Club, located on the second floor of 1721 Broadway, between 54th and 55th Streets, was his headquarters. There he could be found in the wee hours many mornings after a long night on the town.

Given the inverse moral universe of the Roaring Twenties, the gangster's status as an underworld renegade did not hinder the club's popularity. On the contrary: The fact that Diamond was at odds with the Combine added an element of danger that only fueled the fire of the city's renowned entertainment scene. With a target on his back, Legs Diamond was a bigger draw than most jazz musicians.

Eddie Condon and Mezz Mezzrow both wrote about Diamond in their respective memoirs. Separately, the two sidemen had moved from Chicago to New York to make a living, and, for a time, they were playing in the same band. They both recalled a night when the gangster and his entourage took over a nightclub called the Castilian Gardens, located in Valley Stream, Long Island, twenty-five miles outside of Manhattan.

As was usually the case with bootleggers who had rivals and competitors who were out to get them, when Legs came into a club it was cleared out so that the hoodlums could monitor who came and went. Castilian Gardens was paid a nice price, and the entire establishment was turned into a private party. Club personnel, including the musicians, were not told anything about the party they would be entertaining. In these situations, the musicians never objected, as the spontaneous gangster soirees often paid better than the original booking.

Eddie Condon had never heard of Legs Diamond, which was not unusual for a traveling musician. Capone and Diamond aside, most gangsters were not household names. Furthermore, in adhering to the principle of the three monkeys (hear, speak, and see no evil), many

musicians did not want to know whom they were entertaining—a self-imposed ignorance that presented its own problems. As Condon detailed it in *We Called It Music*:

> One night a large party came in and drinks were sent to us by the skinny man who was acting as its host. I found myself mixing with the guests. The prettiest girl at the table was none too good for me. I danced with her, sat with her, and held her hand. As I passed the bandstand with her, dancing to "I Can't Give You Anything But Love, Baby," I threw the boys a superior smile . . . When the music stopped . . . I went to the stand. Sydney [Jacobs, the drummer] grabbed me and pulled me behind the piano . . . "Lay off that dame. Her name is Kiki Roberts and she belongs to the guy who's giving the party."
>
> "The skinny guy? Hell, I can—"
>
> "No, you can't. His name is Legs Diamond. He eats six guys a week. Don't be the seventh."
>
> "Who is Diamond?" I demanded. "What's he ever done?"
>
> Sydney told me. After a ten-minute recitation of Diamond's career as a New York gangster I changed my point of view.

In *Really the Blues*, Mezzrow remembered it somewhat differently:

> One night Jack "Legs" Diamond fell into the joint with scumpteen of his henchmen and ordered the doors closed, and Jim, it was on. Our music hit Legs' girlfriend so hard, she jumped out on the dance floor and began rolling her hips like she was fresh in from Waikiki, with ball-bearings where her pelvis should of been; then she pulled up her dress till it was more off than on, showing her pretty linens or what she had of them. I nearly swallowed my horn, gunning Legs to see how he felt about it. I was all set to stop the band as soon as he batted an eye. The boss almost shook his wig off giving me the office from behind a

post—he knew Legs wasn't so well liked in the underworld, and the last time this gang was in they almost wrecked the place. But the moment the music stopped this grave-bait ran pouting to her daddy, and Legs motioned for us to keep on playing.

For Condon and Mezz, incidents like these comprised a kind of cautionary atmosphere that characterized life as a jazz musician in the 1920s and 1930s. A gangster like Diamond coming into a club could go any number of ways. Mezzrow, more gangster-savvy than Condon, was aware that Diamond was a hunted man by the Combine. There had been one attempt on his life already, and there would be many more in the years ahead. Having the gangsters around added excitement, up to a point. Nobody wanted to be collateral damage in a hit attempt on an underworld pariah, no matter how well the pariah—or the hitmen— tipped the band.

Gangdom

The bullets rained down from different angles at the Hotsy Totsy Club. The clubgoers screamed and dove for cover. Just before the shooting started, the club's manager told the Hotsy Totsy orchestra, "Play it loud, boys. To drown out the gunfire," and so they did. It was hard to tell the gunfire from the drumrolls, skittering cymbals, or the wail of the clarinet. By the time the band trailed off and stopped, the forty or so patrons in the club were tripping over one another to get to the exit.

Within minutes, a couple of street cops who heard the commotion and saw people streaming from the club arrived on the scene. They found two dead bodies riddled with bullet wounds, and another man, barely alive, who was rushed to the hospital.

The shooting had taken place in the early morning hours of July 14, 1929. The famous stock market crash of October 1929 was a few months away. The crash would alter the trajectory of the American economy over the next decade and, parenthetically, have a detrimental impact

on the livelihoods of many musicians and gangsters. For anyone who had been at the Hotsy Totsy Club that July morning—musicians, club employees, potential witnesses to the crime, and the shooters—the sense of doom had already arrived.

Not many people who partook of Manhattan nightlife were surprised to hear that there was a shooting at the Hotsy Totsy. Though the place had only been around for nine months, it had a reputation. Jimmy Durante, a beloved piano player, singer, and jokester in the manner of Joe E. Lewis, was a semi-regular at the club. Famously known as "The Schnoz" because of his large proboscis, Durante got his start performing in Coney Island at what were known as "come-on joints," speakeasies where gunmen (known to musicians as "torpedoes"), whores, and gamblers liked to hang out. Durante would eventually perform nearly everywhere in town, from after-hours clubs in Chinatown and Harlem to dancehalls and fancy theaters on Broadway. Eventually, he opened his own place, the Club Durant, on 58th Street near Broadway.

Club Durant attracted the cream of the legitimate theater set— entertainers like Jolson and George M. Cohan, and writers like Winchell and Damon Runyon. The Hotsy Totsy Club had no such pedigree. Durante described the place in a book he published in 1931, a surprisingly astute survey of the Roaring Twenties called *Night Clubs*:

> One of the most famous—yet short lived—night clubs New York ever saw was a place called the Hotsy Totsy. A night club? It was only a speak-easy, really; a throw-back to the Bowery and Coney Island joints . . . The entertainers were the piano player named Jerky Benson, a couple of singing waiters named Jo Jo and Harry Delson, and a half dozen hostesses . . . The place was open twenty-four hours a day, the entertainment starting at ten thirty and running until seven or eight in the morning . . . Before long the Hotsy Totsy was known as the hottest spot in New York. Everyone went. It was almost impossible to get a seat, and the mob ranged six and seven deep at the bar. Receipts

ran to between two and four thousand dollars a night. Nothing like it had ever been known—and nothing like it has been seen since.

Durante was not on the premises the night of the shooting. Had he been, he would not likely have noticed anything different from other nights when he was there. The place was crowded and lively. The band was decent. Most speakeasies—as opposed to full-fledged nightclubs like Connie's Inn, the Savoy, or the Cotton Club in Harlem—did not have big-name bands, but they did have solid trios and quartets. This particular band had a violinist named Tommy Merola, who, when he wasn't playing music, worked as a waiter at the club.

In walked three men who were typical of the type who usually wound up at the Hotsy Totsy Club late in the evening. Two brothers—off-duty longshoremen from nearby Hell's Kitchen—and a friend took their place at the bar. They had just come from a boxing match at Rockaway Beach arena and were filled with loud opinions about the fight they had seen. After a few drinks, they crossed over from loud to obnoxious. Said the lone survivor of the three, "We were all drunk that night and we were ready for anything, a fight or a frolic."

What they got was Legs Diamond, the co-owner, who was in the club that night with an underling, Charlie Entratta. Either Legs or Entratta told the loud ruffians to keep it down. Not knowing whom they were dealing with, one or all of the ruffians told Legs to mind his own business. That's when the shooting started.

In the immediate aftermath, one of the officers on the scene was the top man, Commissioner Whalen. The commissioner's appearance was an indication that the police department knew this was a "mob joint" and the shooting deserved a higher-than-normal level of scrutiny. Seventeen slugs were dug out of the woodwork and plaster at the bar; seven more slugs were extracted from the bodies of the three victims. One of the dead men had been shot with a .38 caliber revolver and the other with a .32 caliber. Two guns, two shooters.

Among the dozen or so witnesses detained by the cops—primarily club employees who had not scampered away like most of the patrons—was Tommy Merola, the violin player.

The coppers were able to establish the basic facts: The ruffians had exchanged words with Diamond and Entratta. Guns were drawn, put away, and drawn again. The three patrons had brought it on themselves, but still, they were unarmed. It seemed to be an open-and-shut murder case.

Only problem was, neither of the perpetrators, Diamond or Entratta, were anywhere to be seen, nor would they be for many months. In the meantime, slowly, body by body, the case turned from being open-and-shut to being one of the most deadly murder investigations of the era.

Over the next six months, the death total would rise to seven, with three more potential witnesses who disappeared and were never found. Ten people missing or dead—all of them because they had been in a gangster nightclub during Prohibition, when things like this could happen.

Somebody was determined to make sure the witnesses never had a chance to talk. Bullet-riddled bodies started turning up in various locations around New Jersey, among them the club's manager and three witnesses. Other potential witnesses, those who were not eliminated by killing, were so terrified that they developed a collective loss of memory. The police case against Diamond and Entratta was stillborn.

One year after the shooting, Entratta was apprehended and put on trial, but without witnesses the prosecution floundered.

One witness who had survived, held in custody for his own safety, was Tommy Merola, the violinist. A journeyman fiddler, at best, Merola benefited from an era when even marginal musicians were in high demand. Like others who approximated the thrilling chord changes and syncopation of the new music in mob-controlled venues, Merola adhered to the principle of the three monkeys. "I was dozing on the bandstand," he explained in court. "I didn't see anything, I didn't hear anything."

After the acquittal of Entratta, Legs Diamond turned himself in. He was questioned and then let go. The cops and prosecutors had no case because most everyone who might have seen anything was dead.

Afterward, Commissioner Whalen held a press conference and stated the obvious: "Gangdom is in control of the nightclubs." He added, "All decent people will shun such places."

Going to Slice City

Violence, or the possibility of violence, had become part of the night-club scene, but this had little to do with jazz. The demonization of the music had been there from the beginning: Jazz was "jig music" and therefore violence-prone and dangerous, according to white (and some Black) opinionators, politicians, socialites, and race-baiters. This repre-sented a strain of Americana that would continue throughout history, where music designated as "Black" (early rock and roll, rap, hip-hop) was characterized by polite society as innately violent. In the 1920s and 1930s, a shooting in a nightclub by a white gangster—with white victims—was viewed as a product of "the Jazz Age." "Decent people" were the opposite of those who patronized the clubs or were patrons of the music; whites who liked jazz were viewed by decent people as slum-ming in Black culture.

Efforts to marginalize jazz continued to be a losing cause. A growing audience of Americans, Black, white, and everything in between, loved the music, and they were sometimes willing to even risk death to have a jazz experience, whether "the Law" wanted them to or not.

For musicians, the gangsters and violence they represented was sometimes a point of contention. Most were like Fatha Hines in Chi-cago: They kept their eyes, ears, and mouths shut. Some were repulsed.

Mezz Mezzrow, in his memoir, described how depressed he became when he moved from the South Side of Chicago to Harlem and dis-covered that his new neighborhood and its jazz scene was as overrun by

white gangsters as his old neighborhood. "I'd had a bellyful of gangsters and musclemen by that time," he wrote. "They'd always been luring me on, trying to win me away from the music to their loutish ways—all of them, from the gamblers and pimps in the Chicago syndicate to . . . the hophead mugs over in Detroit."

Mezz described a night when it all boiled over for him. He was on the bandstand at a place called the Woodmansten Inn, on Pelham Parkway in the East Bronx.

> A bunch of ugly-looking gangsters had taken the joint over for a big party, and they were all wobbling around the floor with their floozies, so drunk they could hardly stand. One of these mugs danced right up under the bandstand and just stood there, staring at me. When I swayed, he swayed. When I stomped, he stomped . . . I watched that yegg while my clarinet weaved a spell around him, and I thought, Jesus, this music sure has got a hold of him. Suppose he owns some club and likes my playing so much he wants me to go to work for him? Maybe he's thinking it over right now, while he's casing me. If I have to work for him I'll really be under his thumb, and if I try to make a move they'll cut me open just like they did poor Joe E. Lewis.

Mezzrow was so unnerved that he quit his gig that night and rushed home.

> I sprinted all the way from the bus stop to my house and took those stairs three at a time. I heard footsteps dogging me all the way, right up the stairs and into the house.

Nobody was following him; it was all in his head. Before long, the clarinetist had a nervous breakdown that contributed to his becoming a full-on dope fiend.

Other musicians had their own ways of internalizing the tension. One source of relief, an endeavor that in some ways mimicked the mentality of the gangster life, was the notorious cutting session.

"Cutting" was an informal, competitive form of playing between musicians that began as a friendly show of prowess and sometimes turned into musical bloodletting. It was not violent, per se; it did not involve an actual knife or blade, nor did it result in the destruction of the flesh or the puncturing of internal organs, but it was definitely aggressive and occasionally ruthless.

Cutting sessions first became common in the early 1920s at "rent parties" or "rent shouts" in Harlem. Rent parties were an ingenious way for people to accumulate money to pay the monthly rent on their apartment. Local folks would gather at a friend or family member's apartment, preferably someone who had a piano on the premises. People brought food and drink. A modest fee would be charged, a hat passed for the musicians, and then the revelry began. Rent parties often lasted all night or even over the course of a weekend.

In Harlem, rent parties were often tied in with the local numbers boss. In the decades before any legal state lotteries existed, betting on a daily number was a racket controlled by organized crime. A numbers boss, and the numbers runners who worked for that person by canvassing the neighborhood taking bets, were well known in the community. Numbers operations were ubiquitous from the highest strata of society to the lowest. As such, they were a great way to spread the word about upcoming rent parties. In some cases, numbers runners sold tickets to a particular rent shout with the names of some of the musicians who would be performing on the ticket. It was yet one more way that the jazz scene became entangled with the forces of organized crime.

The competition at rent parties was fierce. Primarily piano players were showcased, and some of the most prodigious pianists of the day— including Willie "The Lion" Smith, James P. Johnson, Fats Waller, and a young kid from Washington D.C. named Edward "Duke" Ellington— made a name for themselves at the rent parties.

Eventually, the spirit and camaraderie of the rent parties evolved into the cutting sessions or cutting contests, which usually took place in the basement of a music hall, at a speakeasy, or at an after-hours club. Cutting sessions were rarely advertised. As word of mouth spread like a brushfire through the neighborhood that a cutting session was underway or about to go down, jazz fans excitedly flocked to that location.

Cutting sessions were an essential way for musicians to establish themselves with other musicians. Harlem at the time was the most multilayered and sophisticated jazz scene in the entire world. There were dozens of clubs, ranging from speakeasies patronized by Blacks only, to midlevel clubs like Smalls Paradise and Club Hot Cha, where bands played four sets a night, to hifalutin dance clubs like Connie's Inn, the Cotton Club, and the Savoy Ballroom. For musicians, it was a veritable Gold Rush. Especially for a player from out of town, as many were, the only way you were going to get hired was by proving yourself at the cutting sessions. Even for a hot new gunslinger in town, your reputation only went so far; you had to prove yourself by engaging in a shootout in the town square.

Trumpeter Rex Stewart, who came into New York from Philadelphia, remembered the process:

> To a degree, all musicians, white or Black, underwent the same test of strength. After arriving in the big town, a player first got squared away with a room. The next thing he'd do was to ask where the musicians hung out . . . By day, most of the fellows could be found congregated on the street around the offices of the musicians' union, Local 802 . . . Night or day, Bert Hall's Rhythms Club at 132nd Street, just off Seventh Avenue in Harlem, was the main testing ground . . . Some piano man— and there were always a few of them in the place—would amble over to the keyboard and start comping a tune like "Sweet Georgia Brown" or "Dinah." This was the cue for the stranger

to pull out his instrument and show what he could do. Meanwhile, the word had gone out all over the neighborhood—"stand by"—because if this cat was really good, it was the duty of every tub to drop whatever he was doing and rush to the club.

If the great Willie the Lion was in attendance, watch out. As soon as he entered, he might shout at whomever was at the piano, "Either play something or get up, you heathen. The Lion is in port, and it's my mood to roar!" Others might encounter far worse put-downs and humiliations. At their rowdiest, cutting contests were like a Jazz Age version of Amateur Night at the Apollo. If you were bested by a competitor, you might be booed out of the room. Stewart remembered a night when no less a personage than Billie Holiday goaded tenor sax titan Coleman Hawkins to take on another sax titan, Lester Young. Holiday adored Young, to whom she gave the nickname "Pres," as in "President," in part because no one could outdo his brilliance and inventiveness in the cutting sessions. On this particular night, in the opinion of those in attendance, Hawkins was better. In defeat, Lady Day and Pres slinked out a back door of the club.

Were the cutting sessions intentionally cruel? In a way, yes, they were. They were intended to determine whether you had what it took to survive and even flourish in a harsh environment. The biggest clubs in Harlem were either partly or completely owned by white gangsters. At these clubs, the owners and many of their hoodlum underlings were a constant presence. Setting aside speakeasies like the Hotsy Totsy, violence at the fancier clubs was a rarity, though the potential for violence was ever present. Many musicians had stories of being intimidated by hoodlums for one reason or another. Working at a jazz club was not for the faint of heart. A thick skin was required. If you could not handle a verbally assaultive cutting session among fellow musicians, how were you going to be able to handle the demands of being employed and surrounded by some of the most ruthless killers in the city?

Cutting sessions were a proving ground, but they were also a re-

leasing of tension, like a street fight or an especially unruly version of Playing the Dozens, the trading of insults, the more vicious the better. Only the strong survived.

Fats

What was required was swagger. A particular kind of swagger that came from the streets and did not wilt at the sight of a gun, or the snarl of a notorious thug, or the sight of blood. It could be an elegant swagger, like that of Duke Ellington, who spoke with a deliberately affected poshness while surrounded by uneducated hoodlums; or a physical swagger, like that of Willie the Lion or Hawkins, big men who took no lip from anyone; or it could be an outrageous comical swagger, like that of Fats Waller, who disarmed anyone he met with jitterbug eyebrows and a clever quip, all the while laying down a dazzling allegro set of scales on the piano that made listeners cock their ears in disbelief.

Fats was the man. Heavily influenced by Jelly Roll Morton, that braggadocio genius from New Orleans who claimed to have invented jazz, Fats birthed some of the music's most immortal tunes and brought to his work an utterly original performance style. As with Louis Armstrong, audiences watched and listened to his playing with a smile on their faces. He brought a joyful, enticing spirit of naughtiness to his entire presentation. He was also ambitious and, throughout the 1920s and 1930s, created a body of work that would define the music for generations to come.

Fats knew how to handle gangsters perhaps better than anyone. He had survived being snatched by Al Capone's henchmen and delivered as a surprise to a private gathering at the mob boss's birthday party. That was a couple of years earlier, in 1926, when Fats was twenty-two years old. In the intervening months, he had matured in more ways than one. He was a composer and producer of Broadway musicals, made possible through the application of his prodigious talent but also by seducing and securing the financial backing of the richest gangster in town.

Waller first met Arnold Rothstein at—where else?—Lindy's, where Blacks were not allowed to sit at prime tables unless they were invited by a white customer. Waller and his songwriting partner, Andy Razaf, were introduced to the mob boss and invited to take a seat.

Rothstein had seen Fats play at Connie's Inn in Harlem, and he loved what he'd heard. The two men hit it off. They made an odd pair: Rothstein, with his slicked-back hair and bow tie, was an upwardly mobile Jew among the goyim, a Broadway dandy. Waller, in keeping with his nickname, was chubby, jocular, and hip, the coolest cat in Harlem.

Rothstein was a breed apart. Born into wealth, he had—much to the chagrin of his parents—chosen a path contrary to his upbringing. His father was a prominent businessman named Abraham Rothstein, who went by the nickname "Abe the Just." The oldest son in the family became a rabbi. As a youngster, Arnold was a mathematics wizard, but early on he lost interest in school. What he really liked to do was gamble—at card games, the roulette table, on sporting events, political elections, you name it. "I always gambled; I can't remember when I didn't," he told an interviewer in 1921, when he was thirty-nine years old. "Maybe I gambled just to show my father he couldn't tell me what to do, but I don't think so. I think I gambled because I loved the excitement. When I gambled, nothing else mattered."

Rothstein took chances, and more often than not—far more often—the risks paid off. With his winnings he made investments in things like real estate, a casino, a horse-racing track, dope, and entertainment propositions. Among his nicknames was "The Big Bankroll"; he was the dough behind some of the city's biggest ventures, legal and otherwise.

Prohibition turned out to be the best thing that ever happened to Arnold Rothstein. He invested in illegal booze and did business with nearly every big bootlegger on the Eastern Seaboard. Working with Legs Diamond and Lucky Luciano, he introduced heroin into New York City. He financed an elaborate carjacking scheme with two young Jewish machers, Meyer Lansky and Bugsy Siegel. He co-financed nightclubs with Frank Costello. Through it all, as far as anyone knew,

he never killed anyone, committed an act of violence, nor did time in prison.

He cheated at gambling and fixed horse races. He was even rumored to have fixed the 1919 World Series, the notorious Black Sox scandal. At trial, on the witness stand, he denied he had anything to do with it. He was acquitted.

The reason that Fats Waller, a jazzman from Harlem, was seated at Lindy's with Rothstein was that among the Big Bankroll's many investments were Broadway musicals. Fats was in the process of writing the music for *Hot Chocolates*, the all-Black musical revue that showcased the theatrical debut of Louis Armstrong. Even with Armstrong on board, financing an all-Black Broadway show was a daring proposition, which likely made it attractive to Rothstein, who loved to take risks. It was also the sort of arrangement between an enterprising musician, which Fats certainly was, and a mobster that had become a major chord in the ongoing boogie between jazz and the underworld.

Rothstein let it be known that he was interested in investing in *Hot Chocolates*. The details would be worked out by producers and lawyers.

As Waller and his partner, Razaf, rose from the table at Lindy's to go catch an uptown cab, the piano man decided to test the mobster. "Arnold, baby," he said. "How 'bout some trash for a cab?"

"Sure, boys," said Rothstein, "how much do you need?" He pulled a roll of bills out of his pocket and peeled off five hundred for both Waller and Razaf.

On the way uptown, Waller was positively giddy. From then on, he referred to Arnold Rothstein as "The Golden Goose." "I got big plans for that man," said Fats to his partner.

Black and Blue

Like many jazz musicians and entertainers of all stripes, Fats Waller liked to have a good time. He was known for it. He liked to drink— perhaps too much—and smoke muggles. It's fair to say he sometimes

overindulged. He was a man of voracious appetites, full of life; alcohol seemed to soften the edges of his unrelenting ambition. He was sometimes drunk during performances and would sneak offstage between songs to have a shot. Sometimes the bottle of booze was right there on top of the piano during a show. It caused him problems in his personal life. His first wife divorced him because of his drinking and carousing. In a biography of Fats written by his son Maurice, it is noted that when people asked his other boy what his father did for a living, the young son answered, "Drink gin."

It was an unfortunate assessment, given the jazzman's meteoric career and accomplishments, but could the son be blamed for what he saw? Fats's drinking was so detrimental to his health that it undoubtedly contributed to his premature death from pneumonia at the age of thirty-nine.

Before Waller left the corporeal world, he gonged the bell as few ever would. Part of his method involved seizing upon any and all opportunities to showcase his prodigious talents, and this involved utilizing the beneficence of gangsters.

Rothstein came through with the financing so that *Hot Chocolates* could be cast, staffed, and begin rehearsals. Occasionally, the dapper gangster came by the theater to sit in on rehearsals. Fats always treated him like royalty.

Rothstein never made it to opening night, however. On the night of November 4, 1928, the Brain was shot multiple times at a business meeting at the Park Central Hotel in Midtown Manhattan. For the next two days, he lingered at Stuyvesant Polyclinic Hospital, drifting in and out of consciousness. Detectives came to his room. The dying gangster refused to identify his killers, saying to the cops, "You stick to your trade, I'll stick to mine." Then he expired.

Rothstein's assassination was attributed to a marathon poker session in which he had taken part at the Park Central Hotel a few days earlier. Uncharacteristically, he lost big that night, to the tune of $319,000 (the equivalent of $4.8 million today). Rothstein came to the conclusion

that the game was fixed. As they say: You can't cheat a cheater. He refused to settle his debt, which led to his death.

With his fingers in so many pies in both the upper- and the underworld, the passing of Rothstein was a landmark event. For Fats and his partners, it seemed like a crippling blow. But another gangster boss who loved jazz even more than the Big Bankroll stepped in and saved the day.

Arthur Flegenheimer (the birth name of Dutch Schultz) was a German Jew born in the Bronx. He was the opposite of Rothstein, who disdained violence. The Dutchman had killed his way to the top, and he elbowed his way into the Harlem nightclub scene both through his role as a bootlegger (he supplied the booze to Connie's Inn and many other clubs) and through his control of the lucrative numbers racket.

Schultz was a brute, but he had a soft spot for jazz. He was known to hire some of the biggest names in the music, including Fats, to play at private parties, and he was a major financial overlord at Connie's Inn and other clubs.

With the sudden demise of Rothstein, Schultz stepped in with the money to have *Hot Chocolates* up and running by its opening night on June 20, 1929. But not before he put his own creative stamp on the proceedings.

According to Andy Razaf, Waller's co-lyricist on *Hot Chocolates* and many other shows, one day he was approached by Schultz, who had an idea for a song. It was unusual for a mobster boss to impose himself in this way. Even though they had financial stakes in a show or in one or more of the clubs, the gangsters let the musicians and entertainers handle their own business. For some, this was even a point of pride. With all the money Rothstein had invested in show business, he never sought to intrude creatively. As Fatha Hines said about Capone and his crew in Chicago, they had their business, we had ours, and as long as they stayed out of each other's business, the relationship was copacetic.

Though Dutch Schultz, by most accounts, was anything but a raconteur or entertainer, he may well have been a frustrated songwriter.

To Razaf, one of the most prolific lyricists of the era, the Dutchman suggested an idea for a song—and a comical one at that. Dutch thought it might be hilarious to have a song where a dark-skinned Black woman, late at night in an all-white room, lying on white sheets, sang a song lamenting how she had lost her man to a lighter-skinned woman, and how this had become the bane of her existence. Schultz meant for the song to be a joke.

Razaf was Harlem royalty, born to the daughter of the first African American consul general to Madagascar. As a songwriter, he rose through the ranks of Tin Pan Alley, the legendary breeding ground for aspiring songwriters who came to New York from all around the United States. There were few Broadway lyricists more accomplished than Andy Razaf.

Delicately, not wanting to offend the gangster, Razaf told Schultz that there was really no room in the show for a song like that.

Schultz pulled out a gun and held it so that Razaf could see it. He made it clear that the lyricist would write the song, "Just like I said it."

Technically, Razaf was employed by the Immerman brothers, George and Connie, not Dutch Schultz. But when a gangster with a gun gave you an order, it was hard to say no.

Razaf wrote the song, but what he did with it would go down in Broadway lore as one of the most memorable origin stories in jazz history.

The song was called "(What Did I Do to Be So) Black and Blue," and it was sung on opening night by the actress Edith Wilson. Razaf constructed the song as Dutch Schultz had described it, only, as written, it was anything but funny. With a delicate, mournful melody composed by Fats, the song was an emotional treatise on skin color written in a way that most African Americans would intuitively understand.

On opening night, Razaf stood backstage—with Dutch Schultz looking over his shoulder—as the song was performed by Wilson. The song packed an emotional impact; the audience was transfixed as Wilson sang the song as a mournful lament. Razaf feared that Schultz would

be irate that he had completely changed the tone of the song, and as the audience sat in hushed silence, the lyricist sensed he was in big trouble. But then the song ended and the crowd applauded heartily, with some standing. Clearly, it was a hit. Dutch slapped Razaf on the back; he was pleased.

A few days later, unexpectedly, Razaf received a call from Schultz. It was late in the afternoon. Schultz sounded chipper; he told Razaf to be ready for a car that would be coming to pick him up in an hour.

Razaf was suspicious. Though, at age thirty-five, he was six years older than Schultz, he feared the man—with good reason. Schultz wore his underworld power on his sleeve. Razaf didn't entirely believe that the crime boss was willing to accept his artistic liberties with "Black and Blue." Razaf was a cultured person; in his mind, a gangster was, by nature, a duplicitous person. Not knowing for sure what Schultz had up his sleeve, Razaf was feeling paranoid.

A car picked him up, and the driver took the lyricist to Polly Adler's brothel on West 54th Street in Midtown Manhattan. Razaf knew the place; he'd been there before. Adler had become an infamous madam. The clientele at her numerous brothels in town included show people and entertainers, as well as gangsters and some of the city's biggest power brokers.

Schultz was there waiting for Razaf. He seemed to be in a good mood. He led Razaf to a choice room in the brothel, where three women were waiting. "Take your time," said Schultz. "Take all night if you want. It's on me. A little bonus."

Even years later, Razaf remembered the incident well. One of the girls he recognized; she was known to be a personal favorite of the Dutchman. This made Razaf even more suspicious. If he were to accept this gratuity and bed down with the gangster's own personal concubine, would it not put him in a position of indebtedness to Schultz that could never be repaid? And if he said no to Schultz, if he turned down the gangster's gratuity, would there be unpleasant consequences?

Razaf stewed in his paranoia and uncertainty. The colored lyricist

and the Jewish mob boss smiled at one another. Schultz left the room. As Razaf later put it, he sat in a chair in the corner for hours and "kept to it, clung to it, for dear life." In the wee hours, he left and took a taxi back to Harlem.

For the show people, the jazz musicians, and the people of Harlem in general, the Dutchman was a force to be reckoned with. When it came to the neighborhood's criminal entanglements, Schultz wasn't necessarily the plantation owner—that was the Combine itself—but he was the plantation manager, a hands-on boss who treated Black folks as if they were his personal property. Harlem was his territory. He influenced a certain aspect of life in the community through his business ventures, primarily the numbers racket (also known as the policy racket), which, in Harlem, was a huge source of revenue.

The policy game was a multiheaded hydra that required many participants if it were to function on a daily basis. There were numbers runners who circulated in the community taking down bets, recording the numbers, and centralizing the actual money that was wagered. Usually, these bets were in small denominations—as little as dimes and nickels, as there was no limit on how much could be bet. The number was determined by the total mutuel handle at the local racetrack; the daily number was the last three digits of that number. The total mutuel handle was printed daily on the sports pages of the newspaper and could therefore not be manipulated; it was set in stone, so to speak.

The Dutchman's policy empire in Harlem raises an obvious question: Were there no Black gangster overlords in Harlem?

Yes, there were. Before Schultz took control of the local numbers racket, there were a series of prominent mob bosses in Harlem who had a piece of the action. One was Baron D. Wilkins, a silky club owner originally from Washington D.C. Wilkins was the proprietor of numerous clubs, the most renowned of which was Baron's Exclusive Club, at 198 W. 134th Street at Seventh Avenue. The club was a cabaret that showcased many well-known performers. The great Count Basie made his New York City debut at the Exclusive Club. And one of the anon-

ymous chorus girls at the club named Lucille LeSueur later changed her name to Joan Crawford and became an Academy Award–winning actress.

Wilkins established a practice that was often attributed to the white gangsters but, in fact, started at the Exclusive Club. The musical entertainers were Black but the audience was white. A proud member of the Harlem bourgeoisie, Wilkins, who was himself a creamy shade of brown, did not allow Black folks into his club unless they were light-skinned or Black celebrities. Heavyweight champ Jack Johnson was a business partner of Wilkins and a regular at the club. In 1920, the champ branched off to start his own club, which he called Club DeLuxe, located on Lenox Avenue.

When it came to the numbers racket, Wilkins was a financier but he remained mostly hands off in terms of the daily mechanics. As a club owner of considerable wealth, he was a major power broker and philanthropist in Harlem. He was also a gambling addict who made large bets on horse races and crap games. His graft payments to the New York police, which allowed him to sidestep Prohibition laws, were considerable. Some considered Baron Wilkins to be the Black Arnold Rothstein.

It all came to an end suddenly and shockingly on May 24, 1924, when Wilkins was shot dead on the street in front of his club. He was killed by a local hood who went by the name Yellow Charleston. There were many witnesses to the crime. Wilkins, who was known to lend money to people who were on the run from the law, had turned down a request from Yellow Charleston, who killed a man in a card game earlier that day and urgently needed to get out of town.

The murder of Wilkins was a stunner. As the *New York Times* noted: "For hours after Wilkins was killed his place was surrounded by more than 500 negro men and women, weeping and wailing over the loss of the man many of them termed 'the finest man that ever lived.'"

After Wilkins's death, the man who carried on the tradition was Casper Holstein. Born in the Danish West Indies, on the island of St. Croix, Holstein was mixed-race African and Danish. He moved

with his mother to Harlem when he was a child. He served in the U.S. Navy in the First World War, stationed on the USS *Saratoga* in the Virgin Islands, and upon his return to New York he worked for a time as a messenger for a commodities brokerage firm on Wall Street. There he developed a head for numbers. Holstein was the one who established that the daily number would be derived from pari-mutuel betting totals printed in the newspaper, rather than from a lottery system, as it had been before. This made betting the number a more trustworthy endeavor and therefore more attractive to street-level gamblers.

Under Holstein, the policy racket commonly became known as "bolita" (little ball), a Cuban term used by Latinos, who were major patrons of betting the numbers. By expanding his clientele beyond Black Americans to include Cubans and other Caribbean immigrants, Holstein created an empire and became known as "The Bolita King of Harlem."

Like Baron Wilkins before him, the dapper mobster became a figure of great renown in the community. Proceeds from the numbers racket were used to finance a host of community projects, particularly in the areas of education and literature. According to the *Encyclopedia of the Harlem Renaissance*, Holstein was a "race man" devoted to uplifting the lot of African Americans in the United States, and he was an early civil rights activist.

Later in life, Holstein was arrested on gambling charges and sentenced to three years in prison. He issued a statement that was published in the *New York Age*, a Black newspaper:

> We cannot enjoy half slavery and half freedom. We want it all or nothing. We don't want to be revolutionists; we don't want to be communist; we don't wish to be branded against organized government. We want to be the same as every member of this American nation, and we are entitled to that privilege. I am told you cannot oppose government, but by god government

can hear us cry, and must hear us protest and we are going to protest until we get the form of government we wish.

In his heyday in the 1920s, Holstein owned and operated the Turf Club, located at 111 W. 136th Street, a gambling parlor and nightclub where cutting sessions were known to last into the wee hours.

In 1928, the dapper mobster was snatched off the street in Harlem by five white kidnappers and stuffed into the back seat of a car. The kidnappers were led by a young hoodlum named Vincent "Mad Dog" Coll, a notorious Irish immigrant hitman who freelanced in the New York underworld of the 1920s. Coll, just nineteen years old, had been hired to kidnap Holstein by Dutch Schultz, who was looking to take over Holstein's operation. The numbers king was roughed up, and Coll demanded a payment of $50,000 to be released. Holstein refused to pay and was eventually kicked out of the car on Seventh Avenue.

Schultz was looking to intimidate Holstein and bring him into line but not kill him. The Dutchman likely knew that he did not have the skills or the respect of Harlem residents to run Holstein's operation. It was a typical gangster move: Instill fear and then leech off an already successful criminal racket, profiting off the labor of others. This same mentality, it could be argued, was behind white gangsters like Schultz, Capone, Matranga in New Orleans, Lazia in Kansas City, and all the others who profited off the talents of Black jazz musicians.

In the late 1920s, yet another numbers boss rose in the neighborhood pecking order. Madam Stephanie St. Clair, also a Caribbean islander by origin, established her own policy operation in Harlem. For a time, she was a rival of Holstein's, though eventually they would combine forces in an effort to stop Dutch Schultz from taking over all of Harlem. As a woman, Madam St. Clair is unique in the history of the American underworld, and her ability to gain traction is an indication of Harlem's standing as an equal-opportunity criminal underworld.

All of these prominent policy bosses—Wilkins, Holstein, and

St. Clair—had considerable power in Harlem—so much so that Schultz, as predatory as he was, could not simply kill them and take over their businesses. Their standing in the community was a kind of life insurance policy that made it possible for them to operate, thrive, and survive. And yet, all Black mob bosses faced the same problem. They had access to power in Harlem, but it ended there. Beyond that was a Caucasian universe of power brokers: mayors, governors, senators, and the president. Law enforcement and the judiciary were nearly as white as the grand council of the Ku Klux Klan. Given this reality, African American gangsters were never going to have the same access to power as the average white gangster. Sure, the immigrant class—Italians, Irish, and Jews—did not constitute the ruling class in America. The real money and power was in the hands of the WASPs, who disdained the immigrant rabble. But it is also true that the immigrant class held many of the civil service positions in the police, politics, and labor trades that made organized crime such a bullish enterprise in the age of Prohibition.

It was as true in the underworld as it was in the upperworld: People of color, no matter how accomplished, were held in check by a racial glass ceiling. In Storyville or Bronzeville or Harlem, they could, by establishing working relationships with the mafia or the syndicate or the Combine, carve out a niche for themselves. They could make money for themselves and their own, but their access to real power and autonomy, their ability to own and control the fruits of their labors, was circumscribed by the racial realities of the city, state, and country at large.

No matter how much a Black gangster accomplished locally, it had always been, and still was at the time, a white man's world.

7

DOWN ON THE PLANTATION

The man who made the world go round in New York City was Mayor James "Jimmy" Walker. Born and raised in Greenwich Village to Irish immigrant parents, he was, among other things, a frustrated song-and-dance man. Before entering politics, he wrote lyrics for a number of Tin Pan Alley songs, including the sentimental hit "Will You Still Love Me in December as You Do in May." Walker was a romantic. He was lean and dapper, a character right out of *The Great Gatsby*, which was published the year he was voted into office as the city's chief executive. What everyone knew, because it was chronicled in the city's many newspapers and gossip columns, was that Walker loved partaking of Manhattan's nightlife. He may have been a bon vivant who dressed like a Broadway dandy, but he was, nonetheless, especially loved by the "common man," who rightfully believed that he was on their side. A political liberal, he was a product of the Tammany Hall machine, pro-immigrant, pro-labor, firmly democratic. He was one of the few Caucasian politicians of note who publicly condemned the Ku Klux Klan. Black voters supported him. He was also beloved by the avatars of arts and entertainment. His nickname, Beau James, would eventually become the title of a Hollywood movie based on his life starring Bob Hope.

Walker was also believed to be, if not personally corrupt, perhaps overly sympathetic to the Combine. As an assemblyman and state

senator, he had vehemently opposed Prohibition, and it was understood that he would not interfere unduly with the flow of booze into the city's many speakeasies and nightclubs. When Walker first ran for mayor in 1925, no less a personage than the composer Irving Berlin, a personal friend, penned the candidate's campaign song. In those days, a catchy tune—preferably one with wit and heart—was an essential aspect of a political enterprise. Berlin's lyrics indicate how much Walker's links to organized crime were viewed with a wink and a smile.

> It's a walk-in with Walker
> It's a walk-in with Jim
> He's a corker—and one of the mob
> A real New Yorker—who's fit for the job.

Walker's time in office seemed to epitomize the Jazz Age. Unlike Tom Anderson in Storyville, Walker was not much of a hands-on legislator, nor, for that matter, a businessman or political administrator. He was not a political boss like Tom Pendergast in Kansas City. These power brokers, though they were, like Walker, of Irish descent and shared political inclinations that were "of the people," were removed from the vice districts they helped to create. Walker was a regular in the speakeasies and nightclubs. Though Walter Winchell and other major gossip columnists were discreet about linking the mayor, in print, to clubs where booze was sold, having the mayor present in these locations was part of the glamor. Yes, drinking in these establishments was against the law, but, guess what? The mayor is here with his mistress. He's out on the dance floor dancing the Charleston, drinking up a storm, so don't tell me that what I'm doing is wrong.

The mayor's mistress, by the way, was Betty Compton, a Ziegfeld Follies dancer and showgirl.

The soundtrack for the era was jazz. The music had moved from being a mode of expression primarily for Negroes and a novelty for Sicilian immigrants and other whites willing to embrace and exalt the

fruits of Black culture, to being a mainstream phenomenon. By now, radio broadcasts had transported the music across the airwaves to virtually every hamlet in the United States. It was taking hold from coast to coast, but it was in Manhattan that the Jazz Age reached new heights of sophistication and glamor.

Mayor Walker understood and loved the music. He patronized the musical extravaganzas on Broadway created by Fats Waller, Andy Razaf, and others, and he was an occasional presence at many of the most renowned clubs. His favorite club was one where the music was in the process of evolving from the whorehouses and honky-tonks of its origins to become as complex and varied as any symphonic orchestration from the capitals of Europe. This club, located in Harlem, was owned by an Irish American gangster from the West Side of Manhattan who was cut from the same cloth as Walker.

With Beau James firmly ensconced in City Hall, and the Jazz Age in full flower, the Cotton Club would come to represent the relationship between jazz and the underworld at its highest pinnacle—an unholy alliance, some might say, but one that dressed up the concepts of sin, sensuality, and jazz as a song-and-dance revelry, a "Black and Tan fantasy," with energetic, scantily clad showgirls and a house band that elevated the music to dazzling new levels of artistry.

Madden's No. 1

Unlike Sicilian immigrants and, to a lesser extent, immigrant Jews, the Irish in America were on a course of assimilation that sometimes brought them into direct conflict with their African American brethren. In his provocative history *How the Irish Became White*, author Noel Ignatiev posits the theory that the Irish, who had arrived en masse in the United States in the wake of famine and oppression—and suffered as much as any immigrant group from bigotry and discrimination—were in the process of identifying more with their masters than with the proletariat. Ignatiev suggests that the Irish were accorded the status of

"whiteness" through their newfound commitment to military service, law enforcement, and politics. As cops, they took on the role of keeping Blacks and the lower classes in their place. As a result of this unspoken bargain with the WASP ruling class, they were viewed as having earned a kind of symbolic access into the American middle class.

There were exceptions. In the early twentieth century, Irish Americans in certain big cities (most notably Chicago, Boston, and New York) still filled out the ranks of the mob. In some cases, they had moved from the lower levels as "muscle" and strong-arm men to become powerful overseers of the Prohibition era. A handful had been successful enough to branch out beyond the business of illegal alcohol into other areas, such as sports and entertainment. Both were endeavors that involved interacting with African Americans. Jazz, in particular, was dominated by Black musicians, and certain sports—like boxing, which was a popular source of investment for organized crime figures—adhered to a plantation dynamic that would come to characterize American capitalism in the century. The performers might be Black, but the owners, managers, and money changers were some version of Caucasian.

One gangster who operated successfully within this universe was Owen Vincent Madden, known to his friends and associates as Owney. Some historians make the mistake of identifying Madden as British. Yes, he was born in Leeds, England, on December 18, 1891, and spent some time in Liverpool, but even in those years the dominant characteristic of his childhood was Irishness. Both of his parents were from Ireland and had been forced to flee in the wake of the Great Potato Famine. In both Leeds and Liverpool they had lived in an Irish slum. Then, in 1902, Madden's father died of tuberculosis, and his mother made the decision to move to America. Owney was eleven years old.

In Hell's Kitchen, the New York City neighborhood in which the Maddens settled, Irish immigrants and first-generation Irish Americans had established a ragged, street-level fiefdom. The neighborhood was located on the West Side of Manhattan, alongside the Hudson River. As in many poor neighborhoods, youth gangs were a common feature.

Almost immediately, Owney Madden took up with a gang called the Gophers, so named because they met in tenement basements. Madden was short and wiry, not the least bit physically imposing, but he was hungry and tough. A local policeman referred to Madden as "a banty little rooster from hell."

The Gophers were primarily a burglary squad; they raided the freight trains and warehouses that populated the neighborhood's riverfront docks. They also fought often with rival gangs, most notably the Hudson Dusters, who were based farther south in the neighborhood of Greenwich Village. Madden distinguished himself in these battles. He was good with his hands and also with a knife, brass knuckles, a gun, and his weapon of choice, a metal pipe wrapped in a newspaper. Owney soon lost his slight British accent and spoke in the clipped, wiseguy dialect of the West Side. He self-identified as an Irishman, which made him part of a New York City tribe that had, in a generation or two, risen from the gutters to produce shining lights like Mayor Jimmy Walker.

Through guile and fearlessness, Madden became a leader of the Gophers. This was partly due to his role in a number of murders. On the street, they referred to him as Killer Madden. As is often the case when someone takes on such a bold sobriquet, Madden's reputation brought him many challengers. On November 6, 1912, Madden was jumped by a squad of hitmen from the Hudson Dusters. The incident took place at the Arbor Dance Hall on 52nd Street and Seventh Avenue. Madden was shot half a dozen times, and he lay in a pool of his own blood.

"Who did it?" asked a detective arriving on the scene.

Barely conscious, Madden replied, "It's nobody's business but mine who put these slugs in me. The boys'll take care of them."

Madden was rushed to the hospital and miraculously survived.

In less than a week, three of the suspected shooters were bludgeoned, shot, or stabbed to death in various locations around the West Side.

Sometimes the challengers came from within. Patsy Doyle was a minor member of the Gophers who, as Madden lay in the hospital convalescing from his wounds, declared himself leader of the gang. Once

Madden had recovered, he and Doyle became embroiled in a gang war that involved many violent attacks and counterattacks, until Patsy was gunned down in front of a Hell's Kitchen social club. Madden had not pulled the trigger, but he orchestrated the hit. In 1915, he was put on trial and convicted for his role in the murder, receiving a sentence of ten to twenty years at Sing Sing prison.

It was a forbidding place, medieval, where death by electrocution was administered by the state. Something happened to Madden while he was at Sing Sing. By the time he was released in 1923, after serving eight years and being released early for good behavior, the world had changed. Prohibition had been instituted as the law of the land, inaugurating a new era of criminal possibilities. Madden was determined to rise above his previous incarnation as a street thug and killer. His desire was to be a boss, to use his skills as an arranger and facilitator of illegal businesses. In this regard, his connections among the New York Irish became the foundation of his power. There were the Tammany Hall political figures who protected his interests; the cops, both among the department's rank-and-file and its hierarchy, who acted as his business partners; judges, portly, self-satisfied men who had risen from the ranks of ward bosses and assemblymen to become masters of the judiciary, who played the crucial role of keeping Madden's minions—the worker bees in his bootlegging enterprise and other rackets—out of jail and on the street.

By the mid-1920s, after Madden had been out of prison only two years or so, he was the biggest bootlegger in Manhattan. He produced a beer called Madden's No. 1, which, by most accounts, was the best beer in New York, maybe the best illegally produced beer in the entire country. At the Phoenix Cereal Beverage Company, a massive brewery located at 262–266 Tenth Avenue, occupying the entire block between 25th and 26th Streets, Madden's organization churned out enough suds to supply the country's entire Northeast Corridor. The brewery was guarded around the clock by local police.

Madden's success as a bootlegger led to his impressive diversifica-

tion into other businesses. He controlled aspects of the city's laundry business and was a major, behind-the-scenes profiteer in the taxicab industry. He owned Thoroughbred racehorses and a stake in the careers of many boxers. It was said over time he owned a piece of five heavyweight champions. Of all his endeavors, however, none were as prestigious as his role as owner of the Cotton Club.

He bought the place from boxer Jack Johnson in 1923, when it was still called Club DeLuxe. At the time, Owney was still in prison serving the final months of his sentence. Even then, he had a vision of the club's potential as a showcase for his bootlegging ambitions.

Johnson was a dapper former heavyweight champion with a following in the sports world, but he did not have the kind of connections that were needed to keep the booze flowing during Prohibition. Negotiating a deal that allowed him to stay on as a manager, the champ gladly sold the club to an underworld consortium, with Madden as primary owner and, before his murder, Arnold Rothstein as a silent partner.

Having come of age in Hell's Kitchen, a neighborhood that straddled the city's world-renowned Broadway theater district (one of the West Side mob's rackets had traditionally been the control of jobs for ushers and ticket-takers at the theaters), Madden was attracted to show business. One of his best pals from the old neighborhood was George Raft, who, while Owney languished at Sing Sing, had launched a career in the budding movie business as an actor who often played tough guys and gangsters. Raft claimed to have once been a member of the Gophers, Madden's former gang. In an occurrence that was typical of Manhattan's shady, star-studded nightlife of the era, the actor introduced Madden to many motion picture stars, including a fellow up-and-comer named Jimmy Cagney, who later copped to having partly based his on-screen persona on Madden. Raft also introduced the mob boss to bawdy star of stage and screen Mae West, with whom Madden proceeded to have an affair that lasted, on and off, for years. (West referred to Owney as "sweet but vicious.")

Madden devoted much time and effort into developing his new

club. Though the establishment was located in Harlem, at 142nd Street and Lenox Avenue, the mob boss knew that white audiences were becoming fascinated by Negro culture and that jazz was a major part of the attraction. The venue was completely redesigned and christened the Cotton Club, as a paean to an era when whites were in charge and Blacks were viewed as mere supplicants and entertainers.

In 1925, after the new club had been in operation for two years, it was raided and shut down by federal Prohibition agents. There was a problem having the name of well-known criminals associated with the club. Even the headline in the *New York Times*, citing the federal raids, referred to the establishment as "Owney Madden's club." The place was padlocked for three months and forced to pay a fine before it could reopen. Madden's name was officially removed from the list of owners, but the club remained well stocked with Madden's No. 1, the only beer it sold, and Madden remained a hands-on overseer. He had a penthouse office constructed in the building where the club was located that included, on the roof, a pigeon coop for his sizable collection of birds. Madden had been a lover of pigeons since his upbringing in Hell's Kitchen, where he flew the birds from tenement rooftops.

It is tempting to view the overheated aesthetic prerequisites of the Cotton Club as a metaphor for the relationship between jazz and the underworld. The club's décor was based on a plantation motif designed to evoke a racial caste system from the antebellum South. Black bodies were fetishized in the club's fantabulous stage shows, with dancers both male and female in skimpy costumes, in dance numbers that were lusty and sexually explicit. The dominant theme was one of jungle exotica. The Cotton Club's admission policy was mostly Jim Crow: Black patrons were not allowed into a club where the overwhelming majority of stage performers and musicians were African American. There were exceptions: Black celebrities were allowed in, but they were usually seated at a table near the kitchen that was reserved for family members of the performers.

As regressive as this may have been, Madden's Cotton Club was

not the only venue in Harlem to institute such a policy. The Exclusive Club, owned and operated by Baron D. Wilkins, a Black man, also denied entry to everyday Black folks. Wilkins's club was still in operation when the Cotton Club opened, and it continued with its exclusionary door policy right up to the day Wilkins was murdered and the club ceased to exist. The Cotton Club, on the other hand, did eventually change its policy and allow Blacks to enter, though not many could afford the club's $3 admission fee (close to $50 today), nor its steep prices for food and drinks.

Where the Cotton Club excelled was in its status as an unparalleled showcase and source of opportunity for African American singers, dancers, and jazz musicians. By the late 1920s, the club was firmly established as the pinnacle for cabaret entertainment during the Jazz Age. Extravagant musical revues opened at the club twice a year, with newly minted dance numbers and songs written and composed by the best in the business. For a Black entertainer to be employed at the Cotton Club, whether a local Harlemite or young showgirl or jazzman from the hinterlands, was akin to being signed by the New York Yankees. You had reached the top of your class.

Said Carolyn Rich Henderson, who was employed as a showgirl at the club, "It was a real distinction to belong to the Cotton Club line . . . Wherever you went, people pointed you out as the highest type of glamor."

"If you were a Black person," said singer-pianist Bobby Short, "that was a very, very important gig to get." Born and raised in the Midwest, Short attested to the club's far-reaching reputation. "As colored people in Illinois, all we dreamed about was New York and the Cotton Club. That was glamor."

Not everyone was enamored with the place. In his autobiography, Harlem native and legendary poet Langston Hughes wrote:

White people began to come to Harlem in droves. For several years they packed the expensive Cotton Club on Lenox

Avenue. But I was never there, because the Cotton Club was a Jim Crow club for gangsters and monied whites. They were not cordial to Negro patronage, unless you were a celebrity like Bojangles. So Harlem Negros did not like the Cotton Club and never appreciated its Jim Crow policy in the very heart of the dark community. Nor did ordinary Negros like the growing in-flux of whites toward Harlem after sundown, flooding the little cabarets and bars where formerly only colored people laughed and sang, and where now the strangers were given the best ring-side tables to sit and stare at the Negro customers—like amus-ing animals in a zoo.

To many who worked at the club, the gangsters who owned and ran the place (co-owner George "Big Frenchy" DeMange was a criminal partner of Madden's; and Herman Stark, the floor manager, effectuated the persona of a cigar-chomping thug) were not much different from the owners and managers at other clubs. Where things sometimes became sticky was when a popular entertainer tried to leave the club.

Lena Horne had just turned sixteen when she was hired as a chorus girl at the Cotton Club. Nobody knew she could sing until she was called on to fill in for another singer who had fallen ill. Later, Horne ad-mitted that she wasn't very good ("I couldn't carry a tune in a bucket," she said), but she was strikingly beautiful, and she was a hard worker. Within two years she had improved enough as a songstress that she was singing solos at the Cotton Club and was hired to sing in a Broadway show.

Her exposure to Broadway made her believe that she had a future beyond the club as a jazz singer. She was offered a job to front the band of Noble Sissle, who had a major hit with the Broadway revue *Shuffle Along*. Though Horne was only eighteen, she was ready to leave the club that the press routinely referred to as "the Aristocrat of Harlem," but the club was not ready to let her go. She was told by a manager, "Nobody leaves the Cotton Club until we say so." When Horne's agent

stepped in to argue her case, "they got nasty," she remembered years later. "They beat him up . . . They dunked his head in the toilet and threw him out." A former dancer at the club, Howard Johnson, recalled that Horne's stepfather was "beaten unmercifully" when he once "took issue when the mobsters refused to raise Lena's pay" of $25 a week.

Horne did leave the club, but it wasn't easy. Her stepfather and mother had to take emergency measures. "Actually, they had to kidnap me," Horne remembered. "When we wanted to leave, we literally had to flee in the night."

For some, the Cotton Club was the greatest show on earth. For others, it was a gilded cage.

Harlem Nocturne

What made the place was the music, and the man who made the music was Duke Ellington. The young composer and pianist had been play-ing with his band, The Washingtonians, at a basement venue in Times Square called the Kentucky Club. He was well known in Harlem, where he'd been living and playing at rent parties and cutting sessions since his arrival from Washington D.C., where he'd been born and raised in relative middle-class comfort. Ellington adored Harlem, its people and its ways, and his commitment to its cultural development would become an essential element of what became known as the Harlem Renaissance.

When the Fletcher Henderson Orchestra moved on from the Cot-ton Club in 1927, the club's musical director, Jimmy McHugh, scoured the city for a replacement. He liked what he saw with Ellington, who was not only a skilled composer and gifted pianist with a top-notch band, but exhibited a debonair personal style that was perfect for a club that prided itself on presentation. After an audition at which Owney Madden had to be convinced that the sleek Washingtonian was the right man for the job, Ellington was hired.

He had a slight problem. The very night that Duke and his band

were scheduled to debut at the Cotton Club, they were already booked at the Standard Theater on South Street in Philadelphia, playing in a vaudeville show. The producer of the show, Clarence Robinson, refused to release Ellington from his obligation. Madden took control of the situation. He called Maxie "Boo Boo" Hoff, a powerful bootlegger in Philly who frequently did criminal business with Madden. The Cotton Club owner explained the situation to Hoff and stressed that it was urgent. Hoff sent a number of his underlings to visit Clarence Robinson. One of them—Yankee Schwartz, a former light-heavyweight boxer— told the producer, "Be big or be dead." Robinson released Ellington from his booking.

The bandleader and his men made their debut at the Cotton Club on December 4, 1927. The music unleashed at the club by Duke Elling-ton and his orchestra was a revelation. For years, Ellington had been studying and playing every form of jazz that had come down the pike. He was also an aficionado of symphonic and classical music from Eu-rope. It was Ellington's contention that jazz, as amazing as it was, had not yet reached its fullest capacity, not only musically but also as an ex-pression of what W.E.B. Du Bois referred to as "the Souls of Black Folk."

Part of it had to do with creating an aural palette for the music that was unprecedented. Incorporating wah-wahs and trumpet growls, along with soaring passages of ethereal beauty, then abruptly descend-ing into eight bars of knowing, bawdy gutbucket blues, Ellington was inventing a form of jazz that was a summation of everything that came before and, yet, was entirely fresh. Songs like "The Mooche," "Creole Love Call," and "Black and Tan Fantasy" were characterized as "jungle music" (some contend that George Gershwin, who was a huge fan of Ellington's, coined the term), but really Ellington's compositions were multilayered. He wasn't just creating music *from* the underworld, he was making music that commented *on* the underworld—music that reveled in the rapscallion nature of human beings vastly enjoying their time in Sodom and Gomorrah, while he, the artist, brought meaning to the current condition through his art.

Mostly, this was a result of Duke's hard work and talent, but there was something else. Black intellectuals like Langston Hughes may have resented the incursion of whites into Black culture, but Ellington realized that what whites wanted from jazz (at least hip whites, not those who listened to the Paul Whiteman Orchestra and other watered-down versions of the music) was not that different from what Black audiences wanted: music that reflected the joy, naughtiness, and pain that came from the blues and represented a deeper reflection on the African American experience. In other words: authenticity.

When the great blues and jazz singer Ethel Waters, the product of a mother who was raped while still a teenager, stood on the stage at the Cotton Club and sang "Stormy Weather," no one doubted that she plumbed the depths of her soul to express the pain of her people. It may have been to an overwhelmingly white audience, but onstage what transpired was something transcendent: a Black artist from the humblest of circumstances making the most of a golden opportunity to create art—an American form of art—that reached for the heavens. For all its many failings and transgressions, the Cotton Club provided this moment. Ellington, for one, was not about to waste such an opportunity. The music he performed at the club reached deeper and deeper into his genius, until, in 1930, he published an essay that expressed ideas that were the culmination of his time at the Cotton Club.

> The music of my race is something more than the "American idiom." It is the result of our transplantation to American soil and was our reaction in the plantation days to the tyranny we endured. What we could not say openly we expressed in music, and what we know as "jazz" is something more than just dance music . . . The characteristic melancholy music of my race has been forged from the very white heat of our sorrows.

Ellington went on to explain that he was working on a project (which would eventually become "Creole Rhapsody") that would

chronicle the history of his race in sound, explaining that he was "en-
gaged on a rhapsody unhampered by any musical form in which [the
intention is] to portray the experiences of the colored races in America
in a syncopated idiom." The work, he added, would consist of "four or
five movements . . . I am putting all I have learned into the hope that
I will have achieved something really worthwhile in the literature of
music, and that an authentic record of my race *written by a member of it*
shall be placed on the record."

All of this while working for gangsters.

Of course, the music did not take place in a vacuum. Making a
living by working in nightclubs involved all the close calls and compli-
cations for Ellington as it had for Armstrong, Earl Hines, Mezzrow, and
all the other musicians of the era. In his entire career, Ellington rarely
spoke of the hoodlums for whom he worked over the years. It may have
been a product of his discreet nature, or an understanding of the pop-
ular street dictum, later crystalized by the Irish poet Seamus Heaney:
"Whatever you say, say nothing."

In Ellington's charming though elusive memoir, *Music Is My Mis-
tress* (published in 1973), he offered an explanation:

> The episodes of the gangster era were never a healthy subject
> for discussion. People would ask me if I knew so-and-so. "Hell
> no," I'd answer. "I don't know him." The homicide squad would
> send for me every few weeks to go down. "Hey, Duke, you didn't
> know so-and-so, did you?" they would ask. "No," I'd say. But
> I knew all of them, because a lot of them used to hang out in
> the Kentucky Club, and by the time I got to the Cotton Club
> things were really happening!

Sonny Greer, the drummer in Ellington's orchestra at the Cotton
Club, was not nearly as reticent as Duke. Years later, removed from the
era by decades, he told an interviewer, "I keep hearing about how bad
the gangsters were. All I can say is that I wish I was still working for

them. Their word was all you needed. They had been brought up with the code that you either kept your word or you were dead."

Greer remembered Madden coming into the club and treating Ellington like royalty. "[Madden] loved Duke because him and Duke used to sit up and play 'Grits' and all that, 'Coon Can' all night long. He loved Duke and he loved me."

By 1931, Ellington was a major star. Partly this had to do with the fact that shows from the Cotton Club were broadcast live over the radio all around the United States. This level of notoriety made Ellington famous, and fame brought its own set of entanglements. There were rumors that Mad Dog Coll, the reckless Irish hoodlum who had kidnapped the Harlem numbers king Casper Holstein, was going to kidnap Duke Ellington and hold him for ransom. Madden assigned round-the-clock protection for his prized bandleader. "There was this guy, he was Duke's bodyguard," said Barney Bigard, a clarinetist in the Ellington orchestra. "He'd go get Duke from the theatre with his machine gun between his legs, and they had bullet proof glass [on the cars]. You see, there were competing factions . . . They had to protect their men from each other."

Whether or not Ellington appreciated the bodyguards is not known; he never spoke about it. What is known is that, later in 1931, after the Ellington orchestra had moved on from the Cotton Club to make a name for itself in Hollywood, the tradition of assigning gunmen to protect prized talent remained. The club took care of its own.

Singer Cab Calloway and his orchestra took over from Ellington as the house band. Calloway was not a musical genius like Duke, but, with his zoot suits, big cartoon smile, and hipster patter, he was a tremendous entertainer. His hit "Minnie the Moocher" became a theme song at the club. Calloway understood the game. He knew the place was owned by gangsters, but he could never get used to the club's policy of insisting on armed protection for the bandleader. He remembered one night at the club: "Four guys were sitting there with their coats and hats . . . from the mob. Wide-brimmed hats, long cloth coats, one of them had on shades. They were all white guys. I tried to be cool but

inside I was scared to death." He added, "The mob didn't play games. They were for real."

My Buddy

For a musician, there were multiple ways to handle the reality of gangsters in their midst. One way was to simply stay away from the hoods. To an extent, this was possible. A star performer like Ellington or Calloway might need to be protected, but, for the most part, the musicians went their way and the gangsters went theirs. Some musicians, like Sonny Greer, saw the situation as an opportunity. Born in New Jersey and raised in New York, Greer, in addition to being a consummate drummer, was a pool hustler, heavy drinker, and something of a street character himself. Greer enjoyed the presence of hoodlums in the nightclub realm; he saw it as a challenge and a chance to augment his $45 a week salary. "Any time we needed a quick buck," he said, "we would push the piano up next to the table of the biggest racketeer in the joint. I would then sing 'My Buddy' to him . . ."

> Nights are long since you went away
> I think about you all through the day
> My Buddy, my buddy, no buddy quite so true
> Miss your voice, the touch of your hand
> Just long to know that you understand
> My buddy, my buddy, your buddy misses you

"I never remember getting less than a twenty-dollar tip for such an easy five minutes work," said Greer.

The problem was, the relationship could be treacherous. You might think a gangster was your buddy, which might be the case in the conviviality of a nightclub; but when it came to business, as Cab Calloway put it, the mob didn't play.

Calloway knew from whence he spoke. For much of his career, he'd

been around gangsters. Born in 1907, he came of age at the dawn of Prohibition. As a teenager growing up in Baltimore, he started out singing in speakeasies like the Gaiety, which was located next to a burlesque house. "Baltimore at that time was one of the centers of jazz," he noted. Young Cab was mixed race, handsome, and outgoing. With his straightened, slicked-back hair that flopped around when he sang, the ladies loved him. He understood that in the intersection between jazz the music and jazz the business, musicians and gangsters operated side by side. Even if this did occasionally make him uncomfortable, he accepted it as a fact of life.

In the mid-1920s, while still in his teens, Calloway traveled to Chicago and was booked for a period of time at the Sunset Cafe, the club famously owned by Al Capone and managed by Joe Glaser. Calloway became the house singer at the Sunset, belting out popular tunes like "St. James Infirmary" and "Bye Bye Blackbird." It was there that he first met Louis Armstrong, who was getting ready to make the move to New York. Armstrong suggested to the singer that he should try his luck in the Big Apple as well.

By 1930, even before he formally succeeded Duke Ellington as house bandleader at the Cotton Club, Cab had been playing there on a semi-regular basis. As Ellington's group became more famous and was occasionally called on to play at benefits and in motion pictures, Calloway and his band would fill in. He got along just fine with Madden, DeMange, Stark, and company because he never challenged their authority. "These guys liked me. I was loose and open and from the streets. I could drink and swear with the best of them, and I loved women and a good time. We got along well. And I never meddled in their business. They would have meetings at the Cotton Club with mobsters from all over New York and the place would be guarded like Fort Knox. I'd be around there, but I'd mind my own business. I kept my mouth shut and my nose clean, as we used to say in those days."

Calloway also never challenged the racial regulations of the day. Decades later, in the aftermath of the civil rights struggles in the 1960s,

he was sometimes called upon to explain how he and other Black enter-tainers were able to accept such an onerous system. Calloway was un-apologetic. "Some of the proudest Negro musicians in the world played there and adhered to that policy of racial separation. The money was good, the shows were fine, and the audiences and the owners respected us and our music. What else can I say about it? I don't condone it, but it existed and was in keeping with the values of the day. It couldn't hap-pen today. It shouldn't have happened then. It was wrong. But on the other hand, I doubt that jazz would have survived if musicians hadn't gone along with such racial practices there and elsewhere."

Though his relationship with management was always cordial, if Calloway believed this accorded him any kind of special sway with the bosses, he was wrong. He learned as much in 1930, when he contracted with a brand-new Harlem club called the Plantation to be their open-ing act.

A survey could be done of the number of jazz clubs around the United States in the 1920s and 1930s called the Plantation—or, for that matter, the Cotton Club. There were at least three Cotton Clubs: the original Harlem outpost, one in Chicago (owned and operated by Ralph Capone), and Frank Sebastian's Cotton Club in Los Angeles. There were probably twice that many Plantation Clubs around the country. Clearly, there was something about the days of the antebellum gentry, with Blacks catering to the whims of a white ruling class, that seemed to fit the economic dynamics of jazz, capture the imagination of underworld club owners, and titillate white audiences.

Located at 126th Street near Lenox Avenue, the Plantation Club had been launched to capitalize on the success of the Cotton Club, which was farther north. Rumor was that the club was being partly fi-nanced by a consortium of African American numbers bosses, includ-ing Madam Stephanie St. Clair and Bumpy Johnson. Calloway was so proud to be the opening entertainment at the new club that it never occurred to him that, by taking the gig, he was flying in the face of Owney Madden and his crew.

"The Plantation was [designed to be] a fine, fine place. It would hold about five hundred people, the same as the Cotton Club. It was made up like an old southern plantation, with slaves' log cabins and so forth, just like the Cotton Club. The show was to be a big revue. Man, the Plantation Club was going to be something . . . [The club] was ready. I was ready. The band was ready. We had our last rehearsal in the club the afternoon before the show was to open. Then we left the music on the bandstand and all went our separate ways to get some rest for the evening."

It was a night that Calloway would never forget:

That evening . . . I got dressed to come down to the Plantation Club . . . I got into my old Studebaker and drove down Lenox Avenue. As I approached the corner of 126th Street and Lenox, I noticed there was a lot of commotion out on the street. Firetrucks were there, and police cars and a huge crowd. I parked the car a couple blocks away and pushed my way through the crowds. As I broke through, I saw strewn all over the sidewalk, cracked and broken and shattered, the Plantation Club's lovely bar. All the windows of the club had been broken, and pieces of half the tables and chairs were on the sidewalk. My heart sank, because as soon as I saw the wreckage, I knew what had happened.

Inside the club, the damage was even worse:

There had been mirrors on all the walls, but now they were smashed to smithereens. Somebody had taken an axe to the tables and chairs. The hanging chandeliers had been pulled down and smashed . . . What had happened was simple. In typical gangland style, the owners of the Cotton Club had made sure they wouldn't have the Plantation Club for competition after all. And they were successful. The club never opened.

Not long after that, Calloway got a call that Big Frenchy DeMange wanted to see him at the Cotton Club. Calloway's first instinct was to be concerned. If they smashed up the Plantation Club, what might they do to him? When he got to the club that day, he was startled when DeMange offered him the prized position of house band that had just been vacated by Duke Ellington.

Calloway was relieved but also chastened. He learned a valuable lesson that day, one that had been learned in Chicago by Joe E. Lewis and was learned by many other jazz musicians throughout the land, especially those who were dependent on nightclubs for work.

The mob could build you up, or they could tear you down. They might give you a break or break your legs. Having gangsters as your "buddy" could be beneficial, but it was also illusory. It was best not to kid yourself: First and foremost, the plantation master had his own interests in mind, not yours.

The Dotted Line

On December 5, 1933, the "Noble Experiment" came to an end. With ratification of the Twenty-First Amendment by the U.S. Congress, all Prohibition-era statutes relating to the sale and manufacture of liquor were officially repealed. It was a major modification in the psyche of a nation. What this meant for jazz musicians was uncertain. Literally overnight, thousands of speakeasies went out of business, though some made the transition from being an illegal venue to being a legitimate, tax-paying bar or club. Whether or not jazz bands, or live music, would continue to be such an integral part of the urban landscape remained to be seen.

For the mobsters, it was apparent that some things were going to change. The most profitable single racket the underworld had ever known had been taken away from the massive bootlegging organizations that had made it all so profitable. There was bound to be a shifting

of power within criminal structures in the nation's major cities. This became apparent fairly quickly.

On October 23, 1935, twenty-two months after repeal, Dutch Schultz was gunned down in Newark, New Jersey, at the Palace Chop House, a restaurant where he frequently dined with his inner circle. Unlike Owney Madden, who was admired and even revered by some, the Dutchman was, by and large, a reviled figure. He had become the enemy of Madam Stephanie St. Clair, Bumpy Johnson, and other numbers bosses in Harlem, where he had amassed much of his fortune. Mafia leaders in New York became concerned about Schultz when he threatened to kill District Attorney Thomas E. Dewey. Smart mob bosses knew that to kill a legitimate, high-profile law-enforcement personage like Dewey would bring down an unprecedented level of heat from government authorities. This would be highly detrimental given that the mob was currently in such a precarious state of transition. The forces of organized crime could not risk such a destabilizing event in these uncertain times. A loose cannon like the Dutchman had become a major threat to their existence. He had to go.

It was clear from the nature of the killing that it had been a well-planned hit. Schultz had been set up by members of his own organization. He was shot numerous times in the men's room of the restaurant, then he stumbled back into the dining area, slumped in a chair, and leaned face-first onto the table. His gray fedora tipped from his head, and blood from his wounds leaked out onto the white tablecloth.

A photo of Schultz, taken by a police photographer, was reproduced in newspapers in New York and all around the world. It is one of the most iconic images in the history of organized crime, Schultz having collapsed as if he were already dead, though he would be rushed to the hospital and live for another twenty-four hours before being declared deceased.

It is nearly impossible to calculate the number of people who may have seen this image, but one person who likely did see it on the front page of a newspaper was Louis Armstrong.

Satchmo had a particular interest in Dutch Schultz. A few years earlier, when the trumpet master was threatened by gangster Frankie Foster in the dressing room of a Chicago nightclub, the mob boss who had instigated that encounter was the Dutchman. Armstrong had reneged on a contract he signed with Connie Immerman, proprietor of Connie's Inn. Everyone knew that Connie's Inn was a Schultz-controlled establishment. Schultz had bankrolled the club, and he exclusively supplied the booze that kept the place wet during Prohibition. Also, the mob boss had taken an unduly meddlesome interest in the musical revues at the club, along with playing an active role in determining which musicians were hired and fired.

At the time, Armstrong never did return to Connie's Inn, as Frankie Foster had threatened that he must. Instead, after contesting the matter with the American Federation of Musicians, which he had come to believe was in the pocket of manager/hoodlum Tommy Rockwell (and, by extension, the pocket of Dutch Schultz), Armstrong left the country. Essentially, he went on the run. For two years, the most renowned jazz musician in America lived in exile in Europe, partly because he believed his life was in danger back in the States. Armstrong lived in London and Paris and toured in Scandinavia, where he was adored in Copenhagen and Stockholm. In early 1935, he returned to the United States, but he lay low for months, hardly performing anywhere. His career was in flux. He lived quietly with his old pal and muggles dealer Mezz Mezzrow in an apartment in Jackson Heights, Queens.

For Satchmo to reemerge, he knew what he needed: muscle.

At the time, Dutch Schultz was very much alive. And even though Prohibition had come to an end, Armstrong knew that the business of jazz was not likely to change. Gangsters still owned the nightclubs, and the managers, agents, lawyers, and record company impresarios who wrote the contracts were still a bunch of hoodlums.

And so Armstrong fired his current manager, Johnny Collins, and reached out to the only man he felt could save him: Papa Joe Glaser.

More than a decade had passed since Glaser first insisted that Arm-

strong's name be put up in lights on the marquee at the Sunset Cafe. Al Capone had objected, but Glaser insisted, which made him Big Daddy Number One to the budding jazz star. Since at least 1927, when Glaser was charged with bootlegging and indicted twice for statutory rape, his career had stalled.

More recently, in April 1935, he was again charged with a crime: receiving stolen liquor in connection with his interests in various mob-controlled nightclubs in Chicago and New York.

Years later, when Glaser and Armstrong recounted how they reunited after a decade apart, they told different versions. Said Glaser, "When Louis came back from England, he was broke and very sick. He said, 'I don't want to be with anybody but you. Please, Mister Glaser, just you and I. You understand me. I understand you.' And I said, 'Louis, you're me, and I'm you.' I insured his life and mine for one hundred thousand dollars apiece. Louis didn't even know it. I gave up all of my other businesses, and we [became a team]."

Armstrong remembered it another way: "I could see he was down and out. He had always been a sharp cat, but now he was raggedy ass. I told him, 'I want you to be my manager.' He said, 'Oh, I couldn't do that. I'm stony broke.'"

However it transpired, the two men were partners once again. They signed a contract that gave Glaser full control over Armstrong's career.

One of the first things Glaser did as Armstrong's manager was to audaciously book him for a four-month engagement at Connie's Inn.

It wasn't exactly the Connie's Inn of old. The club had moved from its Harlem location to Times Square (as would the Cotton Club a few years later). The Immerman brothers had divested and were no longer involved. But, still, it was Connie's Inn, where Satchmo's management problems had begun. Symbolically, the venue had significance.

When Glaser made the booking in September, Schultz was still alive. There were rumors that he was on the outs with the Combine. With his underworld contacts, Glaser may have been privy to these rumors. Even so, to book Armstrong at Connie's Inn was a major statement.

The engagement was scheduled to begin on October 29. With just days to go before opening night, across New York Harbor in Newark, the Dutchman was eliminated.

Already, the horn player's return to this particular venue was an act of liberation; now it was a celebration. One of the first songs he sang that night was his recent hit "I'll Be Glad When You're Dead You Rascal You."

For Joe Glaser, the night was a triumph. After years in the wilderness, he was back as a force in the music business. Armstrong adored the man, but not everyone agreed. His reputation was problematic. Max Gordon, owner of the Village Vanguard, which had opened a few years earlier, said of Glaser, "He was the most obscene, the most outrageous, and the toughest agent I've ever bought an act from." George Avakian, a producer at Columbia Records, said, "Joe was a professional tough guy. He put on a very tough front. He was a tough man and he believed in being pretty abrupt with people because that's how he got things done." Said George Wein, producer of the Newport Jazz Festival, "Joe Glaser had the wonderful ability to lie with total impunity. You know, there aren't many people who can do that. Joe Glaser didn't care what he said."

To Armstrong, this all would have been music to his ears. As he sought to reenergize his career, this, he felt, was what he needed. Since his youth in New Orleans, he'd come to believe that jazz and the underworld were intrinsically bound together. Joe Glaser may no longer have been a partner of Capone's, a pimp, pedophile, rapist, and racketeer, but he still had what was a necessary requirement to be an effective player in the jazz business: He still had the instincts of a gangster. Satchmo was depending on it.

PART TWO
FLATTED
FIFTH

8

THE CROONER

As a teenager living with his parents in Hoboken, New Jersey, Francis Albert Sinatra had a bad case of hero worship. Unlike many of his friends who worshipped athletes or political figures, the person Sinatra admired more than any other was a singer. This was not entirely surprising. After flirting briefly with the idea that he might want to become a sportswriter, Frank began singing at the age of sixteen. He was not yet a professional, but he showed promise. He had become an informal student of contemporary vocalists. Like many people who were listening to jazz and popular music on the radio and on records in the 1930s, Sinatra found his attention most captured by the singer Bing Crosby.

At the time, Crosby was the biggest recording star in America. He could not have been more different from Sinatra. Born in Tacoma, Washington, and raised in Spokane—a long way from Hoboken—Bing had a temperament that was "fine and mellow," as Billie Holiday used to sing. Crosby had revolutionized singing in America through his understanding and use of the microphone. Gone were the days when an Irish or Italian tenor needed to project his voice all the way to the back of an auditorium. Bing brought intimacy and a melodic, soothing baritone to his interpretations of such jazz tunes as "Someday Sweetheart," made famous by Jelly Roll Morton, and "Ain't Misbehavin'," by Fats Waller and Andy Razaf.

The person Crosby worshipped most was Louis Armstrong, whom he first saw perform at the Sunset Cafe in Chicago. What he loved most was Armstrong's singing style, which he described as "pure jazz." Crosby revered Armstrong, and Sinatra revered Crosby. And the trajectory of jazz vocals in the United States would never be the same.

What Sinatra likely did not know about Crosby was that he had a history with hoodlums. From the time of his earliest solo successes in the early 1930s, Crosby had frequently been extorted by gangsters. Especially after he began starring in movies in 1932, Bing was a target. In Chicago, where the singer often performed, gangsters would show up at his dressing room and demand payments in the thousands of dollars. Crosby later reported these extortions to the FBI, but still they persisted. Finally, he turned to his manager, Jules Stein, founder of MCA. Stein was from Chicago and known to have had intimate dealings with the Capone syndicate in its heyday. Stein knew exactly whom to turn to find out what was going on: Machine Gun Jack McGurn. Stein arranged for Crosby and McGurn to meet.

McGurn had come a long way since his days as part owner of Green Mill, the North Side club from which Joe E. Lewis walked away, resulting in his near-death experience at the hands of Momo Giancana and two others. It was McGurn who had orchestrated that attack. In recent months, as his boss, Al Capone, became enmeshed in a tax-evasion case that would ultimately land him behind bars, McGurn had emerged as a possible heir apparent. There were few mobsters in Chicago more notorious than Machine Gun Jack McGurn.

Crosby likely knew nothing about McGurn's involvement in the brutal assault on Lewis. The incident was well known among showbiz people, but the perpetrators had never been identified. Crosby probably did know that McGurn was rumored to have engineered the infamous St. Valentine's Day Massacre. That had been reported in newspapers, though the mobster was never charged with the crime.

Was Crosby concerned about meeting with a famous mobster? Who knows? But if he wanted to stop his ongoing ordeal at the hands of un-

derworld extortionists, he would have known that he was meeting with the right man.

McGurn met Bing backstage at the Chicago Theater on Wabash Avenue. He was sympathetic to the singer's predicament. They devised a plan to bring a halt to the extortions. One night after Crosby's show at the theater, McGurn hid in his dressing room. Two thugs arrived to extort Crosby and were startled to encounter McGurn. An informant later told the FBI: "They knew very well who Jack was and what they were in for. Jack beat the shit out of them and then threw them out into the back alley, which borders the dressing room." The extortions immediately ceased.

Crosby was appreciative; he felt that he owed McGurn a return favor.

"What can I do to repay you?" the singing star asked the gangster.

"Well," said Jack, "I hear you like to play golf. So do I. How 'bout we play a round together?"

Crosby agreed. They met and played golf at Chicago's Evergreen Country Club—not just once but numerous times. Bing seemed to be fascinated with the hood, who was a snazzy dresser. The two men—the singer and the gangster—were drawn to one another. They continued to meet until someone informed Crosby, "You know, Bing, you really shouldn't be paling around with one of the most famous gangsters in Chicago. If word gets out, it might not be good for your image."

Crosby cut all ties with McGurn, who was murdered less than a year later, gunned down in a bowling alley on the South Side.

Frank Sinatra also had dealings with the underworld. Unlike Crosby, Sinatra was born into a world where hoodlums and mafiosi were literally just around the corner. It some ways, this would come to define his career in music.

In later decades, much would be written about Sinatra's relationships with mafiosi. Some journalists and commentators would go so far as to claim he was a "made man." Sinatra himself would deny everything, even stories that were corroborated by witnesses or actual participants.

As is the case with most controversies or tall tales, the truth was far more interesting than either extreme.

On December 12, 1915, when Frank Sinatra was pulled from his mother's womb, Hoboken was euphemistically known as "Guinea Town." A teeming waterfront enclave across the Hudson River from Manhattan, the place was crawling with Italian immigrants, one of whom, Marty Sinatra, had arrived from Sicily just twelve years earlier. He was nine years old at the time and spoke no English. Nine years later, he met Dolly Garaventa, whose people were from the north of Italy, near Genoa. The two eloped and were married at City Hall in Jersey City.

Not long after Frank was born, Marty and Dolly opened a bar in Hoboken on the corner of Jefferson and 4th Streets. They called the bar Marty O'Brien's. This was the name the elder Sinatra had fought under during his short-lived boxing career. In the early twentieth-century urban pecking order, it seemed the Italians were always following after the Irish; it was advantageous to have a Celtic surname, both in boxing and the bar business.

In the underworld, things were different. Hoboken was a mafia town, though the surrounding region was controlled by a powerful Irish political machine lorded over by a boss named Frank "I Am the Law" Hague.

Young Frank Sinatra was an indifferent student, though he had a sharp mind, a feel for the streets, and he liked to perform. Sometimes, as a youngster, he was hoisted up onto the bar at Marty O'Brien's where he belted out a tune. It was all in good fun. No one expected that young Frank might one day view music as a career path. His mother, who was domineering and a force of nature, did not encourage his fascination with Bing Crosby. She wanted her only child to be a doctor or a civil engineer. Instead, in his late teens, Frank put together a local band and began singing at community events like school dances, Democratic Party meetings (his mother was politically active), and at the Hoboken Sicilian Culture League.

The mafia was a visible presence. This was long before the onset of what came to be known as "la cosa nostra," a highly structured national syndicate that allegedly elected presidents and then had them killed. There were no movies or television shows in which the country's most charismatic actors played mafiosi as men of honor to an audience of millions. The mafia existed as a small, mostly localized tribe, as it had in Sicilian villages where it had gotten its start. It did exert considerable local influence in matters of business and social advancement. Mafia thugs did break legs and kill people. Some Italian immigrants convinced themselves that the mafia was nothing more than a benevolent association with muscle. Just as the Irish used the civil service—the police and fire departments—to rise up out of the ghetto and get ahead in life, Italians, it was argued, used the mafia to help them out when it was needed.

Of course, the mafia had another purpose. The dirty little secret of the American Dream was that violence was an integral part of social advancement. The control and punishment of slaves and the eradication of indigenous populations are two notable examples. Labor struggles and myriad aspects of American commerce were also sometimes bloody. The mafia was predicated on this propensity for violence. And not always for business reasons. Sometimes the mafia used violence for something more primal: revenge.

Once it became clear that the skinny kid from Hoboken was determined to be a professional singer, Dolly Sinatra directed her considerable powers toward helping him out. Her role in the area as a paid abortionist ("midwife" was the more discrete term) brought her into the orbit of the underworld. Abortion was illegal and a sin. In a Catholic city like Hoboken, this meant that the procedure had to be carried out in secrecy, and with the utmost discretion. Neighborhood mafiosi sometimes played the role of arbiters and facilitators in these transactions. Everyone knew "Hatpin Dolly," as some called her, and they would come to know Dolly's kid, who had big dreams of making it in show business.

Sinatra's big break came at the Capitol Theater in Manhattan, where, at the age of nineteen, he performed as part of a group called the Hoboken Four. They were performing as part of the *Original Amateur Hour*, which was broadcast live around the country. Those who heard Sinatra's voice on the radio recognized that the kid had something special. He was copying Crosby, his idol, as was just about every young singer in America at the time. His crooning was decent, but, more important, he had a sincerity in his singing as if he truly believed the lyrics. He was a storyteller, a talent he would perfect over the years until he was arguably the greatest that ever was.

At the Capitol Theater, it was clear that Sinatra had something else going for him. Though he was part of a quartet, when Sinatra stepped forward to sing a solo, the young girls in the theater went crazy. Nobody had seen anything like it. It wasn't that he was blindingly handsome. He was cute, certainly, but he had acne scars, and he had the kind of metabolism that made it difficult for him to keep on weight. He was so skinny that his bandmates often made fun of him. And yet, apparently, he had some kind of dreamy quality that made the girls swoon. He was vulnerable and approachable, and there was an air of romance to his singing and his persona that would, in the years ahead, lead young women to take off their panties and throw them onto the stage.

It was heady stuff for the relatively unsophisticated kid from Hoboken, and it would soon get him into trouble.

In November 1938, at the age of twenty-two, Sinatra was arrested on a charge of "seduction." It happened while he was performing at the Rustic Cabin, a club in New Jersey, while sitting with his fiancée, Nancy Barbato, a local Hoboken girl. While Sinatra was on a break, two cops came into the club and cuffed the young singer. The arrest warrant stated that Frank Sinatra, "being then and there a single man over the age of eighteen years, under the promise of marriage, did then and there have sexual intercourse with the said complainant who was then and there a single female of good repute for chastity whereby she

became pregnant." The headline in the *Jersey Observer* read: "Songbird Held in Morals Charge."

The charges didn't stick. For one thing, the woman wasn't pregnant; and she wasn't, in the eyes of the law, "chaste" in the sense that she was—unbeknownst to the judge who signed the warrant—already a married woman.

In the meantime, Frank was held overnight in jail until Dolly posted his $500 bail. Among other things, the charges resulted in a mug shot of Sinatra looking young, handsome, and defiant that would burnish his reputation as a "player" and a friend of the boys.

Later, the charges were reduced to adultery and Sinatra was arrested again, also while performing at the Rustic Cabin. It was beginning to seem like a shakedown or some kind of harassment. Dolly Sinatra took control of the situation. Rumor had it that she applied her political connections—and, perhaps, her familiarity with the local mafia—to convince the judge to dismiss the charges, which the judge did a few months later.

That year, Frank married Nancy Barbato, his childhood sweetheart, and they moved into a house in Hasbrouck Heights, New Jersey. Down the block and around the corner, his neighbor was Willie Moretti, a Hoboken native who had risen to become the mafia boss of North Jersey. Moretti had done time for armed robbery at Elmira Prison in New York State, and he was partner to some of the biggest gangsters in Jersey and the New York area.

He was also a cousin of Nancy Barbato's father. Moretti was literally in the family. Like many Jersey-based "wiseguys," he had taken an abiding interest in Sinatra's career. Rumor was that the mob fronted money to the singer so he could buy clothes and pay for studio space to record. To Sinatra, Moretti was like an uncle—or, more appropriately in this case, a godfather.

In later years, when asked by a reporter if there was any truth to the rumor that the mob helped launch the singer's career, Moretti said, "Well, let's just say we took very good care of Sinatra."

Moretti liked his pasta; he was short and rotund, and he had an outgoing, backslapping manner. He was drawn to the entertainment world. Along with owning a piece of the Rustic Cabin, where Sinatra performed, he was the mafia's point man at Ben Marden's Riviera, a prestigious casino-nightclub in Fort Lee, New Jersey.

It became second nature for Frank to fraternize with the likes of Willie Moretti. He was comfortable with the wiseguys, and they were comfortable with him. Some noted that, over time, Frank began to adopt their ways.

In June 1939, Sinatra joined the Harry James Orchestra as a vocalist. It was a major step forward in his career. He traveled with the band to perform in cities all around the United States. He was making a name for himself, but soon Frank became frustrated with the James band's arrangements. The music wasn't jazzy enough, and Sinatra became bored. In January 1940, he split with Harry James and signed as vocalist with the orchestra of jazzman Tommy Dorsey.

The Dorsey orchestra was more to Sinatra's liking. Since launching his career, Frank had become convinced that he was, first and foremost, a jazz singer. This became apparent to Sinatra when he first saw Billie Holiday singing at a small jazz club on 52nd Street in Manhattan. Holiday's style of singing was a revelation. She didn't have the best voice, in a technical sense, but she sang the lyrics of a song as if she was telling you about her life. She understood the music—not just the formal components, but the emotional potency of jazz and how it related to the lyrical content of a song.

Sinatra told whoever would listen: "Someday I want to be able to sing like that." It seemed as though it was a ways off, but Frank realized that by fronting Tommy Dorsey's band he was one step closer to jazz heaven.

In a way, it did and didn't pan out. With the Dorsey orchestra, Sinatra was launched into the stratosphere as a popular entertainer. All around the country, when he performed, the girls screeched, cried, and

fawned over Sinatra in a way that had never been seen before. "Bob-bysoxers," they were called by the press, meaning teenagers or women in their early twenties who were barely out of adolescence. They lined up around the block to see Sinatra, packed the large theaters where the Dorsey orchestra performed, and, to a large extent, dictated the kind of music the band played. The girls wanted romantic ballads, not swing music, and bandleader Dorsey was determined to give them what they wanted.

Not everyone in the band was pleased. Drummer Buddy Rich, for one, found it dull and unsatisfying. Born and raised in Brooklyn, Rich was two years younger than Frank. He was a drumming prodigy who had fallen in love with jazz, especially swing music, which was the latest craze in jazz. Swing was propulsive, and it was meant to be played loud. At rehearsals, the two men would go at it, confrontations that were exacerbated by the fact that Rich, by most accounts, was an egomaniac; while Sinatra was imbued with the knowledge that he, not Buddy Rich, was the straw that stirred the drink.

One afternoon, while rehearsing at the Astor Theater in Times Square, Sinatra and Rich got into an aggressive shouting match. Sinatra felt that the drummer was attempting to overwhelm his voice. Rich fumed for the same reason he always did: He felt that Sinatra's popularity had derailed the band's ability to play real jazz. Rich called Sinatra a "son-of-a-bitch wop bastard," and Sinatra threw a glass pitcher at the drummer's head, barely missing, with the pitcher shattering against a wall. The two charged each other, wrestled to the floor, and had to be separated.

It was Sinatra who was sent home. "I can live without a singer tonight, but I need a drummer," said Tommy Dorsey.

Sinatra was beside himself with anger; he plotted his revenge.

A few nights after this encounter, on a break between sets at the Astor, Rich went over to Childs Restaurant, which was located near the theater. On his way back for the second set, he felt a tap on his

shoulder and turned around. Before he even knew what was happening, he was being pummeled by two men on the sidewalk. As later reported in *DownBeat* magazine, the bible of jazz:

BUDDY RICH GETS FACE BASHED IN

> New York—Buddy Rich's face looked as if it had been smashed in with a shovel last week as Buddy sat behind the drums in the Tom Dorsey band at the Astor Hotel. No one was real sure what happened except that Buddy met up with someone who could use his dukes better than Rich.

In the months that followed, Sinatra and Rich buried the hatchet and became friends. Two years later, as the singer prepared to leave the Dorsey band, Buddy asked him, "Frank, hey, it's water under the bridge now, no hard feelings, but I'd like to know. Did you have anything to do with me getting beat up that night outside the Astor?"

Sinatra hesitated, then smiled. Yes, he said, he had called on a couple of his "Hoboken pals" to do him a favor and rough up the drummer.

It was not the last time Sinatra would lean on the mob for a favor. And as was usually the case with mobsters, when a favor is extended, it is understood that the favor will one day be repaid.

Sinatra had entered into a relationship that was dangerous and yet enticing. He may have felt his connections to "the boys" gave him an edge in his personal and professional life, but he was playing with fire. As Cab Calloway put it, "The mob didn't play games."

Back East

By the mid-1930s, the relationship between jazz and the underworld was going through a metamorphosis. The Great Depression had settled like a massive nimbus cloud over the country. In the cities where jazz had become a major drawing card for musicians, many of the most famous

nightclubs closed or would be closing in the years ahead. The Roaring Twenties were a thing of the past. And yet, ironically, jazz entered into the most commercial phase of its development, largely because of the emergence of big band jazz and the popularity of swing.

Swing was dance music. It was played on the offbeat, with less emphasis on improvisation and chord changes. Swing was all about the groove. This was not music where you sat and listened; its appeal was that it drew a listener in, got into the bloodstream, and made an audience feel the music in a physical way. Young people loved it, and white social commentators were less likely to denigrate swing than other forms of jazz. It was not played in bordellos or smoky nightclubs; it was played mostly in large ballrooms with big dance floors where people did the Lindy Hop or the jitterbug. In the years before and during World War II, the music was associated with recreation, celebration, and victory.

The era lasted roughly from 1935 to 1946. For Frank Sinatra and other jazz singers, it was a golden era. Most of the major bands such as those led by Benny Goodman, Glenn Miller, Artie Shaw, Ellington, Basie, and others all featured singers, both male and female.

The popularity of swing music trickled down and sustained jazz during this era. As the big bands traveled by bus around the country, playing in ballrooms and large theaters, local jazz scenes were reinvigorated. It was good for jazz, and it was good for the mob—especially in localities where organized crime was already entrenched. This was especially true in the northeastern part of the country, where the underworld had ascended to new heights during Prohibition.

In Newark, jazz was a central aspect of life for many African Americans. In the late 1920s, there developed a teeming district known as Newark's Barbary Coast, populated with street prostitutes, pimps, numbers bankers, and hustlers. Jazz bands were employed in many clubs, most notably the Kinney Club at Arlington and Augusta Streets, which was touted as Newark's version of the Cotton Club.

Most clubs in Newark were under the domain of Italian or Jewish

mobsters. The risks for musicians in Newark were the same as in other cities. Howard "Duke" Anderson was a young pianist in town in the late 1930s. He remembered a time when he forgot to show up for a gig at a club owned by a prominent Newark gangster. "Right then and there, I got the worst whippin' I ever got in my life. They broke my jaw and wrist. I went back to playing, but from then on, I was scared stiff of anyone who looked like a gangster."

Despite threats to the musicians, jazz districts remained viable. Along with Newark, nightclubs generated income for mobsters in Philadelphia, Baltimore, and Washington D.C. These were all cities with growing African American populations, though admissions policies in the clubs remained mostly segregated.

As swing ascended, the music became a central element in another kind of urban setting: resort towns.

Atlantic City, New Jersey, had been a haven for jazz since the 1920s. In May 1929, the music served as backdrop for the most notorious gathering of mob bosses in American history. Under the auspices of local boss Enoch "Nucky" Johnson, bosses from around the country gathered to discuss how they were going to handle the ending of Prohibition, which appeared imminent. Present at this conclave were Al Capone, Lucky Luciano, Meyer Lansky, Johnny Torrio, Dutch Schultz, Frank Costello, Moe Dalitz, Joe Adonis, Albert Anastasia, Lepke Buchalter, and others. The *Evening Journal* of New York carried a photo of Nucky Johnson and Capone strolling down the Boardwalk together.

Atlantic City was especially well suited for the swing era of the 1930s and 1940s. Many of the ballrooms where the bands played were located inside the hotels where the musicians stayed, which was conducive to drinking and late-night carousing. Numerous clubs thrived in this environment. The Paradise Club was where most of the Black bands played. Clubs on or near Kentucky Avenue, such as Club Harlem and the Wonder Garden, booked some of the biggest names in jazz, including many of the big swing bands.

By the early 1940s, the king of clubs in town was the 500 Café, also

known as the 500 Club or The Five. Located at 6 Missouri Avenue, the club had been around since 1918, but it wasn't until 1942, when it was purchased by Paul "Skinny" D'Amato, that The Five became a mobster hangout and citadel of jazz. The Duke Ellington orchestra, Benny Goodman, Artie Shaw, Count Basie, and many other big bands played the club's main showroom, the Vermilion Room, which seated one thousand people. The Will Mastin Trio (which included Sammy Davis Jr.), Eartha Kitt, and Nat King Cole also played The Five. In a back room at the club was an illegal casino.

The reason all the major jazz performers were drawn to The Five was its owner. D'Amato was the kind of gangster associate who gave gangsters a good name. Smooth and handsome, he dressed and carried himself like a movie star. He had once been convicted for being a pimp, a violation of what was known as the White-Slave Traffic Act. He got caught transporting prostitutes across state lines (New Jersey to Pennsylvania) for the purposes of an illegal act. He pleaded guilty and was sentenced by a judge to one year and a day. He served his time at the Lewisburg Federal Penitentiary in Lewisburg, Pennsylvania.

D'Amato did not hide his hoodlum associations. The 500 Club was a gathering place for prominent mobsters from Pennsylvania, New York, New Jersey, and elsewhere around the Northeast.

Born and raised in Atlantic City, Skinny was a local boy made good. And it wasn't just his role as a club owner and entertainment host that made him popular; he was a relentless booster of Atlantic City. He routinely hosted charity events and made public appearances for philanthropic causes. He practiced the kind of dual morality that was popular with some in the underworld: During the day, he put forth the image of an exemplary citizen, a friend of priests, cancer patients, and local police and fire departments. At night, he hung out with people who killed other people for a living. He reconciled these two worlds with no apparent internal conflict, though he was said to drink fifty cups of coffee and smoke seventy cigarettes a day, which some psychotherapists might define as a coping mechanism.

One man who adored D'Amato was Frank Sinatra, who debuted at the 500 Club in 1946 and played there many times until the club burned down in 1973. Sinatra appeared there so often that they didn't even need to put his name on the marquee. Whenever Frank was scheduled to appear, the marquee read simply: "He's Back."

Farther down the Eastern Seaboard from Atlantic City, in the state of Florida, the relationship between jazz and the underworld had a Latin flavor.

In Tampa, on the Gulf Coast, the primary spot was Club Chateau, inside the DeSoto Hotel, located downtown. Jimmy Lumia, a high-ranking Tampa mobster, operated the club. The city was on "the Chitlin' Circuit," so jazz was frequently presented in unsavory establishments on a double bill with Delta blues.

Bolita was a thriving criminal racket in Tampa, especially in Ybor City, a neighborhood within the city that was home to more Cuban immigrants than anywhere else in the United States. Various Cuban underbosses oversaw the daily betting of the numbers in Ybor City and the rest of Tampa for Santo Trafficante Sr., the reigning mafia boss in the area.

Central Avenue was the street in Ybor City that became lined with nightclubs. The Cuban Club was a social center where jazz was featured, and the Centro Asturiano, formed by immigrants from Asturias, Spain, staged concerts where jazz and elements of Spanish music began to mix. In the mid-1940s, Machito and His Afro Cubans played at a club in Ybor, signaling the dawn of a new strain of the music that would become known as Latin jazz. This music was characterized by certain Afro-Cuban rhythmic elements and introduced new instruments, such as conga drums, timbales, and maracas. Not only was the music fresh and exciting, but it also inculcated into jazz a whole new strata of organized crime—Cuban gangsters who loved the music and were in the process of making bolita one of the mob's most lucrative rackets.

In South Florida, the city of Miami was not yet the Cuban enclave it would become decades later following the Cuban Revolution. At

the time, the city was a sleepy burgh that, in underworld terms, served mostly as an offshoot of Trafficante's operations in Tampa. Most of the action in South Florida was in Broward County, up the Atlantic coast from Miami, where Meyer Lansky had instituted a number of "carpet joints" (illegal casinos), some of which included showrooms with live entertainment. Lansky's partner in these ventures was Vincent "Jimmy Blue Eyes" Alo, a high-ranking member of the Genovese crime family, originally from New York, who had moved to South Florida and begun organizing criminal activities in the area, most notably casino gambling.

Lansky and Alo were the first to recognize the benefits of linking casino gambling with popular musical acts as a way of drawing in customers. Casino gambling was technically illegal in Florida, but Lansky had as a partner the local sheriff who controlled Broward County as if it were his own private fiefdom. Working together with his brother, Jake, who served as manager at some of the carpet joints, Meyer booked swing bands and smaller jazz trios to play music at the bar.

His most prestigious venue was the Colonial Inn, on Hallandale Beach Boulevard, which Lansky bought from Lou Walters (father of future television personality Barbara Walters). Lansky booked Brazilian bombshell Carmen Miranda as his opening-night act. He even made a special trip to Havana to purchase a set of maracas that met her specifications. Another act that played at the Colonial Inn was the Xavier Cugat orchestra, a hugely popular band that performed regularly at the Waldorf Astoria Hotel in Manhattan and Coconut Grove in Los Angeles. The Cugat band was a leading practitioner of Latin jazz, or at least a kind of ersatz Latin jazz diluted with a heavy dose of saccharin ballroom dance music.

Hot Springs Serenade

Just as illegal booze and speakeasies had served as the engine that drove organized crime in the 1920s, from the end of Prohibition onward the organizing factor would be casino gambling. The mob was bullish on

gambling as a racket. It was thought of largely as a victimless crime. It was relatively easy to buy off local political regimes and law enforcement to make gambling operations possible whether it was legal or not. Around the country, resort towns sprang up that seemed to be competing with one another as the latest "wide open town" or "sin city."

One of the earliest such towns was Newport, Kentucky. Located along the Ohio River, Newport had thrived during Prohibition and maintained its popularity into the 1930s and 1940s as a gambling resort. Jazz had always been part of the equation. Ever since the days of riverboat gambling in the early part of the century, gambling and jazz were linked. Technically, there is no existential connection between these two endeavors. Some musicians liked to gamble and even developed serious addictions; others did not. Whatever disposable income a musician might have, they were more inclined to spend it on booze, women, or drugs, not on a capricious game of chance. Gambling was for suckers; not many musicians had what could be called expendable income.

By the late 1930s, Newport and nearby Covington maintained a bevy of racetracks and gambling parlors that were under the domain of the Mayfield Road Gang, otherwise known as the Big Four, a former bootlegging consortium led by mob boss Moe Dalitz. Based in Cleveland, Dalitz and his partners also owned a piece of criminal rackets in Cincinnati, Toledo, Steubenville, and much of northern Kentucky.

The gangsters in this area were remarkably similar in appearance and attitude to those in Chicago, New York, and elsewhere. There was a certain universal type that seemed to defy regional characteristics. Vocalist Jon Hendricks, raised in Toledo, observed things firsthand while working the clubs in Ohio and northern Kentucky: "[Because I was Black] I would have to spend my time in the back near the kitchen door. I would watch this big pack of touring cars drive up. These four men would get out with the big overcoats and the big Borsalino hats. They would come in, take off their overcoats, take these big shotguns out from under their coats and stack them in a barrel by the door." At times, "they would rub my head" since "it was considered good luck in

those days to rub a nigger's head . . . That was degrading and it was awful. I would feel so mad." The gangster would then peel off a couple of fives or tens and stuff the bills in Hendricks's pocket.

Of all the U.S. resort towns in the pre–Las Vegas era, perhaps the most renowned was Hot Springs, Arkansas. Partly, this had to do with the fact that it had become the unlikely domain of New York mobster legend Owney Madden.

Back in late 1931, while he was still running the Cotton Club in Manhattan, Madden was indicted on a parole violation. Given his long criminal record, he was facing significant time. His lawyer negotiated what is thought of by some as one of the sweetest deals a major racketeer ever secured for himself. He would do one year in prison and then be released, but he could never again do business or set foot in New York City.

Upon his release in 1933, Madden settled in Hot Springs. He knew the place well, having traveled there in the 1920s during the heyday of Prohibition. The attraction for Madden, as it was for many people, was the hot springs and natural baths. Having survived being shot multiple times during his days as leader of the Gopher gang, Owney liked to convalesce in the bathhouses. The town had fewer than twenty-five thousand local inhabitants, but it was a popular tourist destination because of its numerous casinos and nightclubs.

Mobsters flocked to Hot Springs for the same reason they would later patronize Las Vegas: gambling, women, and entertainment. Al Capone and his crew were regular visitors in the late 1920s. Rival gangsters once tried to take out Capone in a drive-by shooting on the town's main drag, riddling his bulletproof touring car with lead. Events like this only added to the town's luster.

In Hot Springs, Madden married the postmaster's daughter and settled in as kind of an organized crime liaison in town. He helped settle disputes, backed politicians for office who were gambling-friendly, and acted as host to the many underworld figures who passed through town. His local power stemmed from the fact that he owned the racing wire,

the means by which horse racing results and sports betting totals were instantly communicated nationwide (the wire was based in Louisiana and controlled by mafioso Frank Costello).

Located well off the beaten path, forty miles from any interstate highways, Hot Springs was a popular hideaway for gangsters on the lam. In 1936, Lucky Luciano showed up from New York, where he had been indicted by District Attorney Thomas Dewey on prostitution charges. Most people in Hot Springs, including the local press, knew enough to keep their mouths shut on the subject of notorious fugitives hiding out in town. Though Luciano was a fugitive, he wasn't hiding. He circulated openly, until he was spotted by an FBI agent who was in town on an unrelated matter. Under pressure from federal authorities, Hot Springs police reluctantly held Luciano at the local Garland County jail. While there, the New York mafioso ordered a feast from Pappas Brothers, a local Italian restaurant, to feed all the prisoners. It was a memorable occasion for all the cops, vagrants, wife beaters, and cow thieves who happened to be in jail at the time.

That morning, a dozen Arkansas Rangers and police from Little Rock surrounded the jail. They demanded that the locals relinquish their famous prisoner, who had been served with an extradition order and was wanted for prosecution back in New York. Owney Madden negotiated for Luciano to peaceably submit to the extradition order, and Hot Springs went on about its business of illegal gambling and jazz.

Given his former associations in Manhattan, Madden was able to help book some major acts in town. Cab Calloway and Ella Fitzgerald appeared at Club Cameo, and in 1942 the Duke Ellington orchestra appeared at a club on Malvern Avenue, on the colored side of town.

The appearance of Ellington was a special occasion, given that Madden and the elegant bandleader were associates from the old Cotton Club days, when, after a show, they used to play card games into the wee hours. Ellington was a national star, thanks in part to his shows at the Cotton Club having been broadcast on radio all around the country. As one of the most popular swing bands touring the United States in

the 1930s and 1940s, he was in high demand. It is unlikely that Hot Springs, even with its reputation as a southern nightlife center, would have been able to book such a popular act were it not for the influence of Madden, the town's equally renowned retired mobster.

The Judge's Wife

Compared to illegal booze, gambling, or, in later years, narcotics, it might seem that the profit margin for a nightclub was beneath the dignity of the average mobster. The overhead could be sizable, especially for a club that featured big band music, and the returns were far from guaranteed. But these venues had value beyond their possibilities as money-making propositions. The 1930s and 1940s were a crucial time for the syndicate. As organized crime spread its tentacles beyond the obvious strongholds of Chicago and the Northeast, jazz clubs and casinos became part of the mob's brand. You could drive into any large or midsized city in the United States and the jazz venues were likely owned by local gangsters or by gangster representatives from the nearest major city. The clubs were a way for the mob to franchise itself by establishing beachheads in many of the country's most commercially active cities or regions:

St. Louis: Some music historians argue that early jazz in "the Gateway to the West" was as influential as the music coming out of New Orleans. This argument stems primarily from the fact that ragtime, which predates jazz, had its roots in the city. Scott Joplin and others invented ragtime in honky-tonk saloons such as the Rosebud Café. By the Prohibition era, jazz had emerged as the music of the day, and it was linked to speakeasies and gambling clubs in St. Louis controlled by the mob.

In 1931, a fancy new club opened on Enright Avenue complete with risqué musical revues and jiggly showgirls. It was called—what else?—the Plantation Club. Like most clubs of this type, the model was the Cotton Club in Harlem. The entertainers were Black and the audiences were white. If anything, in a former slave state like Missouri,

racial segregation was even more rigidly enforced. Musicians were not allowed to come in the front door of the club. They could not use plates, glasses, or silverware that were used by white clientele. The menu at the Plantation featured a lurid illustration of a dark-skinned, Sambo-like female pouring a cocktail with the tagline "No, No, a Thousand Times No."

The club was owned by Tony and Jimmy Scarpelli, two mafiosi with criminal records and links to the Capone syndicate in Chicago. After Prohibition, the club continued to thrive. It instituted a bring-your-own-booze policy so that it could sidestep state liquor laws that prohibited the sale of alcohol after midnight.

In 1940, the Plantation moved to a larger space down the block to better accommodate big bands led by the likes of Jimmie Lunceford and Benny Carter. Despite the belief that mob clubs were more orderly than others, the Plantation could get rambunctious. Trumpeter Clark Terry, who was born and raised in St. Louis, remembered a night when Benny Carter was leading a big band at the club. "Somebody insulted this lady, the singer, and [trombonist] J.J. Johnson stood up for her." This ignited an attack by two gangsters in the club; they "pistol-whipped J.J." until Carter jumped down off the bandstand and confronted the gangsters. He pulled out his own gun and challenged the hoods: "Now pistol-whip me." The gangsters backed down.

Trumpet master John Birks "Dizzy" Gillespie recalled a night at the Plantation when he was playing in a band led by vocalist Billy Eckstine. One of the club's mafia owners "took me down into the basement one time . . . and says, 'I want you to turn on the light. When I give you the sign, turn on the light.' He say, 'Okay, turn it on.' He took out his gun, and a big rat ran across the basement. Pow! He shot that rat dead." Added Dizzy, "A lot of shit happened to us in St. Louis. All of us had pistols, too, so it didn't make any difference. Everybody in that band had a pistol. If you went down South, you better have one and a lot of ammunition. We were musicians first, though, and fun-loving, peaceable men. But don't start no shit."

Eventually, the Eckstine band ran into trouble at the club. Remembered Gillespie:

The Plantation Club was a white club. They fired [the band] because we came in through the front door, and they wanted us to come through the back. We just walked right in with our horns, in front. And the gangsters—St. Louis was a stronghold of gangsters—said, "Them guys got to go."

The Eckstine band left the Plantation and traded places with a band down the street at Club Riviera, a Black-owned club. There they played their hearts out until late into the morning.

Pittsburgh: Smoketown was where it was happening. Encompassing the Hill District, Pittsburgh's Negro section, Smoketown produced some of the best jazz musicians in America and some of the most formidable African American gangsters, especially those in control of the numbers racket.

William Augustus "Gus" Greenlee was a man of contradictions, an African American war hero who was wounded at Verdun and returned to the United States to become a businessman, philanthropist, and criminal. In the 1920s, he bought his own taxicab, which he used to deliver booze to speakeasies in Smoketown, so named because of the nearby smokestacks that spewed industrial sludge into the sky. Greenlee was a big man who presented himself as a local potentate, and few would argue with that. He was part owner of the Paramount Club on Wylie Avenue, where bootleg liquor and jazz were on the menu. In the late 1920s, the Paramount closed down amid charges that Caucasian women were "running wild" at the establishment. The club later reopened and Greenlee operated a musical booking agency on the premises.

With the end of Prohibition, Greenlee parlayed his business acumen into the numbers racket, which he started up with two partners. Soon he became the most powerful numbers banker in town. Like other Black numbers bosses in other cities (most notably Felix Payne in

Kansas City's 18th and Vine District and Casper Holstein in Harlem), Greenlee accumulated considerable political power in Pittsburgh. He became a very rich man, using his wealth to purchase clubs, including the Crawford Grill on Wylie Avenue, which became the hottest venue in the Hill District.

Pittsburgh was a jazz town. African Americans whose families had migrated from the South found their musical calling on the Hill. Piano players like Fatha Hines and Mary Lou Williams, singers such as Billy Eckstine and Lena Horne, and many others either got their start or came of age in Pittsburgh. The best known or most well-connected musicians played at the whites-only clubs downtown, but later they wound up in the Hill District playing at the Crawford Grill, the Ellis Hotel, Stanley's, the Bamboola, or the American Legion's Carney Post.

The man who emerged as the impresario of this scene was Gus Greenlee. When big-name acts like Duke Ellington, Chick Webb, or Jimmie Lunceford came into town, Greenlee made sure they were introduced to local talent. In fact, the numbers boss is credited with introducing Ellington to composer Billy Strayhorn, a Pittsburgh native with whom the bandleader would go on to form perhaps the most storied songwriting partnership in the history of jazz.

Greenlee was said to be a man who eschewed violence. This was not the case with his primary underling, Rufus "Sonnyman" Jackson. Sonnyman Jackson was the man who oversaw the day-to-day activities of Greenlee's numbers empire. He sent out a bevy of numbers runners into the Hill District to solicit bets and collect money. When other criminals tried to cut in on the Greenlee organization, Sonnyman was the one who would show up to make threats and break legs. Twice charged with racketeering, Jackson beat the charges in court. He also survived being stabbed by his wife.

In 1931, Jackson founded the Manhattan Music Company, which was both a cover for his numbers activities and also a legitimate enterprise. The company supplied jukeboxes to the city's restaurants, saloons, and nightclubs.

Both Greenlee and Jackson were powerful businessmen in Pittsburgh's Black community. By using two time-tested avenues of power—racketeering and the business of jazz—they were viewed as successful entrepreneurs, not as criminals. Both played a founding role in the creation of the Negro Baseball League and channeled their ostensibly ill-gotten gains from bootlegging and numbers into community-based projects. Their financial backing of clubs and individual musicians who went on to become great jazz artists made Pittsburgh one of the most significant breeding grounds for the music.

Denver: Jazz spread west, and as it did, it was especially popular in frontier towns. In Denver, African Americans arrived as part of the Great Migration and, due to fierce segregation in housing and most other matters, settled in an area near downtown known as Five Points. On Welton Street, jazz clubs proliferated, and many of the biggest names passed through town. Excluded from staying in most hotels because of their skin color, Black musicians usually stayed in Five Points at the Rossonian Hotel, which was also a popular music venue.

The most notorious jazz club in Denver was located on the outskirts of town. It was called the Moonlight Ranch (only in the American Southwest would a jazz club have the word "ranch" in its name). Owned by organized crime boss Manlio "Mike" Rossi and his brother Eugene, it was a staple of the Prohibition era.

Pianist and bandleader Andy Kirk, who would later achieve fame in Kansas City as leader of the Clouds of Joy, was raised in Denver and performed frequently at the Moonlight Ranch. Even after playing at some of the most renowned mob-controlled clubs in Kansas City (including Johnny Lazia's Cuban Gardens), he never forgot his beginnings in Denver:

The Moonlight Ranch was pretty high class for a roadhouse. Roadhouses were the thing then, a part of the scene. They were low and spread out, like dance pavilions, not like the architecture of clubs in town. There'd be booths along the sides, tables

near the dance floor, the band set up on one end. Dim lights. Romantic, but also kind of dangerous . . . We saw plenty of action most nights, even blood sometimes. Mostly jealous husbands tracking down their wives' lovers. But the band stayed clear of those contests. We had our music to tend to.

Mike Rossi, the club's owner, was born in Marsicovetere, in southern Italy, the son of a wealthy physician. Upon arriving in Denver, he became a bootlegger, a pimp, and an opium dealer. Convicted numerous times for violations of the Volstead Act, he was known to have a violent temper. In his autobiography, Kirk describes a night when Rossi pistol-whipped an unruly customer. When the man's wife exclaimed, "Stop it. That's my husband," Rossi responded, "Sorry lady, I see no blood—yet." He kept on pounding.

Kirk and his bandmates kept Rossi at bay by playing that old gangster chestnut, "My Buddy."

Rossi may have been tough with disrespectful customers, but he was always marvelous to the musicians, always had a little smile for us. Some nights he would ask the band to stay another hour or so after closing and play for a private party, the main idea seemed to be to give the girls a chance to show off their dancing . . . Usually, we played until four in the morning, then went into the kitchen for breakfast—spaghetti and hot peppers!

Mobsters throughout the Denver area flocked to the Moonlight Ranch. Clyde Smaldone, leader of the most notorious mafia family in the city, remembered visiting the club for the first time. Smaldone was just a teenager but already a noteworthy bootlegger who would go on to bigger things:

Here was this lady at the bar. The place was full [of] dancing. All white people except the people playing in the orchestra . . .

And she started taking off her clothes. I said to [my friend], "Do you see what I see?" Everybody was watching. She stripped herself practically naked . . . So we went back a week later, and I'll be damned, here it comes again. The same thing. I finally talked to one of the guys [who] was working there. He says, "You know who that is, Clyde?" I said, "No." He said, "That's federal judge [J. Foster] Symes's wife." I said, "WHAT!?! I don't believe it." He says, "You believe me."

When the club was later cited on liquor charges, the presiding judge was John Foster Symes.

Upon sentencing the owners, the judge proclaimed, "The Moonlight Ranch is a stench in the nostrils of decent and respectable citizens."

The club endured, but Mike Rossi did not. He was convicted of murder after he shot his wife to death in their lawyer's office, as they were negotiating the transition of ownership of the Moonlight Ranch. He was given a life sentence.

The person who took over ownership of the club was Louis "Two Gun" Alterie, a well-known gangster from Chicago. Alterie was one of the owners of the New Rendezvous, the downtown Chicago club that had lured Joe E. Lewis away from Green Mill, with violent results.

Alterie was one of the boys. Having him transplant himself from one mob-friendly club to another in a different city was a common syndicate tactic. Jazz was used as a hook to facilitate underworld harmony and keep the good times rolling.

The Coast

Of all the western cities where the music found fertile soil, few could compare with the City of Angels. In the annals of jazz history, the Central Avenue district near downtown Los Angeles is remembered alongside Kansas City's 18th and Vine, the Hill District in Smoketown,

or Denver's Five Points. On Central Avenue, there were many bars, nightclubs, and hotels, as well as the main offices of the American Federation of Musicians Local 767, the Black musicians' union. Like most American cities in the 1930s and 1940s, Los Angeles was fiercely segregated, and the Avenue, as it became known, was a gathering place for a group of people that, collectively, were doing their best to make it on their own.

Jazz took its time in Southern California. In 1920, at the start of Prohibition, African Americans comprised less than 3 percent of the Los Angeles population. That began to change with the arrival of work on the Southern Pacific Railway. As the economy grew, so did the Black community, which was herded together on what was called the Central Avenue corridor, with the social center of the community located at 12th and Central.

Jazz arrived in a big way when New Orleans maestro Jelly Roll Morton came to town. Between 1917 and 1922, Morton was a semi-regular fixture on the Avenue. He debuted at the Cadillac Café on Central between 5th and 6th Streets. According to Ada "Bricktop" Smith, singer, dancer, and vaudevillian, Jelly Roll was like a man without a country: "He was still trying to figure out what to do with his life. He couldn't decide whether to be a pimp or a piano player. I told him to be both."

Emboldened by Morton, other New Orleans musicians made their way to Los Angeles, including bandleader Kid Ory. Clubs sprang up along Central Avenue, along with numerous Prohibition-era speakeasies. The city was so segregated that most whites didn't even know the district existed. Central Avenue was a self-contained universe.

In some ways, the area's isolated status within the larger city made it possible for Central Avenue to weather the onset of the Depression better than some white commercial districts. If Black folks wanted to socialize, Central Avenue was the only game in town, and the new music was a major part of the scene.

For musicians, it was an exciting time. Drummer Lee Young, brother of legendary saxophonist Lester Young, was a fixture in the clubs on

Central Avenue. "There was a lot of work over there," he recalled. "It wasn't a lot of money, but it was enough for you to make a living and be all right and feel all right about yourself."

The mob paid little attention to the district until the 1930s. As gambling and narcotics became a more common feature of the scene, gangsters could see that there was money to be made in "the colored section." Mafiosi from back east had been coming to Los Angeles to sniff out extortion prospects in the movie business. Mafia slickster Johnny Roselli, who was from Boston by way of Chicago, reported back to mob bosses in Chicago and New York that, yes, the moving picture biz was ripe with possibilities, but so were other aspects of the city's underworld. The local mafia boss, Jack Dragna, and his brothers were, by most accounts, asleep at the wheel. Basic criminal rackets like gambling, shylocking, numbers, and protection rackets were decentralized and poorly organized. Given the sprawling nature of urban development in L.A., it would not be easy, but someone with vision and a firm hand could turn Los Angeles into an underworld domain on a par with New York and Chicago.

In 1936, Benjamin "Bugsy" Siegel was sent from New York to L.A. by mobster leadership back east (Lucky Luciano, Meyer Lansky, and Frank Costello). His mandate was to organize L.A. into a viable source of plunder. It was made clear to Jack Dragna and his people that they would maintain their turf and all established sources of revenue, but Ben Siegel was now in charge.

Brooklyn born and bred, Siegel was an attractive figure. Handsome, impeccably dressed in bespoke suits, with silk ties and underwear, he was similar to Owney Madden in that he rose from being a terror in the streets—his rap sheet brimming with violent assaults and murders—to being a businessman/prince. He took elocution lessons and spent years molding himself into a presentable man about town. In L.A., he soon endeared himself to movie industry celebrities and notable restaurateurs. Presenting himself as a legitimate player in town, not a gangster (though most were familiar with his past), he was Jay Gatsby goes to Hollywood.

But don't call him Bugsy. That was a moniker that carried with it the stench of his Hebrew roots in Williamsburg, and his underlings were forbidden to use it in his presence.

In social circles, Ben Siegel was a star. The problem was that he wasn't really doing what he'd been sent to L.A. to accomplish. Siegel was not detail oriented. If the syndicate was looking for someone who could manage the nuts and bolts of creating a racketeering enterprise from the ground up, Bugsy was not the guy. That guy was Mickey Cohen.

Another Brooklyn Jew burning with ambition, Cohen was cut from a different kind of cloth. If Siegel was cashmere, Mickey was mohair. At five foot five, he was half a foot shorter than Siegel, with a gutter sensibility that had come in handy in his early career as a boxer. In the ring, as in life, he had more guts than brains, though, over time, he would fashion himself into a capable mob boss.

What he and Siegel both had, in spades, was ambition. Mickey worshipped Ben Siegel and would do most anything on his behalf. They were a Brooklyn Jewish version of Don Quixote and Sancho Panza, tilting at windmills, until Siegel's lack of attention to detail led to his right eye being shot clean out of its socket, and Cohen ascended to the throne.

Long before that, Mickey was the new kid in town doing whatever Ben Siegel asked him to do. Cohen had been chosen for this task partly because he knew L.A. Though born in Brooklyn, the future mob boss was three years old when his single mother moved him and his brother to L.A. "I have no memory of my father whatsoever," he would later say. In L.A., Cohen grew up in the Boyle Heights, which at the time was, according to Cohen, "strictly a ghetto neighborhood—Italians, Jews and Mexicans." The section where the Jews congregated was known as Russian Town.

In his teens, Cohen became serious about boxing. This led him back to the city of his birth, New York, where he trained for a time at Stillman's gym on Eighth Avenue in Manhattan. Men from the rackets hung around the gym, looking for teenage tough guys to recruit as muscle. Cohen made the transition from pugilist to hoodlum, which

led him to Cleveland and then on to Chicago, where he distinguished himself in the waning days of the Capone empire. Cohen worshipped Big Al just as he would later worship Ben Siegel. The underworld was chock-full of wayward young men in search of surrogate fathers.

One of Cohen's first assignments when he arrived back in L.A. as a full-fledged racketeer was to organize "the colored section." There was money to be made among the *shvartzas*—gambling, narcotics, numbers, liquor, jukebox concessions, protection rackets, you name it. Ben Siegel, who spent his time with movie stars, wining and dining at the Trocadero and Ciro's on Sunset Strip, or in Hollywood, was not likely to dirty his hands on Central Avenue. This was a job that called for Mickey Cohen.

For jazz musicians, white gangsters muscling their way into the business was nothing new. Many musicians in L.A. had come from elsewhere—New Orleans, Detroit, Pittsburgh, or New York. They all had stories to tell about the gangsters back home.

Cohen immediately made his presence felt. He drove a convertible Cadillac, always the latest model, and, both through words and action, he let it be known: "Things are gonna be different now."

In 1940, Buddy Collette was a nineteen-year-old flutist and sax player, born and raised in L.A. As it was for other aspiring jazzmen of his generation, Central Avenue was his training ground and sanctuary. One of the bands that Collette played in was an eight-piece group led by Cee Pee Johnson, a drummer and vocalist who'd grown up in Algiers, Louisiana. Johnson was a flamboyant performer, with slicked-back hair and a Cajun accent. He also had a serious drug habit. Before and after shows, he would shoot up in the dressing room.

One night at a club called the Spot, Johnson's band was just finishing up a set when Mickey Cohen and a couple of bodyguards stormed into the place. According to Buddy Collette, when Cohen locked the doors, "We knew something was going to happen." The band skedaddled upstairs to a dressing room—"you know, to get out of there."

From the dressing room, the bandmates could hear chairs being

thrown around and staff members being slapped and/or pistol-whipped. Cohen's crew was demanding to know "Which of youse been stealing the liquor?"

Soon Cohen himself came upstairs and burst into the dressing room, wearing his usual wide-brimmed fedora. "Hey, you're getting paid to play, so get down there and play."

Collette was terrified, but Cee Pee was unimpressed. "[He] was fixing up his hair. He had this conked hair, and he was fixing it, and he stayed high most the time."

Casually, Cee Pee said to Cohen, "No. I'm not playing."

The gangster was startled. From his waist, he pulled out a pistol and raised it, as if he were going to strike Cee Pee with the butt of the gun.

Collette took a deep breath. "I was standing there and I could [imagine] Cee Pee's head being gashed in, which it frightened me, of course, being nineteen years old. But I guess Mickey was just trying to frighten him. But when you look at a guy and he's not even frightened, I guess you just leave him alone. Cee Pee said, 'I'm not playing,' which is a wild thing. But that was the gang life. He lucked out. [Mickey] hit two or three people downstairs already, but he didn't hit Cee Pee."

For a few years, Cohen was a regular presence at the Spot and other Central Avenue clubs: the Downbeat, Club Alabam, Elk's Hall, the Dunbar Hotel, which was the epicenter of the jazz scene in Los Angeles. Like a bantam rooster, Cohen made the rounds, a little man with two big thugs over each shoulder. Eventually, he opened his own club on Highland Avenue near Hollywood Boulevard called Rum Boogie. The opening act was the Treniers, a swing and boogie-woogie group made up of former members of Jimmie Lunceford's orchestra whom Cohen recruited from the Avenue.

Buddy Collette also played in a band at Rum Boogie. He frequently saw Mickey there being polite and solicitous of his white celebrity clientele, not like his time in the colored section, where he would strut around, puff out his chest, and posture as if he were Tarzan, King of the Rackets.

9

SWING STREET

At some point during the 1930s, as the heady years of Prohibition receded and became the hazy nebula of memory, the American gangster faced an identity crisis. For a long stretch, mobsters had not only garnered huge profits for themselves and the organizations they created, but they were viewed as semi-legitimate figures. By supplying a product that was technically illegal but in high demand, they were able to have it both ways. They may have been criminals, but they were admired by many. With repeal of the Volstead Act, mobsters not only lost their primary criminal racket, but they also lost their stature in the culture. They became simply hoodlums who were out to make a buck for themselves at the expense of legit society.

There was a certain amount of resentment on the part of some esteemed mobsters, who had grown accustomed to being seen as underworld noblemen. In later years, as some of these men occasionally voiced their views in congressional hearings, newspaper interviews, or ghostwritten memoirs, they expressed bitterness that society viewed them as disreputable figures when they were no different than other titans of business. The names of Joseph P. Kennedy and Edgar Bronfman Sr. often came up. These were men who had allegedly played a covert role in the supplying of liquor, via smuggling, to the bootleg syndicates of Capone, Madden, and others. After Prohibition, they resumed their

careers as legitimate businessmen, pillars of virtue in the larger arena, a fact viewed by some mobsters with jealousy and cynicism.

Meyer Lansky was one gangster who, from early in his criminal career, seemed to yearn for respectability. Sometimes referred to as "the mob's accountant," Lansky had, as far as anyone knew, never killed a man with his own hands. Part of the reason he had formulated a partnership with the likes of Charlie Luciano and Ben Siegel was for protection. Both of these men had violent reputations, which cleared the way for little Meyer to focus on business.

In the early 1940s, Lansky likely believed he had made his most serious bid for legitimacy. That would explain the rarity of a published photo of Lansky—with a smile on his face, no less—shaking hands with representatives from the Wurlitzer jukebox company. The picture appeared in *Billboard*, the official trade paper of the music business. Lansky had reason to smile: He and his business partner, the mysterious Ed Smith, had just negotiated a deal with Wurlitzer to serve as the sole distributor of the company's machines in the highly lucrative Northeast Corridor of New York, New Jersey, and Connecticut.

The press conference took place in Manhattan at the Times Square offices of Lansky's Emby Distributing Company. For this deal, he had created a subsidiary company called Manhattan-Simplex. Ed Smith, his partner, was actually Vincent Alo, Lansky's co-conspirator on his various illegal casinos in South Florida.

It was highly unusual for Lansky to take part in such a public display of capitalist consolidation. In his career up until now as a car thief, extortionist, bootlegger, and illegal gambling impresario, many of his deals were conducted in back alleys, cars, speakeasies, and private clubs. Times had changed.

Said Milton Hammergren, vice president and general sales manager for Wurlitzer: "We know that in Meyer Lansky we have a man who is liked and respected by everyone. He is an intimate friend of many music merchants and we are confident that as Wurlitzer's new distributor in this territory he will make new friends."

The *Billboard* article that accompanied the photo of Lansky and the Wurlitzer representatives stated "When questioned regarding his plans for Manhattan-Simplex, Lansky intimated that he would much prefer to have his actions speak for him."

Years later, those actions were explained by Hammergren, by then a former official with the Wurlitzer company. In 1958, Hammergren appeared in Washington D.C. before the Senate McClellan committee, testifying about the activities of organized crime in the labor unions. Hammergren was asked by the committee chief counsel, Robert F. Kennedy, if his mob-affiliated distributors used unseemly tactics when peddling his machines to their clients.

Hammergren: Yes, there was violence, such as blowing out windows of the store or blowing up an automobile or something of that nature, or beating up a fellow.

Kennedy: Is that part of the characteristics of the industry?

Hammergren: Yes, I would say so.

Kennedy: Were there also killings?

Hammergren: Yes, there was.

Hammergren went on to detail murders that took place as a consequence of the jukebox business.

Kennedy: Were company officials upset about the use of force?

Hammergren: Company officials, of which I was one, yes, we didn't like it, but we still had to sell jukeboxes. We knew all about it, and we knew what the problems were. We tried to go along with it the best we could.

Kennedy: I mean if somebody, just in the course of trying to get your boxes distributed, if somebody was killed, that was taken as part of the trade?

Hammergren: That is one of the liabilities of the business, I would say.

By the early 1940s, jukeboxes were a significant racket for the mob. Major distribution companies were owned by mafiosi like Carlos Marcello in Louisiana; Sam Giancana, Jake Guzik, and Tony Accardo in Chicago; Abner "Longie" Zwillman on the East Coast; and Ben Siegel and Mickey Cohen in California.

By signing their new deal with Wurlitzer, the largest single manufacturer of jukeboxes in the United States, Lansky and Alo now had the most lucrative distribution company of them all.

New technology made it possible for the latest jukebox models to load up on single records known as 45s, which were installed by the distributor of the machines. Placed in bars, restaurants, diners, and arcades, jukeboxes became a major means—second only to commercial radio—to create hit records. At a time when jazz represented by far the largest share of the commercial music business, jukeboxes were, for musicians and the record companies, a major key to success. Theoretically, records were selected for installation based on their standing in weekly sales charts published in *Billboard*. There was a built-in logic to this method: Machines that sucked up the most nickels per play were the most remunerative. Nobody wanted a jukebox that didn't generate profits.

But the mob also saw the jukebox audience as a way to promote musical acts that were, to coin a phrase, in their pocket: that is, bands, musicians, or singers they either owned a piece of or had a vested interest in seeing make it on a large scale. There was no single performer the mob was more interested in promoting than Frank Sinatra.

Your Signature or Your Brains

The bobbysoxers turned Sinatra into a cultural phenomenon. It wasn't long before he was bigger than even Tommy Dorsey, the leader of the band and Sinatra's boss. With the Dorsey band, Sinatra played all over the United States, from coast to coast. In May 1940, the band had its first number one hit on the *Billboard* chart, "I'll Never Smile Again," a shmaltzy, slow-tempo ballad that must have driven Buddy Rich crazy

(you can hear the normally energetic drummer on the tune gently brushing the cymbals as if he were on Quaaludes). The band traveled to Hollywood to perform in not one movie but two. *DownBeat*, in its annual poll, named Frank Sinatra "Male Vocalist of the Year." The winner of the poll the previous six years was Bing Crosby.

By February 1942, Sinatra was ready to leave the Dorsey band. It was a tricky maneuver. He and Dorsey, who was stern and taciturn, had nonetheless become close. Dorsey was a tightly wound Irishman with a temper, a brilliant musician and demanding bandleader. He and Sinatra were sometimes at odds, but they always made up, like father and son. Dorsey had reason to believe that he had "made" Sinatra. The singer had signed a three-year contract with Dorsey that still had nearly two years remaining. It was Sinatra's intention to give notice to the bandleader that he would be terminating their business relationship in one year.

One night after a gig at the Golden Gate Theatre in San Francisco, Sinatra told Dorsey his intentions. According to Sinatra, Dorsey said, "Sure." Tommy was the type of person who simmered when angry, then exploded. He likely felt deeply betrayed. That night, Dorsey said to a journalist about Sinatra, "He's a damn fool. He's a great singer, but you know, you can't make it without a band. Does he think he can go out on his own, as good as he is?"

Sinatra had every intention of going out on his own. He was ambitious, and he would use whatever means necessary to make it happen.

For weeks, Sinatra's agent pestered Dorsey about signing some sort of termination agreement, so that the singer could get out of his contract. Sinatra, meanwhile, was still performing with the band, selling out engagements at the Paramount Theatre in Times Square and elsewhere around the country.

Dorsey knew that he had Sinatra over a barrel. Frank was asking to be released from an ironclad agreement. Dorsey could have said no, but he was a proud man. If Sinatra wanted out, so be it. But he was going to get his pound of flesh. Sinatra would be henceforth released from his

contract, plus receive an advance of $17,000 (nearly $250,000 today) to start his solo career. In return, Dorsey would be Frank's manager and receive 33.3 percent of the singer's gross earnings "in perpetuity."

It was an insane deal, and some might ask why Sinatra would sign such an onerous agreement, but to such an impulsive young man as Frank (he was twenty-seven years old), "in perpetuity" was likely a meaningless term. He wanted out, and the rest would take care of itself.

In early 1943, Sinatra went out on his own. Not only did he soon become the number one performing and recording star in America, but he also went into motion pictures—not as a musician but as an actor. It would be a few years before he could be classified as a movie star, but he was working steadily and making more money than he ever had before. The more he made, the more he realized that his old mentor Tommy Dorsey had seared deep into his flesh with a torch-heated branding iron. He wanted out of that onerous deal—pronto.

Dorsey was visited by lawyers and agents. Sinatra wanted a separation agreement. Dorsey would be paid a tidy sum, but the bandleader would no longer own a piece of the singer. Sinatra was not going to be his slave for life.

Dorsey smiled. He said he would think it over, but it soon became apparent that the bandleader was either going to drag things out until he squeezed Sinatra dry, or he was never going to sign the agreement at all.

Sinatra was in a pickle. So he did what he had back when he needed to settle a score with Buddy Rich: He reached out to the boys.

The incident that occurred—if it did occur—has gone down in mob and music business lore, with slight variations. Willie Moretti started the rumors by telling people the story of how he was sent by the New York mob to "muscle" Tommy Dorsey. Moretti and two others confronted Dorsey backstage at a club in Los Angeles, telling the bandleader that he had no choice but to sign a release that absolved Sinatra of all financial obligations. When Dorsey demurred, Moretti pulled out a gun.

Comic Jerry Lewis of Martin & Lewis fame, a comedy duo that would later frequently perform on a bill with Sinatra, had a different version. Lewis's account, he claimed, came directly from Sinatra, who told him that the mob sent Frank Costello, Albert Anastasia, Frankie Carbo, and Moretti to confront Dorsey. "Frank told me years later—laughing—how the talk went. Carbo said, 'Mister Dorsey, could you play your trombone if it had a dent in it? Could you play it if you didn't have a slide?' It was all just like that, and Dorsey got the idea."

Yet another version was put forth by a lifelong Hoboken pal of Frank's named Joey D'Orazio. As one of numerous errand runners and bodyguards in Sinatra's entourage, D'Orazio heard stories. According to him, two New Jersey thugs, unbeknownst to Sinatra, were sent to settle the dispute. The thugs told Dorsey that if he didn't sign the papers, they were going to break his arms. The bandleader "laughed in their faces . . . [saying] 'Oh, yeah, look how scared I am. Tell Frank I said, "Go to hell for sending his goons to beat me up."'" Dorsey then told the men, "I'll sign the goddamn paper, that's how sick I am of Frank Sinatra, the no good bum. The hell with him."

Likely the definitive account comes from Tommy Dorsey himself, who was quoted in *American Mercury* magazine: "Three guys from New York City by way of Boston and New Jersey approached me and said they would like to buy Sinatra's contract. I said, 'Like hell you will.' And they pulled out a gun and said, 'You wanna sign the contract.' And I did."

Years later, after Willie Moretti had died, Dorsey was even more specific: "I was visited by Willie Moretti and a couple of his boys. Willie fingered a gun and told me he was glad to hear I was letting Frank out of my deal. I took the hint."

Over the years, Sinatra denied any and all accounts, claiming that the separation deal with Dorsey had been negotiated by his entertainment lawyer. This was the official account that appeared in *Billboard*, which stated that Dorsey had agreed to a "buyout" in exchange for a cash settlement of "over 50G" (later revealed to be $60,000). *Billboard*

noted that the overall deal was brokered by Jules Stein, president of MCA, who put up the money to pay off Dorsey. Why MCA would do so was "not crystal clear," stated the trade paper, given that the company did not officially represent Sinatra.

Over time, the incident became one of those fabled stories that, like the mob attack on Joe E. Lewis decades earlier or the episode of Louis Armstrong being threatened with a gun backstage in Chicago, reverberated throughout the music business. It may have died out at some point were it not for Mario Puzo, who gave a fictionalized account of the incident in his novel The Godfather. In Puzo's rendering, Don Corleone himself goes to visit a bandleader who has entrapped the singer Johnny Fontane (a Sinatra stand-in) in an unfair personal services contract. The Don offers the bandleader $20,000 to release Fontane from the contract. The bandleader scoffs at Corleone, who nonetheless convinces the man to take the deal. As Puzo described it:

> Don Corleone did this by putting a pistol to the forehead of the bandleader and assuring him with the utmost seriousness that either his signature or his brains would rest on that document in exactly one minute. [The bandleader] signed. Don Corleone pocketed his pistol and handed over the certified check.

In some ways, Puzo's fictional account provided Sinatra the cover he needed. He would argue for years that he had been slandered by The Godfather, that the story as concocted by Puzo, in a bestselling book that became the basis for the highest-grossing movie in history (when it was released), was concocted out of whole cloth. Assuming the role of victim, Sinatra claimed that, in the eyes of the public, fiction had become fact. More likely, in this case, fact had become fiction.

To the singer, it may have appeared that he was now a free man. Never again would he agree to such a long-term contract. From now on, he would be beholden to no one.

His friends in the mob didn't see it that way.

Strange Fruit

As Sinatra's career headed for the stratosphere, the business of jazz once again adapted to changing times. In some ways, the emergence of Sinatra as a megastar brought about the end of the swing era. Singers, which had initially been an addendum to the big bands, stepped forward as the stars. Billie Holiday, Sarah Vaughan, Anita O'Day, Ella Fitzgerald, and many others became the main attraction. The big bands did not disappear entirely, but jazz aficionados wanted to experience the vocalists in a manner that was more nuanced and intimate. Small jazz clubs were back in demand.

The problem was that the social environment in which the clubs had once thrived was going through an evolution. Nowhere was this truer than in Harlem, U.S.A.

Of all the great jazz districts of the Prohibition era, few had more to offer than Uptown Manhattan, where the Harlem Renaissance had for Black folks given rise to the possibility of a thriving, cultured, self-sustaining universe of artists, intellectuals, race activists, and sports heroes all rolled into one. For a time, Harlem had more jazz clubs than anywhere, but those days were long since past. By the 1940s, Harlem had become an example of municipal neglect and commercial decay that would only get worse in the decades ahead.

Some point to the riot of March 1935, when the beating of an Afro–Puerto Rican teenager, believed to have shoplifted a penknife at the Kress five-and-dime store, led to community action against white-owned businesses on 125th Street, Harlem's main commercial artery. Tension had been building since the onset of the Depression, when Black-owned businesses—including some jazz clubs—had gone under while white-owned businesses secured bank loans and stayed afloat. The tension turned into violence, with three deaths and much property damage attributed to the riot.

The Harlem riot of '35 was a harbinger of things to come. In the wake of the riot, many of the big jazz clubs (the Cotton Club, Connie's

Inn, the Savoy Ballroom) either moved out of the neighborhood or closed altogether. On West 133rd Street between Seventh and Eighth Avenues, which had once been the location of nearly two dozen clubs— some of them Black owned—doors were padlocked and gates shuttered, with the businesses to never open again.

If this weren't detrimental enough, in August 1943 another riot occurred. This one started outside the Braddock Hotel, located around the corner from the Apollo Theater. The Braddock had been a popular place for out-of-town jazz musicians playing gigs in New York, but it had recently fallen into disrepair. On a hot summer night, a police officer arrested a Harlem woman for disturbing the peace outside the Braddock. A local man who was an off-duty soldier in the U.S. Army tried to intervene and was shot in the shoulder by the cop. As the Black soldier was taken to the hospital, rumors circulated in the neighborhood that he had been shot dead by the cop.

Smoldering resentment over segregation, police abuse, and commercial apartheid in Harlem reached a boiling point that night. This riot was even worse than the one in 1935, with six deaths, seven hundred injured, and upwards of $5 million in damage. Again, the primary target of the rioting were white-owned businesses in Harlem.

The residue of these urban uprisings was commercially and culturally catastrophic. White people became fearful of Harlem and stopped going there. Stores went bankrupt. Random street crime became an epidemic. In a single generation, Harlem had gone from being a majestic example of Black advancement to a major example of urban blight.

For jazz, the consequences were indelible. Some clubs remained, and some new ones opened up, such as Minton's Playhouse on 118th Street, which opened in 1938 and remains open to this day. But Harlem as the center of the jazz universe had been all but eradicated, and it wasn't coming back any time soon.

All that creative energy had to go somewhere. Jazz remained a creative force among both Black and white musicians, and the music's fan base had, if anything, moved more securely into the mainstream of

American culture. New York City was still the Big Apple, and jazz was still in demand. And so the locus of attention shifted and morphed from individual clubs to different pockets of the city, until, unexpectedly, organically, a new jazz district evolved in the center of Manhattan, on a raffish, rundown Midtown street that had once been home to a string of speakeasies and cheap bordellos.

Nobody had pre-designed West 52nd Street between Fifth and Sixth Avenues to be one of the most commercially concentrated and exciting jazz scenes to ever appear in the United States. There were no urban development commissions or corporate benefactors involved, unless you count the mob. In a way, organized crime provided the economic and cultural context that made it possible for 52nd Street to come into being, though it would take a few years for observers to recognize the telltale signs that the Street was at the nexus of the relationship between jazz and the underworld.

The clubs were mostly located in the basements or at street level of tenement buildings, many of which had been around since the previous century. Crammed side by side or located across the street from one another, the clubs had awnings and neon signs, with music that spilled out into the street any time someone opened the front door. There was a carnival-like atmosphere that could be found on other renowned music and entertainment thoroughfares—Bourbon Street in New Orleans, Beale Street in Memphis, or the Boardwalk in Atlantic City. Except that on 52nd Street, beyond the glowing neon and barkers outside the clubs touting the occasional burlesque dancer, there was a level of jazz taking place that was as serious and profound as anything that would ever exist. The Street was a jazz laboratory, and within the confines of these crowded, occasionally dingy denizens of booze and cigarette smoke, the music reasserted itself as the moody, nocturnal soul of a nation that was still in the act of inventing itself.

The Onyx, located initially at 35 W. 52nd, was one of the first clubs; it had opened back in 1927 as a speakeasy and then transitioned, post-Prohibition, into a jazz club. Like many nightclubs on the Street, the

Onyx seemed to relocate every few years to a different tenement building nearby, depending on building code violations, fires, or rent considerations. The Famous Door, another popular early club, opened at 35 W. 52nd after the Onyx moved, then moved to 66, 201, and then 56 W. 52nd. Jimmy Ryan's, a mainstay on the Street, uncharacteristically lasted at one location for nearly twenty years. Other legendary clubs included 3 Deuces, Club Downbeat, the Hickory House, Club Carousel, the Yacht Club, the Spotlight, and Kelly's Stable.

It was on 52nd Street in the late 1930s that Frank Sinatra first heard Billie Holiday, though it is hard to know exactly at which club. Holiday sang at both the Onyx and the Famous Door, and she was let go by both clubs due to lack of sufficient audience. Holiday was ahead of her time, her voice quirky and raw with emotion, unlike many popular singers at the time. Sinatra was one who understood immediately what he was witnessing. "It is Billie Holiday," he said, "who I first heard in 52nd Street clubs in the thirties, who was and still remains the greatest single musical influence on me."

Holiday did eventually emerge as a major sensation on the Street. In the early 1940s, she performed regularly at Kelly's Stable. By now, she had recorded "Strange Fruit," "God Bless the Child," and other timeless classics. In her band was an unknown pianist from Los Angeles named Nat Cole, who had his first singing gig one night when Billie called in sick, and the owner of the Stable convinced him to take her spot as lead singer. Cole was such a success that he was later given the nickname "King," and, as Nat "King" Cole, became one of the biggest draws in jazz history.

The Street was like that: Legends were being born nearly every night.

Sinatra never performed on the Street, but he came often to take in the talent. It was at the Famous Door that he first heard the Red Norvo Swing Sextet. Norvo was one of the first vibraphonists in jazz. With his group, he was able to create the full-bodied sound of a large orchestra but maintain the torrid tempo of a small group. For the next

thirty years, Sinatra called on Red Norvo to back him for live or studio gigs whenever the singer was ready to ditch the pop music and indulge his true love: jazz.

The Street was an environment for serious listeners. Musicians loved to hang out there, either to sit in with a group—if the chance arose—or simply experience the best jazz music of its day. As the Street grew in popularity, the serious listeners sometimes had to compete with the tourists and, during the war years, soldiers on leave.

One night at the Onyx, while listening to pianist Johnny Guarnieri, Sinatra told a loud customer in the club to "give it a rest." When the customer kept yakking loudly, Sinatra got up and punched the guy in the mouth. Guarnieri's band kept playing.

It was only a matter of time before the mob took an interest. In some quarters, jazz was so strongly associated with organized crime that it seemed only natural that hoodlums would have a vested interest in the clubs. There was money to be made through jukebox installation, cigarette machines, hat- and coat-check concessions, laundry services, liquor and food delivery, and at the door. Gambling was a subterranean presence, with bookies and loan sharks circulating in the clubs, and before long the Street was where you would go if you wanted to buy heroin—not necessarily in the clubs or on the street but to be directed to where a purchase could be made.

Few of the clubs, despite the drawing power of big names like Art Tatum and Count Basie, were extravagant money makers. Profit margins ebbed and flowed but mostly hovered at the break-even level. In many cases, club owners needed the mob to stay in business. Mobsters invested for the same reason they always had: The clubs were showcases for the mobsters, or a way to launder ill-gotten gains, or a way to enjoy the kind of music that had practically been the soundtrack of their lives since the days of Storyville.

As had been the case from the beginning of jazz and the dawn of organized crime, the musicians and hoodlums sometimes rubbed elbows. Billy Daniels, an African American singer who performed at numerous

52nd Street clubs—sometimes two or three different clubs in one night—didn't think much about the gangsters in his midst.

All the Murder Inc guys used to come into Mammy's Chicken Koop. Blue Jaw and Abe Reles and Pittsburgh Phil—their wives and girls hung around the joint. Pittsburgh Phil used to leave his girl with me, go catch a plane, rub somebody out, and come back. He carried a satchel, and believe it or not, I thought he was a salesman. Sweetest guy you ever want to meet. Nice, quiet, slip me a tenner, a twenty to sing something . . . We never had a bit of trouble with any of these guys . . . But then one day I opened a newspaper and I almost fainted. There they were—the whole lineup. All indicted, and I couldn't believe it. The attorney who knocked them out—was his name Burton Turkus?—used to come into the Koop, too. When I saw all those mugs in the paper, I thought I would faint. They were all good, regular customers.

As long as a musician didn't aggravate a gangster, there was little to fear. In some cases, the clubs became so familiar to the hoods they acted as if they were among friends and associates. This could be either good or bad. Sherman Edwards, a pianist who later became an award-winning Broadway composer, performed on the Street during and after the years of the Second World War.

When we came back to the clubs after the war, the influence of the underground criminal element was rather strong. I remember a club where we used to go into the kitchen between sets. There was a table where we played cards . . . What stands out vividly in my memory is a night when our card table was occupied by four or five hoodlum types. They were sitting and talking very quietly . . . And it was evident that they were talking about a contract to kill somebody. I remember hearing that the hit

would be made in the Williamsburg section of Brooklyn under the bridge—"and we'll leave him there in the car," one of the hoods said. We got out of the kitchen as quickly and as quietly as we could, despite our curiosity. Sure enough, about a week later, the papers carried the story of a Greenpoint mafia guy who was found full of bullets in an abandoned car under the Williamsburg Bridge. What we heard never got out of the club. We didn't talk about it to anybody, not even among ourselves.

Frankie Carbo was a notorious mobster and a regular on the Street. Carbo was the mob's man in charge of boxing at Madison Square Garden. After a major night of fights at the Garden, Carbo and his entourage would come over to the Street for some late-night jazz. Rumor was that Carbo had been trying to muscle in on the Famous Door and had even staged a robbery at the club. Robberies on the Street were rare, given that many of the clubs were partly owned by the mob. Physical altercations were also rare but did happen. Arnold Shaw, a former public relations man who went on to write a brilliant book about 52nd Street (originally titled *The Street that Never Slept*, later retitled simply *52nd Street*), described one of those nights at the Door.

A fight started between Carbo and another racket guy named Arnie Johnson. Club procedure was to push the guys who were fighting out onto the street. Outside, as the two were swinging at one another, a crippled fellow came by. He had no feet and no legs, just a torso on a skateboard. He propelled himself along by pushing against the sidewalk with his hands. Somehow he got entangled with the fighters. He tried to maneuver around them but could not. One of the guys kicked his board and almost turned him over. In desperation, he tried to run the guy down. At that point, a bodyguard pulled a gun and began aiming it at the cripple. But the cripple kept twisting and turning his board about so that the bodyguard could not take a shot.

By then, a crowd began gathering, and the fighters, who never liked witnesses, decided they had had enough.

It was just another crazy night on the Street.

Oh Angelina!

Louis Prima was the first performer to become a sensation on 52nd Street. He brought the spirit of New Orleans to the Big Apple, and the city would never be the same. A trumpet player and vocalist of great originality (though he would be the first to admit that he borrowed liberally from Louis Armstrong), Prima was brash and rambunctious. He was imbued with the holy spirit of his Sicilian mother, Angelina, whom, as a child, he watched perform in blackface at the King of the Zulus Mardi Gras parade back in Little Palermo. Prima never missed a beat. He retained what was useful from Dixieland, which experienced a revival in the urban cities of the north in the late 1930s, and, man, could he swing. In fact, he contributed mightily to the invention of swing by composing "Sing, Sing, Sing!," a tune that Benny Goodman and others turned into the biggest dance hit of the era. Opening at the Famous Door in 1935, Prima put that club on the map, filled with energy, enthusiasm, and a vaudevillian's sense of humor.

Prima harnessed the power of swing and brought it down to size, to be performed in clubs where the bump and grind of burlesque and striptease were not out of the question.

Prima's band was called the New Orleans Gang. With plenty of brass and Louis singing in his jivey, Satchmo-influenced style, the band was extravagant. With the addition of the brilliant Pee Wee Russell on clarinet, the New Orleans Gang was not only fun but hot beyond compare. As a group, they never broke tempo to play a sweet, romantic ballad; it was molten, gutbucket jazz from beginning to end. *Billboard* described the music as "savagely rhythmic, almost primitive in its quality." Thanks to live radio broadcasts from the Famous Door, "The Lady

in Red," "(Looks Like I'm) Breaking the Ice," and the band's signature song, "Let's Have a Jubilee," dominated U.S. jukeboxes throughout the late 1930s and into the 1940s.

But it wasn't only the music. As a performer, Prima personified the relationship between jazz and the underworld, at least the New Orleans version: Sicilians and Blacks cross-pollinating—and cross-breeding—to create entertainment that animated the dark, sexy corners of the American Dream. Onstage, Prima jumped around, grinned maniacally like a minstrel showman, and engaged in call-and-response with the band and the audience. He had tremendous carnal energy, which was appreciated by the many female fans who patronized his act. Sam Weiss, who served as host at the Famous Door, recalled: "When he shouted, 'Let's have a jubilee,' a lot of those sex-starved dames would practically have an orgasm. I think they thought he was shouting, 'Let's have an orgy,' in that hoarse, horny voice of his."

The Italian gangsters loved Prima. But not all the gangsters were Italian.

Both Prima and Pee Wee Russell were extorted by a couple of hoodlums who did not appear to be Italian. At knifepoint, the hoods demanded a weekly payment of $50 in protection money from Prima and $25 from Russell. The musicians had no intention of meeting this demand. Russell, who had once played at an event for none other than Charlie Luciano, in a moment of boldness contacted Luciano and asked if he could help. Luciano told Pee Wee that he would send over a couple of bodyguards.

The man who arrived in a chauffeur-driven car to protect Russell and Prima was a well-known gangster/psychopath named Louis "Pretty Boy" Amberg. With a high forehead, beady, close-set eyes, big ears, and a mouth that never smiled, Amberg could scare a man simply with a cold stare. He was a Russian Jew with a bad temper. In the show business world, he was known as the guy who had stabbed comic Milton Berle in the cheek with a fork. While performing his act at a club, Berle had made a joke about Amberg's date. The stabbing occurred later

that night, and the comic had to be rushed to the hospital to receive stitches.

Amberg was, as they say, "a real piece of work." But if you wanted someone to scare off a couple of hoodlums who were shaking you down for protection, Amberg would seem to be the right man for the job. Many years later, Pee Wee Russell recalled that "Prima sat in the back with Amberg and I sat in the front with the bodyguard . . . For a week they drove Prima and me from our hotels, picked us up for work at night, and took us home after. We never saw the protection money boys again."

The problem was, Pretty Boy Amberg now thought he was best pals with the musicians, especially Louis Prima, who was the biggest star on 52nd Street. Amberg would come to Prima's shows at the Famous Door. He demanded a prime table, and if Prima didn't come to talk with him between sets, he became offended and caused problems with the waiter.

Prima knew all about mafiosi; he had been schmoozing with Sicilian gangsters since he got his start in Little Palermo. But Amberg was implacable, a hardened killer with killer eyes and the charms of, well, a killer.

A jazz publicist who was a regular at the club recalled a night when things took a wrong turn:

> Once Amberg showed Louis the picture of a girl on whom he was sweet—Donna Drake, who later achieved stardom on the screen, and who was then a close friend of Louis's. Things came to an unanticipated head one afternoon when Louis answered a knock at his hotel door and found Amberg outside. Pretty Boy wanted to kill some time gabbing. While they were talking, Amberg spotted a framed picture of Donna on Louis's dresser. It had an inscription like, "To my dearest Louis." For a tense moment, Prima held his breath . . .

Suddenly, in a moment of divine intervention, it occurred to the jazzman that Amberg was also named Louis.

[Prima] handed the frame to Pretty Boy and apologized for not
having given it to him sooner. "Donna gave it to me one night
at the door to give to you," he explained.

Amberg looked at the picture, then looked at Prima. He said noth-
ing and left the room.

Prima had dodged a bullet. But a few nights later at the club, when
Prima did not perform a song that Amberg had requested, the gangster
punched the singer in the jaw.

It may have come as a relief to Prima when, not long after that, he
read an item in the newspaper that the dead body of Louis "Pretty Boy"
Amberg was found naked, bound, shot multiple times in the head, and
left in a car near the Brooklyn Navy Yard. The car had been set on fire.
At a press conference, a reporter asked the police chief if there were any
suspects. Said the chief: "Yeah. Brooklyn."

Louis Prima did not need this shit. He left New York for an extended
engagement in his home city of New Orleans and then continued on to
Los Angeles, where he found further fame and fortune in Hollywood. It
would be three years before he set foot again on the Street.

Dope

Through literature and movies, the rituals of a heroin user are familiar
even for those who have never touched the stuff: finding a fresh vein in
the crux of an arm, tightening a belt or rubber cord around the bicep
until the vein engorges, piercing the bulging vein with a hypodermic
needle and administering a shot that enters the bloodstream, sending
the user cascading toward an illusory world of sensual pleasures and inner
euphoria. It is said that a person can become addicted after the first hit.
Sometimes, they die from injections that are too pure, or, if the dope has
been cut, not pure enough. Smack flows through the system, disrupting
the personal narrative of individual users, but also, when administered
en masse, becomes part of the narrative flow of the human experiment.

In New York City, heroin had been creeping into the body politic since at least the mid-1920s, when Arnold Rothstein, Charlie Luciano, and Legs Diamond engineered what is believed to be the first large-scale importation of the product. Mezz Mezzrow claimed to have had his first experience with opiates in 1927 in Detroit. During the latter years of the Roaring Twenties, dope was in circulation. But it wasn't until the 1940s, with the onset of the Second World War, that the mass importation of heroin began to have a noticeable impact, primarily in New York, and even more specifically, in the neighborhood of Harlem.

The overseer of this phenomenon was likely Luciano, though it is hard to pin down. Following the killing of Rothstein in 1928, Luciano believed that he needed to secure what might possibly be the most lucrative single racket this side of booze. Many gangsters knew that the days of illegal booze were limited. At some point, the government and the people would realize that Prohibition was a ridiculously extravagant gift to the underworld, and it would all be ended by electoral fiat. Heroin, on the other hand, was presumably forever.

Having been born in Lercara, Sicily, and raised on Manhattan's Lower East Side, Luciano had a sense of entitlement. His lineage in the Honored Society could be traced to the Morello crime family, New York's first mafia family, which was based in East Harlem and downtown in Little Italy. In 1920, Luciano became a hitman for Joseph "Joe the Boss" Masseria, who had risen through the ranks of the Morello family. Luciano remained a loyal *soldati* until 1931, when he arranged for the murder of both Joe the Boss and his primary rival, Salvatore Maranzano.

Now that Luciano had eliminated the old "Mustache Petes," he ascended as the boss of a new kind of mafia, one with a "commission" of leaders, multiethnic affiliations with Jews, Irish, and African Americans, and a vision of national and even international expansion. What had formerly been known as the Morello crime family was now known to law enforcement as the Luciano crime family (and would later be called the Genovese crime family, one of New York's infamous Five Families).

Luciano saw heroin as a significant avenue of enrichment. Impor-

tation would not be a major problem. Since the mob largely controlled the docks through its infiltration of the International Longshoremen's Association (ILA), dope could be smuggled into the United States in large shipments.

Some mobsters were against it, recognizing the steep legal penalties and potential social devastation. It was recognized that heroin should not be peddled into white working-class neighborhoods. Black and Latino neighborhoods would be targeted. The problem was how to distribute the product at the street level. Potential customers in Harlem were not going to purchase the product from white mafiosi; it had to come from within.

Luciano had anticipated this problem. From the day he eliminated the Mustache Petes, he had not only established links but met face-to-face with top hoodlums in Harlem, most notably Bumpy Johnson.

A former underboss in the bolita numbers organization of Madam Stephanie St. Clair, Johnson was the Godfather of Harlem. Having come of age as a criminal during the Harlem Renaissance, Johnson was on a first-name basis with the neighborhood's most renowned jazzmen. His connections to the social world as well as his mastery of the street is what drew Luciano to Johnson. Initially, their partnership had to do with bootlegging and numbers—a street-level racket that was stronger than ever. If Harlem were to serve as a central marketplace for heroin, men like Bumpy Johnson were the key.

Luciano and Johnson met numerous times to discuss their future enterprises together, but as often happens in the underworld, events interceded. Johnson was convicted on an assault charge and sent off to prison. In 1936, Luciano was tried and convicted for prostitution and given a sentence of thirty to fifty years in prison.

Though these two men were now out of the picture, the criminal underworld was still driven by an entrepreneurial imperative, and that imperative dictates that you can't keep a good racket down. There was money to be made. Vito Genovese, an up-and-coming mafioso from Little Italy, part of Luciano's organization, took up the mantle of the dope business.

The onset of the war provided the mob with a golden opportunity. Genovese, who was on the lam in Italy in avoidance of a murder charge, formed a relationship with the fascist government of Benito Mussolini. Having friends in high places made it possible for Genovese to organize one of the world's most thriving black markets. Genovese was able to begin smuggling heroin from Turkey, by way of Sicily, into the United States. Later, when Allied forces invaded Italy in 1943, Genovese switched sides and offered his services to the U.S. Army. While based in Naples, Genovese was appointed to a position of interpreter/liaison at U.S. Army headquarters. He was still smuggling heroin, and he was also a trusted employee of the Allied Military Government of Occupied Territories (AMGOT).

Dope entered New York through the harbor, and it was stored in warehouses in the Bronx, Brooklyn, and Harlem, just as booze had been a generation earlier. Elsewhere in the United States, it arrived in Philadelphia, Boston, Cleveland, Detroit, Los Angeles, and other port cities where importation was managed by the ILA. Heroin was offloaded and distributed in those cities, or smuggled overland by trucks under the auspices of the International Brotherhood of Teamsters, another union that was heavily infiltrated by organized crime. Through these well-worn routes, dope made its way into ghetto neighborhoods in U.S. cities from coast to coast.

Dope hit at the community level, and then it hit the nightclubs, and then it hit the musicians. Jazz had always been a target. Shooting up became fashionable. Some musicians felt that it enhanced their playing, while others felt that it lowered the stress of an uncertain financial path, nocturnal lifestyle, capitalist exploitation, or racism. Some musicians got high for the same reason that nonmusicians did: Because they could.

Dope washed over 52nd Street, especially in the years immediately after the war. It seemed to fit the film noir tenor of the times: multicolored neon signs glimmering off the rain-slicked pavement, a torrid piano solo, the slow swirl of smoke rising from a cigarette clipped on the neck of a sax, as the player waited to take his turn at the mic.

Many musicians got hooked; some did time in jail on narcotics charges, and some overdosed and died. Bud Powell, Dexter Gordon, Stan Getz, Thelonious Monk, Miles Davis, Jackie McLean, Anita O'Day, Chet Baker, Art Pepper, and others took the plunge. Among the most visible was Billie Holiday, whose drug habit was an open secret; and Charlie Parker, the greatest musician of his era, who became notoriously unreliable, showing up late for gigs or not showing up at all because he was nodding off somewhere or out trying to score.

Drummer Max Roach remembered a time when he was playing in Dizzy Gillespie's band at 3 Deuces. At the time, the band was the hottest act on the Street. It was the dawn of bebop, the latest and newest manifestation of a music that periodically reinvented itself. Bebop was ferocious and polyrhythmic, with complicated chord changes, sometimes atonal melodies, and a quirky sensibility (especially when played on the piano by Monk) that was not for everybody. Bebop was an act of rebellion. Older musicians found it difficult to play. Louis Armstrong, in an interview in *DownBeat*, referred to bebop as "Chinese music," meaning that it was incomprehensible. "These young cats now they want to carve everyone else because they're full of malice, and all they want to do is show you up, and any old way will do as long as it's different from the way you played it before. So you get all them weird chords which don't mean nothing . . . Soon they'll get tired of it because it's really no good and you got no melody to remember and no beat to dance to."

In the late 1940s, Dizzy Gillespie's band emerged as the epitome of bebop, largely because of the band's alto sax player, Charlie Parker. Bird, as he was known, had hands that floated over the keys of his instrument like a hummingbird, with feverish, daring chord changes and an ability to blow that made other horn players want to genuflect. He was the patron saint of bebop. Bird also had a monkey on his back. According to Roach:

Bird came in late and instead of coming right in and going to the bandstand—we were on the bandstand playing—Bird

came in, went right to the bathroom . . . Diz went to the bathroom which had swinging doors and was right next to the bandstand . . . He peeped over the stall where you sit down, and Bird was obviously in there shooting some shit. Diz came out the door . . . "Do you know what that muthafucka is doing?" he said. "He's in there shooting shit." It hit the microphones, and it went through the whole house to the speakers.

It was no secret that Charlie Parker was a junkie, or Billie Holiday, or many other musicians who had fallen under the sway of heroin's seductive and destructive might.

Finding where to purchase the stuff was not difficult. Miles Davis, in his autobiography, recalled that he and other Black musicians usually headed north to Harlem, because they preferred buying their dope from a brother or sister rather than a white man, who might just turn out to be an undercover narc.

One place you could score was in the lobby of the Cecil Hotel, which was connected to Minton's Playhouse. Davis remembered how he and other musician friends would get high and watch the tap dancers.

There was a lot of dope around the music scene and a lot of musicians were deep into drugs, especially heroin. People—musicians—were considered hip in some circles if they shot smack . . . We'd buy three-dollar caps of heroin and shoot up. We'd do four or five caps a day, depending on how much money we had . . . In the daytime, outside Minton's next to the Cecil Hotel, tap dancers used to come up there and challenge others on the sidewalk. I especially remember duels between the dancers Baby Laurence and a real tall, skinny dude named Ground Hog. Baby and Ground Hog were junkies, and so they used to dance a lot in front of Minton's for their drugs, because the dealers liked to watch them.

One of the preferred dealers at Minton's was Dillard "Red" Morrison, a local organized crime figure of great renown. Morrison had once been an underling of Bumpy Johnson but he'd branched off to establish his own heroin connections. His center of operation was Minton's, where he was famous because he had once thwarted a robbery there. Two gunmen had come into the club near closing time and attempted to rob the register. Morrison just happened to be there drinking. He jumped one of the robbers and disarmed the man. He and some others proceeded to beat the robber into a bloody pulp. Ever since that incident, Red Morrison could do no wrong at Minton's.

Morrison had a certain look: He dressed well, conked his hair, and doused himself with fine cologne. His style would later be perfected by the actor Billy Dee Williams. Mayme Johnson, Bumpy's wife, referred to him as "mean, handsome, and ambitious as hell . . . Lord help me for saying it, but Red Dillard Morrison was the best-looking man I've ever set eyes on."

Born and raised in Alabama, he was a country Negro who reinvented himself as one of the "classiest" pimps in Harlem. He could take a poor, frumpy young woman from the streets and turn her into a glamorous piece of arm candy. And then he would treat the woman like dirt, taking most of her earnings for himself to finance his drug business.

At Minton's, bebop was king, and Red became friendly with many of the most renowned practitioners at that time. Monk, Bird, bassist Charles Mingus, and others bought their dope from Red Morrison or one of his minions. Morrison was revered by the beboppers. It was said that Miles modeled not only his look but his street attitude on Morrison. For a time, Red served as arm candy himself for the singer Carmen McRae, who was drawn to his good looks and hoodlum charms. Being a dope peddler in Harlem had no negative connotations. From the outside, Morrison might have been viewed as a merchant of death, a pimp and peddler of an illegal product that destroyed lives. At the street level, he was a prince who delivered an essential product that musicians used to facilitate the bebop revolution, one of the most adventurous

and profound of all jazz derivations, a movement that was fostered at Minton's and in the clubs on 52nd Street.

To the musicians, dope was merely a fact of life. And some resented that it was used to demonize the Black community. Sure, it was sold in the clubs and at the street level by men like Red Morrison, but from whom did they get the product? Most everyone knew that the mafia was the mastermind and chief supplier of dope in the ghetto. "I mean, we couldn't get the drugs if white people wasn't selling any," said saxophonist Budd Johnson, a popular sideman of the bebop era. "We don't have the money to afford to buy it in quantities like that in order to distribute. All of your big distributers gotta be white. They make it a big business."

Like other well-known Harlem gangsters, Red Morrison had a criminal career that involved stints in prison for crimes such as pimping, assault, narcotics possession, and distribution. He was never convicted of murder, though he was believed to have been involved in more than a few. His rivalry with Bumpy Johnson was the stuff of legend. Occasionally, the two gangsters would draw down on one another, resulting in shootouts in the streets in the middle of the day. As Mayme Johnson put it, "Red didn't like Bumpy, and Bumpy didn't like Red, but the two of them would later admit that they did truly admire one another. But I'm sure one of them would have killed the other if Red hadn't gotten busted on a cocaine charge in early 1950."

Morrison died in prison. Johnson served various prison stints and always returned to the neighborhood to resume his gangster ways, until he died of congestive heart failure in 1968. It seemed as though all of Harlem was at his funeral, including many jazz musicians. Vocalist Billy Daniels, who was a regular at Minton's and passed the time with Murder Inc on 52nd Street, was the featured entertainer at the funeral reception. In a smooth, elegant baritone, Daniels sang the song that had come to personify a romanticized version of the relationship between the hoodlum and the musician, that old gangster favorite "My Buddy." According to Bumpy's widow, Daniels's rendition of the song brought many mourners to tears.

10

"JAZZ PROVIDES BACKGROUND FOR DEATH"

The leading lights of organized crime in America had often dreamed of establishing a base of operations in Havana, Cuba. Back in the late 1920s, during the glory days of Prohibition, mob bosses from around the United States made the pilgrimage to Havana: Al Capone from Chicago, Johnny Lazia from Kansas City, Moe Dalitz of the Mayfield Road Gang (Cleveland), Santo Trafficante Sr. and Jr. from Tampa, Meyer Lansky and Vincent Alo with interests in New York and South Florida, Frank Costello—the list goes on and on. Music was always part of the attraction. The first American jazz band to play in Cuba was the Paul Whiteman Orchestra, which played at Hotel Presidente and at the Jockey Club in 1928. This was also the year that Capone, Lansky, Lazia, Costello, and other mobsters made their first trip to Havana. Some American musicians settled in Havana in the 1920s. Radio broadcasts from the United States were also available in Cuba; native musicians heard the great orchestras of Ellington, Lunceford, Goodman, and Basie. Thus began a cross-pollination that would, in the decades ahead, result in another derivation, or genre of the music, known as Latin jazz.

The Jockey Club was located in Marianao, on the outskirts of

Havana, on a compound that included the Oriental Park Racetrack and the Gran Casino Nacional, with a spectacular water fountain at the entrance. Lansky, in particular, was intoxicated by what he saw (and for a man who barely drank alcohol, that was saying a lot). For Lansky and an entire generation of mobsters, Havana's elegant melding of gambling, drinking, dancing, and music became a major inspiration—one that took hold long before the thought of a similar arrangement way out west in the Nevada desert was even a twinkle in anyone's eye.

In 1933, Lansky first set his sights on the man he believed might be able to help make his dreams come true: Fulgencio Batista, who at the time was a thirty-two-year-old soldier who had just taken control of the Cuban military through an internal coup known as "the revenge of the sergeants." Cuba had been ruled by a series of dictatorships in which the military was the true ruling power on the island. Batista was now ensconced. Given his youth and skills as an orator, as well as his physical attractiveness (his nickname was *el mulatto lindo*, or the "handsome mulatto"), it appeared that he would be in power for decades to come.

In a hotel room in Havana, Lansky presented Batista with a large suitcase filled with $3 million in cash. Batista liked what he saw. The deal was that Batista would allow the American mob to begin constructing hotels, casinos, and nightclubs in Havana. The $3 million was a down payment. There would be more to come if Batista could get himself into a position of power that would help make Lansky's plans a reality.

It was a smart investment on Lansky's part; it seemed he had backed the right horse. Batista not only led the military for years, but he also eventually became the Cuban president. His time in power had, in political terms, been so successful and thorough that in 1944 he retired from politics. Still relatively young at age forty-three, he had accomplished everything he had hoped for, so he moved to Daytona Beach, Florida, with a new wife (who had previously been his mistress) in anticipation of a life of leisure.

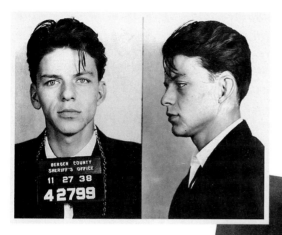

Frank Sinatra at age twenty-three, arrested on charges of "seduction and adultery" in Bergen County, New Jersey.

(Getty Images)

Sinatra in 1942, singing with the Tommy Dorsey Orchestra.

(Hoboken Historical Society)

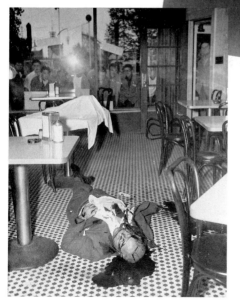

Willie Moretti was Sinatra's first mentor in the mafia, and then, in 1951, he got whacked.

(Getty Images)

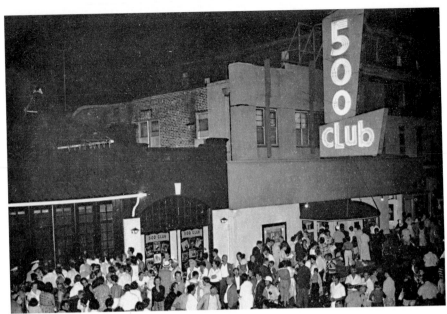

The 500 Club in Atlantic City, owned and operated by Paul "Skinny" D'Amato, was one of the most renowned jazz venues on the East Coast.
(Getty Images)

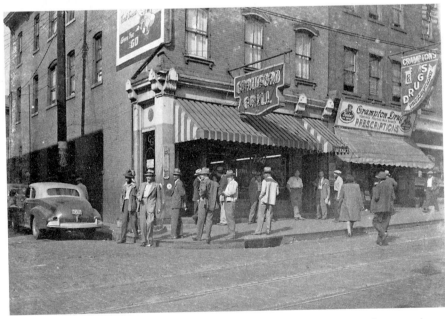

In Pittsburgh's Hill District, the Crawford Grill was a popular jazz spot where numbers runners, bookies, and gangsters liked to hang out.
(Carnegie Museum of Art, Charles "Teenie" Harris Archive)

Bing Crosby had a fascination with Chicago gangster Jack McGurn. They were briefly golf partners.
(*Wikimedia Commons*)

In the years following Prohibition, Charles Luciano and Meyer Lansky (center, left to right) were architects of the mob's expansion into many aspects of American commerce. One highly lucrative racket was the jukebox business, which the mob controlled from coast to coast. The mob later made inroads into the recording business.
(*Everett/Shutterstock*)

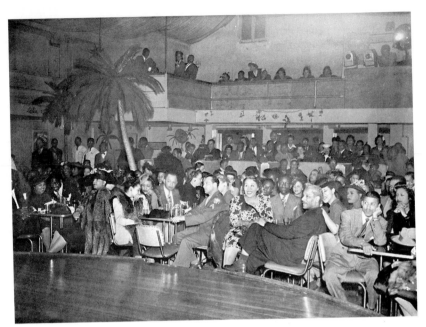

Few jazz scenes were more active than the Central Avenue District in Los Angeles during the 1940s. Club Alabam was one of the most popular venues.
(Los Angeles Public Library/Shades of L.A. Collection)

Gangster Mickey Cohen owned a piece of numerous clubs on Central Avenue. He ran his business like a plantation, where the musicians were chattel and he was the boss.
(Associated Press)

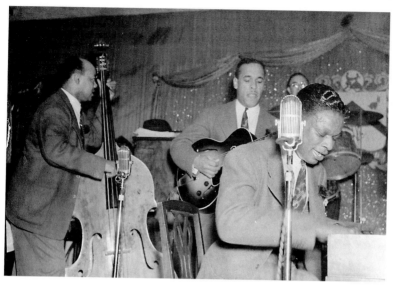

Pianist/vocalist Nat King Cole was a fixture in all the great jazz scenes where the gangsters ruled, from L.A. to Las Vegas, New York, and Havana.
(*Library of Congress, William P. Gottlieb Collection*)

In the late 1940s, heroin hit the jazz world like a tidal wave. Many great musicians got hooked, including Thelonious Monk (far left).
(*Library of Congress, William P. Gottlieb Collection*)

The man who brought dope to the United States, Vito Genovese.
(*Library of Congress*)

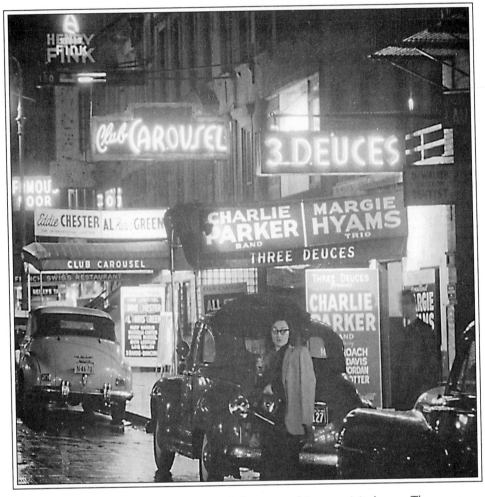

Perhaps the greatest jazz scene of all time, 52nd Street in Manhattan. This photo was taken in 1948, when the street was lined with clubs. Today, there is little physical trace that they ever existed.

(*Library of Congress, William P. Gottlieb Collection*)

Trumpet player and singer Louis Prima dealt with gangsters during a career that stretched from New Orleans to 52nd Street, Los Angeles, and Vegas.
(Library of Congress, William P. Gottlieb Collection)

Louis "Pretty Boy" Amberg.
(Library of Congress)

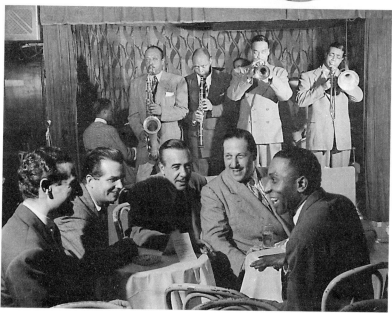

At the Famous Door nightclub on the Street, circa 1947, a band led by tenor sax master Ben Webster (standing left) holds the stage, while at the table, musician Cozy Cole regales "the boys" with stories.
(Library of Congress, William J. Gottlieb Collection)

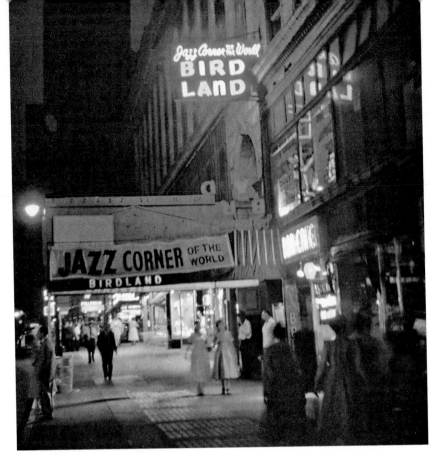

Birdland, owned and operated by Morris "Mo" Levy, was one of the most mobbed-up clubs in history. It was also one of the most musically progressive.

(Leo T. Sullivan Collection)

Miles Davis was beaten bloody by a policeman while standing in front of Birdland. The average Black musician had more to fear from a cop than a gangster.

(Getty Images)

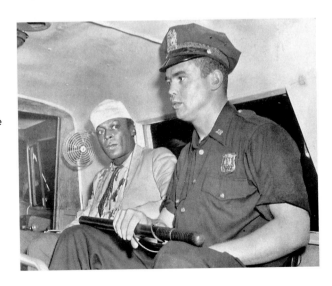

Mo Levy, seated in his office at Roulette Records, his highly lucrative recording label. As he once said to an artist, "You want royalties, go to England."

(Richard Carlin, Wikimedia Commons)

By the 1950s, the uneasy alliance between the gangster and the jazz musician was showing signs of wear and tear. Artists were tired of being ripped off by gangster/ businessmen like Mo Levy and others. For master pianist Art Tatum, it seemed that in the clubs there was always a gangster standing over your shoulder.

(Gjon Mili/The LIFE Picture Collection/Shutterstock)

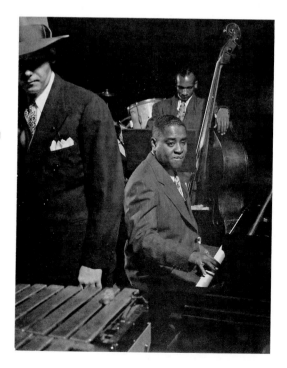

Meyer Lansky took the lead in making Havana, Cuba, a dream come true for the mob.
(*Library of Congress*)

In 1950s Havana, the mob achieved its longtime goal of a jazz and gambling paradise in Cuba.
(*Getty Images*)

Latin jazz reinvigorated the music. Conga player and composer Chano Pozo was a transformative figure, until he was murdered in Harlem at the age of thirty-three by his marijuana dealer.
(*Herman Leonard*)

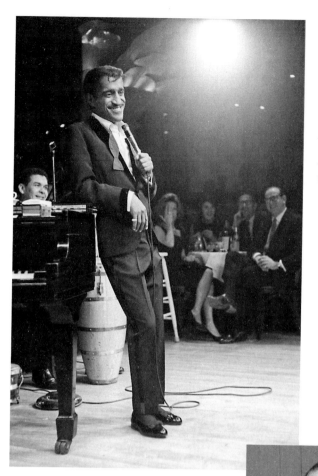

The Copacabana was perhaps the most mafia friendly of all the New York clubs. Sammy Davis Jr. always filled the place, though he endured many racial indignities while performing there.

(Getty Images)

Jules Podell, who managed the Copa, had such a thuggish personality that the mob considered removing him because he was bad for business.

(Getty Images)

Mary Lou Williams, a brilliant pianist, had ups and downs in a long career that spanned all the major jazz eras. In the end, she transcended the dark side of the business.
(*Library of Congress, William P. Gottlieb Collection*)

The jazz business was especially treacherous for women. The musicians were mostly men, the club owners and managers were men, and the gangsters were all men. Even big stars like singer Sarah Vaughan were constantly taken advantage of.
(*Library of Congress, William P. Gottlieb Collection*)

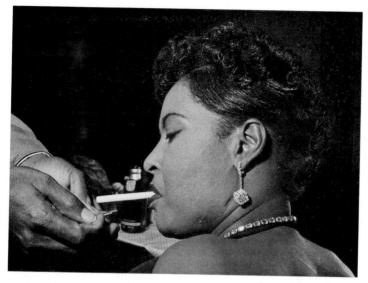

Billie Holiday was tough, but the jazz world, when combined with the
underworld, fed her addictions and sucked the life out of her.
(Leigh Wiener Photography)

By the 1970s, the
music recording
business had shifted
from its traditional
bases in New York
and Chicago to Los
Angeles, where
conglomerates
like MCA traded
on long-standing
connections with
the mob—in MCA's
case, its roots in the
Chicago outfit.
(Getty Images)

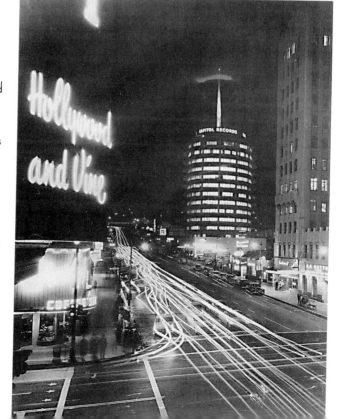

The Sands Hotel and Casino in Las Vegas was created with Frank Sinatra in mind. The club inside the hotel was called the Copa Room, and the entertainment director was Jack Entratter, who was imported from the Copacabana in New York.
(*Getty Images*)

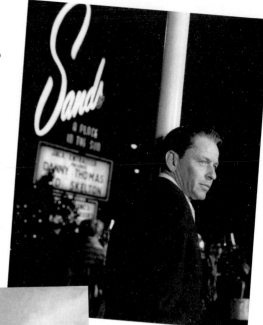

Whenever Nat King Cole played the Copa Room at the Sands, the place was packed.
(*University of Nevada Las Vegas Library*)

Notorious mobster Sam Giancana, seen here with girlfriend Phyllis McGuire, lead singer of the McGuire Sisters, was a secret financial partner of Sinatra's at the Sands, and in other business and political ventures as well.
(*Associated Press*)

Mo Levy was called "the Octopus" by *Variety* because of his far-reaching control of nearly every aspect of the music business. It was only a matter of time before the FBI took an interest, which it did, with a criminal investigation that lasted more than a decade.

(Getty Images)

For years, mafia boss Vincent Gigante wandered the streets in pajamas and a bathrobe, laying the groundwork for an insanity defense. At the same time, he partnered with Levy in the criminal exploitation of the music business. Eventually, both were arrested and convicted.

(Getty Images)

Sinatra and the boys, circa 1988. The singer had an ownership stake, along with various mafiosi, in the Westchester Premier Theater, where this backstage photo was taken. Some of the most powerful mobsters in America, including Paul Castellano (far left), Carlo Gambino (third from right), and Jimmy "the Weasel" Fratianno (second from right), are seen in this photo.
(*FBI Photo*)

Satchmo says goodbye. When his longtime manager Joe Glaser was on his deathbed, Armstrong visited him in the hospital and allegedly said, "I'll bury you, you motherfucker."
(*John Loengard/The LIFE Picture Collection/Shutterstock*)

As for his deal with Lansky and the American mobsters, it had seemingly died on the vine. Charlie Luciano's conviction and imprisonment in 1936 had thrown a wrench into the plans. Then came the Second World War, which, given the binational nature of Lansky's scheme, put things on hold. The mob had not given up on its plans for Cuba—at least Lansky had not—but like all great plans, patience was required.

With the end of the war on V-J Day, September 2, 1945, Lansky started dreaming about Cuba again. As a new plan began to formulate in his head (one of Lansky's rules was that he never put anything down on paper), it was clear that it would have many moving parts. Numerous people within the orbit of the mob would be called upon to help bring the plan to fruition. And one of those people was Frank Sinatra.

For years, the mob had been waiting for an opportunity to call in its chits with Sinatra. Gangsters had helped Frank in his dispute with bandleader Tommy Dorsey. In the three and a half years since then, Sinatra had gotten to know some of the biggest names in the underworld. He dined with Willie Moretti and Frank Costello in New York. In Los Angeles, where he now lived, he was on a first-name basis with Ben Siegel and Mickey Cohen. The singer had practically adopted the Chicago outfit as his *paisano*, especially the Fischetti brothers, Rocco, Joe, and Charles, cousins of Al Capone who were originally from Hoboken (Sinatra had not yet met the mafioso with whom he would become most associated, Sam Giancana).

These relationships went well beyond mere acquaintances. Sinatra did not hide the fact that he had great admiration for underworld figures. Some saw it as a kind of hero worship. Said singer Eddie Fisher, a contemporary of Sinatra, "Frank wanted to be a hood. He once said, 'I'd rather be a don of the mafia than the president of the United States.' I don't think he was fooling."

The assignment was as follows: The mob needed to smuggle a large amount of cash into Cuba. Because of the amount ($2 million, the equivalent of $23 million in today's dollars), it would be undeclared.

The cash would be placed in a suitcase, in neatly stacked bills. It would be somewhat heavy, but not too bad.

Sinatra would be able to get the money into the country. Because he was a celebrity, he would not have to go through customs. Surrounded by bodyguards, he would be waved through the airport in Havana.

No one was supposed to know that Sinatra was in the country. He would proceed to the Hotel Nacional, the city's most prestigious hotel, where he would be checked in under a false name. He would then deliver the suitcase to a fellow guest at the hotel who was also residing there under a false name. That person was Charles Luciano.

The means by which Luciano had arrived in Havana had been a top-secret undertaking. Less than two years earlier the boss of the mafia had unexpectedly been released from prison, after serving nine years on his prostitution conviction. The circumstances of his release were part of a process that, at the time, was known to very few people.

It all began at the height of the war, when the United States military became concerned about the sinking of American military vessels in the Atlantic Ocean by German U-boats. The government came to believe that many United States ports of call, especially along the Eastern Seaboard, had become infiltrated by German spies. Since it was widely believed that the mob exerted control over the longshoremen's union and the docks, the United States Navy came up with the idea of reaching out to the mob to be its eyes and ears on the waterfront.

United States Naval Intelligence first contacted Meyer Lansky to make the pitch. Appealing to his sense of patriotic duty, the navy asked Lansky if he could enlist the support of mobsters on the waterfront. Lansky said that the only person who could authorize such a thing was Charlie Luciano, who currently resided at Dannemora prison in upstate New York.

As a preliminary step, Luciano was moved from Dannemora, in the far northern reaches of the state, to Great Meadow Correctional Facility, located in the town of Comstock, closer to New York City. This was explained to the imprisoned mob boss as a routine transfer. He had

no idea what was going on, until the day he was told he had visitors. Those visitors turned out to be Lansky, his lawyer, and the commander of U.S. Naval Intelligence. The pitch was made: As a patriotic American, would Luciano allow for the mob to serve as covert military agents along the waterfront?

Luciano knew a gift horse when he saw one: Ingratiating himself with the United States military might just get him out of prison early. He pledged his full cooperation with the U.S. war effort.

The results were immediate, as German secret agents were arrested in Long Island, Florida, and Chicago. Eventually, attacks on Allied ships at sea decreased dramatically. Later in the war, Luciano, at the behest of the navy, also supplied the United States Army with important logistical information in support of the July 1943 invasion of Sicily.

Throughout Luciano's top-secret cooperation with military intelligence, there had never been a quid pro quo arrangement that the mob boss would be released early from prison. Nonetheless, when the war ended, Luciano's attorney applied for a grant of executive clemency for his client based on his exemplary cooperation with the war effort. After much legal wrangling, Governor Thomas Dewey—the very man who had, as district attorney, convicted Luciano at trial—acceded to his release.

It seemed as though Luciano's nickname—Lucky—had taken on new meaning, but upon his release the mob boss learned there was a catch. Yes, he was a free man, but he would not be allowed to reside in the United States. He was deported back to Sicily, the place of his birth, and forbidden from ever setting foot in the country again.

Luciano was angry at being deported as a common "undesirable," but his childhood pal Meyer Lansky was there to soothe him. Visiting Luciano in Italy, Lansky cautioned: *Cool your heels for now, Charlie. Soon enough, we'll smuggle you into Havana. All your friends will be there for a gathering of the tribe. And you can expect to receive a big cash delivery and possibly a private performance from someone who owes us all a big favor—that skinny gavone from Hoboken, Frank Sinatra.*

Sinatra arrived on February 11, 1947. As he disembarked at the airport in Havana, he was flanked by Al Capone's cousins, Rocco and Charlie Fischetti. At 145 pounds dripping wet, Frank struggled with the oversized valise that contained the $2 million in cash. Still, he wasn't about to let anyone else carry it; he would hand deliver the suitcase to the man himself.

Sinatra and Luciano had never met before, though they both felt a kinship since Sinatra's people came from the same town—Lercara, Sicily—where Luciano was born.

By the time Sinatra got there, a big mobster conference had already taken place. Six weeks earlier, during the Christmas and New Year's holiday season, twenty-two of the most powerful underworld figures in America had met to talk business, eat, drink, and take advantage of Havana's many amusements—including gambling, prostitution, and fabulous musical floor shows at the Tropicana nightclub. Also, in smaller clubs around Havana, there was no shortage of jazz with a Latin beat. It was like the glory days of Prohibition, only sexier, and it was all legal and out in the open.

Along with Luciano, Lansky, and the Fischetti brothers, in attendance at the mob conference were Willie Moretti, Vito Genovese, Frank Costello, Moe Dalitz, Santo Trafficante Jr., and Albert Anastasia, among others. The conference took place over three days in a banquet room at the Hotel Nacional. The mobsters would first enjoy a massive feast, then light up cigars and discuss business.

The major points of discussion were, number one, to welcome Charlie Lucky back into the fold as boss. Most of these men had not seen Luciano since he was sent away to prison ten years earlier. The second most important topic was Cuba. Lansky laid it all out for his partners, how they would construct in Havana a series of hotels, casinos, and nightclubs unlike anything seen outside of Monte Carlo. The skim from the casinos alone would make them all rich. With a friendly government in Cuba (one of the costs of doing business would be under-

the-table payoffs to the Cuban president), they would be beyond the reach of U.S. law enforcement. They would be untouchable.

The final topic of discussion was what to do about Bugsy Siegel. At the same time the Havana conference was going on, the mob's Las Vegas project was also in development. Out in the Nevada desert, various hotel/casinos were being constructed, and the biggest and most expensive of all was the Flamingo. Managing the construction and opening of the Flamingo had been put in the hands of Siegel. By late 1946, it was clear that Siegel was in over his head. The project was millions of dollars over budget, with no clear end in sight. The only question was whether this was a case of mismanagement or outright thievery. The mob had done something they normally did not do: They hired private investigators to look into the project's finances. The conclusion was that there was definitely skimming going on. Was it being done by Siegel or by his lady friend Virginia Hill? A bona fide hustler in her own right, Hill had been depositing substantial funds designated for the Flamingo into an overseas bank account.

Inside the banquet room at the Hotel Nacional, the decision was made that Ben Siegel, one of the founding fathers of the mob, would have to be whacked.

By the time Frank Sinatra arrived in town with his suitcase filled with cash, some of the mobsters had returned to the States. Hearing that Sinatra would be performing for the boys, most of them got on a plane back to Havana. In a private show at the Hotel Nacional, the most popular singing star in America performed exclusively for the cream of the American underworld.

For the few days that Sinatra was in Havana, he and Luciano were nearly inseparable. They were seen together at the racetrack, the Gran Casino Nacional, and out on the town together. They also partied indoors.

According to a report hidden away in the files of the Federal Bureau of Narcotics (the precursor to the Drug Enforcement Administration),

at some point during Sinatra's stay in Havana, he and Luciano took part in an orgy together. The details were corroborated by Robert Ruark, a syndicated columnist who was the first to report on Sinatra's arrival in Cuba. An informant later told the FBI, who also kept a file on Sinatra, that "a planeload of call girls" had been sent to Havana courtesy of the Fischetti brothers. They were supplied for "a party at the Hotel Nacional attended by Sinatra." Along with Luciano, another guest at the party was Al Capone's older brother Ralph.

In the midst of a ribald bacchanalia, somehow a contingent of Cuban Girl Scouts escorted by a Catholic nun were allowed to visit Sinatra's suite. According to an account preserved in the files of the Narcotics bureau, the Girl Scouts were there to present Sinatra with an award of some sort and had been allowed past security "through a series of disastrous mistakes by various personnel." The call girls were quickly hidden away in a back bedroom. When the Girl Scouts entered the suite, there were bottles on the floor, lingerie was hanging from lampshades, and the air was filled with the stench of stale perfume. Sinatra entered the front room in a robe and silk scarf as if nothing were wrong. The ruse was exposed when four naked bodies fell giggling into the front room. The nun and her charges quickly left the room in a state of shock.

The following week, columnist Ruark filed a story, dateline Havana, which appeared in numerous U.S. newspapers. Although he left out the part about the orgy, in his attack on Sinatra, Ruark revealed for the first time in the media that Lucky Luciano was living in Havana:

> I am puzzled as to why Frank Sinatra, the fetish of millions, chooses to spend his vacation time in the company of convicted vice operators and assorted hoodlums . . . He was here for four days last week and his companion in public was Luciano, Luciano's bodyguard, and a rich collection of gamblers . . . There were considerable speculations of a disgusted nature by observers who saw Frankie, night after night, with Mr. Luciano at the Gran Casino Nacional, the dice emporium, and the racetrack.

The article was explosive. Outside of the mobsters and their closest allies, nobody was supposed to know that Luciano was in Cuba, especially the U.S. government.

Back in the States, Sinatra issued a statement that read, in part: "Any report that I fraternize with goons and racketeers is a vicious lie."

In the long history of jazz and the underworld, numerous musicians had fraternized with mobsters, but few had entered into such an intimate dance with the devil. Sinatra was charting new territory, and there was no turning back.

Birdland Presents

The scene on 52nd Street had been as epic as any of the great jazz eras in history, but like those other eras in New Orleans, Kansas City, Newark, Pittsburgh, Los Angeles, and elsewhere, it all came and went in a relatively short period of time. The clubs sprouted up on the Street in the late 1930s, proliferated during the war years and directly after, but by 1949 they were nearly all gone. It took some months to fully realize what was happening. In the past, like a bebop version of now-you-see-me, now-you-don't, clubs closed at one location and then reopened somewhere else down the block or across the street. Now they were closing and not reopening anywhere. And the clubs that remained open were transitioning into sleazy strip clubs and clip joints.

Leonard Feather, the influential British-born jazz critic who wrote for *Metronome*, noted: "The Street's reputation has been blackened by . . . its fringe of dope addicts, dope peddlers, pimps, prostitutes, and assorted characters." *DownBeat* ran an article with the headline "The Street Just a Dead Alley Again."

Some felt that it was mobster infiltration of the clubs that drove a dagger through the heart of the Street. Narcotics (marijuana and heroin), prostitution, gambling (bookies, numbers, and dice games), and graft turned the business side of things into a drag. Periodic raids and arrests put a damper on the good times. Wrote Arnold Shaw, "The hoods

who came as customers and stayed as partners demonstrated the relevance of Gresham's Law about bad money driving out good. Only it was vice, not money, that spread like an inkblot and eventually blotted out the greater profits that came at first."

Behind these critiques and postmortems was the usual touch of WASP moralism. Drugs, sex, and jazz were linked and then cited as the reason for the Street's decline, when, in truth, those were the very elements that had established the scene as edgy and exciting. A far more relevant death knell for the Street was its attractiveness to real estate interests. It had always seemed anachronistic that 52nd Street existed as it did in the first place. Located in Midtown Manhattan not far from Times Square, the Street could not survive the postwar development boom. Starting with Rockefeller Center, the twenty-two-acre complex on West 51st that opened in 1939, the area was hit with the real estate equivalent of the Blitz. One by one, the old tenements that housed the clubs were demolished, to be replaced by massive concrete and later glass office towers. In a few short years, not only were the clubs obliterated and one of the most vibrant jazz scenes gone, but there was little trace that it had ever existed in the first place.

A host of mobsters may have sunk their fangs into the Street and sucked it dry, but they were no match for the Rockefellers and other developers. They altered the physical landscape in a way that made it seem as though the Street had been nothing more than a figment of the imagination.

Even so, jazz was not dead. The Street had fostered and nourished the music in such a way that it could not be denied. A question remained: Was there any economic model by which musicians, business interests, and mobsters could still make beautiful music—and make money doing it?

In 1949, the same year 52nd Street ended as a viable jazz district, there opened in Times Square a club, just blocks from the Street, that would be considered an inheritor of the legacy. Located at 1678 Broadway, just north of 52nd Street, Birdland was named after Charlie Parker,

the guiding light of modern jazz. The proprietor—or at least one of the proprietors—of Birdland was Morris "Mo" Levy. Another was Joseph "Joey the Wop" Cataldo, whom the FBI knew to be a member of the Genovese crime family and a heroin dealer.

Cataldo put up the money that made the club possible, but Mo Levy and his older brother, Irving, would be the day-to-day managers of the place. In defiance of the belief that jazz clubs were on the way out and no longer profitable, Birdland thrived. For the next sixteen years Bird-land hosted perhaps the greatest array of jazz artists and styles to ever be showcased by one club, and, at least for a time, made a profit while doing so. In contrast to most of the clubs on 52nd Street, Birdland was an interracial establishment where not only Black musicians predom-inated but Black clientele were also welcome. This would contribute to Birdland's eventual stature as one of the most cutting-edge enter-tainment venues in the city, where celebrities like Marlon Brando, Ava Gardner, Sugar Ray Robinson, Jack Kerouac, Norman Mailer, and Igor Stravinsky went to be seen.

Birdland was also perhaps the most mobbed-up club in history, with an owner—Mo Levy—who set the standard in thuggish business prac-tices that blurred the line between gangster and businessman.

Born August 27, 1927, Levy would never know his father, who died of pneumonia when he was one year old. He and his brother Irving were left with a mother who suffered from various ailments, including lockjaw, which necessitated the removal of her front teeth so that she could eat. The mother had a hard time holding down steady work, and the boys were left to fend for themselves. Morris, in particular, became a difficult student. In the 1930s, in junior high school, he was once made to stay after class by a female teacher who called him a troublemaker. According to Levy, "I got up—I was a big kid—took her wig off her head, poured an inkwell on her bald head, and put her wig back on her fucking head. Walked out of the school and said, 'Fuck school.' Never really went back to school after that. I was sentenced to eight years in reform school by the children's court."

Levy never showed up for reform school. Instead, he ran off to Florida and landed his first job in a nightclub as a hat-check boy.

Hat- and coat-check concessions were among the myriad of ways that the mob profiteered off night clubs. Holding a person's hat or coat for a small gratuity was a surprisingly lucrative racket. Various mob factions engaged in bidding wars for control of these concessions in nightclubs all over the United States. A young kid like Levy could do well for himself and also establish working relationships with some nefarious characters. "When I was fourteen or fifteen I worked for people that were in the mob because they were the people that owned the clubs. They liked me because I was smart, I was hard working, and I was a tough kid." Working in the clubs, Levy learned about life. "In those days, even the judges and politicians would kiss [the mobster's] ass . . . They'd want to be seen with these guys. If you wanted to be somebody, you came in contact with them."

Returning to New York City in his late teens, Levy was already a nightclub veteran. He advanced up the ladder to working as a darkroom boy. At the time, an additional sideline business at the clubs were the camera girls who would take flash photos. The photos were developed right there in a small darkroom on the premises. Levy's darkroom skills were such that he could have the photo ready in fifteen minutes.

He was a big kid, over six feet tall by the time he was nineteen. Though he was Jewish (his nickname at the clubs was Moishe, the Yiddish version of his name), he carried himself like an Italian mafioso. His gravelly voice was more mobster than the mobsters. His speaking style was punctuated with profanities and tough-guy jargon right out of Damon Runyon. Between his budding knowledge of the ins and outs of nightclub operations, and his cultivation of underworld figures who admired his chutzpah, it didn't take long for Levy to emerge as an owner.

The mob backed the opening of his first club, the Royal Roost, located on Broadway at 47th Street. The club focused on bebop; Dexter Gordon, Charlie Parker, and Miles Davis all played there in the opening week. The Roost pioneered the concept of a double bill, two major

acts performing back-to-back on the same night. And also, in order to establish a strong following among a young clientele, the club set up a bleacher area for those who were not old enough to drink. The admission charge was the same, but you could forgo the two-drink minimum. For a few bucks, you could take in the best live music in town.

Within the first eighteen months of operation, the Royal Roost was so successful that Levy and his partners went looking for a larger space, which they found a few blocks north. With Charlie "Bird" Parker established as a living legend, they named the new place after him.

On December 15, 1949, the night Birdland opened, Levy was twenty-two years old. Unlike the Royal Roost, his new club was not an immediate success. With a seating capacity around five hundred, it was bigger, with higher rent and a much larger overhead. Thus, Levy kept his day job: He ran a bookie operation out of an office at the club—that is, until he was arrested in May 1950. Levy was found to have in his possession "a sheet of paper bearing the names of horses, amounts wagered, and the identity of players." Levy was given the option of thirty days in jail or paying a $250 fine. He paid the fine and returned to the club.

Birdland's awning and stylish neon signage claimed that the place was "The Jazz Corner of the World." Down a flight of stairs, sans windows, the club held the promise of an intense musical experience. Like the Royal Roost, Birdland provided a separate area (the "bleachers") for nondrinkers. There were booths along the walls and seats up front for serious listeners. The room was cozy though not unduly cramped. It was, in many ways, the perfect jazz club.

The shows were hosted by Pee Wee Marquette, a three-foot-nine-inch tall African American who usually dressed in a tailor-made tuxedo. Marquette spoke in a high-pitched voice with a slight southern accent (he'd been born in Montgomery, Alabama). His style was sometimes comically florid, with an exaggerated sense of theater that added a carnivalesque element of levity to what were often serious displays of modern jazz. Birdland was a club for aficionados.

Shows at the club were broadcast nightly by Symphony Sid, a

popular deejay who maintained a small booth in the back of the club, from which he interviewed musicians between and after sets. Many seminal live recordings were made at Birdland over the years, by a Who's Who of 1950s jazz artists including Charlie Parker, Art Blakey, George Shearing, Stan Getz, Lester Young, Sarah Vaughan, Lennie Tristano, Count Basie, and John Coltrane.

A booth to the right of the stage was where the mobsters normally sat. This contingent included not only Joey the Wop, who was a silent partner, but members of the Bronx-based Genovese crime family, who would become integral partners in Mo Levy's business ventures. They included, at times, Vito Genovese, the boss of the family, and Dominic Ciaffone, an underboss and co-financier of Birdland. The presence of prominent mafiosi brought undercover FBI agents and investigators, making the club feel, at times, like a crossroads of the underworld.

Roulette Records

To some, Mo Levy was a glorified hood; to others, he was a jazz visionary. An argument could be made on both accounts. There emerged in the 1950s what would become an ongoing discussion about what constituted serious jazz. Was the music intended to be frivolous, toe-tapping entertainment, or was it a serious art form? Birdland offered mostly the latter. Levy understood that true jazz fans were drawn to authenticity, not trends and fashions. From a business perspective, steady money was to be made by appealing to hardcore aficionados.

It was a booking philosophy that paid off for Levy. As a brand, Birdland became identified with progressive, adventurous jazz. Levy was able to take certain acts on the road and, under the Birdland banner, put on shows in large theaters and showrooms. With four or five acts on the bill, all under the rubric "Jazz Stars of Birdland," these shows were, throughout the early and mid-1950s, highly profitable for Levy. Many of these shows were broadcast live on the radio and recorded as albums. Levy copyrighted the Birdland name so that, unlike in the past when

various Cotton Clubs and Plantation Clubs sprang up around the country, Levy owned the rights to his club's name. He opened a branch of Birdland in Miami in December 1953, insisting that the club be open to all, regardless of race. Wrote *Jet* magazine:

> When Birdland opened its canopied doors on ultra-swank Miami Beach, Jim Crow went out the back door. Negro and white jazz fans sat side by side in mixed groups for the first time in Florida history . . . Such toppling of racial barriers in the South—along with enticing salaries—are encouraging previously reluctant Negro performers to accept more club engagements below the Mason-Dixon line.

The spreading of the Birdland name inspired Levy to expand his operations into virtually every aspect of the business, including recording, composing, publishing, concert production, promotion, and management. As Levy's tentacles spread, he became more thuggish in his methods, more inclined to rip off an artist, to deny them their financial due and to cut corners. He founded a music-publishing company called Patricia Music. Having started his career running hat-check and photo concessions, Levy understood that there was money to be made out of nickels and dimes. Patricia Music became notorious for stealing revenue streams from clients that they didn't even know existed.

The granddaddy of all Levy's business ventures was Roulette Records, founded in 1957. In the ecosystem of the music business, a record label was the great white shark, with far more lucrative revenue potential than a nightclub. Roulette established Levy as a titan in the business and a gangster in disguise. Announcing to his Genovese family investors that "publishing is where the money is," Levy made sure he received a songwriting credit on his artists' records, whether he wrote the song or not (usually not). He denied his artists royalties, saying to them, "If you want royalties, go to England." Up front, he warned his clients, "I might fuck you on a contract, but I always keep my word."

The Roulette offices took up four floors of a building located at Broadway and 50th Street, two blocks from Birdland. A neon sign announced "Roulette Records—Home of the Stars." Office employees, business partners, and visiting artists took note of the fact that Levy's mafia partners were a regular and highly visible presence. Dominic Ciaffone, whose nickname was Swats Mulligan, officially owned 5 percent of Roulette Records. He also cooked pasta in the office's kitchenette and served meals in Levy's executive suite, where mafiosi routinely met to kibitz and make deals.

Bob Thiele, a jazz producer whom Levy hired to work at the label, found the atmosphere unnerving. He wrote:

A few minutes in the office corridors or reception area was all anyone needed to be aware that Roulette was a small subsidiary of a vast international mega conglomerate that never filed with the Securities and Exchange Commission, and whose board of directors and shareholders met in clam bars in Brooklyn, Las Vega, Naples, and Palermo . . . The miasmal hoodlum atmosphere at Roulette Records was so heavily oppressive that it was often difficult for me to concentrate on the musical matters that were my direct and only responsibilities . . . Every day I felt I was improbably and inescapably trapped in a grade B gangster epic.

Thiele was a pro who had worked at some of the most prestigious labels in the business. Though he recognized that Levy was, at minimum, a gangster wannabe, and possibly an actual made member of organized crime, he appreciated that he was mostly left alone to do good work. At Roulette, Thiele was able to accomplish something about which he had always dreamed, a collaboration between Louis Armstrong and Duke Ellington, whom the producer considered to be the two greatest living practitioners of jazz. Under Thiele's guidance, Roulette released two Armstrong-Ellington collaborations, *Together for the First Time* and *The*

Great Reunion, believed by many to be among the most important jazz albums ever recorded.

That was Roulette Records in a nutshell: on the cusp of greatness, and down in the mud.

Business managers, agents, and artists who stopped by the company offices later told stories of beatings they had witnessed. Bud Katzel, a sales director at Roulette, recalled the time a record producer tried to collect on money that was owed him.

> Bob Krassnow lived in San Francisco and had a local hit record he couldn't seem to spread . . . Morris picked up the record and made it a hit single . . . Of course Bob never saw a dime and couldn't get Morris on the phone. So he hopped on a plane to New York. Not knowing how "connected" Morris was, he stormed into the office and asked to see him. When told Morris was busy, Bob pushed his way past the secretary, walked right into his office, and said, "Morris, Bob Krassnow. Where's my fucking money?" Morris went into his drawer, pulled out a .38, and said to Bob, "Look you motherfucker, I'll give you five seconds to get out of my office or I'll blow your fucking brains out all over the carpet. And furthermore, don't ever let me see your face again." With that, Bob walked out.

With methods like these, why would anyone want to do business with Morris Levy?

One answer was to be found in the thinking of Louis Armstrong and other jazz musicians, which had become the thinking of most anyone and everyone in the music business: If hoodlums dominated the business, why not have the biggest hoodlum of all at your side?

There were other reasons as well.

One of the musicians who signed with Roulette Records and quickly became part of Levy's stable was Count Basie. In 1949, Basie had disbanded his orchestra. After the passing of 52nd Street, where he

had maintained a semi-regular residency for years, Basie downsized to a group he called the Kansas City Seven. Billy Eckstine, the singer and bandleader, had said to Basie that conducting a small group was like playing miniature golf. Basie might have agreed, but he, like other big bandleaders, had succumbed to the financial realities of the business. There weren't many clubs willing to book a fifteen-piece orchestra.

Enter Mo Levy.

The boss of Roulette Records understood that Basie was a one-of-a-kind entertainer. He was a preserver of the Kansas City sound—he could swing with the best of them—but he also had credibility with the beboppers. On top of all that, there were few performers more enjoyable to watch than Basie. He was a cool cat and an elegant hipster whose minimalist style on the piano was rendered with a sly joie de vivre. There was a reason that Sinatra and everyone else in the jazz universe wanted to collaborate with Basie: He was a joy to work with, listen to, and watch do his thing.

Levy suggested to Basie that he put his big band back together. The pianist was startled. Usually it was the club owners and businessmen who told him he needed to downsize, that they couldn't afford to book his big band. Levy was suggesting the opposite. But by 1957, Levy had certain advantages that other record label owners did not. If Basie signed with him on Roulette, Levy could showcase his band at Birdland, arguably the most prestigious jazz club in the world. He could then guarantee the Basie band multiple recordings, including a live album recorded at the club and studio recordings that he could promote through his label.

Levy had another advantage with Basie, one that, as a former bookie and quasi-gangster, he knew how to manipulate. Basie was a notorious gambling addict. He tended to lose far more often than he won. Trumpeter Clark Terry was among those who recognized the problem: "Basie had lost his ass playing horses . . . He'd blown so much bread on those ponies that he was working his behind out of debt . . . He had problems like that all his life."

Said jazz composer and arranger Quincy Jones, "Basie was the worst gambler that ever hit the planet, man. The worst." Jones remembered a time when he was gambling with the bandleader in Las Vegas. "Basie would [bet on roulette] five hundred dollars on everything from one to thirty-six, double zero, zero, red, black, odd, even, first, second, third, twelfth. I said, 'Basie, I don't know how to do this, but mathematically that doesn't work at thirty-five to one.' He said, 'I know what I'm doing, man. I've been doing this a long time. Just watch what I'm doing.' And I followed his ass, and I lost $150,000 the first week."

Much to the chagrin of members of Basie's band, due to his gambling habit he was inclined to accept whatever deal came his way. He was sometimes late in paying the band as well as paying his own everyday expenses. On the bandstand and in the clubs, Count Basie was jazz royalty, but out on the street he was a scuffling, perennially in need gambling junkie.

Levy put Basie to work, but he also fronted the pianist money knowing full well he would gamble it away and thus be deeper in debt. It was a form of indentured servitude.

Sometimes, from a jazz perspective, the results were golden. In 1957, Roulette released Count Basie's *Atomic Café*, considered to be among the greatest big band albums ever produced. *Atomic Café* not only revived Basie's career as a bandleader, it also assured his legacy as one of the greatest stars in the entire jazz pantheon.

There were other less noble collaborations. Not long after the album's release, Levy coerced Basie to take part in one of his sleazier efforts to grease the wheels of record promotions in his favor. At an annual convention of radio deejays in Miami, Roulette put up the money for a lavish all-night barbecue that the *Miami Herald* described as an orgy of "Booze, Bribes, and Broads." Buying off deejays in a manner later described as "payola"—a criminal offense—was becoming a common practice in the music business, thanks in part to Mo Levy. Besides throwing the all-night barbecue, Roulette rented a hotel ballroom where deejays from around the country could gamble on a roulette wheel that seemed

to always fall in their favor. "I was a little naïve," said one participant from out of town. "I was betting blackjack and losing but they kept paying me. I said, 'But I lost. Why are you giving me this stuff?'"

Levy also bussed in prostitutes from New York to talk up the latest Roulette releases while keeping the deejays company.

The entertainment that evening was Count Basie and his orchestra. Levy got the most out of his star client: After playing the gig in Miami, Basie had to rush back to New York to fulfill an engagement the following night at Birdland.

Basie was indebted to Levy, in more ways than one.

Despite Levy's reputation for thuggery and questionable business practices, musicians knowingly signed with his record label, partly because it gave them access to extended engagements at Birdland. Even as other forms of popular music—country western, folk, rhythm and blues, and the earliest inklings of rock and roll—began to make headway in the commercial marketplace, Levy remained loyal to jazz. Bud Powell, Dinah Washington, Sarah Vaughan, and other musical luminaries signed exclusive contracts with Mo Levy and Roulette Records. Some would live to regret the day.

The Right to Live

There were a myriad of ways a jazz musician could get squeezed in the 1950s. The proliferation of record labels was a minefield. Recorded music and albums presented numerous opportunities for an artist to get screwed without even knowing it. For the average musician, whether bandleader or sideman, live performances remained the simplest way to make a living, but that also could be fraught with pitfalls.

Most cities required some form of licensing for musicians to work in nightclubs. The most onerous was in New York City, recognized by now as the jazz capital of the world. Since 1926, the city had imposed some form of cabaret licensing but it wasn't until 1940 that the process expanded to institute the concept of a cabaret card, which was ad-

ministered by the city's police department. It was a vaguely humiliating process, as it was possibly intended to be. Every two years, a cabaret entertainer—primarily musicians but also dancers and comics—were required to report to the police department's licensing division to be photographed and fingerprinted. Since most jazz performers were African American, it carried a stigma of criminality. If an artist was charged with a crime of any kind, or had legal matters outstanding, they were denied a cabaret card and thus denied the opportunity to make a living.

For some musicians, having their card revoked was a death sentence. New York was one of the few cities in the United States where a jazz musician could make a steady living, and it was highly dependent on the gig culture, playing the clubs four or five nights a week. Having your card taken away meant that it could not be reinstated until a musician was again up for licensing; this could be weeks, months, or even the full period of two years.

By design, the musicians who suffered the most were drug addicts, or at least those who were unlucky enough to get pinched on drug charges. Narcotics use was identified in society as the "scourge of the ghetto." As a councilman from Brooklyn put it, "The people of this city would feel a little easier if they knew that performers had been O.K.'d as people of good character."

The entire process was characterized by corruption and graft. A musician could possibly avoid losing their license by making an under-the-table payoff to the licensing division. In later years, when the cabaret card system came under investigation, it was noted that fees levied on entertainers went into the Police Pension Fund.

Some musicians lived in fear of this system, and others simply resented it. Trombonist J.J. Johnson, who was not a heroin user, once lost his cabaret card when he was arrested while carrying a needle for someone else. Musicians who were known to be addicts were targeted by the police. Billie Holiday, Thelonious Monk, and Charlie Parker all lost their cabaret cards when they were at the peak of their creative and earning potential. That these three artists were also known to be

struggling with mental health issues did not matter to the cops. A cabaret performer who was an addict could be forced into a corner; they either paid off the licensing division or lost the ability to make a living for an extended period of time. It was all part of a larger system of servitude that made some African American jazz musicians feel as though they were still living on the plantation.

Monk and Holiday paid an extremely high price. Both had to deal with criminal narcotics charges and were not able to work in New York clubs for extended periods of time—in Holiday's case more than a year while at the height of her popularity. Even after she served a prison sentence and "paid her debt to society," the institutional intransigence of the system could not be swayed.

The artist who paid the highest price of all was Charlie Parker. In 1946, Bird had moved with Dizzy Gillespie and his band to Los Angeles, where they found steady work. On July 29, Parker was arrested after a drug-induced altercation with a hotel manager. He was committed to Camarillo State Hospital for six months, a stay that was commemorated in "Relaxin' in Camarillo," recorded in Los Angeles by Charlie Parker's New Stars a month after his release. A move back east in April 1947 was followed four years later by his New York City cabaret card being revoked for two years, due to drug abuse. It was a devastating blow.

Parker did jail time, and he was prohibited from practicing his art. His life spiraled downward. When he couldn't get his hands on dope, he drank prodigious amounts of alcohol. In a letter to the New York Liquor Control Board, Bird pleaded his case: "My right to pursue my chosen profession has been taken away, and my wife and three children who are innocent of any wrongdoing are suffering . . . I feel sure that when you examine my record and see that I have made a sincere effort to become a family man and a good citizen, you will reconsider. If by any chance you feel I haven't paid my debt to society, by all means let me do so and give me and my family back the right to live."

Bird did get his cabaret card reinstated, and then it was revoked again. Treatment during a 1954 voluntary commitment at Bellevue Hos-

pital after two suicide attempts did not lead to any improvement of his health. He continued to produce some of the most dazzling sounds on his alto saxophone that jazz fans would ever hear. The joys were transcendent, but the stress and disruptions were ruinous.

On March 12, 1955, while watching the Tommy Dorsey show on television in the apartment of a friend, Parker died from a heart attack brought on by advanced cirrhosis of the liver and a perforated ulcer. He was thirty-four years old at the time of his death, though the coroner estimated that he had the body of a fifty-five-year-old man.

The cabaret card system lived on for another decade. It was done away with in 1967, thanks in part to Frank Sinatra, who wrote to the New York City Council:

> For many years, I have denied myself the privilege and enjoyment of playing before New York audiences in nightclubs because I have refused to submit to the demeaning requirement that New York has imposed on entertainers. It has been difficult for me to understand why the city of New York, which aspires to be the entertainment capital of the world, has continued to treat people who work in cabarets as second-class citizens.

The cabaret card system existed as an institutional byway of the underworld, a racist con game disguised as civic leadership and law enforcement on behalf of the common good. The truth was something uglier. In this instance, the shackles of servitude were eventually broken, but the plantation remained in effect.

Half Past the Unlucky

Mo Levy wasn't seen nearly as often around Birdland as he used to be; Roulette Records took up most of his time. He advanced from being a mere club owner to being a mogul, and in so doing he spread the mentality of the underworld into every aspect of the music business. He

was not alone. His was a mentality that originated in Black Storyville, at Matranga's; it thrived in clubs all around the United States during Prohibition and beyond, and it sought to capitalize on each and every technological advancement in music recording and distribution. Levy was driven. He genuinely believed he was being fair when he said, "The music business is like a big pie. There are slices for everyone. You don't fuck with my piece; I don't fuck with yours." And there was no doubt whose slice was the biggest.

The day-to-day management of Birdland was left to Irving, his brother. Irving had some of the same personality characteristics as Mo. A former member of the U.S. Navy, he ran the club with an iron hand. The bassist Charles Mingus related to an author how he saw Irving push musicians down the stairs when they were late for a set, yelling, "Get down the stairs, nigger." Mingus also claimed to have witnessed a fight between a cop and Max Roach in late 1952 or 1953, saying that Birdland's bouncer held Roach while the cop hit him. Inside the club, Irving was in charge. If anything, his attention to detail was superior to his brother's. One of his duties was to oversee the parameters of vice allowable at the club.

According to accounts of the era, there were heroin sales and prostitution going on at Birdland. For management, the idea was to monitor and control these undertakings so that they did not exceed what was allowable and agreeable to management and to the police. Once a month, officers from the NYPD's 54th Precinct came to the club's office to pick up an envelope stuffed with cash. In part, these payments were to guarantee that the club would not be hassled, but this arrangement involved a set of rules. Regarding vice, the club could designate a set number of dope and vice operators. Anything beyond that, it was understood that the police would come down hard on violators. This meant that Irving Levy and other club managers needed to maintain a strict eye on the potential for violations.

On the early morning of January 26, 1959, the Urbie Green Big Band was playing a late set. Around two thirty, Irving approached a

woman he believed was a prostitute and asked her to leave the club. The man who was with her began arguing with him. There was a momentary scuffle, then the man pulled out a knife and viciously stabbed Levy in the gut. The man and the woman quickly left the club. Levy staggered from the bar to the service area/kitchenette, where he collapsed, bled out, and died in a matter of minutes.

The band and most club patrons had no idea what had happened. Hal McKusick, a sax player with the band, described the scene:

> I had just started my alto sax solo when we heard a fight start near the bar. We could hear shouting and scuffling but the bandstand lights were in our eyes and we couldn't see what was happening . . . As the scuffle continued, we went into our finale—"Cherokee"—a real wild arrangement. A woman yelled. Some glasses crashed. We finished the number, left the stand, and learned Irving was dead.

It took a while for the press and police to piece together what had happened. Initial reports suggested that it was perhaps a case of mistaken identity—the real target had been Mo Levy. The younger Levy had made many enemies and was known to have many disreputable partners. Maybe Mo had finally stepped on the wrong toes. The Long Island–based newspaper *Newsday* reported that "Morris Levy had been [previously] involved in scuffles with patrons. In one instance, he threw out a man who had cut his ear with a knife. In the other, he was flung through a glass doorway by a customer. Police refused to disclose the reasons for the fights."

A later report stated that Mo's ear had been cut only a few weeks before Irving's death, in an incident with a customer over the paying of a bill. The FBI, in a later investigation, was told by an informant of a stabbing of an unidentified man that occurred at Birdland "some months before Irving Levy was killed." Said the informant, "After his recovery, [the man] was summoned to a 'meeting downtown.' At the

meeting, he was told that this stabbing was to be forgotten and nothing further was to be done." The informant noted that Dominic Ciaffone (aka Swats Mulligan) was present at that meeting, as were other members of the Genovese crime family.

Eventually, Irving's killer was identified as Lee Schlesinger, a pimp and low-level hood, who on the night of the stabbing was out on bail for having previously shot a tavern owner in Yonkers. Schlesinger claimed he had stabbed Levy in self-defense.

Many still wanted to believe that the killing involved a mob hit-man and a case of mistaken identity. Even Mo was not so certain. The death of his brother inside the establishment both had founded was a shocker. The brothers had been close. With the early death of their father and a mother who was nearly incapacitated, they had practically grown up together as orphans. They looked out for one another. Mo was distraught, but also circumspect. There were rumors he had fled the United States for Israel, though there was no evidence to support that. He did hide out in Miami for a while.

The killing of Irving Levy received major coverage in the press. In many ways, it conjured up aspects of jazz and the underworld that were easy to sensationalize. United Press International described Levy's assailant as "a hopped-up jazz enthusiast." The Associated Press, in an article that was picked up by many newspapers, opted for an almost cosmic note of guilt by association, with the headline: "Jazz Provides Background for Death."

A *Newsday* reporter found it coldhearted that the club reopened only a few nights after Levy's death. Echoing the hard-boiled ethos of *The Sweet Smell of Success*, an irresistibly cynical film noir about Manhattan nightlife released one year earlier (with a jazzy musical score by the Chico Hamilton Quintet), the reporter concluded his article this way: "In this sanctuary, a murder turns no heads. It is slick and hard, it is the city, it is Birdland."

11

THE GHOST OF
CHANO POZO

The American mob of the postwar era was not your grandfather's mob. Localized mafia organizations in cities like New Orleans, Kansas City, St. Louis, and others did still exist, but they were now part of a much larger tapestry. Luciano, Lansky, Costello, and Siegel all envisioned a world in which the Mustache Petes of yesteryear represented *il vecchio modo*, "the old way," an outdated Italian ballad played by Luigi the organ grinder with his monkey at his side. In this day and age, the mob was to be a corporation connected not only by geography but by criminal ambition. Nightclubs and the music business played a role, as did labor racketeering, loan sharking, political corruption, and gambling, all of which were now connected by a series of underworld alliances that infected every region of the country.

The gambling activity was what caught the attention of Senator Estes Kefauver of Tennessee. Partly because he himself was a gambler. Meyer Lansky called the senator on it when they first met in a private backroom session. "What's so bad about gambling? You like it yourself. I know you've gambled a lot."

"That's quite right," answered the senator, "but I don't want you people to control it."

You people.

Kefauver was a proud WASP who once campaigned for office in a coonskin cap. Lansky took the "you people" comment as an anti-Semitic jab and launched into a defense of his Jewishness. But Kefauver meant it as a more generalized form of slander aimed at the Italian, Irish, and Jewish gangsters who formed the bulk of witnesses who were to be served with subpoenas to appear before his senatorial committee.

The Kefauver hearings, conducted by what was officially known as the Senate Special Committee on Organized Crime in Interstate Commerce, were designed to be a barnstorming tour, with subpoenas served and public and private sessions held in many major cities throughout the United States. In seeking to expose the existence of an underworld commission governed by mobsters in various jurisdictions, it was unprecedented in scope. There were public hearings in Los Angeles; San Francisco; Chicago; St. Louis; Covington and Newport, Kentucky; New Orleans; and other cities. In South Florida, hearings in Miami exposed Lansky's carpet joints in Broward County and the police and judicial corruption that made them possible. The casinos were abruptly shut down.

Throughout 1950 and 1951, the hearings garnered media attention from coast to coast. The grand finale was expected to take place in New York City, with Lansky, Frank Costello, Willie Moretti, and others having been served with subpoenas to appear before the committee.

With his wire-rimmed spectacles and folksy southern demeanor, Kefauver recognized the public relations appeal of his efforts. In many localities, the hearings were televised live. Given the newness of television and its power to harness a mass audience, the committee searched far and wide for potential witnesses who might make for riveting viewing.

Joseph Nellis, a member of Kefauver's legal counsel, was startled when the chairman, in early 1951—eleven months into the committee's investigation—handed him an envelope that contained a dozen eight-by-ten glossy photos. They were all pictures of Frank Sinatra. "I almost fell off my chair," Nellis later recalled. "I opened the envelope and saw a picture of Sinatra with his arm around Lucky Luciano on

the balcony of the Hotel Nacional in Havana. Another picture showed Sinatra and Luciano sitting at a nightclub in the Nacional with lots of bottles having a hell of a time with some good-looking girls. One picture showed Frank getting off a plane carrying a suitcase, and then there were a couple of pictures of him with the Fischetti brothers, Lucky Luciano . . . Kefauver wanted to know more about Sinatra's relationship with Luciano, who was running an international narcotics cartel in exile."

Perhaps Sinatra should not have been surprised when his lawyer contacted him to say that the Kefauver committee wanted to question him. Though the singer routinely denied accusations that he was affiliated with mobsters, the rumors persisted. Recently, a gossip item had appeared in the *Los Angeles Herald* claiming that Frank had paid off a mafioso named Jimmy Tarantino to squelch a story about his involvement in a rape.

Sinatra balked at the overture from the Kefauver committee. Already, his career was in the midst of a precipitous decline. In August 1947, he had punched out Lee Mortimer, a gossip columnist with the Hearst newspaper chain who for years had taunted Sinatra with accusations that not only was he a fellow traveler of the mob, he was also a communist sympathizer. Sinatra decked the diminutive Mortimer at Ciro's supper club on Sunset Boulevard, a favored hangout for movie stars and mobsters such as Ben Siegel and Johnny Roselli. The altercation became a major media scandal, with the singer being arrested on assault charges and eventually reaching a settlement with the columnist wherein he paid a sizable cash penalty and issued a public apology.

At the same time, Sinatra's marriage was going down the tubes. His many public dalliances with starlets such as Lana Turner and Ava Gardner (whom he eventually married in November 1951) were chronicled by Mortimer and other gossip columnists. The singer's brazen affairs came off as a cruel public humiliation of his first wife, Nancy. Frank and Nancy formerly separated on Valentine's Day, 1950, and divorced in October 1951.

After a couple of years of unrelentingly negative press, Sinatra was concerned that his career could not withstand being dragged into the middle of a three-ring circus such as the Kefauver hearings.

Committee counsel Nellis offered a compromise: If Sinatra would come into the office for a private session, outside the prying eyes of the public, it was possible he could avoid public testimony. If, accompanied by his attorney, he submitted to questions from Nellis, the committee might be convinced that his appearance would be of no use to their investigation.

Reluctantly, Sinatra agreed.

The meeting took place on March 1, 1951, in Midtown Manhattan. So that no one would know it was happening, the parties involved met in the wee hours of the morning, at four o'clock, at a law office on an upper floor of Rockefeller Center on West 51st Street. The irony would not have been lost on Frank. He had first seen Billie Holiday sing at a nightclub on 52nd Street, a block away. The club where she performed was likely one controlled by the mob, as were many of the clubs on the Street. And now Frank was back in the area to deny that he knew or had any significant dealings with known criminals.

Kefauver was not present. Nellis, the committee's chief counsel, noticed that Sinatra looked "like a lost kitten, drawn, frightened to death . . . He kept shooting his cuffs, straightening his tie, and he smoked constantly . . . He knew that I was going to ask him about Willie Moretti and Lucky Luciano, but he didn't know about all the photographs that I had. He also didn't know that I had a report about a rape he had allegedly been involved in and the blackmail that had reportedly been paid to keep that story from ever being published."

As nervous as he was, Sinatra tried to strike the proper note of indignation. He was certain that he had broken no laws, he said, and he was getting tired of having to answer for every mafioso who crossed his path. It was nothing more than Italian American guilt by association. The singer had been putting forth this argument for a few years now. Issued as a statement to be published in the press, it was a good

argument. It was a tougher position to adopt when presented with photos and documentation of his traveling with the Fischetti brothers and cavorting with Luciano.

With a stenographer present, Nellis asked Sinatra a series of questions about his February 1947 trip to Havana. Frank explained that he had met the Fischettis by coincidence in Miami a few days before that trip. He knew Joe Fischetti from the previous year, having met him in Chicago when the singer was performing there. Joe introduced him to Rocco and Charlie. That night in Miami, Sinatra recalled, "I said to Joe, it is too cold. I think I am going to get out of here and go where it is warm. I said I think I will go down to Havana."

"Did you have any business with any of the Fischettis?" Nellis asked.

"Not an ounce," Sinatra replied. "[Joe] told me they had also contemplated going to Cuba. I think the next day he called me on the phone and wanted to know when I was going down to Cuba. Apparently, at that time I probably did say what morning I was going, either the following morning or the morning after he called me, and when I got out to the airport, they were checking the baggage through; that is when I saw them on the plane."

"Were you carrying any baggage off the plane?"

"Yes."

"What was it?"

"A tan piece of hand luggage, a briefcase like."

Nellis had FBI intelligence reports; he knew about the money. "What was in the bag?" he asked.

Sinatra shrugged. "Sketching materials, crayons, shaving equipment, general toiletries."

"Did either of the Fischettis give you anything to carry into Cuba?"

"No sir."

"Did anybody else give you anything to carry into Cuba?"

"No sir."

Sinatra recalled checking into his room at the Hotel Nacional. When he came down to the lobby, a reporter he knew from New York

pointed out to him a man he said was Lucky Luciano. "I said, that name is familiar. He said, yes, that's the guy you think it is. He started to tell me something about the history of this man. I was a boy and remember when his trial was on and remember reading about it."

Nellis looked hard at Sinatra. "There has been stated certain information to the effect that you took a sum of money well in excess of one hundred thousand dollars into Cuba."

"That is not true."

"Did you give any money to Lucky Luciano?"

"No sir."

Nellis ran down a number of names—Willie Moretti, Frank Costello, Joe Adonis, Longie Zwillman—a Who's Who of the mob, all men who had attended the Havana conference weeks before Sinatra's arrival there.

"Well," said Frank, "Moretti made some band dates for me when I first got started, but I have never had any business dealings with any of those men."

"But you know Luciano, the Fischettis, and all those I have named?"

"Just like I said, just in that way."

The back-and-forth went on for more than an hour. The darkness outside gave way to the earliest inklings of dawn.

In an almost pleading tone, Nellis asked Sinatra, "What is your attraction to these people?"

"Well, hell, you go into show business, you meet a lot of people. And you don't know who they are or what they do."

Finally, the lawyer became exasperated. "Do you want me to believe that you don't know the people we have been talking about are hoodlums and gangsters who have committed many crimes and are probably members of a secret criminal club?"

A club: as if they were members of a homicidal version of the Racoon Lodge.

Said Frank, "No, of course not. I heard about the mafia."

"Well, what did you hear about it?"

"That it's some kind of shakedown operation. I don't know."

Nellis moved in for the kill. "Like the one you were involved with in the case of Tarantino?"

Sinatra allowed himself a sardonic smile. It was like he had a microphone in his hand, standing onstage in front of a room full of screaming girls. Nellis asked a series of questions about Sinatra's payoff to squelch the rape story in the press. By now, the singer knew that his grand inquisitor was more smoke than fire.

Joseph Nellis reported back to Senator Kefauver. He was pretty sure that Sinatra was lying through his teeth. They had plenty of circumstantial evidence about his relationships with various mobsters, but what good was it? To call Sinatra as a public witness would only open up the committee to accusations of grandstanding.

When Sinatra heard that he would not be subpoenaed to appear, he was relieved. That night, the Jack Daniel's flowed at Toots Shor's in Manhattan, one of his favorite watering holes. Over the next few months, he kept his eyes on the Kefauver hearings, which became a television sensation. Like everyone else, he watched as Frank Costello testified. In a deal with the committee, Costello's face was not shown. As he testified, the camera remained only on his hands. Somehow, it was all the more sinister.

To Sinatra, the moment of greatest interest might have been when his godfather, Willie Moretti, was called to testify. Apparently, Moretti had not gotten the memo that the committee was a hostile entity that deserved little more than a terse Fifth Amendment invocation for every question. Though the pudgy New Jersey gangster revealed nothing of any criminal importance, he did seem to be enjoying himself while testifying in front of the committee. When Kefauver himself asked Moretti if he was a member of the mafia, he answered, "What do you mean, like do I carry a membership card that says 'mafia' on it?"

The spectators in the gallery and the media loved Willie Moretti. He sounded a note of levity in proceedings that were otherwise deadly serious. Mob leadership, however, was not at all amused. Moretti's

testimony seemed to indicate a lack of discretion. Already, there were rumors within the mob that Moretti was losing his marbles. There was a meeting over espresso and Sambuca, as there often was in these situations. Vito Genovese was said to have characterized the results of this meeting as the decision to engage in a "mercy killing."

On October 4, 1951, Moretti, age fifty-seven, was having lunch with three acquaintances at Joe's Elbow Room Restaurant in Cliffside Park, New Jersey. He was talking and joking in Italian with the men. They were alone in the restaurant. According to the waitress, when she left the dining room and entered the kitchen, she heard four shots. When she returned, Moretti was on the floor in a pool of blood. He had been shot in the face and head. The other men were gone.

Moretti's murder received lavish coverage in the press. Sinatra, who was an avid reader of the New York tabloids (he had them shipped to him in Los Angeles), would have read the headlines with great interest. In a graphic crime scene photo, there was his godfather and former neighbor from Hasbrouck Heights splayed out on the tiled floor of Joe's Elbow Room, a pool of blood near his head. Police reports and the press were assertive in their speculation that Moretti's death was the result of his testimony before the Kefauver committee.

No doubt, Sinatra let out a short, tight breath, and the thought crossed his mind: That could have been me.

Lansky's Dream

Meyer Lansky stood on the Malecón, the famous seaside walkway in Havana, and looked out at the Gulf of Mexico, a quixotic body of water that could go from placid to angry in a matter of moments. The mob boss liked to come to this spot near the monument to the USS *Maine*, a ship that was allegedly sabotaged and sunk in 1898, touching off the Spanish-American War. In the middle of a circular plaza, two stone columns supported a large bronze eagle with its wings spread wide, sur-

rounded by concrete steps and benches. It was a popular gathering spot for young lovers, old folks on their morning or afternoon constitutionals, and American mobsters pondering the maximization of power and profit on this auspicious island ninety miles off the coast of Florida.

It had been a long, bumpy ride. More than five years had passed since twenty-two major American mobsters held their conference at the Hotel Nacional. Since then, there had been unexpected developments. For one thing, in the wake of Luciano and Sinatra gallivanting around Havana together, leading to much consternation in the press, the State Department put pressure on the Cuban Foreign Ministry to deport Charles Luciano off the island back to Italy—which they did. Luciano was out. It had seemed like a blow to the mobsters and their scheme for a gambling and entertainment empire in Havana, but, ultimately, it was advantageous. At the mobster conference, everyone had committed to a contribution of $1 million each to the project. They were all in. As far as Lansky was concerned, though he thought of Luciano as a brother, it was a relief to not have him around. Luciano liked the limelight; he chased after women, partied into the night, and caused problems. He had ideas of his own, and not all of them were great. Lansky was the one who knew Cuba. He was the one who had been cultivating various key military and political leaders for two decades. He was better off managing the situation by himself.

There were other problems. After Luciano was forced off the island, the Cuban president balked at cooperating with the mobsters. He was concerned that it was going to cause him political problems with the U.S. government. He got cold feet. This had necessitated Lansky making a trip to Daytona Beach to meet secretly with his old pal Fulgencio Batista, the retired president. Lansky convinced Batista to make a comeback. "All the pieces are in place for that gamblers' paradise we talked about," he told Batista.

The former president had gone through a staggeringly expensive divorce with his first wife. No one would have believed it, but he was

nearly broke. What Lansky was suggesting—the creation of casinos and nightclubs, with a weekly, guaranteed skim for Batista in the millions—was too good an offer to refuse.

And so Batista returned to Cuba. He set about running for president, thinking his election was a foregone conclusion. But he had been away from the scene for a long time and didn't have the votes he expected to have. So he did what any despotic former head of the country's military might be inclined to do: He coalesced around him commanders in the Cuban armed forces who were still loyal to him. Then he staged a coup d'état, rolling into Havana in the dead of night with armored vehicles, rocket launchers, and thousands of armed soldiers. He chased the sitting president off the island and declared himself president.

Lansky followed these happenings with a great sense of expectation. It was all coming together. In the fall of 1952, after Batista had been in office for a few months, he appointed Lansky as his advisor on gambling reform. Lansky moved into a room at the Hotel Nacional. It was the official beginning of an era of gambling and entertainment in Havana that would go down in history.

A consortium of mob bosses ran the show; they brought in veteran casino managers from Las Vegas, Kentucky, Hot Springs, and South Florida. Along with Lansky, another major player was Santo Traffi- cante Jr., who owned the gambling concessions at the Sans Souci and Tropicana nightclubs and was a co-owner of the Capri and Deauville hotels.

Neither Lansky, Trafficante, nor the other American gangsters knew that they were contributing to the development of an unprec- edented musical scene. The idea was to build casinos and hotels—the music was an afterthought. Nightclubs already existed at the city's most prestigious hotels, the Nacional and the Sevilla, and there were smaller clubs all around Havana. In the 1950s, new hotels were constructed— the Capri, Deauville, Hilton, Comodoro, Habana Riviera, and others. All of these hotels had a nightclub or two (usually one large room and a smaller lounge), as well as gambling. In addition, there were world-

famous clubs like the Sans Souci, the Montmartre, and the Tropicana, which staged elaborate floor shows that hearkened back to the days of the Cotton Club in Harlem and the Sunset Cafe in Chicago. The clubs all had gaming rooms for cards, roulette, baccarat, and the ubiquitous slot machines.

The games of chance may have been the raison d'être, but jazz was the emollient that fueled the engine. Partly, this had to do with what was happening simultaneously in New York. At clubs like the Palladium Ballroom, located on Broadway one block away from Birdland, bands led by Machito, Tito Rodriguez, and Tito Puente were incorporating Afro-Caribbean rhythms into jazz. Latin and American jazz musicians moved between the Palladium and Birdland, sitting in with one another and working out the melding of jazz 4/4 time and the clave, the five-beat rhythm at the heart of all Afro-Cuban music. The bebop musicians, in particular—Dizzy Gillespie, Charlie Parker, drummer Philly Joe Jones, Cal Tjader, and others—were drawn to the music and even created a subgenre the critics referred to as Cubop.

One musician who was central to this movement was Havana-born Luciano "Chano" Pozo, a percussionist and composer of immense gifts. Pozo was raised poor in the neighborhood of Cayo Hueso, in El Africa solar, a housing project that at one time had been a slave quarters. El Africa was dangerous and also a locus for Afro-Cuban religions such as Santeria and Abakuá, of which Pozo was not only a practitioner, he was a *babalao*, or "priest," of the faith. Pozo is rightly remembered as the greatest conga player of his generation, but he was also—despite minimal formal education—a brilliant creator of music who composed tunes like "Manteca" and "Tin Tin Deo" that would become Latin jazz standards.

Pozo was from the streets, a difficult character who spoke little English and often found himself in the midst of confrontations.

On the night of December 3, 1948, just months after his debut performance at Carnegie Hall with Chico O'Farrill, Machito, and Gillespie, Pozo was excited. It was the eve of the celebration of Santa Barbara,

whose affiliated orisha, or "saint," was Chango, the god of the drum. Few doubted that the spirit of Chango lived in Chano Pozo, arguably the greatest living conguero, or conga player. He left his apartment in Harlem on a cold winter night to celebrate at the River Café on Lenox Avenue between 111th and 112th Streets. Chano liked the River Café because on the jukebox was "Manteca," his own masterful Latin jazz composition, which he had recorded live with Dizzy, Chico, and Machito at Carnegie Hall. That night, according to witnesses, Pozo slipped a coin in the machine (likely owned by Meyer Lansky's jukebox company), and, upon hearing his own opening conga playing, and then Dizzy's trumpet, a smile came to his face.

Later, a local weed dealer named Cabito entered the bar. A few days earlier, Pozo had purchased weed from Cabito and felt that it was bogus. Pozo accused Cabito of ripping him off. Cabito told Pozo to "fuck off," or words to that effect. So Pozo slapped Cabito across the face.

Had no one else been in the bar, it might have ended there. But there were a dozen or so patrons in the bar who saw Pozo slap Cabito. As a matter of honor, Cabito demanded that Pozo apologize. Now it was Pozo who uttered the words "fuck off."

Cabito rushed out of the bar and came back only minutes later with a gun. He fired a shot that hit Chano Pozo in the chest. Pozo fell. As he squirmed on the floor, Cabito shot him five more times.

By the time police arrived, Cabito had fled and Pozo was declared dead. His body was wrapped in two red tablecloths and taken away. It was ten minutes before midnight, ten minutes before the Feast of Santa Barbara and the celebration of Chango.

Chano Pozo was thirty-three years old when he was murdered. His passing was a big loss for Latin jazz, but his spirit and contributions to the music continued to energize the Latin jazz scene from Manhattan to Havana.

In the decade following El Maestro's death, American jazz musicians flooded into Cuba. Gillespie, George Shearing, Stan Getz, Buddy Rich, and many others played gigs in Havana but also came just to soak

up the vibes. Vocalists were especially popular. Eartha Kitt opened at the Club Parisién, a gorgeously designed new lounge inside the Hotel Nacional. Italian American crooner Tony Martin headlined the Sans Souci. The biggest act of them all was Nat King Cole, who performed at the Parisién and enjoyed a weeklong engagement at the Tropicana.

Like all the great jazz eras and districts that evolved under the auspices of the mob, Havana in the 1950s was characterized by sex, cocktails, dancing, gambling, and more sex. Tourists from all over the world came to Havana to let themselves go in a way they could not back home. Businessmen on junkets, political groups of congressmen and governors, gambling addicts, jazz fans, and sexual tourists filled the hotels during the fall and winter. Gangsters from around the United States visited Havana with the notion that they were part owners. Most of the mob bosses who attended the 1946 conference controlled some percentage of one or more of the hotel/casinos. Lansky was the organizing force, hosting weekly meetings of the Havana mob, and making sure that Presidente Batista received his payment of the casino skim, which was rumored to be $1.25 million in cash on a weekly basis.

Light and Shadows

Nat King Cole had been front and center for all the major mobster-enhanced jazz eras of the century. As a teenager in Chicago, raised in Bronzeville, he snuck in a side door at the Grand Terrace nightclub to hear Earl "Fatha" Hines on piano. Cole was an aspiring piano player at the time, not yet a singer, and he worshipped Hines the same way horn players worshipped Louis Armstrong. The Terrace was a Capone club, which meant that you might catch sight of not only Big Al himself but also many of the rank-and-file hoodlums who populated the era as if they were knights at the Round Table.

A few years later, having begun his own career as a jazzman, young Nat Cole moved to Los Angeles and played many of the clubs on Central Avenue at a time when that scene was at its pinnacle. Cole didn't

make much money on the Avenue, but he played nearly every night and honed his craft to perfection. The Jewish mobster Mickey Cohen haunted the Avenue; he and his minions genuinely appreciated the music, but they also treated the clubs as if they were subsidiaries in their gangster portfolio. Mostly, if you kept your head down and played your music, everything was copacetic.

In 1941, Cole traveled to New York and settled in for a residency at Kelly's Stable on 52nd Street in Manhattan. His group, the King Cole Trio, backed the great Billie Holiday. Cole learned much from Holiday's vocal stylings, lessons he would eventually apply to his own breakout career as a singer. He also once again absorbed the lessons of working in an environment where the business side of things was controlled by organized crime and the sight of gangsters on the premises was as common as a bare butt in a strip club.

Cole had seen and experienced it all. And now, here he was in Havana as the local entertainment scene assumed its role amongst the great musical eras in the ongoing gangster narrative of the Americas.

Even if you had witnessed the lavish floor shows at the Sunset Cafe or the Cotton Club; even if you had experienced the intimacy of a smoky club in Storyville, on the Hill, the Avenue, or the Street; even if you had seen it all, Havana was something to behold. Partly, it was the excitement of the mob now doing its thing in an "exotic" foreign land. The great jazz scenes had always strived for a certain kind of exotica, with floor shows and interior design elements based on the primitive world—or at least an ersatz version of the primitive world: jungle motifs and skimpy outfits tricked out and dolled up in Hollywood or, later, Vegas style.

Havana had its own version of this, only it wasn't artificial. It was an expression of an organic Afro-Cuban culture, to be found in the music, the dance styles at the clubs, the décor, and a reverence for entertainment that had put Havana on the map since the days of conquistadors, pirates, and international profiteers.

Few habaneros viewed the involvement of American mobsters in

the city's nightlife as a problem. The casinos were patronized mostly by gringo tourists and rich Cuban socialites. The entertainment scene, however, was a tremendous source of employment for local dancers and musicians. The island was exceptionally rich in this regard, with a culture that embraced music and dance as a high calling and near sacred form of expression.

The crown jewel of the city's nightlife was the Tropicana nightclub. Located in the outer reaches of Havana, in the middle of a lush six-acre tropical garden, the club was owned by Martín Fox. A bolita impresario who had funneled his winnings into the nightclub business, Fox was a country bumpkin who would become the unlikely avatar of "class" in Havana nightlife in the 1950s.

The Tropicana opened December 30, 1939, long before U.S. mobsters had launched their incursion into Havana. The club included an outdoor cabaret and a casino. Originally, Fox merely rented a table inside the casino as part of his gambling business. In 1950, he took over the club's lease and hired famed Cuban architect Max Borges Jr. to design an expansion. *Los Arcos de Cristal* ("Arches of Glass"), a Borges creation, was an indoor cabaret with glass walls and concrete arches that made it possible to have performances in any kind of weather while still preserving the impression that the shows were being held outdoors. The seating capacity was 1,700, the largest of any nightclub in the city.

The Tropicana's success was immediate and unprecedented. Fox spared no expense in hiring the best choreographers, dancers, and musicians for the fabulous floor shows at the club. Even with all the money generated by the entertainment, Fox often noted to friends and associates, "If it wasn't for the casino, we would be broke."

The casino concession was owned by both Lansky and Santo Trafficante, in a special arrangement with Fox. To run the casino, the mobsters brought in Lefty Clark, a veteran casino manager from Las Vegas whose mobster affiliations went back to the Purple Gang in Detroit.

At the Tropicana, the casino generated hundreds of thousands of dollars, if not millions, on a weekly basis. The proceeds were skimmed

and divided among the mobsters, club management, and various figures in the Batista government who were on the take. The rest was rein-vested back into the club's operations and floor shows, which were so famous that they drew tourists from all around the globe.

According to Aileen Mehle, a syndicated society columnist based in the United States whose pen name was Suzy Knickerbocker:

> Tropicana was heaven. You couldn't keep me away. Everything was *yayaya*: smoking and drinking champagne and laughing, having fun. And all those fabulous dances and songs. It was the acme every night, the height of glamor, up there with the Ziegfeld Follies. It was the only place to go. Cuba was wonderful because it was sexy, especially if you're young and you're a girl and you have friends who'll take you to clubs with music all night long. It never stopped. I remember this little Black piano player . . . he was a bit rotund, and always dapper in a dinner jacket. His name was Bola de Nieve, meaning snowball, and I recall him sitting at the piano like a little king singing, "*Yo soy negro social, soy intellectual y chic* . . ." ("I am a high-society negro, I am intellectual and chic . . . ")

Beginning in 1956, the King Cole Trio performed three times at the Tropicana. Each time, *Los Arcos de Cristal* was filled to capacity. Though the club had the most renowned house orchestra in Havana (led by pianist Bebo Valdés, whose son Chucho Valdés would later move to the United States and become one of the biggest names in Latin jazz), Nat King Cole preferred to perform along with his trio, as he did in the States. The audience was enraptured, including well-off Cubans who could afford the entrance fee. Locals especially loved it when Cole sang in Spanish. Though he didn't speak the language, he sang the lyrics phonetically in a manner that was clearly not his native tongue. It could have been interpreted as an awkward kind of cultural appropriation; instead, Cubans were flattered by Cole's romanticism,

his smooth voice, charm, and sincerity. The singer even stayed over to record two Spanish-language albums at San Miguel Studios in Central Havana, including songs such as "Besame Mucho" and "Quizas, Quizas, Quizas," which became major hits in the United States.

Cole was also invited to perform for Presidente Batista. The private show was arranged by Lansky and the mob.

Cole was accustomed to performing in mob-controlled venues and before hoodlums of all varieties, in clubs from Central Avenue to 52nd Street, but even he was unnerved by the Batista show. He had specifically requested that the audience, which he was told would consist of soldiers from the Cuban military, not be armed. And yet they were anyway. Throughout the show, the soldiers sat with rifles in their laps. Cole was annoyed. Though he was not a political creature, and he would later receive criticism for his lack of commitment to the civil rights movement, he had a strong sense of decorum. Though gangsters undoubtedly brought concealed weapons to his shows in Chicago, Los Angeles, and New York, an audience brazenly armed to the teeth was something new.

To the seasonal gamblers and revelers who came to Havana, Cole was the epitome of class, and his shows at the Tropicana became legendary. Cole's opening act was singer Omara Portuondo, who decades later would find musical rebirth, and further acclaim, as a member of the Buena Vista Social Club.

For the gangsters, the entertainment choices in Havana were sometimes more lowbrow. High art was appreciated by the likes of Lansky, whose preferred musical style was *danzón*, a kind of Afro-Cuban waltz. Other gangsters eschewed music altogether and sought out entertainment in the city's notorious sexual marketplace.

The Shanghai Theater, located in what had once been Havana's Chinatown, was a burlesque and live sex emporium that attracted the daring and the curious. The star draw at the club was a performer who called himself Superman and was notorious for his fourteen-inch *pinga*, or "penis." Among his many acts were public masturbation, live sex, and swinging on a trapeze over the audience, naked, with his *pinga* flapping

in the wind. Santo Trafficante routinely brought visiting gangsters—
and others—to the shows at the Shanghai. Though raunchy sex shows
had been a staple of jazz districts from Storyville to Kansas City and
beyond, Superman doing his thing at the Shanghai was a must-see for
anyone looking to experience Havana's decadent underbelly.

Revolution

Fidel Castro did not dance, nor was he known to be much of a jazz fan.
Castro viewed the kind of frivolity taking place in the island's capital
city as a symptom of a larger problem. In a letter to a friend on Janu-
ary 1, 1955, he could hardly hide his contempt for the kind of Cuban
nightlife that was then attracting tourists from around the globe: "What
do our homeland's pain and people's mourning matter to the rich and
fatuous who fill the dance halls? For them, we are unthinking young
people, disturbers of the existing social paradise. There will be no lack
of idiots who think we envy them and aspire to the same miserable idle
and reptilian existence they enjoy today."

Inequities in Cuban society had fueled revolutionary movements
on the island going back at least a century. Through a series of dramatic
events—including the failed July 26, 1953, attack on the Moncada mil-
itary barracks in Santiago de Cuba, and Castro's imprisonment and later
release by Batista—the bearded firebrand had emerged as a leader of
the resistance. But in fact, by the mid-1950s political and armed rebel-
lion was spread throughout Cuban society, among labor groups, student
organizations, and even the mothers of young men who had been in-
carcerated or murdered by Batista's increasingly ruthless dictatorship.
Mobsters like Lansky, Trafficante, and others were slow to recognize the
extent of disenchantment; they were in so deep with the fraudulent
president that they could not see the forest from the trees.

Much of the anger in Cuba had to do with U.S. industrialization on
the island, how megacorporations like United Fruit Inc. had monopo-
lized land and industry. Utilities on the island were owned by AT&T and

other foreign corporations. In the area of tourism, Pan Am and the Hilton hotel chain were given sweetheart deals to exploit the economy to their benefit. It was the proverbial unholy alliance, with U.S. corporate industrialists, the mobsters, and the American government seemingly operating as a unified conglomerate. This reality, combined with the island's rural poverty, underdevelopment, lack of political freedom, and violent repression on the part of Batista's secret police, had fomented a powerful underground insurgency. The 26th of July movement led by Castro was in the hills, and revolution was brewing—mostly on the eastern part of the island, far from Havana.

Lansky and the others did not see it coming. Since Batista controlled the island's media, dictating how the revolution was portrayed on the radio and television news, the mobsters—like much of the island's wealthy elite—believed that the regime was beyond reproach. To them, Castro was a joke. All that really mattered was that in Havana money from the casinos continued to flow and the music played on.

By the tourist season of 1956, there were signs that could not be ignored. At the Montmartre nightclub and casino, one of Lansky's most esteemed properties, Colonel Manuel Blanco Rico, chief of Batista's secret police, was exiting the club's main casino with a group of associates. Onstage at the Montmartre, Italian opera singer and budding movie star Mario Lanza was singing an encore of his signature song, "Arrivederci, Roma." As Blanco Rico waited in the lobby for an elevator, two men entered the club and whipped out weapons—one a pistol and the other a submachine gun. They opened fire, spraying the lobby with gunfire. Two of Blanco Rico's people, including the wife of an army colonel, ran headlong into a glass mirror. By the time the two gunmen ran out of the club, the chief of military intelligence was dead.

It was a daring political assassination conducted in the lair of the mobsters' operations in Havana.

Two months later, on New Year's Eve, 1956, an even more auspicious act took place. It occurred at, of all places, the Tropicana nightclub.

Headlining the show that night was Beny Moré, a singer referred to by many as the Nat King Cole of Cuba. Moré—silky smooth and elegant, just like Cole—was the preeminent practitioner of a type of singing known as "feeling," a romanticized interpretation of boleros, or "ballads," sung in a smoky jazz style. Moré and another popular Cuban singer, Francisco Fellove, had been influenced by Cole, Ella Fitzgerald, Sarah Vaughan, Sinatra, and other American jazz singers to the point where it was—despite the differences in language—difficult to discern the origins of this style or determine who was flattering whom.

At the Tropicana, about an hour and a half into the New Year, a bomb exploded near the bar area, rocking the entire club. Glass shattered and tables were upended. Pandemonium ensued. Screams and shouts for help rang out. Fearing there might be a follow-up explosion, patrons fled the club. A young woman, seventeen years old, stumbled from the rubble. Her arm had been blown off. It turned out she was the rebel who had planted the bomb.

The Batista government and the city's tourism czars tried to give the appearance that it was a one-time event, but clearly the momentum had shifted. Bomb scares, and actual bombings, became a semi-regular occurrence all over Havana. By the season of 1958, the sense was that Batista's grip was slipping, and the revolution was imminent. Ironically, this did not affect activity in the clubs and casinos. As with the presence of American mobsters in Havana, the thought of an approaching revolution only seemed to add to the excitement. The 1958 season was the most profitable to date.

Even so, the inevitable came to pass. On New Year's Eve, 1958, Batista fled the island under cover of darkness. He did not give warning to Lansky and his gangster associates that he would be leaving. They were abandoned to fend for themselves. The gangsters feverishly sought to secure their cash in the counting rooms of the casinos. By the following morning, truckloads of *bardudos*, bearded young rebels, flooded into the city. Many of the casinos were trashed by citizens delirious that the revolution had finally arrived. At the Riviera Hotel and Casino, which was

considered Lansky's pride and joy (he had initiated its construction and overseen its design to the tune of $17 million), the rebels unleashed a gaggle of pigs. The swine pissed and shit all over the lobby of the hotel.

A week later, Castro rode into town. In a quote that was widely circulated in Cuba and the United States, when asked about the casino and nightclub owners, Castro declared, "We are not only disposed to deport the gangsters, but to shoot them."

Lansky and most of the other mobsters fled the island. Santo Trafficante was held for a time in prison. He heard that he was on a list of prisoners to be executed, until he allegedly paid a cash ransom of $1 million directly to Raul Castro, Fidel's brother.

The fall of Cuba would go down in history as an unprecedented flop for the mob. As Lansky put it years later when asked about the fiasco, "I crapped out."

Certainly, fortunes were lost. Castro seized the casinos and the business holdings of American industrialists. These events set in motion a series of events and activities that would inflame the imaginations of numerous gangsters and exiles for generations to come. Attempts to assassinate Castro, alliances between the mob and the CIA, the rise of the "Cuban mafia" in the United States—a narrative was put into play that would unfold over the next half century. Though it would take years to recognize the trajectory of events, the biggest beneficiary was Las Vegas.

There had existed a rivalry between Havana and Vegas that the Cuban capital had been winning throughout the 1950s. Now gaming interests and investments, and a newfound energy in entertainment and jazz, would shift from Havana toward that artificial, man-made creation in the Nevada desert. Cuba became a bad memory. Not only had the mobsters been chased off the island, but an economic embargo imposed by the U.S. government prohibited Americans to even visit the place. It was as if it never happened.

For the musicians, it had been a glorious time. Like all the great jazz eras of the past, the moral complications of having your livelihood underwritten by organized crime took a back seat to the opportunities and

sheer exuberance of the music's unbridled development. Jazz in Havana in the 1950s left a legacy that continued to flourish in the United States for decades to come.

Uppity

Meanwhile, back in the Big Apple, jazz sought to reassert itself—though there seemed to be a rumbling at the core of the American music business. The date that is usually pointed to as the genesis of this rumbling is July 9, 1955. That is the date when "Rock Around the Clock," by Bill Haley and the Comets, supplanted Sinatra's "Learnin' the Blues" as the number one song on the *Billboard* singles charts. Rock and roll had arrived, but this did not mean that jazz was dead. Some felt that jazz was on the verge of losing the youth market, that it needed to be reinvigorated with an entirely new perspective, something fresh and original. Musicians and producers had been toying with new elements. And then along came Miles Davis.

On August 17, 1959, Davis released *Kind of Blue*. There had never been anything quite like it. Spare and contemplative, it was an example of what jazz critics described as a "modal" approach to the music. Up until now, jazz was based primarily on chord changes, with soloists improvising over the chords. With *Kind of Blue*, Davis and a sextet of brilliant jazz artists (John Coltrane on tenor sax, Cannonball Adderley on alto sax, Bill Evans on piano, Paul Chambers on bass, Billy Cobb on drums, and bassist Wynton Kelly) went into a studio and rewrote the language of jazz. The music was hip, soulful, and utterly original.

Eight days after the release of the album, Davis and his band were booked to play Birdland. The show was being broadcast live as part of Armed Forces Radio, on the Voice of America. The response to *Kind of Blue* was just beginning to take flight. Eventually, the record would be the bestselling jazz album of all time.

For Davis, the reception to this album was the culmination of a

journey. Having come on the scene at the age of twenty-two as part of Charlie Parker's band, Davis was a prodigy, but he had been struggling to establish an independent voice. In the years leading up to *Kind of Blue*, he'd been playing in the hard bop style, which he had begun to feel was confining and predictable. He had been exploring new modes of expression, a style on the trumpet that was more spare and melodic, with fewer notes and complicated chord changes and more modal compositions that seemed to meander off the page, out the window, and up into the sky. The new music was cubist in nature, and it challenged the ear. Reviewing *Kind of Blue*, one critic called Davis "the Pablo Picasso of jazz."

The way the record business was structured, though the album was on its way to becoming a megahit, it would be months before Davis or his band reaped the rewards. Miles still needed to play live shows to make a living. It was a conundrum faced by all jazz musicians: The labels were owned primarily by faceless corporations (*Kind of Blue* was produced by CBS Records), and the clubs were owned by gangsters. It was jazz capitalism in a nutshell.

On the night of August 25, 1959, Birdland was packed. Davis had lit a fire in the hearts of jazz fans from coast to coast. Screw rock and roll. Miles was the biggest thing since Satchmo.

It had been eight months since the stabbing death of Irving Levy. All that summer, Mo Levy had been incommunicado. There were rumors that he had left the city. For a time, he'd been living in Miami. Eventually, Levy would return to New York, if not as a regular presence at his club, certainly as a majordomo at the offices of Roulette Records.

That night, the band finished the first of a scheduled three sets. Davis headed upstairs from the basement club to help a friend, who was female and white, flag down a taxi. Miles was looking dapper that night, as he usually did. He was wearing a cream-colored sports coat, a white shirt, and a gray tie that complemented his khaki slacks. In front of Birdland, on Broadway, the trumpeter put his friend into a cab and

waved goodbye. As he turned to reenter the club, he noticed a uniformed NYPD patrolman watching him from the sidewalk. As Davis stopped and looked at the cop, the cop said, "Move along."

Replied Davis, "What do you mean move along? I'm working downstairs. That's my name up there, Miles Davis." Miles pointed at the club's marquee, with his name up in lights. The cop didn't even look at the marquee. To music critics Miles may have been the Pablo Picasso of jazz, but to this New York cop he was just another uppity Negro on the street.

"I don't care where you work," said the officer. "I said move along. If you don't, I'm going to arrest you."

Miles described what happened next:

I just looked at his face real straight and hard, and I didn't move. Then he said, "You're under arrest!" He reached for his handcuffs, but he was stepping back . . . I kind of leaned in closer because I wasn't going to give him no distance so he could hit me on the head . . . A crowd gathered all of a sudden from out of nowhere, and this white detective runs in and BAM! hits me on the head. I never saw him coming. Blood was running down the khaki suit I had on.

Davis was handcuffed and taken to the nearby 54th Precinct station house. By now, his wife had come to the precinct and nearly a dozen reporters and photographers had gathered. As Davis was fingerprinted and processed, cops continued to taunt him.

They're saying to me in the station, "So you're the wiseguy, huh?" Then they'd bump up against me, you know, try to get me mad so they could probably knock me upside the head again. I'm just sitting there, taking it all in, watching every move they make.

Davis's head was bleeding profusely; the blood had splattered onto his cream-colored jacket.

The police charged the musician with resisting arrest and assault and battery on an officer. Davis was stunned. He knew he had done nothing wrong. He was certain that the white cop had initiated the altercation because he had seen him fraternizing in the street with a white woman. The cop was going to teach this uppity spade a lesson.

> I would have expected this kind of bullshit about resisting and all back in East St. Louis [his hometown], but not here in New York City, which is supposed to be the slickest, hippest city in the world. But then again, I was surrounded by white folks, and I have learned that when this happens, if you're Black, there is no justice. None.

Davis missed the rest of his show at Birdland. He was taken downtown to central booking and spent the night in jail, until his lawyer could secure his release the following morning.

Newspaper headlines dutifully noted that Davis had been arrested for an "attack" and "assault" on a policeman, which belied the fact that the musician was the one beaten up and bloody, not the cop. In those days, the press mostly reported the charges as fact, with no trace of skepticism. Luckily for Davis, at Birdland on the night of the assault was Dorothy Kilgallen, an influential columnist whom he knew well. Kilgallen had emerged from the club just as the altercation was taking place; she saw it with her own eyes. Her column presented an entirely different version from what the NYPD was contending had happened. Other jazz musicians rallied around Davis, and soon the charges were dismissed. Even so, the jazzman's cabaret card was temporarily revoked, which prevented him from performing in city nightclubs until he was able to get it restored.

All in all, it was a transformative event. Davis later wrote, "That incident changed me forever. [It] made me much more bitter and cynical than I might have been."

Miles wasn't the only one.

For white musicians—and white citizens in general—the police were not normally viewed as being part of the underworld. There were gangsters and there were cops; generally, the cops were the good guys. For non-white musicians, however, it was a different story. A menacing cop—a brutal cop—or a cop on the take was an all-too-common reality. A cop—even an anonymous patrolman on the beat—was often cause for alarm. In a sense, cops were part and parcel of the underworld. Just as the downtrodden in Cuba had come to see the gangsters, the businessmen, and the politicians as part of the same system, African American jazz musicians saw club owners, record executives, and cops as representative of the same configuration. Oppression was a motherfucker, and it manifested itself in a myriad of ways, at every level of the game.

After the Birdland incident, Davis acquired a reputation as a "bad Negro." "Around this time," he wrote, "people—white people—started saying that I was always 'angry,' that I was 'racist,' or some silly shit like that. Now, I've been racist towards nobody, but that don't mean I'm going to take shit from a person just because he's white. I don't grin or shuffle and didn't walk around with my finger up my ass begging for no handout and thinking I was inferior to whites. I was living in America, too, and I was going to try to get everything that was coming to me."

This was a new kind of attitude for a Black jazz musician, a new kind of attitude for a Black citizen in general. And it suggested that there was another kind of revolution in the air, righteous, angry, a cultural reckoning that had the potential to reconfigure the dynamics between jazz and the underworld in the years ahead.

12

FEAR AND LOATHING AT THE COPACABANA

Being a woman in the world of jazz was not easy. From the beginning of jazz as a commercial venture, it had been a male domain. Wives, mothers, girlfriends, and sisters made meals for the boys and took care of the children as mostly male musicians rehearsed in the basement or played at clubs late into the night and early hours of the morning. When there were females in the music, invariably they were singers. Bessie Smith, Ma Rainey, and Ethel Waters had all been stars in their own right, but they were in a league by themselves. To be a rank-and-file musician was to be a member of a boys' club. You could count the number of prominent female instrumentalists on one hand.

The underworld was also a boys' club. The nightclubs were owned by men. The talent managers were all men. Record label executives were men. And the gangsters were most definitely of the male persuasion. Generally, the only time women were allowed into the music or business of jazz was as figures of frivolity and diversion.

One prominent exception was Mary Lou Williams. She was born in Georgia; that was where she first learned to play the harmonium, the forerunner of the electric organ. At the storefront Beulah Baptist Church, she used to sit in her mother's lap while her mother played for the congregation. One day when Williams was three years old, and her

mother was practicing in the empty church, suddenly tiny Mary reached up and played back, note for note, what her mother had been playing. Wrote Williams years later, "It must have really shaken my mother. She dropped me and ran out to get the neighbors to listen to me . . . I never left the piano after that. Always played. Nothing else interested me."

At the age of eight, Mary Lou moved with her family to Pittsburgh (Smoketown), a fertile breeding ground for jazz. During her youth, Smoketown became known for great piano players—Earl Hines, Billy Strayhorn, Erroll Garner, Ahmad Jamal. Williams watched, learned, and listened, and sometimes she sat at the piano and played. By the time she was a teenager, she was known for her ability to pick up a melody after hearing a tune just once. She was a prodigy. But jazz was not an endeavor where a person could apprentice at music academies or by seeking to join the local philharmonic. Mary played gigs in roadhouse saloons, and she took to the road with a band that was comprised of all male musicians—as were all bands large and small.

There was another issue: As a young Black woman on the road, she confronted racism at every turn. In the South, club owners sought to rip off her band. She wrote to a friend:

[One club owner] refused to honor our contract, saying, "I can get all the niggers I want on Beale Street for two dollars a dozen." I couldn't talk, I was so angry, but when I returned to the boys and told them, they told *me* to forget it, that we were in Mississippi. I refused to listen and they split, leaving me there alone. But I wouldn't leave until I had collected our loot.

Her being a preciously talented Black woman was hard for some men to accept. As a friend of hers noted, looking back:

She was very attractive and very talented, but you know how they were to women in those days. They didn't want women to be in the band and the musicians would get really upset; seemed

like the musicians were jealous. But she was just so determined
to play that piano.

Mary Lou endured physical violence and sexual assaults at the hands
of paramours and band members. Being on the road was a brutal place
for a single woman. Eventually, she married one band member—not out
of love but because it would make her appear "taken" and therefore less
likely to be raped.

As a musical artist, Williams's talents as a pianist and a composer
put her in a rarefied category among the best musicians in the business:
Jelly Roll, Ellington, Basie, and others who put pen to paper and created
great works. When she played with Andy Kirk's Clouds of Joy, very few
people knew that she had composed many of the band's biggest hits
because credit for those songs was routinely usurped by the bandleader.
As a pianist, she was sublime. When Williams played a solo, audiences
were often transfixed. She had absorbed elements of all the great pia-
nists who came before her, and yet everything she played seemed fresh
and spontaneous, as if she were playing notes the way some people speak
words, syllables and phrases rolling off the tongue, the eloquence of cre-
ation in real time. As she would say in later years, the joy she derived
from playing, and whatever talent was on display as she performed, was
a direct result of her respect and love for the music.

It was with the Clouds of Joy that Mary Lou first came to know
Joe Glaser, who was the manager for the band and then, later, when
she went solo, for Mary herself. When Glaser first began representing
the band in the late 1930s and then throughout his career, musicians
knew that he was a disreputable person, but given his special relation-
ship with Louis Armstrong—the biggest star in the business—and his
ability to deal with gangster club owners, all the best musicians wanted
to sign with ABC, as Associated Booking was known. Andy Kirk was
speaking for many when he said, "I didn't like Joe Glaser too much,
but I couldn't dislike him, because he was bringing in the money. [We]
played Yale, Harvard, all of them, through Joe Glaser's office . . . If I

could have knocked him in the mouth, he would love me. If you cursed him out, he liked you . . . He acted like a crook."

Mary Lou maintained a love-hate relationship with Glaser. Early on, she wrote a boogie-woogie number dedicated to him, "Little Joe from Chicago." Later, she came to resent the man who she felt treated her like the Pimp Daddy he had once been, cultivating her with sweet talk and compliments and then scolding her like a child. It was demeaning and exhausting, a kind of psychological warfare that seemed designed to wear a musician down.

At the height of the jazz era in Kansas City and later on 52nd Street, Williams was aware of the gangsters. They ran the clubs and signed the checks. Some found it charming, but Mary Lou did not. To her, it was all part of the muck and the mud, a moral quagmire that made the jazz scene—as joyous and life affirming as the music could be—feel dirty to Williams. She wrote of the underworld figures she encountered: "An evil person will cause a good person to stumble, will throw you in a trance and take your natural soul if you are not really down with it, for the man is hustling madly for souls." Of the jazz scene in general, she wrote: "Nearly everyone, I discovered, either had a knife or a gun . . . Everyone was like a hoodlum."

Mary Lou was no saint. She developed and then overcame a fierce gambling habit. She sometimes drank too much and liked her muggles, but Williams stayed away from the hard drugs, especially heroin. On 52nd Street, she witnessed the ravages of dope destroy many of her best friends in the business—especially pianist Bud Powell, whose work she adored.

She tried to help Powell, mostly by getting him away from Birdland. She wrote in her diary, "Birdland's vibrations are bad for him . . . The next day I prayed at the altar. Trying to shake off the vibrations of Birdland, I stayed in church five hours."

Eventually, Mary Lou distanced herself from the nightclubs. As rock and roll and pop music ascended in the culture, she wrote compositions for Benny Goodman, Duke Ellington, and other jazz bandleaders

who were struggling to remain relevant in the current climate. In New York, where she moved into a small apartment in Harlem, she taught music at local community centers and opened her own used clothing store for women. She paid attention to what was happening in the business but was barely a participant. Sometimes she sat in on piano with bands or lounge singers in Manhattan, but her bookings were few and far between. After a lifetime in the business surrounded by musicians and gangsters, the jazz scene sickened her. Mary Lou Williams was out.

Il Padrone

"What is your attraction to these people?"

Senator Kefauver's counselor had asked Frank Sinatra the right question. Throughout his professional life, the singer had fraternized with gangsters. Publicly, he denied it, but to his friends and associates, it was no secret. To some, he expressed misgivings. The heiress Gloria Vanderbilt, one of Sinatra's many girlfriends in the years following his separation from Ava Gardner in 1954 (they were divorced three years later), claimed that the subject did come up. "He was very open in talking about his relationship with the mob," Vanderbilt told one of Sinatra's biographers. "And how conflicted he was about it. He was drawn to it, he said."

Sinatra may have been conflicted, but he did not back off. Even after the singer had narrowly missed being drawn into the media maelstrom of the Kefauver hearings, which might have ruined his career; even after his godfather, Willie Moretti, had been whacked, many believe, as a result of his testimony in front of the committee, Sinatra continued to forge relationships with mobsters. Some surmise that it was a mutual admiration society. The mob took care of the singer.

In 1952, at a time when Sinatra's singing and recording career was at a low point, and his acting roles were inconsequential bordering on embarrassing, the mob did him a favor. The Sands Hotel and Casino in Las Vegas, the newest and most mob-connected venture to open its

doors on the Strip, signed Sinatra to an exclusive contract as their head-line act. The Copa Room, the hotel's spanking new four-hundred-seat showroom, was designed with Sinatra in mind. Not only was the singer given superstar status and promoted as if he were still the biggest musi-cal act in America, but he was also given part ownership in the place—a 3 percent piece of the action that would later be raised to 9 percent—a cut that would garner hundreds of thousands of dollars for the singer.

The mob gave Sinatra a boost when he was down. Two years later, he took matters into his own hands when he turned in a brilliant per-formance in *From Here to Eternity*, which won him an Academy Award for Best Supporting Actor and put him back on the map in Hollywood. This was followed by a series of record albums in the 1950s that cap-tured the singer at the absolute height of his talent. Not only were *In the Wee Small Hours, Only the Lonely*, and others among the greatest jazz vocal albums ever recorded, they were massive hits, selling millions of copies and making Sinatra, once and for all, the highest paid entertain-ment star in the country.

Sinatra no longer needed the mob, but he still stayed within its orbit, paying his respects to made men from New Jersey to Los Angeles, and in so doing he underscored relationships that were deeply entan-gled in the roots of jazz.

In 1955, on the wings of his newfound momentum as a movie and recording star, Sinatra met Sam Giancana from Chicago. They were introduced by Angelo "Gyp" DeCarlo, a New Jersey mafioso who had helped Sinatra get started in his career. Sinatra was already friendly with Chicago gangsters, most notably the Fischetti brothers. Known variously as Momo or Moony, Giancana was a rising power in the outfit and believed to be a likely successor to the boss, Tony Accardo.

From the Fischetti brothers, Sinatra would have known of Gi-ancana's underworld stature. According to Antoinette Giancana, Sam's oldest daughter, Sinatra gave Giancana a star sapphire pinkie ring as a gesture of friendship.

Though his physical stature was slight and his presence unassuming,

Giancana had a stare that sent a chill up people's spines. His reputation as a thug was formidable. He had risen to power by convincing Accardo to let him engage in a hostile takeover of Chicago's African American numbers operations on the South Side. This involved the kidnapping and torture of the neighborhood's numbers boss, with Giancana's crew assuming control.

Gangland insiders knew of the role Giancana had played in the gruesome assault on crooner/comedian Joe E. Lewis back in 1927. Giancana was nineteen at the time, a small-time hood in the larger schematics of gangland Chicago. That crime, no doubt, burnished his standing in the mob; Momo never looked back.

Whether or not Sinatra knew of Giancana's involvement in this notorious act is interesting to consider. The same year that the singer met Giancana, the book *The Joker Is Wild* was published by Random House. Sinatra himself optioned the rights to the book and began developing it as a movie project. Sinatra and Lewis became good friends, with Sinatra, in preparation for playing Lewis onscreen, a frequent guest at the comedian's nightclub performances in New York, Miami, and Los Angeles.

The Joker Is Wild was released as a movie in 1957. There is in Sinatra's performance a note of noblesse oblige; he does not so much embody Lewis as give the impression that he is repaying a debt.

Around the same time that Sinatra was forging his bromance with Lewis, he was becoming pals with Giancana. The mob boss was a fixture at the singer's performances at the Sands in Las Vegas (though, as a known member of organized crime, he was banned from the casino floor) and at the Fontainebleau Hotel in Miami Beach. Giancana's daughter claimed that whenever they met, they embraced like brothers.

To most people, it might seem odd or even creepy that someone could be good friends with a person who had attempted to murder their other good friend. How did Joe E. Lewis feel about Sinatra's friendship with his assailant? Did Lewis know that Giancana was among those who viciously slit his throat? Did Sinatra know that Lewis knew? And did

Sinatra discuss with Giancana—for his movie project or out of morbid curiosity—the details of the attack on Lewis, his cinematic alter ego?

As Carson McCullers famously wrote, the heart is a lonely hunter. Whatever the implications of this unusual triangle, Sinatra remained on good terms with both men. With Giancana, he embarked on a partnership that would bring him to the brink of underworld execution.

In 1959, Sinatra enlisted the mob boss's support in the presidential campaign of Senator John F. Kennedy of Massachusetts. Sinatra had known Kennedy since at least 1955. That was the year that the young senator, according to FBI files, rented a suite on the eighth floor of the Mayflower Hotel in Washington D.C. (room 812). The files refer to the suite as Kennedy's "personal playpen" and that Sinatra, among others, attended parties there.

Sinatra developed a man crush on Kennedy. He admired his wit and intelligence. Though Kennedy went to Harvard and came from extreme wealth, he was second-generation Irish Catholic, not far removed from an immigrant pedigree that was familiar to Sinatra. Mostly what he recognized in the handsome young senator was the way he leveraged his power and privilege to have a good time.

Sinatra's pitch to Giancana was twofold. It was felt that the mob could help Kennedy in the all-important West Virginia primary, which would help him secure the Democratic Party nomination. Once he had nailed that down, Giancana could help deliver the state of Illinois, primarily through his influence with the mayor of Chicago, Richard J. Daley.

Giancana had serious misgivings. In the late 1950s, John Kennedy's brother Robert had served as lead counsel for the Senate Select Committee on Improper Activities in Labor and Management, otherwise known as the McClellan hearings after Senator John J. McClellan of Arkansas, who headed the committee. As with the Kefauver hearings earlier in the decade, numerous mobsters were subpoenaed to testify, including Giancana.

Momo despised the Kennedys. Nonetheless, Sinatra somehow convinced Giancana that the election of Kennedy, whom Sinatra had nicknamed "Chickie Baby," would be good for the mob. Also, the singer pledged his own personal fealty to Giancana, which he made manifest by partnering with the mob boss on a resort/entertainment club near Lake Tahoe—the Cal-Neva Lodge & Casino; and by appearing gratis—along with his Rat Pack buddies Dean Martin and Sammy Davis Jr.—at the Villa Venice, an extravagant nightclub that Giancana opened in suburban Chicago.

Sinatra delivered for the mob, and the mob delivered for Kennedy. In the West Virginia primary, the services of Skinny D'Amato, proprietor of the 500 Club in Atlantic City and renowned mob associate going back to the years before the war, were used to grease the wheel. According to an FBI informant, the chain of communication went from Sinatra to Giancana to D'Amato, and cash payments were involved. Wrote author Jonathan Van Meter in *The Last Good Time*, a biography of D'Amato: "Giancana sent Skinny D'Amato to West Virginia to get votes for Jack Kennedy. He was to use his influence with the sheriffs who controlled the political machine of the state. Most of them had been customers at the 500 Club and, according to Skinny, loved him like a brother. Whether he helped turn the tide for Kennedy in that crucial primary state is not as important as the fact that Giancana sent him there on Kennedy's behalf."

In the general election against Richard Nixon, Kennedy won Chicago's First Ward—traditionally a mob stronghold going back to Prohibition days—with 78 percent of the vote (four years earlier Adlai Stevenson had received 63 percent). In the closest presidential election in history up until that time, the mob-enhanced vote in the First Ward delivered the state of Illinois for Kennedy and turned out to be the margin of victory.

Kennedy's election was an emotional triumph for Sinatra and a seemingly successful power play by Giancana and the mob.

Friends noted that Sinatra worked his tail off for Kennedy during the campaign. The singer was rewarded by being given the opportunity to produce the inaugural gala. It was a star-studded affair with an unprecedented budget of $4 million. At the event, jazz was well represented. Sinatra saw the inaugural ball as an opportunity to elevate the music that he and many others felt was America's greatest art form. Among the entertainers selected by Sinatra to perform were singers Ella Fitzgerald, Nat King Cole, Louis Prima, Keely Smith, and Harry Belafonte. The house band for the event was Nelson Riddle and his orchestra, which had accompanied Sinatra on most of his recent hit albums.

Having conspired together to elect a president, Sinatra and Giancana became unusually close. In some ways, they were an odd couple.

"You know, I like niggers," Giancana once said to George Jacobs, Sinatra's Black driver and valet. Jacobs had gotten to know Giancana, as well as John Kennedy, Sammy Davis Jr., and many of the other big names that came into Sinatra's orbit. "Niggers made me what I am today," continued the mobster.

"Tell me about it, Mr. Sam," said Jacobs.

It was on a golf course somewhere. Giancana was being philosophical. He explained to the driver that when he was in prison in Terre Haute, Indiana (Jacobs didn't ask why), his fellow inmate was a Black guy who went on to be king of the numbers racket in Chicago. In Mr. Sam's eyes, it was an example of his sense of brotherhood that he and the Black guy eventually became partners in the numbers racket. That is until Giancana, as he told it to Jacobs, was forced to take over the Black guy's operations because his own bosses "didn't want to be in business with no niggers." Giancana left out the part about how he'd kidnapped the numbers king and tortured him until he turned over his business. As Jacobs later put it in *Mr. S*, his memoir about his years working for Sinatra:

Mr. Sam put a much nicer spin on it for me, boasting of how magnanimous he was in setting the Black guy up for life in a

villa down in Mexico. "A lifetime of the shits is still a lifetime," he said. The Big Boys wanted the Black king whacked, and Sam saved his life. He sounded as if he expected an award from the NAACP.

Mobsters were not known for their racial enlightenment, even those who were involved in the business of jazz. Throughout history, people affiliated with organized crime owned nightclubs and employed Black musicians, but it was always clear who was the boss and who was the employee. Race as a signifier of subservience was an irrefutable fact of the business relationship.

In 1960—the same year that Kennedy was elected president—Sinatra inaugurated his own record label. Reprise Records, with offices in Los Angles and New York, was to be an artist-driven label. The idea was for the musicians to have full creative freedom and ownership of their work, including publishing rights. There had never been anything like it.

From the beginning, Reprise signed artists who were friends of Sinatra. One of the first albums produced by the label was one by Joe E. Lewis. Reprise also signed Bing Crosby, Dean Martin, and Sammy Davis Jr. Sinatra pursued and signed premier jazz musicians such as Duke Ellington, Count Basie, Ben Webster, and Ella Fitzgerald. He paid Black musicians what they deserved. The label sought to sign the brilliant bassist Charles Mingus, who had a reputation among club owners and other record producers as being "difficult."

In his capacity as primary shareholder at Reprise Records, Sinatra assumed the moniker "Chairman of the Board." The title fit the man. Among his friends and associates, Sinatra was, metaphorically speaking, the boss of all bosses.

To John Gennari, author of *Flavor and Soul: Italian America at Its African American Edge*, Sinatra's ascension to the throne—and his role as an owner as opposed to a vassal—was based on a particular value system: "We come closer to understanding Sinatra's racial liberalism if

we think about it not just as a deep and genuine repugnance for social injustice but also as a matter of personal loyalty and largesse, as something that nourished his self-image as a Sicilian *padrone*."

I'd rather be a don of the mafia than president of the United States, as singer Eddie Fisher quoted Sinatra as having said.

Reprise Records was Sinatra's mission statement. The business got off to a bumpy start. As chairman, Sinatra insisted on paying the jazz stars big money to lure them away from other labels. There were rumors that he might lean on his mob friends to keep Reprise afloat. The rumors were understandable. The singer had a stake in at least two casinos, the Sands and Cal-Neva, of which he owned more than 50 percent. Both of these ventures were jointly owned by Giancana. But Sinatra was adamant about keeping Reprise Records clean and legit. He already had enough problems with the mob.

In 1961, when President John Kennedy appointed his brother Robert as attorney general of the United States, a sense of outrage rumbled through the American underworld. It didn't take long for this outrage to metastasize into something even more sinister. Within his first year as attorney general, Robert Kennedy had launched an unprecedented crusade against the mob. There were raids and arrests from coast to coast. The number of organized crime prosecutions in the United States went from twelve in 1959, the year before Robert was appointed, to 112 in 1961. On numerous government wiretaps (many of them illegally planted by the Justice Department without judicial authorization), mobsters in numerous jurisdictions were heard cursing the Kennedy name. Some were also angry with Sinatra and his celebrity friends.

"Lying [expletive]! If I ever listen to that [expletive] again . . ." The speaker was Giancana, his voice captured on an FBI wiretap, as he complained to an associate, Johnny Formosa, about Sinatra. "I figured with this guy, maybe we'll be all right. I might have known this guy would [expletive] me."

Formosa replied, "Let's show 'em. Let's show those asshole Hollywood fruitcakes that they can't get away with it as if nothing's hap-

pened. Let's hit Sinatra. Or I could whack out a couple of those other guys, [Peter] Lawford and that [Dean] Martin, and I could take the nigger and put his other eye out."

"No," said Giancana. "I've got other plans for them."

On another occasion, Giancana informed an associate that he had been seriously considering having Sinatra killed. One night he was in bed with his lady friend, thinking it over. His lady friend was the singer Phyllis McGuire, youngest of the McGuire Sisters, a vocal pop trio that scored a number one hit on the charts with a song called "Sugartime." Sinatra was the one who had introduced Giancana to McGuire. Said the mob boss to his associate: "I'm fucking Phyllis, playing Sinatra songs in the background, and the whole time I'm thinking to myself, Christ, how can I silence that voice? It's the most beautiful sound in the world. Frank's lucky he's got it. It saved his life."

Jazz Vampire

In the early 1960s, club owner and record label impresario Mo Levy was feeling the heat. His famous club, Birdland, which had been in existence for thirteen years, was not doing well. The onset of television had led to a downturn in business for nightclubs in general. In previous generations, if you wanted to see Nat King Cole or Ella Fitzgerald up close and personal, there was only one way you could do that: at a nightclub. Now all you had to do was turn on the *Ed Sullivan Show* or any of the many variety shows on TV and there they were, with close-ups that revealed flop sweat, false eyelashes, and beautifully fabricated true emotions.

Birdland had an added problem: Since the assault on Miles Davis by an aggressive cop outside the club, and a few other well publicized racial incidents, the club had acquired a bad reputation among Black jazz musicians. Some were even turning down bookings at the club—a startling development.

Clearly, something was in the air. In 1955, a young civil rights

activist named Martin Luther King Jr. had led the Montgomery bus boycott. More recently, in 1961, the Freedom Rides riveted the nation, as a new generation of activists seemed determined to alter the course of racism in America. These were early though significant steps in what was now being referred to as the civil rights movement, which seemed to be gathering steam all across the country. Celebrity artists—actors, musicians, and writers—both Black and white, felt compelled to march and protest in solidarity with King and other leaders of the movement. No one knew yet how this might affect relationships in the music business or other commercial ventures, but it was already beginning to reshape the larger context of American society.

Levy made his living primarily, but not solely, from the labors of African American entertainers. He was believed to have an uncanny nose for talent that, in the late 1950s, led him to extend Roulette Records beyond jazz into rockabilly, pop, and early rock and roll. He created a subsidiary label, Tico, to record exclusively Latin jazz artists. When it came to making a buck, Levy was racially magnanimous. He signed and promoted Black and Latin artists as vigorously as he did white artists, and he got rich doing it. Artists often signed with Roulette Records to great fanfare and optimism, only to find that the stories about Levy cheating artists out of royalties and other revenue streams were mostly true.

The great Sarah "Sassy" Vaughan signed with Mo Levy's label in 1960. She was one of a number of prominent female vocalists to sign with Roulette, others being Dinah Washington, Nancy Wilson, and Betty Carter. Vaughan was believed to be the logical successor, in terms of sheer vocal talent, to Billie Holiday, who had died tragically—and in near poverty—in a New York City hospital in 1959 at the age of forty-four. Like many African American singers of her generation, Vaughan was determined to not fall into the same traps that Lady Day had. In the 1950s, she recorded a handful of albums with Mercury Records. Known for its unconventional promotional methods, Mercury eschewed the usual route of using radio airplay to establish an artist in favor of juke-

boxes. The problem, as everyone knew, was that the jukeboxes were controlled by organized crime. Sarah Vaughan may have figured that if she was going to have a career that was dependent on organized crime, why not sign with the godfather of the music business, Mo Levy.

At Roulette, Vaughan was assigned to producer Teddy Reig. A renowned ruffian who had done time on marijuana smuggling charges, Reig was corpulent, with a pencil-thin mustache and a jivey street patter that was part Lester Young, part Thelonious Monk. He was also a brilliant producer who had recorded many bebop stars. He knew that Vaughan sounded better live in a club than she did in a recording studio. So he re-created a nightclub atmosphere in the studio, recording at night with as few takes as possible. The finished product, an album called *After Hours*, released in 1961, was exquisite.

Vaughan did some of her best work at Roulette, but she soon became frustrated. Either the label was not properly promoting her records, or she was being cheated out of royalties. Whenever her representatives sought to get a full accounting from Levy's company, they were met with stall tactics and prevarications. In 1964, only four years after signing with Roulette, Vaughan left and returned to Mercury Records.

Levy's reputation for chicanery was renowned. In 1963, when Dinah Washington, age thirty-nine, was found dead in her home in Chicago of an overdose of sleeping pills, her husband came to New York to collect royalties. Dick "Night Train" Lane, a veteran football player with the Detroit Lions, was not a man to be trifled with. In addition to his years as a defensive back in the National Football League, he had served four years in the U.S. Army. He was muscular, fast on his feet, and not likely to take guff from anyone, much less a doughy, slightly balding record executive. When Lane showed up at the offices of Roulette Records, Levy at first tried to duck out a secret doorway he had in the back of his office. When one of his house lawyers noted that Lane was not likely to give up in his efforts to collect on his deceased wife's royalties, Levy acquiesced. Night Train Lane was seen leaving the offices of Roulette Records with a check in his hand, a rare sight indeed.

Levy's shady business tactics went far beyond individual artists or their angry spouses. In 1962, his tactics finally caught the attention of the FBI.

Starting in 1960, Levy had been on the radar of law enforcement authorities due to his partnership with the notorious disc jockey Alan Freed. Levy had used Freed, a popular deejay at WINS (1010 AM), to promote his product, to great effect. Later, it was shown that Freed engaged in "payola," an illegal practice of accepting payments from record companies to play specific records. Eventually, Freed was fired from his radio job and lost his popular television show. In 1962, he pleaded guilty to two counts of commercial bribery, for which he received a fine and a suspended sentence.

Many—including agents of the FBI—wondered how Levy had avoided criminal prosecution. In 1962, the same year Freed was convicted, the Bureau opened a file on the owner of Birdland and Roulette Records, noting that "Morris Levy is under investigation by the New York and Miami offices as a top hoodlum. His activity principally involves his operations as 'front' for hoodlum principals in the entertainment field, including nightclubs and music recording."

Almost immediately, the FBI received an interesting tidbit from one of its numerous informants inside Roulette Records: "NY T-2 stated that on March 19, 1962, SWATS MULLIGAN [aka Dominic Ciaffone] physically beat up MORRIS LEVY in the Roulette offices. The reason for the beating was unknown to the informant."

Levy was under pressure. His restaurant/lounge, the Roundtable, located on East 53rd Street in Manhattan, was running in the red. The Roundtable was co-owned by Ciaffone and other mafiosi affiliated with the Genovese crime family. Auditors from the Internal Revenue Service descended on Levy's operations, and the Manhattan District Attorney's office was investigating whether or not Roulette Records was making illegal under-the-table payments to Local 802 of the American Federation of Musicians. The theory was that Levy was paying off certain officers of the musicians' union to keep them off his back regard-

ing tardy or nonexistent royalty payments to the union's rank-and-file membership.

Levy bragged so often about his mafia associations that the FBI began to believe it was a tactic used by the mogul to inoculate himself. In interviews with talent agents, managers, producers, and artists, many noted that Levy was, in the words of one agent, "a braggart who seemed to be enjoying the reputation that he was a 'friend of racketeers . . .' Levy himself probably encourages these rumors."

Sarah Vaughan was interviewed by the FBI in 1963; she told the agents that she believed she was being ripped off by Levy but knew nothing of his mobster associations.

Whereas some believed that Levy's mafia affiliations were more braggadocio than anything else, the FBI knew the truth.

After the beating in his office at the hands of Ciaffone, Levy realized he needed to protect himself. In an FBI report dated February 1966, an informant noted that "Levy is scared of Ciaffone and would like to break away from him but is afraid to do so." Rather than do what some people might—seek out the aid of law enforcement—Levy did it the Mo Levy way.

Throughout the mid- and late 1960s, Levy began cultivating a relationship with Tommy Eboli, a powerful underboss in the Genovese family. It was the classic Machiavellian gangster strategy: to mitigate disputes you might be having with a fellow member of the organization, cultivate relationships with others higher up in the food chain. It was textbook "check and checkmate": In fostering a relationship with Eboli, Levy was endearing himself with the man who many felt was the logical successor to Vito Genovese, who was currently in prison on a narcotics conviction.

On February 14, 1969, Genovese died in prison of natural causes. Eboli became acting boss of the family.

Born in Scisciano, Italy, in 1911 and raised in the Bronx, Eboli, in his rise to power, was believed to have taken part in twenty-two murders. Early in his career, he operated under the alias of Tommy Ryan.

Levy first met Eboli when he was working as a hat-check boy at the Greenwich Village Inn. At the time, Eboli was serving primarily as a boxing promoter. In 1952, the future boss became the owner of a juke-box delivery company and another business, Tryan Cigarette Services, which leased vending machines to nightclubs, including Birdland.

Eboli was a killer, but he was no galoot. Like Sam Giancana in Chicago, he was physically unimpressive, prematurely bald, and soft spoken. Also like Giancana, he was ruthless and, in his business dealings, prone to employ the use of violence—though now that he was boss, he had others do the dirty work.

Following the death of Genovese, Levy's cultivation of the new boss kicked into overdrive. He and Eboli partnered on a company called Promo Records, with offices in Paterson, New Jersey. The purpose of Promo Records was to purchase remaindered records, also known as "cut-outs," overstock from corporate record labels of product that had long ago stopped charting. There was money to be made selling these records as remainders in the used record section of a store. Also, a re-mainder dealer could buy, say, five hundred copies of an album and il-legally press several thousand copies more by simply copying the record jacket and making a new master of the record. Either way, in selling as a cut-out or as a pirated copy of the original master, the artist did not receive a dime.

These methods were particularly lucrative with jazz records. Al-though jazz had downsized considerably as a percentage of the overall music market, jazz fans were unusually persistent and loyal. Unlike pop music or rock and roll sales, which were based on Top Forty charts, trends, and the whims of an ever-changing youth market, jazz fans still bought vintage records from the likes of Jelly Roll Morton, Sidney Be-chet, Louis Armstrong, Ellington, Benny Goodman, and other mas-ters. The numbers were nowhere near those of the latest pop or rock releases, but if the cut-outs purchased by the likes of Levy and his part-ners were purchased at a low price and then pirated, the profits could be substantial.

Like royalty theft, payola, and bootlegging of records, cut-outs—as a subsidiary criminal racket buried deep within the nuts and bolts of the music business—were yet another scam pioneered by Mo Levy. Even though nightclubs were no longer a sure thing, and the economics of jazz were making it less attractive to the average gangster, Levy continued to find ways to profit from the business. He was the ultimate jazz vampire.

"Get Off My Stage, Nigger"

The Copacabana had become the granddaddy of New York nightclubs. Though it was not a jazz club, per se, it often featured jazz, especially vocalists. It had become the city's premier cabaret and supper club almost by default. Long gone were the famous Harlem venues from the Golden Age: the Cotton Club, Savoy Ballroom, Connie's Inn, and the Ubangi Club. In Greenwich Village, the Village Vanguard was still functioning, but Café Society, Club Bohemia, and the Famous Door were history. Nearly all of the 52nd Street clubs were gone. And then, finally, to no one's surprise, in June 1964 Birdland filed for Chapter Eleven and ceased operations the following year.

The Copa was an anachronism. Anthony Polameni, maître d' at the club for nearly twenty years, remembered the day the Beatles first appeared on the *Ed Sullivan Show*. The club's manager and some of the staff watched the lads from Liverpool on a black-and-white TV in the club's kitchen. "Some of us thought it was a fad. Some thought it was kids' music. There may have been somebody who felt it was a threat to us, but if they did, they kept their mouths shut. We were the Copa. We'd been around since 1940. We weren't going anywhere."

One reason the club may have survived after most of the others closed was its stature as Manhattan's premier mafia lounge. It was part of the legend of the Copacabana. There were the many famous incidents—the night four New York Yankees, including Mickey Mantle and Billy Martin, got into a brawl with some patrons in the club, or the night

Frank Sinatra severely strained a vocal cord and lost his voice—but mostly the place was famous as a veritable man-cave for made members of cosa nostra.

By the mid-1960s, the club was one of a dwindling number of venues that served as a nexus between jazz and the underworld. When Meyer Lansky opened the Riviera Hotel and Casino in Havana in 1957, the hotel's nightclub was called the Copa Room, as was the main showroom at the Sands in Las Vegas. In name and, most important of all, symbolically, the Copacabana brand was the engine that powered mobster-affiliated jazz from New York to Vegas.

The mobster pedigree of the club had been established from the beginning. When the club opened, the name on the lease as owner was Monte Proser, a well-established nightclub and cabaret owner originally from England. Pointedly, Poser had no criminal record. The true owner was Frank Costello, who had invested in the club using money from his upstate gambling operations in Saratoga. The man who actually ran the club for the mob was Jules Podell, who had formerly managed the Kit Kat Club, a burlesque house and strip club on Broadway also owned by gangsters.

The Copacabana was named after the famous neighborhood in Rio de Janeiro, and the Brazilian-themed décor was influenced by cabaret star Carmen Miranda, who was one of the first major acts to perform at the club. The Copa had glamour and excellent Chinese cuisine, but by far the primary attraction was the live entertainment, most notably the Copa Girls, a chorus line of voluptuous women in skintight, sequined costumes whose dance revue opened every show.

In 1944, a few years after the club opened, racket-busting mayor Fiorello La Guardia went after the Copa and other nightclubs in the city. It was an ambitious effort by La Guardia to once and for all sever ties between nightclubs and the mob. The city sought to establish that "there were known racketeers or gangsters frequenting the Copacabana" along with "persons interested or part owners who are disreputable persons engaged in unlawful enterprise." Costello, in particular, was cited

as being the mob's man in control of city nightlife. He was subpoenaed to testify in front of a city commission investigating the club.

Costello and his lawyers contested the subpoena. One person who did appear in front of the commission was Podell, who reluctantly testified that, when applying for city licenses for the Copa, he neglected to mention that he had been arrested at least four times on Volstead Act violations and once for burglary. Podell was what was known in the business as a tough Jew. He had once been shot in the leg but refused to tell the cops who did it. La Guardia's commission threatened to remove Podell from management of the Copa. Instead, lawyers for both the city and the club got together and reached a deal. Though Costello never admitted that he actually had a financial stake in the club, he agreed to render "terminated and severed" any connection he "may now have or have had with the Copa." Monte Proser was out, but Podell was allowed to stay.

If anything, the city's efforts only enhanced the reputation of the club. The place was now referred to in advertisements as "Jules Podell's Copacabana," and mobsters, including Frank Costello, were still a major part of the club's clientele.

By the late 1940s, the Copacabana's reputation was such that it could make or break an entertainer. Sammy Davis Jr., in *Yes I Can*, his bestselling autobiography (published in 1965), described a night when he and his father stood across the street from the club. Davis was a twenty-year-old song-and-dance man who, along with his father, appeared onstage as part of the Will Mastin Trio. Struggling to attain notoriety, they dreamed of one day appearing at the Copa.

> It was a freezing night, but we stood in the doorway of a building at 15 East 60th Street, directly across from the Copa, watching the people going inside, the doorman helping them out of their limousines and cabs, tipping his hat, holding the door open for them until they disappeared inside, laughing. Why wouldn't they laugh? They had everything, importance, clothes

and jewelry like I'd never seen anywhere but in movies . . . I clenched my fists. "Someday I'll play that place, so help me God."

Davis and his father had a problem, and it wasn't just that their small-time act was nowhere near famous enough to secure a booking at the Copa. The problem was that they were Black.

Even by the late 1950s, many of the city's nightclubs were still strictly Jim Crow. The mob-controlled clubs especially seemed to take pride in their segregationist door policy. It was part of a venue's historical identity: Black entertainers, white audience—that is how the mob conducted business. If you didn't like it, what were you going to do, take it up with the mob?

Davis learned firsthand about the Copa's implacable racial policies. Even though he was invited to the club by Frank Sinatra—on a night that Sinatra was performing—Sammy was denied entry. This was a fate also met by Harry Belafonte, who in 1944, as a member of the navy, tried to attend the club with a white girlfriend. Interracial couples were especially frowned upon; Belafonte was turned away at the door.

Ironically, both of these men—Davis and Belafonte—would eventually appear as headline acts at the Copacabana after they became world-famous singers.

The racism at the club was pervasive. It started with management and the staff and spread to patrons in the audience, which, on any given night, included many mafiosi. Even after becoming a star and an honored guest at the club, Sammy Davis Jr. suffered racial indignities.

On a night in January 1957, he was at the club as a patron with a large group of friends. They were seated at a table near the stage. Sinatra had been scheduled to perform that night, but earlier in the day it was announced that actor Humphrey Bogart had died from lung cancer. Sinatra idolized Bogart; they were good friends. At the last minute, Frank announced that he was unable to do the show that night. Jules Podell, the owner, scrambled to find someone to fill in. Comedian

Jerry Lewis agreed to do the show, but he could do only one set. Podell needed someone to fill in for the late set, which usually started around two in the morning.

Sammy Davis did not need the work. By 1957, he was a big star. He had already twice performed as a headliner at the Copa, with fabulous success. He filled the club both times. He agreed to fill in for Sinatra and do the late show. Podell was highly appreciative. He arranged for Sammy and a group of ten friends to have ringside tables throughout Sinatra's two-week run, all of it—food, drink, the tables—on the house.

Sammy and Podell had a history. Podell was a brute of a man, known for his foul mouth and often equally foul disposition. He had a deep, raspy voice, a big head, and the physique of an aging longshoreman. He berated workers at the club and also the entertainers if he felt he had a reason. He wore a large star-sapphire ring on his pinkie finger, and when he wanted something from the staff or an employee, he would loudly bang his ring on a tabletop. It was a sound that instilled fear among the staff.

If patrons at the club approached Podell, he might tell the person, "Get the fuck away from me, asshole." He was so disagreeable that an FBI informant once told his handler, who memorialized it in a memo, that a group of mafia bosses once met to discuss replacing Podell at the Copa because he was believed to be bad for business.

It had taken Podell a while to warm up to Sammy Davis Jr., even though the song-and-dance man filled the club from the first time he appeared there (in 1954). Once, when Sammy's set ran long, which was a no-no at the club (Podell ran a tight ship), Podell banged his ring on a table and bellowed, "Get off my stage, nigger."

The night Davis was in the club to fill in for Sinatra, he came early with a group of friends to support Jerry Lewis. His entire group heard someone behind them complain about "that little nigger in front of me." When a waiter and maître d' could not silence the man, a captain came over to speak with the customer. "It's obviously some kind of mistake," said the patron. "I came here thinking I'm spending my money

in a first-class place, so you can understand my surprise when I find my wife and I seated behind this little jigaboo."

The customer and his wife were immediately escorted from the premises.

Rumors circulated that the National Association for the Advancement of Colored People (NAACP) was going to picket the Copacabana. Previously, the organization had picketed and boycotted the Stork Club, a rival of the Copacabana, for its treatment of renowned international entertainer Josephine Baker. The subsequent protest had been a nightmare for the Stork Club, leading to bomb threats and reams of bad press.

Jules Podell may have been a racist, but he recognized that a boycott by the NAACP could lead to Black entertainers such as Ella Fitzgerald, Johnny Mathis, Nat King Cole, or even Sammy Davis turning against the club.

Davis arranged for leaders of the NAACP to meet with Podell. Quietly, with no fanfare or press announcement, the Copacabana, in mid-1957, agreed to do away with its no-Blacks-allowed door policy.

Even so, rightly or wrongly, the club retained its reputation as a segregationist establishment. Black entertainers were treated well at the club, but Black patrons did not feel welcome. Partly, this had to do with the club's reputation as a "mafia joint."

The relationship between jazz and the underworld had come a long way since the days in New Orleans when Sicilians and Blacks first established working relationships that were at the heart of the jazz business. Somewhere along the line, the plantation mentality, which became an operating as well as aesthetic principle in the presentation of jazz, had come to dominate the relationship. Mob-run clubs, or clubs that were perceived to be "mafia friendly," were likely to be the most backward when it came to treating Black people as human beings of equal stature with whites. Few people offered the opinion anymore that mob-controlled clubs were somehow especially good for Black jazz musicians. With their racist door policies and atmosphere of bigotry inside the

club, those clubs were more likely viewed as an impediment to social advancement, not only in the nightclub business, but in society at large.

Mambo Italiano

Black musicians weren't the only ones chafing under mafia rule in the music business. From nearly the beginnings of jazz history, Italian American musicians sometimes found themselves in a unique predicament. This was especially true for the singers.

Frank Sinatra wasn't the only one who seemed to capture the imagination of his tribe and then move on to conquer the larger population. Singers whose popularity in the marketplace elevated them beyond the tribe became sources of great envy and pride. Just as the Irish might have worshipped those among them who rose in the world of politics, or Jews took special pride in those who achieved great things in literature and academia, the popular Italian American singer represented the height of achievement to many, including the mobsters. Writes John Gennari in *Flavor and Soul*:

> From the 1940s to the 1960s, while many second-generation Italian Americans realized their dream in the security of owning automobiles and homes, Italian American popular singers (Sinatra, Perry Como, Dean Martin, Tony Bennett, Mario Lanza, Vic Damone, Jerry Vale, Joni James, Connie Francis, Bobby Darin) virtually defined the way America dreamed about love and romance.

For the singers themselves, this often involved walking a tightrope between independence and fealty to the dictates of the mob. Pressure came from the business side of things—the nightclubs and talent management—but it could also come from the neighborhood.

Vic Damone, born Vito Rocco Farinola in Brooklyn, described in his memoir an incident so "delicate" that he felt the need to use false

names, even though the events of the story happened fifty years earlier. As a young man in his early twenties, Damone met and fell for the daughter of a mafioso he refers to as Johnny D'Angelo. At the time, in the late 1940s, Damone was already a professional singer with a rising career. He was ready to marry D'Angelo's daughter, until one day he took his fiancée to meet his mother at her home in Bay Ridge. The two women got into an argument, with the fiancée calling Damone's mother a bitch.

"You called my mother a bitch?" said Damone. "Apologize right now or the marriage is off."

Johnny D'Angelo's daughter was stubborn; she refused to apologize. Damone called off the marriage.

D'Angelo the elder was livid. He lured the young singer to the Edison Hotel in Manhattan, under the pretense that they would discuss the matter. When Damone arrived, D'Angelo grabbed him and tried to throw him out the window. Damone was saved by his manager, whom he had brought along to serve as his bodyguard.

In the wake of this incident, a major sit-down among the mafia bosses was arranged. The meeting took place at Hotel Fourteen, a boutique hotel that was part of the same building that housed the Copacabana nightclub. The hotel was owned by the owners of the club and used sometimes as a residence for performers from out of town, or for trysts, or sometimes for highly secretive mob sit-downs.

Damone arrived at Hotel Fourteen, along with his manager. He was met by a bevy of important gangsters, along with Johnny D'Angelo. According to Damone, D'Angelo was seeking authorization to have Damone killed for having insulted his family name by calling off the wedding with his daughter.

Inside one of the rooms in the hotel above the Copa, the mobsters debated the singer's fate. Presiding over the meeting was Frank Costello, known in the press at the time as "Prime Minister of the Underworld" for his ability to broker settlements among various mob factions. Da-

mone gave his side of the story about how D'Angelo's daughter had besmirched his mother's honor.

Much to the singer's relief, Costello sided with him and gave a thumbs-up sign, which meant Damone could not be killed.

Damone was appreciative, but now he was indebted to the mob. When they called on him to perform at wedding receptions, baptism parties, first Communions, or whatever, he had to accept. Even if he had a previous booking, he was expected to cancel and make other arrangements, because from now on, he was part of the family.

Tony Bennett, born Anthony Dominick Benedetto in Astoria, Queens, became a singer in the years following his time in the U.S. Army, where he experienced brutal combat in Germany and took part in the liberation of a Nazi concentration camp.

Upon his return stateside in the mid-1940s, Bennett began to explore the possibilities of becoming what he called a saloon singer. He performed under the name Joe Bari. Singer Pearl Bailey heard the young singer one night at the Greenwich Village Inn, and she sought to help him out. Bari changed his name to Tony Bennett and, in 1944, signed a deal with Columbia Records.

Bennett became frustrated with the slow pace of his development, so he took on a new manager. Ray Muscarella was a wiseguy who had also helped Vic Damone get started. Bennett knew of Muscarella's mob connections; he had misgivings, but it seemed like the only way to go. Said Bennett:

I felt I couldn't pass up on the chance to get the good gigs I was sure Ray could get. I'd been scuffling long enough, on ten cents a day, and I couldn't turn down any kind of help . . . [Ray] ran a few businesses in Brooklyn, his family owned a winery in Little Italy, he managed prize-fighters and he dabbled in show business. In those days, there wasn't a business that wasn't connected, one way or another, with the underworld. They owned

the nightclubs. And ruled the jukebox business, then started up record companies to make records for those jukeboxes and signed up singers to make records, so they controlled it all. And it was understood by everybody that if you really wanted to make it, sooner or later, you'd run into one of those guys.

In 1951, the weekly scandal magazine *Confidential* published a series titled "The Mob Moves in on Show Business." In an adjoining article titled "Gangster Ghouls," the magazine noted that "a character named Ray Muscarella, singer Tony Bennett's manager," had used his muscle to get Bennett's record into eighteen thousand jukeboxes simultaneously. "The jukeboxes involved, for the most part, are owned and/or operated by the mob."

Muscarella was angry about the article. Together with an associate, he stormed the offices of *Confidential* and confronted the editor. The rumor was that they hung the editor outside a window by his ankles. To the mobsters, the editor concurred that he had made a terrible mistake. "From now on, I'm gonna read every article we publish," he said. The following issue of *Confidential* included a retraction that appeared under the headline "When we make a mistake, it's a beaut."

In 1960, Bennett came to the conclusion that his mobster/manager was more trouble than he was worth. The singer had never been comfortable with the arrangement. He suggested a buyout, but Muscarella was not interested. The situation became tense, until Bennett, for a fee of $600,000 and a 10 percent cut of his income for the next five years, was able to secure a release from Muscarella. Even then, he remained concerned that the mob would never stop believing they owned a piece of his career. The crooner never felt completely relaxed until after Muscarella died of natural causes in 1965.

Singer Bobby Darin, born Walden Robert Cassotto in East Harlem and raised in the Bronx, was practically mob royalty. His maternal grandfather was Severino Antonio "Big Sam Curly" Cassotto, an Italian-born mobster who died in prison from pneumonia a year before

Darin was born. Darin's father was believed to have been in business with Frank Costello. Darin hardly knew his father, who died young. Precociously talented as a singer and performer at a young age, Darin was raised by his grandmother and led to believe that his real mother was actually his sister.

When Darin first headlined at the Copacabana, at age twenty-four, he was told by Jules Podell, "If you want to know about your father, I know people who can tell you the whole story." The implication was that the father was "connected." The young singer wisely kept his distance from the mobsters, but they viewed Darin as "a friend of the family," which led to his early booking at the Copa.

The date was June 12, 1960, and the performance was recorded as an album, *Darin at the Copa*. Both the live appearance and the album were a sensation, and from then on the singer was identified with the club where every performer hoped to get a booking. Darin appeared there six times before his death from a lifelong heart condition in 1973. He was thirty-seven years old.

Darin's penultimate appearance at the Copa was the one that brought him into direct conflict with Podell and the mob. Starting in the late 1960s, Darin had begun to come under the influence of the counterculture movement and, particularly, early Bob Dylan. Up until then he had been presenting himself as the last of the great "ring-a-ding-ding"–type singers: always in suit and tie or sometimes even a tuxedo. His jaunty delivery and expert jazz phrasings were in the tradition not only of the great Italian American crooners but also jazz vocalists from Bessie Smith to Billy Eckstine.

But now, Darin started to appear onstage in denim trousers and a jean jacket. He performed without the hairpiece he had been wearing since his midtwenties. And his performance repertoire changed. No longer the finger-snapping dynamo who assumed his role as successor to all the great saloon singers, he appeared onstage with a guitar and sang mostly folk-rock songs. No more "Mack the Knife," "Beyond the Sea," and other songs that were cherished by mafiosi from coast to coast.

Now it was "Blowin' in the Wind," "If I Were a Carpenter," and a song he wrote called "Simple Song of Freedom"—gentle protest songs that seemed to hearken the passing from one generation to the next.

Podell hated it, and so did most of the mobsters. When Darin appeared at the Copa on January 15, 1969, and sang songs that many associated with flower children and the peace movement, some in the audience walked out. This was unheard of at the Copacabana, where landing a ticket was like securing a box seat at Yankee Stadium. The mobsters complained to Podell, and the irascible owner let Darin have it, shouting, "You will never perform here again, do you hear me."

According to maître d' Polameni, there were even jokes and innuendo among the faithful that Darin, because of his new style and musical choices, might possibly get whacked.

Within a year or so, Darin had changed his tune yet again and appeared one last time at the Copa, in February 1972. He had mostly reverted to his original form, which a reviewer in the *New York Times* referred to as "Vegas-flashy." Only now, the mercurial singer's problem was that, by 1972, the times had passed him by. Perhaps this was still the preferred style of entertainment at the Copa, but to the *Times*, it was passé: "Darin belongs to another era . . . Where else could he have learned that tired old show-biz routine of whipping off his tie to prove that he was reaching a feverish state of performing energy—a routine that now looks as humorously antiquated as Al Jolson getting down on one knee to sing 'Mammy.'"

The mafiosi at the Copa loved the loosened tie bit. What had almost gotten Bobby Darin whacked was "Simple Song of Freedom."

13

THE MUCK AND THE MUD

From the beginning, the Sands Hotel and Casino in Las Vegas was designed to be an offshoot of the Copacabana. Not only was the facility's primary showroom named the Copa Room, after the Manhattan nightclub, but the man brought in as entertainment director at the Sands was long considered the person most responsible for the creation of the Copa brand. Jack Entratter got his start as a doorman at the Stork Club, one of many New York supper clubs partially owned by Frank Costello. The brain trust at the Copa, another of Costello's clubs, recognized Entratter's talents and stole him from the Stork Club by giving him a more prestigious position. At the Copa in New York, Entratter became a manager with a particular emphasis on entertainment. Entratter hired the musicians, comics, and singers, and he hand-selected the Copa Girls, who he openly said did not have to be great dancers, they only had to be beautiful.

Entratter was six foot four and two hundred forty pounds, a big hulking figure with hands the size of catchers' mitts. Like Jules Podell, he was a tough Jew, and he could be gruff. But unlike Podell, he had an ingratiating smile, and he never stayed mad for long. The entertainers, in particular, liked Entratter; they felt he was honest with them. And the mobsters liked Entratter because he was big and tough, and he knew to treat them like honored guests when they were in the club.

Jack Entratter was not a gangster, but he spent his entire career doing business with what the FBI referred to as "Top Hoodlums." His ability to do this with equanimity made him a treasured commodity in the business, and when, in 1952, a consortium of East Coast mobsters made the commitment to co-finance the Sands on the Vegas Strip, one of their first moves was to transplant Jack Entratter from the Copacabana to the Sands. Thus began a heralded era for the mob—and for jazz—in the Nevada desert.

Las Vegas was not like other resort towns where the mob had fine-tuned its now classic mix of casino gambling, underworld financing, and live entertainment. Covington and Newport, Kentucky; Atlantic City; Hot Springs; Broward County north of Miami—these were all localities where investments from organized crime and local corruption combined to establish a pattern that was referred by the Kefauver committee as "a threat to the people of the United States." Vegas was different in that the entire state of Nevada had legalized gambling far back in 1931. Some form of casino gambling had become institutionalized in the state, and there wasn't much Kafauver and his committee could do about it—though they did try.

After Havana fell to bearded young revolutionaries in 1959 and the American mobsters were chased off the island, Vegas found itself on the receiving end of renewed attention from the mob. Lansky, Vincent Alo, Moe Dalitz from Cleveland, and Joseph "Doc" Stacher, a mobster who had grown up with Lansky on the Lower East Side of Manhattan who was now based in Los Angeles, had all been major investors in Las Vegas casinos since the mid-1940s. Their baby, the Flamingo Hotel and Casino, whose construction had been mishandled by Benjamin Siegel, leading to his death, nonetheless opened on December 26, 1946. The opening-week entertainment was Jimmy Durante and Xavier Cugat with his Latin jazz orchestra. From the start, it appeared as though the Flamingo was cursed. After Siegel's murder, the name of the place was changed to the Fabulous Flamingo and ownership passed through numerous hands over the years.

With the Sands, investors Lansky, Stacher, and others felt they had learned from their mistakes. Out on the gambling floor was where the money was made, but entertainment was the lure that brought locals, tourists, business conventions, and, most notably, high-roller gamblers from around the world.

Situated in the middle of the Mojave Desert, with summer temperatures well over one hundred degrees, amidst arid, dusty conditions, Las Vegas was barely suitable for human habitation. Unlike previous citadels of jazz like New Orleans, Chicago, or New York, there was no local culture to speak of, unless you consider rodeos, cowboys, and steer rustling a form of culture. This was both a curse and a blessing for men like Entratter. Las Vegas was a blank slate; it could be anything you wanted it to be. Thus the city's forefathers and entertainment directors set about to create an ersatz city that was pure fantasy. Lots of neon flashing late into the night and early morning with the promise of sex, entertainment, and sudden riches (not to mention quickie divorces) became the central motifs to a municipality that, in a matter of three decades or so, saw its population boom like that of no other American city.

Las Vegas may have been a wasteland compared to the great jazz cities of the past, but the type of entertainment showcased there was designed to be "classic." Even in the 1960s, when the entertainment scene in Vegas hit its stride, rarely was rock and roll on the bill. Jimmy Durante, with his links to vaudeville and the jazz clubs of the 1920s, remained a staple in Las Vegas throughout the decade. At the Sands, Entratter looked to establish a reputation for the kind of entertainment that would soon be considered "vintage." Certain jazz musicians, if they were of sufficient celebrity stature, were always welcome: Louis Armstrong, Nat King Cole, Lena Horne, Count Basie, Billy Eckstine, Sammy Davis Jr., and, of course, Frank Sinatra were booked regularly at the Copa Room.

Entratter's old-school sensibility as a booker had an influence on other venues on the Strip. Joe E. Lewis was a regular at El Rancho

Vegas. Louis Prima and his wife, singer Keely Smith, became a sensation in the Casbar Lounge at the Sahara, where, along with saxman Sam Butera, they created what was billed as the "Wildest Act in Vegas." Duke Ellington, Benny Goodman, Stan Kenton, Buddy Rich, Gene Krupa, Peggy Lee, Sarah Vaughan, Ella Fitzgerald, Carmen McRae, Buddy Greco, Quincy Jones, and Johnny Mathis were just a few of the jazz musicians who played either the Strip or at one of the smaller clubs in downtown Las Vegas.

For most musicians, the benefits were obvious. The casino show-rooms and lounges paid better than most anywhere else in the country, and they booked an act for two weeks or even a month at a time. With seemingly unlimited budgets, the casinos were able to book large or-chestras like Ellington and Basie at a time when those types of band configurations were no longer affordable for nightclubs in most any other city in the United States.

It may have been a mob-run town, but only on rare occasions would you see an actual mob boss in Vegas. Those who owned a piece of the casinos—Lansky, Dalitz, and the rest—did not live in Vegas. Mobsters might come to the casinos to gamble or attend a floor show by one of their favorite entertainers (Bobby Darin at the Flamingo was not to be missed), but they blended in with the hordes of gamblers and tourists, some of whom were indistinguishable from the hoodlums.

To say that the mob made a killing in Las Vegas would be an under-statement. The profits were driven by volume: The more gamblers out on the floor of the casino, the better. Music and entertainment played a big role in drawing patrons to the gaming tables and slot machines. In the beginning, admission was free to see the likes of Satchmo and Sinatra. This seemed almost too good to be true, but it was worth it to the casino bosses as a way of attracting gamblers. Eventually, a nominal admission fee was charged, $3 to $6, which was still a bargain.

The floor shows had little to do with profits; that was not where mobsters made their money. Profits were generated out on the gambling floor, where the majority of players lost. Even those who seemed to be

winning ultimately lost; it was the law of averages. What goes up, must come down. If properly managed, a casino was a license to print money.

The counting room of the casino was where the rubber hit the road. "The skim," as it was known, was money pilfered in the counting rooms to be paid directly to organized crime. Any casino that was financed in part by mobsters knew that this was the routine. The process was not subtle. Cash was bound into neat little packets and loaded up in gym bags, duffel bags, or suitcases. The money was shipped out to places like Miami (Lansky and Alo), Cleveland (remnants of the old Mayfield Road mob), and Los Angeles (Stacher and Mickey Cohen). Notably, money was also shipped to Chicago, Kansas City, and Milwaukee, three localities that played a pivotal role in the development of the Strip. Mobsters in these cities were crucial in securing casino financing via the Teamsters Central Pension Fund, which was invested in the construction and management of nearly all the initial casino/hotels.

By the early 1960s, the Las Vegas Strip had become the central banking mechanism of the American underworld. The sideshow that facilitated the process and made it all so profitable was, in large part, music and entertainment.

The Mississippi of the West

For Black jazz musicians, Las Vegas was a different story altogether. Founded as a western outpost by Mormons and fundamentalist Protestants, the city and surrounding Clark County did not hide its racism. Long after Jim Crow had been struck down by federal law in 1954, the hotels and casinos were still racially segregated. Blacks referred to Las Vegas as "the Mississippi of the West" due to its entrenched attitude of racial subservience. Black entertainers were not allowed to stay in the very hotels where they were performing, including big-name performers like Louis Armstrong, Sammy Davis Jr., and Nat King Cole, who were booked at some of the best venues in town.

Most of these performers had experienced American racism and

knew what it was all about; in April 1956, Cole was attacked by KKK members while onstage during a performance in Birmingham, Alabama. "Man, I love show business, but I don't want to die for it," said Cole backstage after the incident. Davis had experienced vile racism while serving as a soldier in the U.S. Army and throughout his entertainment career. These men had been raised with racism all around them and had, to an extent, sought out careers in entertainment as a refuge from the storm. It was especially galling to travel to the Nevada desert to perform at a prestigious showroom on the Strip and then be told they would have to stay in the colored section on the other side of town.

The city's Westside, where Black entertainers were housed, was a desert ghetto. Sammy Davis Jr. recalled his first gig in Vegas as part of the Will Mastin Trio, a group that included his father and uncle. The boardinghouse where they stayed looked like something out of "Tobacco Road . . . A three- or four-year-old baby, naked, was standing in front of a shack made of wooden crates and cardboard that was unfit for human life . . . A woman was standing in the doorway. 'Come right in, folks. You boys with one of the shows? Well, I got three nice rooms for you.' When she told us the price, Will almost choked. 'But that's probably twice what it would cost us at El Rancho Vegas.'

"'Then why don't you go live at El Rancho Vegas?'" The woman knew they were prohibited from staying there.

Eventually, famous Black entertainers were allowed to stay at the hotels on the Strip, but they were prohibited from betting in the casinos or eating in the hotel restaurant. It was an indignity that outraged even some of the white entertainers. When Sinatra saw Nat King Cole eating his dinner in the kitchen of the restaurant at the Sands, he was infuriated. He approached Jack Entratter, demanding that Cole and other Black entertainers be extended the same courtesies as white performers.

"What do you want me to do, Frank? It's company policy."

"Then change the policy," said Sinatra.

Bit by bit, Vegas opened up, but progress was slow. Managers like Entratter, who professed his sympathy for Black entertainers, were quick

to cite the fact that many of the casinos' most esteemed high rollers came from the South, especially the state of Texas. It was believed that white gamblers from Texas would not patronize places like the Sands if they allowed Blacks to circulate openly. In truth, Entratter was up against the same mentality that he had encountered when he worked at the Stork Club and the Copacabana in New York. Establishments that were identified as having mob connections were not normally arbiters of integration and civil rights.

By 1960, with the civil rights movement building steam in the South, activities in Las Vegas were approaching critical mass. Harry Belafonte, Lena Horne, Sammy Davis Jr., and Nat King Cole, along with some major white entertainers like Sinatra, were among those to advocate for full integration in the hotels and casinos. Leaders of the local chapter of the NAACP approached the bosses of the various resorts and let it be known that unless they changed their policies of racial apartheid, their establishments would be picketed by a consortium of activists and entertainers.

Sinatra, Davis, and Cole, in particular, carried significant weight with management at the Sands. They were the three top-drawing acts playing regularly at the Copa Room. For them to take part in a march or protest against the Sands on racial bias grounds could be devastating, if not among the patrons who routinely gambled away their life savings in the casino, then certainly among top-line entertainers who were instrumental in luring those patrons to the card tables and slot machines.

While other casino bosses were resisting the demands made by the NAACP, those musicians were able to convince the Sands to do away with its segregationist policies.

It was a significant decision. Here was perhaps the most identifiably mob-connected hotel/casino on the Strip giving in to the demands of the NAACP. It was bound to have an effect on the other establishments.

Almost immediately, it led to the governor of the state creating an entity known as the Nevada Equal Rights Investigatory Commission.

At first, it looked as though this governmental body might take action, but as it engaged in endless meetings and stall tactics, civil rights leaders announced a date for their March Against Racism, to take place that summer. This lit a fire under the Caucasian asses of the casino bosses. In a meeting between Las Vegas gambling interests and civil rights leaders in March, a pact was signed known as "the Westside agreement," in which the hotel/casinos agreed to do away with their Jim Crow policies and also to integrate their staffs by employing Blacks as doormen, dealers, pit bosses, security personnel, and other positions.

It was a landmark agreement, and the Sands had played a significant role in bringing it about.

Still, signing an agreement and then implementing its terms were different matters. Racist attitudes were deeply ingrained at the Vegas casinos, and mob rule had played a role in undergirding those attitudes.

Not long after the signing of the agreement, Nat King Cole was headlining a two-week engagement at the Copa Room. As he was preparing for a show one night, a flustered stage manager came into Cole's dressing room. "Nat," he said nervously, "Charlie is in the dining room." Charlie Harris was a member of Cole's band.

"Oh?" said the crooner. "Is he climbing any poles? Throwing food? Doing anything unusual?"

"He's eating, Nat." The stage manager explained that he had been sent by the maître d' at the restaurant to see if Cole couldn't help rectify "the problem."

Cole was seated, putting on his bow tie, looking in the mirror. "Get Jack Entratter on the phone," he told the stage manager, who continued trying to explain the gravity of the situation.

"If you don't get Jack Entratter in five minutes, I'm packing up and getting the hell out of here," said Cole.

Five minutes later, Entratter arrived and asked, "What's the problem, Nat?"

Said Cole, standing up from the mirror: "What about my fellows eating downstairs in the restaurant?"

"Of course, they are allowed to do that."

Cole put a finger in Entratter's chest. "Then call those bastards down there and tell *them*."

Nat King Cole had not started out as anyone's idea of a civil rights activist. Years earlier, when asked by *DownBeat* whether or not he would be taking part in the burgeoning movement, he said, "I'm a singer of songs. I'm not a public speaker." That likely changed the night he was attacked by KKK hooligans on a stage in Birmingham. Now he had his finger in the chest of Jack Entratter, creator of the Copa Room, partner of high-ranking mobsters from Las Vegas to New York, making demands. Times were changing.

Hoodlum Complex

In the years since Frank Sinatra had emerged as likely the most well-compensated entertainer in America, there was much about his offstage life that he could point to with pride. His role in speaking out against racial bias and bigotry was undoubtedly sincere. In 1945, he had produced and appeared in a short film titled *The House I Live In*, which addressed the subject of racial intolerance (it was awarded an Academy Award). He was loyal and generous with his friends and others in need. He gave to charities and humanitarian causes. He was on the right side of the civil rights movement, both in words and deed.

This was the Frank Sinatra that the singer wanted the public to acknowledge. Then there was the other Frank Sinatra, the friend of mobsters. He lied about these entanglements in public, but he did not hide it from friends and others in the entertainment business.

In 1960, Sinatra gathered $1 million in cash donations from his mob friends to be delivered to the Kennedy campaign. It was no secret. At a campaign party at the Sands, after the candidate had attended a

show by the Rat Pack, Peter Lawford (Kennedy's brother-in-law) said to Sammy Davis Jr., "If you want to see what a million dollars in cash looks like, go into the next room; there's a brown leather satchel in the closet; open it. It's a gift from the hotel owners for Jack's campaign."

Sinatra wanted his friends to know about the money, and he wanted them to know where it came from.

The singer didn't just hang out with gangsters or solicit cash donations from mobsters; he sometimes acted like one.

In 1967, after stand-up comic Jackie Mason started incorporating Sinatra jokes into his act, he received a mysterious phone call threatening his life if he didn't stop telling jokes about the singer. Mason thought it might be a prank. He hired a bodyguard and kept making the jokes. A few days later, three shots were fired through the glass patio door of his hotel room at the Aladdin Hotel and Casino, where he had been appearing all week. The bullets struck Mason's bed, where he had been sitting just moments before the shots were fired. The Clark County Sheriff's Department launched an investigation but was unable to determine who had fired the shots.

Mason was pretty sure it was someone acting on behalf of the Chairman of the Board. He trimmed back the Sinatra jokes in his act, but a few weeks later, while doing his set at the Saxony Hotel in Miami, he said to the audience, "I have no idea who it was who tried to shoot me . . . After the shots were fired, all I heard was someone singing, 'Doobie, doobie, doo.'"

Recalled Mason, "I was warned by anonymous threats all week, on the telephone and by people I didn't know in the hotel lobby, to shut up about Sinatra." Later, while Mason was sitting in his car with a lady friend a few blocks from the Saxony, "All of a sudden, the door opens and a fist comes in, right in my nose and busted me—a fist with some kind of ring on it that's supposed to bust your face open." As the comic sat stunned with a broken nose and lacerations to the face, the assailant said, "This is not the worst that can happen to you if you don't shut up your mouth about Frank Sinatra."

Comic Shecky Greene had a similar experience. Like Mason, Greene was a Jewish comic who performed on the nightclub circuit and at casino showrooms that were owned by the mob. Often these comics performed as warmup acts for the jazz musicians and singers who were headlining at the venue. It was a tradition that could be traced back to the halcyon days of vaudeville.

Greene had become a friend of Sinatra's. He was a burly, proletarian type from Chicago, an authentic street character whose act was especially popular with Windy City mobsters like Sam Giancana. Sinatra and Greene caroused together, especially when they were performing in Miami Beach at the La Ronde Room inside the Fontainebleau Hotel (the hotel's entertainment director was Chicagoan Joe Fischetti, youngest of the three Fischetti brothers). Greene became Sinatra's opening act at the Fontainebleau and part of his entourage, which was notorious for its raucous, after-hours parties in a series of private suites reserved for Sinatra and his gang on the fourteenth floor.

Greene was drinking heavily during this period; by his own admission, he was a "wild man," which he thinks is the main reason Sinatra liked him and enjoyed his company. Over time, in his sober moments, Greene felt that he began to see the true Sinatra. "The man was a great singer, and I appreciated his talent. But his talent didn't have anything to do with who he was."

One thing Greene noticed was how quick Sinatra was to vent his mania and anger on little people—his valet, stagehands, waiters, and kitchen employees:

I saw him throw food on the floor. I saw him have Jilly kick people. [Jilly Rizzo was a saloon owner from New York who acted as Sinatra's bodyguard and gofer.] Once we went downstairs to the Fontainebleau coffee shop. It was four or five o'clock in the morning. Sinatra liked these hot brown rolls they had, so we went down there to see if they were done yet, and they weren't done. And Frank got mad, and he said something to

DANGEROUS RHYTHMS

Jilly, and Jilly kicked the baker and broke his ankle. I said, "Are you fuckin' guys sick? What are you doing?" I used to see these things, and I didn't want to be with him. I wanted to quit every two minutes.

The relationship soured. As Greene was getting ready to go onstage at the La Ronde Room one night, Sinatra said to him, "Shecky, stick with me and I'll make you the biggest star in the business."

"I looked at him and said, 'If being a star means being like you, then I don't want it.'"

Sinatra's baby blue eyes turned cold.

At four o'clock that morning, walking through the mostly deserted lobby of the hotel back to his room, Greene was attacked by three men: Joe Fischetti and two of Sinatra's bodyguards. Fischetti pummeled Greene with a blackjack. The comic gave as good as he got: "Fischetti, that fuckin' moron—I split his whole face open."

Word quickly circulated about the attack. Both Sinatra and Fischetti became worried that Greene would go to Giancana, his friend, and that Momo would be angry. According to Greene, Sinatra begged him to let it drop. He offered the comic a role in his next movie. Greene found it all pathetic, but according to the morality of the streets, a man didn't snitch. When Giancana called him on the phone to find out what had happened, Greene said he fell down some stairs.

Was Sinatra, after years of endearing himself to thugs and hoodlums, simply indulging in behavior that he thought was emblematic of those mob bosses whom he seemed to admire? Was he reveling in what he felt was his inheritance as an honored player in that dark place where jazz and the underworld came together in business and, occasionally, in violence?

In his career, Old Blue Eyes had done something singular: He had crossed over from being a worker on the plantation to being a plantation owner. With Reprise Records, a movie production company, ownership

points in casinos—true power—Sinatra was beholden to very few people in the music business. He was the *padrone* he had always dreamed of being. No one—not Louis Armstrong, Duke Ellington, Billie Holiday, or any other monumental figure in the history of the music—had been able to achieve what Sinatra had achieved. His talent had been his opening salvo, and though he often protested that his Sicilian American heritage was used against him by bigots, his ethnic entrée with the mafia—and his desire to emulate the very essence of those who dwelled there—was at the core of the matter.

Freedom Now Suite

Black jazz musicians did not have Sinatra's sway. In jazz and most other endeavors in American life circa the 1960s, being Black was a mitigating factor. The very words "Negro" or "Black" were meant to be qualifiers. Billy Eckstine, whom some thought was on a par with Frank as the greatest living jazz vocalist, was sometimes referred to as "the Black Sinatra." Nobody referred to Sinatra as "the White Billy Eckstine."

For some Black musicians, there seemed to be only one alternative: exile. Operating within a racist society, in a business that was under the thumb of gangsters, was debilitating. Pianist Mary Lou Williams, whose sublime talent and artistry had been in evidence since she was eight years old, compared navigating the business of jazz to slogging through the muck and the mud. Choosing to leave your own country was not an easy call; it could be disorienting, lonely, and heartbreaking. But to some, not living as a second-class citizen made the prospect of life as an artist in Paris, Amsterdam, or, later, Japan seem attractive. In these environments, African American jazz musicians were not viewed as chattel. They felt appreciated. Said saxman Dexter Gordon, "I never got a bouquet of flowers in my life before I went to Copenhagen. The first time, I thought, 'What does this mean?' I wanted to give it back. It was so totally unexpected."

Along with Gordon, many others chose to live and perform in exile: Sidney Bechet, Lester Young, Bud Powell, Coleman Hawkins, Benny Carter, Johnny Griffin, Don Byas, and Mal Waldron, to name a few.

At home in the States, others tried to create alternative pathways through the system.

In 1952, bassist/composer Charles Mingus, his wife, and drummer Max Roach launched Debut Records. Both Mingus and Roach had tired of working under the likes of Mo Levy and other mob-connected producers and record label owners. Based in Brooklyn, Debut was designed to be a collective where artists owned their own masters and received actual royalties (terms that Sinatra would later promise but never fully deliver with Reprise Records).

Mingus, who had been toiling in the business for two decades, was not averse to dealing with gangsters. He was managed for a time by Joe Glaser. Mingus admired Glaser's tough-talking ways, but in the end, like so many other musicians who aligned with Glaser, he felt he was being played for a fool.

Almost by accident, one of the first recordings for Debut Records was *Jazz at Massey Hall*, a live recording by a group comprised of Mingus, Roach, Charlie Parker, Dizzy Gillespie, and Bud Powell. This collection of some of the most renowned bebop artists performed under the name the Quintet. Their performance at Massey Hall in Toronto was the only time they performed live together; it is viewed by some as the greatest jazz album ever recorded. Said Mingus proudly, "That [album] is what put Debut on its feet, even though the percentages went to the musicians. Debut only got 10 percent but we still made money on that. I didn't take anything. Max didn't take anything. So the royalty went back to the company. Each musician got [equal shares], minus the 10 percent. The record got a lot of publicity and sold a lot of copies."

The very idea behind Debut Records was to create greater autonomy for Black jazz musicians. Roach, an intense Brooklynite, originally born in North Carolina, was among the first of his generation to think of jazz in Black nationalist terms. Along with the record label, he started

a social club in Brooklyn. The Putnam Central Club, on Putnam Ave-
nue, was headquarters for the label and the genesis of the Jazz Compos-
ers Workshop. The workshop staged a series of concerts and rehearsals
performed by many of the biggest jazz names in New York: Thelonious
Monk, Art Blakey, Kenny Clarke, and others.

The objective was to create a loosely organized group of musicians
interested in collaborative composition and cooperative economics.
The record label and workshop were an unprecedented effort to break
free from the shackles of the jazz slavemasters, but Mingus, in particular,
ultimately gave in to the very impulses he was seeking to escape. In an
effort to create leverage with club owners and record executives, he had
notorious Brooklyn gangster Joey Gallo serve as his agent.

"Mingus, what did you do to me?" said an executive from the Bruns-
wick label one day. "I just asked you to do a record date. You didn't have
to send the gorillas after me."

The bassist was unapologetic. "You're the gorilla, man, you walk
around making me [subservient] to you."

"Look, you got the Gallo brothers after me, man. What are you try-
ing to do to me? These guys will kill you. They'll kill you and me too."

Afterward, Mingus had to admit that he didn't fully comprehend
with whom he was dealing when he hired the Gallo brothers. When
he was reminded by Joey Gallo that he had signed a binding contract
that tied him up in perpetuity, Mingus became concerned. In 1955, he
famously checked himself into Bellevue Hospital. He later said in inter-
views that it was because he believed Bellevue was the one place the
Gallo brothers could not track him down and kill him.

After being released from the hospital, Mingus divested himself
from the short-lived Debut Records. The label was soon bought out by
a larger company.

Trying to break the chains of subservience on the business side was
one thing, but also there was the music itself.

Ever since Billie Holiday first sang "Strange Fruit" in Greenwich
Village in 1939 at Café Society—a club that was not mob-controlled—

people recognized that jazz had the potential to express complex con-
cepts about humanity. The emotional content came from the blues.
Personal hardship, the vicissitudes of life, injustice, heartbreak—these
were the emotional elements that brought the blues to life. "Strange
Fruit" added a sophisticated level of poetry; metaphor, simile, and Bil-
lie's voice were used to burrow deep into the conscience of the listener.
Some thought that Holiday's interpretation of the lyrics would change
jazz forever by summoning new realms of protest, commentary, and
righteousness in the music. The song did have an impact, though it
was more cultural than musical. Jazz was not equipped to incorporate
politics and civil protest into its business plan, at least not as the busi-
ness was currently constituted or had been since the earliest days of
Storyville.

Those who owned the preeminent jazz venues—the Copacabana
(Costello and Podell), the 500 Club (Skinny D'Amato), Chez Paree in
Chicago (Giancana), Ciro's on Sunset Strip in Los Angeles (mobster
affiliate Billy Wilkerson), the Sands (Lansky, Alo, and others)—were
not interested in music with a social consciousness.

By the late 1960s, this had become a conundrum. Some musicians
felt that the business of jazz could never be fully liberated until the mu-
sic itself was liberated.

The clarion call was *Freedom Now Suite*, an album by Max Roach
and his future wife, singer Abbey Lincoln. Officially titled *We Insist!
Max Roach's Freedom Now Suite*, the album was a precursor of the Black
Power movement. Musically avant-garde, angry, thematically ambi-
tious, the five compositions on the album constituted a howl of rage and
anguish—literally—as Lincoln screams over Roach's drum solo for a full
twenty seconds in one section of the record.

The album was not a hit, and it scared some people. When the mu-
sic was performed live at the Jazz Gallery in Manhattan for an audience
of largely NAACP members, the audience was respectful, but no one
was dancing or clapping along with the beat. They were not there to
be entertained.

Roach's album did open up an avenue of expression that others followed. The Student Nonviolent Coordinating Committee (SNCC) established its own band, the Jazz Pioneers. John Coltrane's composition "Alabama" was a searing response to the infamous Birmingham church bombing of 1963, where four little girls were murdered. Nina Simone, the African American chanteuse, sang "Mississippi Goddamn," an appropriately angry condemnation of the current condition. Pianist Randy Weston incorporated more explicitly African elements into his music. Others followed. Don Cherry explored the music of India in his work. Sonny Rollins, Yusef Lateef, Pharoah Sanders, and others explored rhythmic elements from a myriad of cultures, especially those that reflected on African roots. Often, this music was meant to be spiritually enlightening as much as entertaining.

Behind this movement was a growing suspicion on the part of some musicians that the way the music was presented to the public was a big part of the problem. Smoky basement clubs owned and run by gangsters, for many, cast aspersions on the music. As Abbey Lincoln put it:

> I'm jealous when I see ballet dancers in their settings or classical musicians in their setting. That's when you bring your best, not when you're in a smoky, dark, funky room without a dressing room. I railed and railed about that . . . Jazz rooms were [originally] brothels where people with shady characters come and pick up each other . . . The sound [in these places] is an abomination . . . There's nothing romantic about poverty, and that's what these joints are.

Attempts to sustain a more politically oriented version of jazz were mixed. In a commercial environment in which the profit motive was king, gangster-affiliated club owners and record labels were ambivalent, at best, or more likely openly hostile to the distribution and dissemination of what some jazz journalists referred to as "free jazz."

The *Freedom Now Suite* was a universe away from the Copa Room at the Sands, and that was just the way the mobsters wanted it.

A Matter of Respect

At 12:50 A.M. on the morning of July 16, 1972, mafia boss Tommy Eboli was shot in the head and body after leaving the apartment building of his *gumare* ("mistress") in Crown Heights, Brooklyn. On Lefferts Boulevard, he quickly bled out and died. At the age of sixty-one, his soul, according to Sicilian Catholic belief, rose from his body and either ascended skyward into the heavenly embrace of his ancestors, or descended unto Hades, where previous dead mobsters were no doubt awaiting his arrival.

Eboli's driver was not killed in the shooting. It was later determined that he most likely had been in on the hit.

Few men were more startled by the boss's death than Mo Levy. In the three years since Eboli had taken over as godfather of the Genovese family, the record executive had been deepening his relationship with the *capo* in chief. In the spring of 1971, he even took the extraordinary measure of traveling to Europe to meet with Eboli in his home country of Italy. Eboli was already there, meeting with family and "business associates." Levy and Eboli met in Naples, traveled together by train to Southampton, England, and then to London, where they boarded the SS *France*, an ocean liner. On a three-day trip across the Atlantic, the mafia boss and the music mogul no doubt discussed their various joint ventures, analyzing and dissecting ways that they could slice chunks of blubber from the humpback whale that was the American music business.

The entire trip was surveilled and memorialized by FBI agents in a series of reports that were added to Levy's case file.

Following Eboli's murder, two agents interviewed Levy. The record exec was polite with the agents. "Levy said he knows of Eboli's reputation in the underworld but attributes a large part of this to exaggerated

newspaper copy." Levy admitted to his business partnerships with the crime boss, noting that Eboli owned 50 percent of Promo Records. "Although almost illiterate," said Levy, "Tommy had a good business head and was an able worker." Levy claimed to have no idea who would have wanted to snuff out the life of Tommy Eboli.

The FBI for a time deactivated their investigation of Mo Levy. For ten years, they'd had the man under surveillance, with informants in his offices at Roulette Records, IRS agents scrutinizing his financial ledgers, and assorted criminal snitches feeding them gossip and rumors about Levy, who by now had become a living legend. The Feds had everything—except criminal charges.

The case against Levy didn't stay deactive for long.

On an evening in 1975, Levy was leaving the Blue Angel nightclub with a girlfriend and a business associate. A passerby made a flirtatious comment to Levy's girlfriend. The record exec and his associate attacked the man, who, unbeknownst to them, happened to be an off-duty police officer. A police report of the incident stated that Levy's associate held the man down while Levy viciously pummeled him in the face. The off-duty cop lost an eye.

Levy was charged with assault. But, as a man with connections, he was able to make it all disappear. Charges were dismissed before the case reached court, and all records were expunged. A related civil case was settled out of court.

Levy may have escaped criminal charges, but his actions rekindled scrutiny by the FBI. Once again, they assigned agents and cultivated informants.

Though Roulette Records seemed to be up to its neck in debt, Levy was as active as ever. He branched out by founding a company called Strawberries Records, which, by the early 1980s, had established itself as a highly profitable record store chain specializing in bargain-priced LPs and overstock from corporate record labels. The FBI believed that Levy's ownership of Strawberries was a front for the latest boss of the Genovese crime family, Vincent "the Chin" Gigante.

By the late 1970s and 1980s, there were few remaining mafiosi in New York as renowned as Vinny the Chin. Born in the Bronx, Gigante first became an up-and-comer with the Honored Society while still a teenager. His first major act, in 1957, was the attempted assassination of mob boss Frank Costello, Prime Minister of the Underworld. Gigante was eighteen and primarily a modestly talented cruiserweight boxer. He fired a pistol at Costello in front of his apartment building on Central Park West. The bullet skimmed Costello's head but did no further damage.

According to underworld lore, Gigante had been hired to shoot Costello by Vito Genovese, who was looking to move Costello aside. The teenage Gigante was arrested at the scene of the crime and put on trial, but Costello, who had very clearly seen Gigante fire the shot that creased his skull, claimed on the witness stand that he "didn't see nothin'."

Gigante walked free. He transitioned from being a boxer to becoming a made man. A big hulking figure with a broad chin (thus the nickname), he positioned himself to rise in the family, until he was taken down by prosecutors in the same narcotics case that put Genovese behind bars. Gigante was locked up and served eleven months; he was able to secure his release in a way that would shape the direction of his criminal career for the next thirty years. Through his lawyers, Gigante got a criminal psychologist to declare him mentally unstable and therefore not responsible for his actions. This medical diagnosis was accepted by a district court judge, and Gigante was set free.

The young gangster had been declared crazy, but he was, perhaps, crazy like a fox. Gigante spent the next three decades occasionally wandering his Greenwich Village neighborhood in a bathrobe and slippers, unkempt and unshaven, looking very much like, well, a crazy person. The FBI was convinced that it was all a ruse; the wily mob boss was simply burnishing a future insanity defense. Not only did the Feds have information that the Chin was fully compos mentis, they believed he was a high-ranking member in the Genovese family, and among his

business partners was Mo Levy: "Gigante controls by threats of force and induces Levy to participate in financial transactions on behalf of Gigante and the Genovese LCN [la cosa nostra] Family . . . Gigante has developed a stranglehold on Levy's recording industry enterprises, in effect turning Levy into a source of ready cash for the Genovese LCN Family and its leader."

Meanwhile, Levy still had a record empire to run. By the mid-1970s, jazz was no longer a major aspect of Roulette Records. Even so, Levy remained devoted to the music that had launched his career. Since the earliest days of Birdland, presiding over the club with his brother—who had literally shed blood and given his life for jazz—Levy saw himself as a jazz purist. He was not interested in diluting the music with rock and roll or funk (that is, "fusion" jazz), as some record producers had begun to do; he preferred going back to the music's roots.

In 1976, Levy reached out to Betty Carter, a forty-seven-year-old bop-influenced vocalist whose prodigious gifts evoked the spirit of her antecedents Billie Holiday and Sarah Vaughan. Carter was a dynamic singer with startling range who happened to be practicing her art at a time when audiences for undistilled jazz were in remission. Not only did the singer not currently have a record deal, but she also didn't even have a manager.

Levy flattered Carter, assuring her that he wanted to use her to reestablish Roulette Records as the premier jazz label. He signed her to record an album for Roulette and also for her to sign new jazz acts to the label.

By now, Mo Levy was a known entity, like Joe Glaser and other gangster/businessmen, his reputation having preceded him. Betty Carter knew what she was getting into. "Morris Levy and I have a kind of handshake agreement," she told DownBeat magazine. "He respects what I'm about . . . I'm personal with the man I'm with, if he says 'no' we fight and holler—he respects me enough to know that I will holler—and I know he'll holler. I've listened to him holler. But that is what I want. I'd much rather have it out in the open, on top, than underneath."

In a way, Carter was acknowledging a trend in the music business that was part of a larger trend in American life. Mo Levy may have been a thug, but at least he was down to earth and real. Large corporations were taking over many aspects of American commerce—certainly in the music business, where most record labels were now owned by large multinational corporations. Compared to MCA, RCA, or Warner Brothers, Levy's Roulette Records was a mom-and-pop operation, a place where decisions were made by real human beings based on individual tastes, not market studies or faceless executives. Were some of these mom-and-pop operations controlled by the mob? Sure, maybe they were. But even the mob was now seen as something of a mom-and-pop operation.

Ever since the American mobsters had lost control of Cuba and were humiliated by a ragtag collection of bearded communists, the image of the mob as a ubiquitous power whose reach was limitless had been dealt a serious blow. The idea, once advanced by Lansky, Luciano, Costello, and others, that they could establish an organization with far-reaching international power had been brought down to earth. In the 1960s and 1970s, la cosa nostra returned to its roots. The gangsters most revered by the rank-and-file—Anthony "Fat Tony" Salerno, Gigante, and, later in the 1980s, John Gotti—were proletarian mob bosses who stayed close to home. They hung out in local social clubs and engaged in criminal rackets that were rooted in traditional organized crime going back to the earliest days of the underworld.

Mo Levy was cut from this same cloth. He presented himself in the manner of an old-time neighborhood hood. He may have been a gangster, but he was also a human being, not a faceless, corporate executioner. Of course, there was in all of this much magical thinking. Being a gangster was not a coat you wore, then took off and put in the closet. Gangsterism was a way of thinking, a business imperative, a beast that needed to be fed.

In December 1976, Roulette Records issued *Now It's My Turn*, an album that was recorded in a studio by Betty Carter and her trio. Carter was surprised to discover that the album also included live recordings

from 1969 that had been made illegally by a recording engineer and sold to Levy. If that weren't shady enough, Levy did not credit Carter as the composer on her three original songs; he had assigned credit to his own publishing company.

Carter had an amazing ability to hit the high notes, which she no doubt did when she heard about Levy's betrayal. She terminated her relationship with Roulette Records and disassociated herself from the album, even telling fans at one of her performances not to buy it.

For a musician to have to disavow his or her own product while onstage before an audience of their followers was a testament to the current state of the business under Mo Levy and others.

In 1979, Carter sued Levy on various counts, including his flagrant theft of her publishing rights. Two years later, the boss of Roulette Records was made to pay an unspecified amount as part of a settlement.

There would be more lawsuits by artists against Levy and other moguls in the years ahead. The days when a gangster/businessman could willfully and without recompense screw over a musician would no longer stand. Musicians were now inclined to fight back.

14

TWILIGHT OF THE
UNDERWORLD

For the mafia in America, the decade of the 1980s was something of
a final curtain call. Federal prosecutors had discovered the Racketeer
Influenced and Corrupt Organizations Act, the name of which was not
easy to remember so they just called it RICO. This was possibly a nod to
the gangster classic *Little Caesar*, where the main character (played by
Edward G. Robinson) was named Rico, and his final line in the movie,
after being fatally shot, was "Is this the end for Rico?"

RICO was devastating for the mafia, at least as it had existed for
the previous eighty years, with a ruling commission based in New York
City and affiliated families in urban areas all around the United States.

RICO had been on the books since 1968, but it took more than
a decade for prosecutors to figure out how to use it effectively. For the
first time, federal law allowed the U.S. Justice Department to prosecute
criminal organizations as an "ongoing criminal conspiracy." As "pred-
icate acts," prosecutors were able to use crimes that had already been
tried and adjudicated. And they were able to indict multiple conspira-
tors as part of the "continuing enterprise," using crimes committed by
one defendant to implicate another. It was a watershed development for
criminal justice in America.

RICO laws were not used to directly address the relationship be-

tween the mob and the jazz business, but what occurred was even more damaging: RICO was used to destroy the framework by which the relationship existed in the first place.

In Las Vegas, in a series of trials, federal prosecutors exposed the link between criminal financiers and the casinos. The entire structure crumbled. Consequently, large corporations moved in and purchased the casinos, changing the tenor of the city. The gambling and strip clubs remained, but entertainment in the casinos was now geared toward the whole family, not just the high rollers. Instead of Louis Prima, you got Wayne Newton.

In most midwestern industrial cities—Kansas City, Milwaukee, Detroit, and Chicago—mobsters were taken down in major prosecutions aimed at separating organized crime from labor unions, especially the Teamsters.

On the East Coast, the unthinkable occurred: In "the Commission trial" of 1984, heads of the Five Families and the entire ruling structure were prosecuted and taken down, with the defendants put away for life.

The fortunes of jazz and the underworld had always run on parallel tracks. In the 1960s and 1970s, when jazz declined as a significant percentage of the country's entertainment dollar, the mob found other fish to fry. By the time of the major mob prosecutions in the 1980s, there was no relationship. For the mob, whatever was left of jazz as a business was no longer worth exploiting.

For the people whose lives played out against this backdrop, however, the separation was not so clear and simple. The connection between the music and the mobsters was primarily a business proposition, but it was also more than that. There were other entanglements: spiritual and existential. The story wasn't over yet.

Mary Lou's Mass

In the spring of 1981, Mary Lou Williams, at age seventy-one, was in declining health. Life had finally caught up with her—and what a life

it had been. She had lived through many of the great jazz eras, starting with her youth in Smoketown, her time on the road with the Clouds of Joy, Kansas City during the Pendergast era, playing piano on 52nd Street during the heyday of that scene, and everything since.

Back in the 1960s, she thought she was done with jazz. For more than ten years, she stayed away from the business. And then something happened. Unexpectedly, she had a spiritual epiphany.

It occurred in Paris, in 1970, when she visited the grounds of a Roman Catholic church. All her life, she had experienced visions and mystical premonitions, but this was different. In her diary, she wrote, "I found God in a little garden in Paris."

Upon her return to the States, Williams became a devout Catholic. And she started playing the piano again. For Williams, the challenge became to integrate her love of jazz with what she saw as her spiritual calling. This was not as difficult as it might seem. Mary Lou had always seen the music in spiritual terms. "Jazz is healing to the soul," she often said. "Jazz grew up on its own here in America. It grew out of the work songs and the psalms of the Black people here . . . It's the suffering that gives jazz its spiritual dimensions. That's what our jazzmen today have forgotten. Only out of suffering is a true thing born . . . Yet I have faith that jazz is strong, the roots are deep."

In the early 1970s, Williams started playing publicly again, though she was selective about where she performed. She met with Barney Josephson, who had opened a new club in Greenwich Village called the Cookery, on University Place near Washington Square. Josephson was the former proprietor of Café Society, one of the rare clubs that had resisted falling under the sway of mobsters. It was at Café Society that Billie Holiday debuted "Strange Fruit." The club was politically progressive and racially integrated. Mary Lou played there herself in the 1940s.

Josephson wanted Williams to play a regular ongoing residency at the Cookery, which she agreed to do, playing there steadily for six years.

She took on a new manager. Again, her goal was to integrate her spiritual calling with the music, and so the person who became her

manager was an unorthodox choice. Father Peter O'Brien was a young Jesuit priest and part-time pastor at the church where she had chosen to be baptized upon her recent conversion into the Catholic faith. O'Brien could not have been more different than Joe Glaser, her former Pimp Daddy. The priest devoted himself to advocating for Mary Lou, making sure she was given the treatment accorded her status as a living jazz legend.

Mary Lou had a dream. Ever since her religious conversion, she had been working on music and lyrics for a full liturgical service scored to jazz. It had never been done, and her new manager, Father O'Brien, wasn't sure it could be done. Mary Lou's Mass, as it became known, would evolve over the course of years before O'Brien was able to secure full authorization from the papal ministry for the mass to be staged in churches around the United States and even the world.

The mass was part of Williams's belief that jazz needed to be elevated out of the basement clubs run by mobsters, where alcohol, drugs, and sexual transactions were part of the draw, and performed in concert halls, conservatories, and cathedrals. Jazz was an art form, and it needed to start being treated like one.

Officially known as *Music for Peace*, Mary Lou's Mass had its debut in April 1970 at St. Paul's Chapel, at Columbia University. But this was only the music itself. It would be four more years before it was performed as part of a church service proper, which would take place triumphantly at St. Patrick's Cathedral on Fifth Avenue, in the heart of New York City. Mary Lou introduced the mass by saying, "This is the jazz gospel."

For Williams, the mass was a kind of cleansing. Each time it was performed, she washed off the muck and the mud and stepped into the light. She continued to showcase her proudest creation at museums, concert halls, and churches around the world.

In 1977, she was hired to teach music and jazz history as an artist in residence at Duke University, in North Carolina. For the first time in her life, she had a steady income, a permanent place to live, and health insurance.

On May 8, 1981, Williams celebrated her seventy-first birthday. A few months earlier, she had been diagnosed with bladder cancer. She was told she didn't have much more time to live; she was bedridden and approaching her final days.

Two days after her birthday, the president of Duke University came to her bedside to present her with the Trinity Award, which was given to the best-loved faculty member. Williams later told a friend, "That touched me more than any award I've gotten since I've been playing."

Said Father O'Brien, "There were no complaints, no self-pity, and no anger. She was spiritually coherent, even great, as she was dying . . . At the very end, she told me she could hear the music, but she couldn't reach the keys anymore."

Mary Lou left instructions that after her death—which occurred at ten o'clock on the evening of May 28—all her holdings and future earnings would go to the Mary Lou Williams Foundation. Mary Lou's goals for the foundation were stated in its certificate of incorporation:

> To conduct activities which are exclusively charitable, literary and educational . . . including the advancement of public knowledge of the art of jazz music by teaching the same in all its forms to children between the ages of six and twelve, individually and/or in groups, enabling them to perform before audiences, and giving them the opportunity to hear jazz in concert and studio performance.

Mary Lou assigned the duties of director of the foundation to Father Peter O'Brien.

Middle Passage

From the early 1970s into the middle of the 1980s, many of the biggest names in jazz passed on to join that great orchestra in the sky. Louis Armstrong (1971), Mezz Mezzrow (1972), Kid Ory (1973), Willie "the

Lion" Smith (1973), Eddie Condon (1973), Ben Webster (1973), Gene Krupa (1973), Duke Ellington (1974), Cannonball Adderley (1975), Erroll Garner (1977), Stan Kenton (1979), Charles Mingus (1979), Bill Evans (1980), Mary Lou Williams (1981), Thelonious Monk (1982), Art Pepper (1982), Cal Tjader (1982), Sonny Greer (1982), Earl "Fatha" Hines (1983), Count Basie (1984).

The music persevered as these jazz originators became part of the dearly departed, leaving behind tales of triumph and woe.

One of the more complex legacies was that of Satchmo. Before he died, Armstrong had been rejected by some young African Americans as being far too acquiescent to the mobster overseers of jazz. He was referred to as an Uncle Tom, as was Sammy Davis Jr. and other Black musicians who came out of the vaudeville tradition, where entertaining the masses sometimes involved the lampooning of Black culture—the Stepin Fetchit image of the subservient Negro. In the post–civil rights era, this was an image that left a sour taste in people's mouths. In Armstrong's case, part of the critique involved his relationship with Joe Glaser, the gangster/manager who, based on his success with Armstrong, went on to manage many of the greatest Black jazz musicians in the midtwentieth century. In some ways, the Armstrong-Glaser relationship became instructive, an example of the relationship between jazz and the underworld at its most complicated and perverse.

There's no question that Glaser and his company, Associated Booking, did remarkable things for Armstrong and his career. As arguably the most popular figure in the history of the music, Armstrong achieved unprecedented longevity, primarily because of his talent but also due to his infectious smile and ingratiating personality. Glaser supposedly was the one who suggested to Armstrong that he grin and clown it up for his white audiences. The white audiences loved it, the Black audiences not so much. By the end of his life, the trumpet master felt alienated from his own people.

Satchmo never specifically blamed Glaser for this, but he had other reasons to be miffed with his longtime manager.

In June 1969, Glaser suffered a stroke and, at the age of seventy-two, expired at Beth Israel Hospital in Manhattan. In the weeks and months following his death, Armstrong, who was himself in waning health, paid tribute to his former manager. On a television talk show, Louis said, "When that bad colored boy down in the honky tonks [a reference to Slippers, the bouncer at Matranga's] . . . the first thing he said was, 'You get you a white man to put his hand on your shoulder and say, "That's my nigger."' For me, Joe Glaser was that man."

The sense of ownership—the evocation of the slave-to-slavemaster relationship—is what did not sit well with some, and, apparently, it had also eaten away at Armstrong.

According to George Wein, longtime jazz impresario, producer of the annual Newport Jazz Festival, and a friend of Armstrong's, the jazzman was unsettled. In 1970, one year after Glaser died, Wein and his wife went to Armstrong's modest home in Corona, Queens, to interview him for a short documentary that Wein was making to be shown at the Newport festival. Off camera, Armstrong spoke more openly with Wein than he ever had publicly. Of Glaser, he said, "When we started, we both had nothing. We were friends—we hung out together, ate together, we went to restaurants together. But the minute we started to make money, Joe Glaser was no longer my friend. In all those years, he never invited me to his house. I was just a passport for him."

Shortly before Glaser's death, Armstrong had learned about his last will and testament. In the will, Glaser had bequeathed Associated Booking not to Louis Armstrong; he bequeathed a percentage of the company to Sidney Korshak, the former Capone mob lawyer and MCA legal honcho who had loaned money to Glaser decades before so that he could start his company.

"I built Associated Booking," Armstrong told Wein. "There wouldn't have been an agency if it wasn't for me. And he didn't even leave me a percentage of it."

There was in the musician's rancor a touch of naivete. In life, he

had chosen Glaser as his overseer because the former pimp and convicted rapist had the heart of a gangster. Now that Glaser was dead, Louis was startled to learn that his manager behaved like one as well.

Armstrong visited Glaser on his deathbed at the hospital. With his lifelong manager incapacitated and unable to communicate, Armstrong sat in a wheelchair and pondered the nature of his own mortality. He moved his chair closer to Glaser's bed. As he told it to Wein, he leaned over close to the ear of his former manager and whispered the words that would be the final communication between the two men. The words were: "I'll bury you, you motherfucker."

Capo di Tutti Capi

Frank Sinatra sat before members of the Nevada Gaming Control Board with a confident smirk on his face. The year was 1981. Sinatra was older now, sixty-five to be exact. His youthful toupee had been traded in for one that, in keeping with his current vintage, was silver and combed forward in the front. It made him look like an aging version of Nero, the Roman emperor whose reign was associated with tyranny and debauchery. Frank's features were thicker now, and he carried himself with a world weariness that seemed to say: *I'm Frank Sinatra, I've seen it all, and I don't give a damn what you think.*

That he was projecting this view while sitting before the Nevada Gaming Control Board spoke volumes. There was a time, years earlier, when Sinatra's livelihood seemed to hang in the balance depending upon a decision from this group. In 1964, when Sinatra was in his prime, he had been stripped of his gaming license by this same commission. That occurred when it was revealed that he and Sam Giancana were seen together at Cal-Neva, the resort that was jointly owned by the two men (though Giancana's involvement was off the books). Giancana got into a bloody physical altercation at the resort with the road manager of the McGuire Sisters. Sinatra played a role in cleaning up the fight. The incident was supposed to be kept quiet but leaked to the press.

At the time, Giancana's name was one of the most prominent in the commission's "black book" of organized crime figures who were not allowed in Nevada's gambling centers. You could not own points in a casino and be seen doing business or socializing with anyone whose name was in the black book. There were many witnesses to the Giancana fight who saw that Sinatra was there.

When Sinatra heard that he was being investigated by the control board and would likely lose his license, he got on the phone with the chairman of the commission and exploded with invectives, calling him a "goddamn liar." When he heard that he would be served with a subpoena to appear before the commission, he told the chairman, "You just try and find me, and if you do, you can look for a big, fat surprise . . . a big, fat fucking surprise. You remember that. Now, listen to me . . . don't fuck with me. Do not fuck with me."

"Are you threatening me?" asked the chairman.

"No. Just don't fuck with me. And you can tell that to your fucking board and the fucking commission, too."

Sinatra made a big show of hiring lawyers and claiming that he would fight the commission, but when push came to shove, he knew that an appearance before the commission might expose him to revelations about his lifetime of fraternizing with the likes of Momo Giancana and other mafiosi. He acceded to the findings of the commission and lost his license, which meant he was stripped of his ownership points in the Cal-Neva Lodge and the Sands Hotel and Casino. It was a decision that likely cost the singer millions of dollars.

Now, seventeen years later, here was Sinatra in front of the board. Much had changed. The board had a new chairman, and Giancana was dead, shot in the kitchen of his home in Chicago in 1975 while stirring pasta sauce. Sinatra had continued his career as a highly successful entertainer, making untold millions, and he continued cavorting with hoodlums.

The occasion for his current appearance was that he was once again

applying for a gaming license, this time so that he could acquire ownership points in Caesar's Palace, where he had lately been performing at Circus Maximus, the casino/hotel's massive showroom. Vegas needed Sinatra. The town had recently entered into an era of criminal prosecutions that seemed to pose an existential threat. There was, at the time, some doubt as to what the future of the country's preeminent gambling empire might be. In the present climate, Las Vegas could not say no to Frank Sinatra, and Sinatra knew it.

Still, there were formalities. Sinatra's interest in a gaming license had to be approved by the board, and this involved public hearings; that was the protocol. The board was obligated to ask Sinatra about what had transpired back in the day. There were questions about the Cal-Neva Lodge and the late Sam Giancana, though they were asked and answered in a highly perfunctory way:

Board member: There was a fight at the Cal-Neva back then. Not a
 fight you were involved in, but a fight none-the-less.
Sinatra: How did I miss that one.

Board members and press in attendance laughed at that remark. In fact, they laughed frequently during Sinatra's testimony. It was as if the hearing were a mere formality.

Even so, the public record of Old Blue Eyes tended to complicate things. There was the matter of the singer's financial involvement in the building of a large performance space in Westchester County, just north of New York City. In 1980, Sinatra had been investigated by a federal prosecutor in New York for his involvement with the Westchester Premier Theater. The 3,500-seat venue had been constructed in 1975 over a landfill in Tarrytown. Sinatra appeared there ten times—all sold-out shows—between April 1976 and May 1977. In November 1977, the theater fell into Chapter Eleven bankruptcy proceedings after its president resigned amid a federal racketeering investigation.

The theater had been built with mob money raised through a fraudulent stock swindle. Once it was open and doing business, a trio of mobsters affiliated with the Gambino crime family skimmed $800,000 in the first year alone. The following year, they skimmed even more. The mobsters not only skimmed off the revenue from the ticket sales, but they also skimmed from parking, bar, restaurant, and candy concessions, souvenir and program stands, and T-shirts. They even scalped tickets and sold others for seats that didn't exist.

The investigation into the Westchester Premier Theater produced wiretaps that implicated Sinatra in the skim. Prosecutors claimed that the singer received $50,000 under the table from his appearances at the theater in 1976. Not only that, but according to witnesses in front of a grand jury, Sinatra agreed to make appearances at the venue knowing that his shows would pack the place and help fuel the skim. He had a financial stake in the plundering of the Westchester Premier Theater. (After the place went bankrupt, the building was razed in 1982, a mere seven years after it had been built.)

One incriminating piece of evidence against Sinatra was an April 11, 1976, photo that became infamous: the singer standing backstage with a bevy of eight mafiosi, mostly aged gentlemen in their seventies. This was not Frank with Joey Clams from the corner; this was Frank with, among others, Carlo Gambino and Paul Castellano, boss and underboss of the Five Families; and Jimmy "the Weasel" Fratianno from Los Angeles, who would later become an informant against the mob. Sinatra was positioned in the middle of the group with a big shiny smile on his face.

Miraculously, Sinatra avoided prosecution in the Westchester Premier Theater case. The president of the corporation that operated the venue went to prison partly because he was unwilling to testify against the singer.

Members of the Nevada Gaming Control Board asked Sinatra about the photo of him backstage with a Who's Who of the mafia circa the late 1970s. The singer gave his standard response: He didn't know the

men and had no idea what their business might have been. He took a
photo with them as he would with any group of fans who were there to
get an autograph after the show.

The photo was revealing, on a number of levels. For one thing, it
is clear from the photo that the mobsters were there to kiss Frank Sina-
tra's ass, not the other way around. The fact that Frank, after making
hundreds of thousands of dollars off the Westchester Premier Theater,
walked away from the wreckage of the place without a scratch—while
others went to prison—revealed the extent of his power. The mobsters
needed Frank Sinatra; he did not need them. He was bigger than the
mafia. And he was also bigger than the Nevada Gaming Control Board.
He was bigger than Las Vegas.

The gaming board approved Sinatra's application for a gaming li-
cense. He went on to make lots of money off Caesar's Palace and even
more from concerts and other business ventures. When he died from
natural causes in 1998 at the age of eighty-two, the Sinatra estate was
valued at between $200 million and $600 million, which in today's fig-
ures would be over $1 billion.

No one could deny that Sinatra was talented, but his riches reveal
another reality. In the business of jazz, Frank had an edge, and he knew
how to exploit it. Throughout his career, except for that one occasion
with the Cal-Neva Lodge, he had avoided being held accountable for
his mob connections. There may never have been any criminal liability.
The singer's association with gangsters was mostly an amusing sideshow.
He skirted the volcano without ever falling into the fire. He rose up out
of the firmament to become the richest man in this saga. He was the
capo di tutti capi.

Among the singer's legion of fans, most would likely argue that
Sinatra's success was a simple case of fair market compensation. His
talent was immense, after all, and talent is destiny. The Chairman of the
Board worked hard for his riches, with world tours, movie appearances,
wise business investments, and royalties that he had earned.

This argument is based on that uniquely held American belief that

financial wealth is the true indicator of a person's stature in society, and that access to that wealth is the result of a game based on fairness.

Given the racial history of the United States, and the intricacies of the marketplace, fairness is a fungible concept.

If financial compensation were based solely on talent, Jelly Roll Morton, Fats Waller, and Duke Ellington would have been among the richest men in America; Billie Holiday would have lived atop a mountain comprised of diamonds and rubies; Charlie Parker would never have had to stick a needle in his arm out of frustration and sorrow; and they would have had to name a bank after Count Basie.

Moishe's Last Stand

Of all the men on the business side of the ledger who profited from the music business, Mo Levy was singular. He started at a low level, in the coat-check and photo concessions of a jazz club, then rose to become the proprietor of his own clubs. He did so by partnering with mafiosi. From there, he branched out into nearly every aspect of the business. One jazz writer, Ralph Gleason in San Francisco, referred to Levy as "the Octopus" because his tentacles seemed to reach into every financial nook and cranny in the business. Levy openly ripped off artists and got away with it. Eventually, in the late 1980s, he got his comeuppance in a seamy, rudimentary criminal conspiracy that seemed almost too perfect to be true.

It started with MCA Records, the management corporation, whose parent company was also sometimes referred to in the music press as "the Octopus." In real terms, the Music Corporation of America made Mo Levy look like a piker. As influential as Levy was within his world, MCA's world was many times larger. With offices around the globe, the parent company managed some of the biggest artists in the entertainment business, and MCA's subsidiary business holdings were vast. Among other things, the company had recently purchased the entire catalog of Chess Records, an early and influential blues and jazz label that started

TWILIGHT OF THE UNDERWORLD 363

in Chicago in 1950. Chess had produced some major-name artists, and the catalog was likely worth in excess of $1 million. MCA was looking to liquidate some of its back catalog as cut-outs, including the material from Chess.

Executives at MCA turned the deal over to Sal Pisello. Within MCA Records, very few employees knew what Pisello did for the company. Fifty-six years old, salty and abrupt, with a pronounced Brooklyn accent, he had an office at MCA corporate headquarters in Los Angeles. He had been showing up for work promptly at eight o'clock most weekday mornings. He was one of those New Yorkers who moved to Southern California and could never quite shake their East Coast roots. When an executive vice president asked Pisello one day what he was doing for the company, he answered, "Keeping the niggers in line."

Within the ranks of federal law enforcement, there were those who were aware of Pisello. His nickname was Sal the Swindler, and he was a veteran mafioso believed to be affiliated with the Gambino crime family based in Brooklyn. He first came to Southern California in 1979 when, according to the local FBI, he attempted to smuggle heroin through the Fulton Fish Market in New York City to Los Angeles. The Feds were unable to make a case against Pisello because he had disappeared—or so it seemed. In fact, he had moved up in the world into a six-figure job as a "consultant" with MCA Records.

MCA's roots in organized crime stretched back to the early origins of jazz. The company founded by Jules Stein in Chicago in 1924 had started out booking acts at venues owned by Al Capone and the Chicago outfit—the Sunset Cafe, the Plantation, the Grand Terrace Cafe. Stein and MCA's ambitious young legal councilor, Sidney Korshak, had a special relationship with Joe Glaser, whom they helped get started with his own management business. It was the unofficial brotherhood of Ashkenazi Jews from Chicago that would go on to become some of the most powerful players in Hollywood.

In those years, the Sunset Strip in Los Angeles became the boulevard of gangster dreams. Café Trocadero, Ciro's, and the Macambo

(where Ella Fitzgerald held a long residency) assumed their places in the underworld lore of the city. Benny Siegel, Mickey Cohen, Johnny Roselli, and other gangsters used the Sunset Strip as their own personal catwalk, where talent managers, record label executives, and agents from places like MCA paid homage to their status as underworld venture capitalists.

By the 1980s, the late afternoon and early evening sun still cast a magical glow streaming between the huge billboards and Royal Palms along the Strip, but the famous clubs were mostly gone. Those that remained hosted rock and roll, not jazz.

Sal the Swindler felt that he needed a partner to help him unload the Chess back catalog for MCA. So he reached out to a mafia associate he knew named Corky Vastola, based in New Jersey. Vastola had made a career out of feasting on cut-outs, bootleg records, and other financial appendages of the record business. Vastola was a dangerous man, possibly a killer, who represented the DeCavalcante crime family. It was Vastola who suggested to Pisello, "Hey, maybe we should bring Moishe in on this."

MCA, vintage records, and a cut-out deal that offered multiple opportunities for skimming and scamming, involving mafiosi from various East Coast families? It was a caper right out of the Mo Levy playbook.

By 1986, Levy didn't really need the money. He had his own airplane. He owned four homes, in New York, Miami, and New Jersey. In the town of Ghent, in upstate New York, he owned a farm where he raised Thoroughbred racehorses.

Levy also maintained his connections with the Genovese crime family. He had Strawberries, his popular chain of record stores, which the FBI believed was a front for Vincent Gigante to launder criminal proceeds from other ventures, such as narcotics. When Gigante wasn't wandering the streets of Greenwich Village in a bathrobe and slippers, he was now one of the few remaining bosses of stature in the American mafia.

The music business had been good to Mo Levy; he was a multimil-

lionaire. But he was also a hustler. He knew that as an independent operator in the music business, you rarely made millions off one big score; you made your millions by stealing the nickels and dimes of artists over a long period of time.

In the cut-out business, the artist whose work was being bartered didn't make a dime; he or she received no royalties for the sale.

Moishe, Sal the Swindler, and Corky were an experienced team of grifters, but they still needed a buyer for the MCA cut-outs. No problem. Sal Pisello, representing MCA Records, made a trip to South Florida for the annual convention of the National Association of Recording Merchandisers (NARM). This gathering was not unlike the deejay conventions of the early 1960s where Levy used to ply disc jockeys with hookers and booze. The NARM convention was held at the Diplomat Hotel in Hollywood, Florida. The Diplomat was a popular spot for record industry executives and, coincidentally, New York mafiosi on vacation. It was there that Sal Pisello met John LaMonte, owner of Out of the Past, an "oldies" distributer with a warehouse in suburban Philadelphia.

LaMonte looked at the list of cut-outs that Pisello was offering: Benny Goodman, Gene Ammons, Rahsaan Roland Kirk. Over four million total cut-outs for $1 million. LaMonte was excited. Making money off dead artists was always better than trying to grift among the living; they might send lawyers after you.

LaMonte had no idea that the legendary Mo Levy was in on the deal. He found that out later, after he agreed to the deal with Pisello and Vastola.

LaMonte was himself no babe in the woods. He was a convicted record counterfeiter who dwelt on the shady side of the business. Mo Levy, whom he referred to as "that cocksucker Super Jew," sent chills up his spine. He had once been shaken down by Levy. LaMonte tried to back out of the deal, but Pisello invited him to Los Angeles to meet high-ranking executives from MCA. Pisello also added some "sweeteners" to the deal: old Bing Crosby titles that were sure to sell.

The deal was consummated in June 1984, in Levy's office at Rou-
lette Records. Among other items, LaMonte noticed on the wall a
plaque in the name of Morris Levy, in honor of his ten years as chairman
emeritus of United Jewish Appeal.

LaMonte was purchasing 4.2 million records at a price of forty cents
a unit. He was told that he would be paying Levy three cents per record
off the books, in cash. As soon as he received the cut-outs and had
begun selling them, Levy would expect a $15,000 cash payment every
week until the full amount of $120,000 was paid.

The following month, seventy tractor-trailers showed up at Out
of the Past's warehouse in suburban Philadelphia. Not only were the
sweeteners that LaMonte had been promised missing from the ship-
ment, but many of the most valuable titles that had been promised
were also absent. The shipment had been "creamed," as it was known
in the business. John LaMonte had been stiffed. When LaMonte told
his partners what had happened, they claimed they didn't know any-
thing about it. If he'd been stiffed, he would have to take that up
directly with MCA, who was responsible for making the shipment.
Meanwhile, the partners—two made mafiosi and a cocksucker Super
Jew—were demanding that LaMonte pay up immediately or suffer the
consequences.

At the same time, LaMonte was approached by two eager FBI
agents. As it turned out, they had Corky Vastola under investigation
on an entirely separate matter and stumbled upon his ongoing deal
with LaMonte, Levy, and the MCA cut-outs. In wiretap conversations,
Vastola had incriminated himself and Levy.

The FBI was thrilled. Morris Levy was a target of great import to
the Bureau; they had first opened a case on the record exec twenty-four
years earlier. The fact that they had never been able to come up with
anything indictment worthy against Levy was a source of great frustra-
tion. Now it appeared a case against Levy had fallen into their laps.
And yet, they were far from having what they needed for a criminal
indictment.

.

The agents said to LaMonte: *We know you are in trouble with these guys. You may already be criminally liable. From what we hear, your life may be in danger. Cooperate with us and you can avoid prosecution.*

LaMonte said no. That changed two weeks later when he went to a meeting with Corky Vastola in the parking lot of a diner in New Jersey. For the umpteenth time, LaMonte told the mobster that he would not be paying anybody anything until he received the product that had been creamed from his shipment.

Suddenly, Vastola viciously coldcocked LaMonte with a right hook to the face. LaMonte staggered backward and fell, blood rushing from his nose.

Unable to see clearly, LaMonte somehow made it by car to the nearest hospital. He was admitted with a broken jaw.

Now the FBI agents didn't even have to contact LaMonte; he contacted them. He was ready to wear a wire and go undercover against his mendacious business partners.

Using great stealth, an FBI technical team penetrated the offices of Roulette Records late at night and planted a bug in Levy's office and a wiretap on his phone. Two floors below the Roulette offices, they rented an office under the name of a fake company; they used this barely furnished location as a listening post.

Right away, agents learned that Mo Levy's main concern was how blowback from the LaMonte deal could cause him problems with his partner, Vincent Gigante. In a meeting with Vastola, Levy was agitated about "this cocksucker LaMonte." The problem for the music boss was that he had received a letter from MCA threatening legal action against him if he did not make good on money owed from the deal—money that LaMonte was refusing to pay. "MCA served me with a summons," he said to Vastola, waving the letter. "If this blows up the whole world is going to end. I don't even think you know what it's going to create. No, you don't, you don't have no idea what it's going to create. Because if it hurts a certain thing here that we are talking about, you don't know what can happen."

Having assaulted LaMonte, Vastola knew he was in trouble: "We're going to wind up in the joint here—me, I know, definitely."

"I'm hotter than you," said Morris. "I'm hotter than all of youse. They'd love to get me, you know that. They'd love to get me for twenty-five years."

Levy was right about that: In their listening post two floors below Levy's office, the agents could hardly believe their ears. After all this time, with all the man-hours that had been devoted to building a case against the godfather of the music business, the lawmen smelled blood in the water.

The pinch took place in Boston, where Levy had headquartered Strawberries, his successful chain of record stores.

The sight of Mo Levy being led in handcuffs from the Ritz-Carlton Hotel, his residence in Boston, was shocking to many who knew his legend. Levy had always flaunted his power, making it appear as if he had law enforcement in his pocket. Maybe he did at the local level, but this was federal. Levy was charged with extortion, conspiracy to commit extortion, and money laundering. He was facing sixty years in jail if convicted.

FBI agents overseeing the prosecution offered Levy the witness protection program. They told him they were hearing "chatter" on wiretaps that his life might be in danger. The Chin might want to have him whacked. If Morris turned state's evidence against his partners and, more pointedly, Gigante, he could have a nice life for himself living in an undisclosed location under a new identity.

Levy told the agents to "take a fucking hike." In an interview on the *Today Show* the morning after his arrest (he was released on bail), he called the charges "ludicrous," adding, "There is no connection between the mob and the music business."

Later, Levy said, "Let me tell you something about the mob in the record business. You know who owns the record business? There are only six companies—MCA, RCA, CBS, Warner Brothers, Capitol, and Poly-Gram. Those six own nine hundred ninety-nine out of

the one thousand, plus a percentage of the one point that's left. So if there's crime infiltration in the record business, there's where the fuck it's gotta be."

The trial was held in Los Angeles; Levy was on his own. MCA denied any involvement in the scam, and the others were tried separately.

Before the trial, Levy gave an interview to the *Los Angeles Times*. When asked how he had come to know so many alleged gangsters, he gave his standard answer: "I've been on the streets since I was fourteen years old, and I know and like a lot of people that some might say are organized crime figures—I worked for them as a kid in the nightclubs."

Under the city's typically sunny skies tinged with smog, Levy arrived in court each morning dressed in his dark gray suit, his thinning hair rustling in the wind, with a forced smile on his face. Now sixty years old, he had seen better days, but he remained conspicuously upbeat, stopping to chat with reporters in his raspy New York accent that made him seem like a nightclub owner—or a gangster—from another era.

The trial offered some humorous asides. Conversations from the bug planted inside Levy's office at Roulette Records and from the wiretap on his phone were played for the jury. In one recording, Corky Vastola complained to Levy about LaMonte, who was refusing to allow himself to be extorted by the gangsters. "Why are we dealing with this guy? You knew from the start that he was a cocksucker?"

"Yeah," replied Levy. "But I thought he was a controllable cocksucker."

At another point in the trial, Levy could be heard on a phone recording saying to a persnickety business partner, "Drop your pants, get some Vaseline, and we will stick it right up your ass."

The jury didn't take long to convict Levy on charges of conspiracy to commit extortion and money laundering. Three months later, he was sentenced to ten years in prison and given a fine of $200,000. Bail was set at $3 million. As collateral, Levy put up his farm in upstate New York, which was valued at $16 million.

Considering the convicted party's long career as a jazz vampire, the

crimes for which he was convicted—and the sentence he received—seemed like small potatoes. Levy guaranteed to reporters that the conviction would be overturned on appeal. He remained at large while his lawyers fought his guilty verdict. His problems had only just begun. Earlier that year, Levy was diagnosed with colon cancer. By the time of his sentencing, the cancer had spread to his liver. Reluctantly, Morris sold off most of his holdings—Strawberries, his music publishing empire, and, finally, Roulette Records, which he sold to the owners of Rhino Records, a label that showcased mostly novelty acts.

The deals were negotiated from a hospital bed where Levy spent his final days. One of the owners of Rhino noted: "He was still physically imposing. I was surprised how young he looked. And he talked like—he still had that Don Corleone type voice . . . Levy didn't really have any sense of his legacy. His motive was purely financial. I don't think he had any inherent great love for the music. Morris ran Roulette as a cash-today business . . . On the one hand, he was very successful; on the other hand, he was sort of a two-bit operator."

Moishe had the instincts of a gangster; it was all about the money.

In January 1990, he lost his appeal. His body was riddled with cancer. On May 21, before he ever served a day in prison, Levy died, at the age of sixty-two.

To some, it may have seemed ironic that Levy, who all his life did the bulk of his business in New York and Miami, should see his career end far from home in Los Angeles. But maybe it wasn't so ironic. It was in the City of Angels, on most days, that you could feel the warm Santa Ana winds blow in from the south, through the streets of downtown in an easterly direction, past the barrios of East Los Angeles, past the seemingly endless suburban sprawl, past the wealthy homes of Palm Springs (where Sinatra lived), and out into the desert, where, amid the cactus and the rough terrain, jackals gathered to feed on a dead carcass.

In the end, Levy was but one small cog in an epic history of discovery, cultivation, and exploitation of American music that started in New Orleans and, for the better part of a century, flourished all around

the United States. In the sometimes brutal cauldron of American life and the slippery slope of free-market capitalism, jazz was an art form known for its adventurousness and originality. For the music to function as a business, the practitioners and patrons of the music became unwitting underwriters of organized crime.

For better or for worse, these were the people who lit the flame and carried the torch. They spread the gospel according to Satchmo, Jelly Roll, Fatha Hines, Lady Day, the Chairman of the Board, and so many others. If they weren't creating the music, they were on the other side of the equation financing and operating nightclubs, managing careers, and maneuvering the flow of compensation into their pockets. The biz could be highly profitable, filled with glamor and artistry, or it could be tawdry and even deadly.

These were the dangerous rhythms at the heart of jazz and the underworld.

CODA

For some, the passing of the mob, and the severing of its relationship to jazz, raised a question: Could jazz survive without the mob?

At the time, the question seemed relevant. In the mid-1980s, as the mafia was being dismantled in courtrooms across the country, jazz was at a low point both commercially and artistically. What passed for jazz on the radio and in popular culture was so watered down that it was played mostly in elevators, or as something called "dinner jazz," or in television ads, where it was used to sell commercial products. The music had become muzak. True fans of jazz mostly retreated into the archives, listening to cherished albums from long ago, jazz programing on the radio, or music carefully curated and recorded on cassette tapes. To some, it seemed as though traditional jazz was dead.

There were still jazz clubs, but not nearly as many as there used to be. Back in the day, when the mob owned and operated the clubs, they didn't necessarily have to turn a profit. Since some of them existed as a front or tax dodge for their underworld owners, profitability was not the deciding factor. Shorn of that crutch, in the 1970s and 1980s many clubs came and went in a short number or years or even months.

It was a sorry state of affairs. On jazz radio programs and among aficionados, the future of the music was a topic of discussion. Many were concerned, including a young trumpet player and composer from New Orleans named Wynton Marsalis.

Marsalis descended from jazz royalty. Not only was he born and

raised in the cradle of jazz, but most of his family were musicians. His father was a jazz pianist who played with Cannonball Adderley and Al Hirt, among others. Papa Marsalis taught at the New Orleans School for Creative Arts, where his students included Terence Blanchard, Harry Connick Jr., and Nicholas Payton. Wynton's three brothers played an assortment of instruments. Within one family resided the history and future of jazz.

In the late 1970s, Wynton Marsalis settled in New York and became a vocal and articulate presence on the scene. In 1986, he took on the role of creative director at Jazz at Lincoln Center. One of his stated goals was to establish a platform for traditional jazz, as distinguished from what now passed for jazz in popular culture. By presenting the music as part of the Lincoln Center for the Performing Arts mandate, Marsalis was also consciously attempting to raise jazz from what some saw as its infamous roots. No longer would jazz be solely the province of clubs owned by hoodlums.

At Lincoln Center, jazz was presented as part of a program that included opera and classical music. At the beginning of Marsalis's tenure, Jazz at Lincoln Center had an annual budget of $4 million. By 2016, its budget was over $50 million, the money donated by wealthy patrons, philanthropists, and corporate sponsors.

Before Jazz at Lincoln Center, the music had rarely been financed and supported in this way. Now jazz was being presented in concert halls to an audience that turned out to be mostly white, wealthy, and definitely not from the streets.

Not everyone appreciated this approach. Some jazz musicians complained that Jazz at Lincoln Center was an elitist initiative that treated the music as a dusty museum piece, not the progressive, forward-leaning music it was meant to be. The idea that jazz, which was forged in bordellos and honky-tonks, would be coddled and perhaps sanitized by a bourgeois cultural institution was anathema to some.

In 2004, when Jazz at Lincoln Center opened its own nightclub inside the Time Warner Center and called it Dizzy's Club Coca Cola,

some jazz aficionados groaned. Sure, the Cotton Club was racist, and Birdland had been a gangsters' paradise, but—Club Coca Cola? Really? Was jazz now blatantly selling its soul in favor of corporate sponsorship?

Never mind that the club, which nearly everyone referred to simply as Dizzy's, was the most elegant and well-appointed jazz venue to exist in New York in more than a generation. Some saw it as part of a snobbish mentality—crudely capitalistic—that sought to remove the music from its egalitarian roots.

In the decade that followed, this became a tired debate. Jazz at Lincoln Center elevated the music and served as a primary spreader of the gospel by establishing jazz academies for children, training programs for young musicians, and sponsoring festivals and concerts all around the world. Under the guidance of Jazz at Lincoln Center, the music had come a long way since its beginnings in Storyville and on the riverboats, when Satchmo and others traveled upriver toward Kansas City, St. Louis, Chicago, and elsewhere.

As it turned out, jazz did not need the mob to survive. Maybe it never did, if only it had been viewed as something more than the soundtrack to the underworld.

Meanwhile, for those who preferred the more proletarian roots of jazz, in most American cities there still existed the traditional clubs—intimate, dimly lit, with lots of atmosphere (minus the cigarette smoke)—that continued to serve as vibrant manifestations of local nightlife.

If you lived in New York City or happened to be passing through Manhattan for any reason, there was always the Village Vanguard. Located on Seventh Avenue near 11th Street, to descend the steps of the club into the basement showroom remained a trip back in time. A tiny club with a small stage, a bar, and a closet-sized bathroom, the club had evolved into a sacred space for jazz. The walls were adorned with framed photos of all the great musicians who played at the Vanguard over the decades. As a patron, you were surrounded not only by the images but also the spirit of these musicians, everyone from Monk to

Coltrane, Miles to Sonny Rollins. Like all great jazz clubs, the place was cozy enough that no matter where you were seated, you could clearly see the musicians as they played. You could watch them work their instruments, see the concentration and sweat on their faces, the state of bliss and meditative nirvana that overtakes their being as they breathe in and exhale the musical essence of jazz.

Since its opening in 1935, the interior of the club has not changed. Opened by a friendly club owner named Max Gordon, management of the Vanguard never allowed the mob to infiltrate its business—possibly because no mobsters would have thought there was any way to exploit such a modest establishment (seating capacity just over one hundred). When Gordon died in 1989, ownership of the club passed to his wife, Lorraine Gordon. In 2018, Lorraine died, at age ninety-five, and the club was turned over to Lorraine's daughter.

In September 2017, the rising young vocalist Cécile McLorin Salvant took the stage at the Vanguard. It was a big night for jazz fans. Salvant, at the age of twenty-seven, was the latest jazz vocalist in a long line to assume the mantle of Billie Holiday, Sarah Vaughan, Abbey Lincoln, and all the other African American female singers who had reigned as iconic representatives of the music. Many of those women, decades before, had taken their place on that same tiny stage. Salvant had never played the Vanguard before. It was one of those historic jazz nights when past, present, and future seemed to coincide, the kind of symbiosis that could take place only at a club like the Vanguard.

Born in Miami of Haitian and French descent, Salvant maintained a regal presence. With her hair cut close to the contours of her head, she was a thoroughly modern woman, but her vocal stylings embodied the essence of everyone from Ethel Waters to Ella Fitzgerald. It wasn't just that she had mastered the vocal modifications of these singers; she had absorbed their lessons and reinterpreted the music in her own way. She was classic but original, reverential but bold, the past and present rolled into one.

Salvant had not been born into poverty. She didn't learn her art

in the streets or in houses of ill repute. She studied vocal technique at an institution of higher learning, not in a nightclub owned by mobsters who killed people for a living. She likely never met a gangster. But it was clear from this young woman's comprehension of the music, her respect for those who came before, that she honored the pathway that had been forged, and she understood the sacrifices that had been made. By her presence onstage—the depth of her talent, the nuances of her technique, and, when needed, the expressions of sorrow in her lyrical interpretations—it was evident that she had embraced, and come to personify, the essence of what jazz was always meant to represent.

Freedom.

ACKNOWLEDGMENTS

I would like to thank the following people and institutions for providing their knowledge, logistical support, time, energy, enthusiasms, and insights on the subject of jazz and the underworld.

In New Orleans, I uncovered information and derived inspiration at the New Orleans Historical Society and the New Orleans Jazz Museum, where various staff members were courteous and helpful. Jeff Baker, a New Orleans historian, gave me a tour of the neighborhood formerly known as Storyville and helped bring back to life the early twentieth-century jazz scene in that wondrous city. The Howard-Tilton Memorial Library at Tulane University in New Orleans, home of the Hogan Jazz Archive, is also blessed with an attentive staff of workers.

In Kansas City, Geri Sanders, director of collections at the American Jazz Museum, located in the old 18th and Vine jazz district, was most helpful, as were the staff at the Kansas City Public Library, which has a tremendous online exhibition dedicated to the Pendergast years. Authors Pat O'Neill (*From the Bottom Up: The Story of the Irish in Kansas City*) and Terence O'Malley (*Black Hand/Strawman: The History of Organized Crime in Kansas City*) shared their considerable knowledge regarding Kansas City crime and politics. Singer Ashley Davis, a longtime friend, and her father, Michael Davis, helped make me feel welcome in Kansas City.

In Las Vegas, kudos to the Mob Museum for including organized crime's relationship with jazz among its many exhibits. (In the interest

of full disclosure, I'm a member of the advisory council at the museum—
though I had nothing to do with those exhibits.)

In New York, the Louis Armstrong House Museum is a local trea-
sure with a surprisingly extensive archive. Special thanks to Ricky
Riccardi, director of research collections for the museum and the author
of the joyous *Heart Full of Rhythm: The Big Band Years of Louis Armstrong*.

Putting together the photo sections for this book was a monumental
task. I relied heavily on staff workers at the Getty and Associated Press
photo archives, Shutterstock, the Library of Congress, the Los Ange-
les Public Library, the Kansas City Public Library, the Howard-Tilton
Memorial Library at Tulane University, the University of Las Vegas
Nevada Library, and other public photo archives.

A number of personal friends were especially supportive, most nota-
bly Stuart Deutsch, who has his own impressive collection of jazz biog-
raphies and histories that he allowed me to pillage. Special thanks also
to Scott Deitche, the literary mob boss of Tampa, Florida; Dino Mal-
colm, who long ago took me to Green Mill in Chicago; Tom Caldarola
in San Francisco; Michael Becerra and his phenomenal jazz vinyl col-
lection; Teresita Levy; Kevin Corrigan; Bill Nevins; Christina Loren-
zatto; Michael McDermott; Heather Lynne Horton; Kevin Hunsanger;
Alia Volz; Eric Nazarian; Jaydee Freixas; Tony Gonzalez; Ed English; Mike
and Stefanie English; and Angela MacDougall in Vancouver, BC.

In 2019 and into 2020, I hosted a Latin jazz concert series in my
home base of New York City. That series was pure joy and in some
ways an inspiration for this book. I would like to thank my partner in
crime, Charles Carlini, who produced the series, and the proprietors at
two venues where the shows were staged: Alex Kay at Zinc Bar in the
famous jazz neighborhood of Greenwich Village, and Gianni Valenti at
Birdland in Times Square. Special thanks to all the musicians who took
part, including Bobby Sanabria, Jorge Chicoy, Robby Ameen, Junior
Terry, Liz Rosa, Andrea Brachfeld, Zaccai Curtis, Luques Curtis, Mike
Eckroth, David Virelles, Tommy Mattioli, Willie Martinez, Miguelo
Valdes, Caridad de la Luz, Kali Rodriguez-Peña, Hector Martignon,

Chembo Corniel, Gerardo Contino, Cèsar Orozco, Sammy Figueroa, and Manuel Valera.

Special thanks to my agents, Nat Sobel and Judith Weber, and the entire staff at SobelWeber Associates. Also kudos to David Highfill, my perennial editor, who skillfully brought the manuscript into port at William Morrow/HarperCollins, and to Tessa James, David's assistant.

NOTES

Intro

1 **"Strange Fruit":** David Margolick, *Strange Fruit: The Biography of a Song* (Ecco, 2012).

1 **Lynching in America:** Philip Dray, *At the Hands of Persons Unknown: The Lynching of Black America* (Random House: 2002); *Lynching in America: Confronting the Legacy of Racial Terror* (Third Edition) (Equal Justice Initiative, 2017) (https//:lynchinginamerica.eji.org).

3 **Origins of jazz:** Ted Gioia, *The History of Jazz* (Oxford University Press, 2011), 3–26.

3 **"Nothing says 'I want to live' as much as jazz":** Stanley Crouch, *Considering Genius: Writings on Jazz* (Civitas Books, 2006), 25.

3 **Origins of organized crime:** James Fentress, *Eminent Gangsters: Immigrants and the Birth of Organized Crime in America* (UPA, 2010), vii–xiii, 1–77.

7 **Lionel Hampton on *The Tonight Show*:** *The Tonight Show with Johnny Carson*, August 21, 1990, episode #28.313, NBC. In his autobiography, Hampton writes about his uncle Richard working in the bootlegging operations of Capone. Lionel Hampton, *Hamp: An Autobiography* (Grand Central, 1990).

9 **To jazz purists everywhere:** What constitutes jazz music has been the subject of books and essays for many decades. A good starting point on the characteristics of the music is Ted Gioia's *How to Listen to Jazz* (Basic Books, 2016).

Chapter 1: Shadow of the Demimonde

13 **Early life of Louis Armstrong:** There are many biographies of Armstrong that deal extensively with his early years, including Terry Teachout's *Pops: A Life of Louis Armstrong* (Houghton Mifflin Harcourt, 2009) and Laurence Bergreen's *Louis Armstrong: An Extravagant Life* (Broadway Books, 1997). These and other biographies (as well as this account) all lean heavily on Armstrong's own memoir, the highly entertaining *Satchmo: My Life in New Orleans* (Prentice-Hall, 1954).

14 **music in New Orleans:** Ned Sublette, *The World that Made New Orleans* (Chicago Review Press, 2008), 62, 72–73, 110, 257, 277, 280, 287–289, 299.

14 **Legendary bassist Pops Foster:** Tom Stoddard (as told to), *Pops Foster: The Autobiography of a New Orleans Jazz Man* (University of California Press, 1977).

14 **"[Willie] put a two-by-four":** Stoddard, *Pops Foster*, 2.

15 **Jazz funerals:** Alan Lomax, *Mister Jelly Roll: The Fortunes of Jelly Roll Morton, New Orleans Creole and "Inventor of Jazz"* (Pantheon, 1933), xii, 16–21; Gioia, *History of Jazz*, 31–32; Gary Krist, *Empire of Sin: A Story of Sex, Jazz, Murder, and the Battle for Modern New Orleans* (Crown, 2014), 193–194; Nat Shapiro and Nat Hentoff, *Hear Me Talkin' to Ya: The Story of Jazz as Told by the Men Who Made It* (Reinhart and Co., 1955), 16, 21–22; Armstrong, *Satchmo*, 61.

15 **Prostitution in New Orleans:** Herbert Asbury, *The French Quarter: An Informal History of the New Orleans Underworld* (Knopf, 1936); Al Rose, *Storyville, New Orleans: Being an Authentic, Illustrated Account of the Notorious Red Light District* (University of Alabama Press, 1974), 21–72.

16 **Pianists as "professors":** Lomax, *Mister Jelly Roll*, 43–48.

16 **Ferdinand Joseph LaMothe (Jelly Roll Morton):** Lomax, *Mister Jelly Roll*; Rose, *Storyville, New Orleans*, 44, 50, 53, 55–56, 59–60, 83–97, 100–124, 151, 168, 204, 216; Gioia, *History of Jazz*, 30–44, 59, 62, 72, 92; Phil Kastras, *Dead Man Blues: Jelly Roll Morton Way Out West* (University of California Press, 2001).

16 **"Those years I worked for all the houses":** Lomax, *Mister Jelly Roll*, 51.

16 **Congo Square:** Sublette, *The World that Made New Orleans*, 119, 121, 282, 285.

17 **"My grandfather, that's about the furthest"**: Sidney Bechet, *Treat It Gentle: An Autobiography* (Da Capo Press, 2002), 8.

18 **"[They called it the Battlefield]"**: Armstrong, *Satchmo*, 7.

19 **"All I had to do was turn my back"**: Armstrong, *Satchmo*, 26.

19 **"When we were not selling newspapers"**: Armstrong, *Satchmo*, 25.

20 **"We began by walking down Rampart Street"**: Armstrong, *Satchmo*, 34.

21 **Andrew Pons incident**: Armstrong, *Satchmo*, 61–62. According to an article in the New Orleans *Times-Picayune*, Armstrong got the names wrong in his memoir. He identified Andrew Pons as Henry Ponce and Joe Segretto as Joe Segretta. Segretto was a well-known bar owner who later became a manager for up-and-coming trumpeter and singer Louis Prima. James Karst, "Louis Armstrong caught in the crossfire on the Battlefield," New Orleans *Times-Picayune*, July 2, 2017.

23 **Origins of Storyville**: Rose, *Storyville, New Orleans*, ix–xii, 1–19.

25 **Thomas Charles Anderson**: Krist, *Empire of Sin*, 60, 109, 111, 147, 185–186, 303–306, 308–310; Rose, *Storyville, New Orleans*, 22, 42–49, 61–62, 71–73, 75–82, 97–98, 114, 125, 130–136, 142–146, 151–158, 166–167, 174, 206.

26 **Origins of the term "mob boss"**: T. J. English, *Paddy Whacked: The Untold Story of the Irish American Gangster* (William Morrow, 2005), 26.

28 **"[Anderson] had practically everything there"**: Bechet, *Treat It Gentle*, 53.

29 **"Why is the jass music"**: *"Jass and Jassism,"* New Orleans *Times-Picayune*, June 17, 1917.

30 **"Hilma Burt's was on the corner of Customhouse and Basin Street"**: Lomax, *Mister Jelly Roll*, 47.

30 **"Hers was no doubt one of the best"**: Ibid.

31 **"Jelly lived a pretty fast life"**: Rose, *Storyville, New Orleans*, 34.

32 **"Jelly Roll Morton found that out long before I did"**: Stanley Dance, *The World of Earl Hines* (Scribner, 1977), 47.

32 **Jelly Roll Morton on the road**: Kastras, *Dead Man Blues*, 74–171; Lomax, *Mister Jelly Roll*, 113–147, 170–206.

33 **"It's a funny thing"**: Lomax, *Mister Jelly Roll*, 121.

34 **"This Cordelia, she never would back up Ferd"**: Lomax, *Mister Jelly Roll*, 243–244.

36 **"Round about 4 A.M.":** Shaprio and Hentoff, *Hear Me Talkin' to Ya*, 12.

36 **"These pimps and hustlers":** *True* magazine, November 1947.

37 **Armstrong at Matranga's:** Armstrong, *Satchmo*, 113–116.

37 **"[He] liked my way of playing so much":** Ibid.

39 **"The tonk was not running":** Armstrong, *Satchmo*, 125–126.

39 **"While I was in the prison yard":** Ibid.

Chapter 2: Sicilian Message

41 **In New Orleans, corruption and the plundering of municipal funds:** Krist, *Empire of Sin*, 19–21, 68–70, 142–153, 181; Asbury, *The French Quarter*, 21–25, 40–43; Rose, *Storyville, New Orleans*, 61–72.

41 **Influence of Tammany Hall:** English, *Paddy Whacked*, 5, 6.

41 **The Ring:** Asbury, *The French Quarter*, 49–52, 63, 75–76; Krist, *Empire of Sin*, 72, 110–111, 304, 306–307.

42 **Sicilians in Louisiana:** Krist, *Empire of Sin*, 21–22, 28–29, 55, 159–160, 277; Fentress, *Eminent Gangsters*, 1–30; Thomas Hunt, *Deep Water: Joseph P. Macheca and the Birth of the American Mafia* (iUniverse INC, 2007), 32–33; Asbury, *The French Quarter*, 21, 116–118.

43 **The Sicilian Black Hand:** Fentress, *Eminent Gangsters*, 81–82; Krist, *Empire of Sin*, 157–174.

44 **Il *Stuppagghieri* in New Orleans:** Fentress, *Eminent Gangsters*, 12–27.

44 **The Matranga family:** Fentress, *Eminent Gangsters*, 17–18, 23–24, 26–30.

45 **Matranga rivalry with the Provenzanos:** Hunt, *Deep Water*, 137, 139, 154, 176, 186, 189–191, 194, 201–205, 211, 216, 259–260, 280, 361.

48 **Killing of Chief David Hennessy:** Richard Gambino, *Vendetta: The True Story of the Largest Lynching in U.S. History* (Doubleday, 1977), 11–12, 14–20, 26, 34–44; Joseph E. Persico, "Vendetta in New Orleans," *American Heritage Magazine*, vol. 24, no. 4, June 1972.

50 **Lynching of Sicilians:** Gambino, *Vendetta*, 46–53, 55, 57, 62–63; John F. Coxe, "The New Orleans Mafia Incident," *Louisiana Historical Quarterly*, vol. 20, no. 4, 1937, 3–46.

52 **Blacks and Italians:** Gary Boulard, "Blacks, Italians and the Making of New Orleans Jazz," *Journal of Ethnic Studies*, vol. 16, no. 1, 1988, 536–546; Ronald L. Morris, *Wait until Dark: Jazz and the Underworld, 1880–1940*

(Bowling Green University Press, 1981), 18, 84–85, 87–92; John Gennari, *Flavor and Soul: Italian America and Its African American Edge* (University of Chicago Press, 2017), 17, 31–33, 89, 91.

53 **Origins of Louis Prima in New Orleans:** Gary Boulard, *Just a Gigolo: The Life and Times of Louis Prima* (Center for Louisiana Studies, 1989), 1–24.

54 **Dominic James "Nick" LaRocca:** H. O. Bruno, *The Story of the Original Dixieland Jazz Band* (Louisiana State University Press, 1960), 1–3, 11–25, 27, 83–96, 150–176, 202–204. The legacy of Nick LaRocca in New Orleans is a troubled one. In the 1950s, in a series of letters to various publications, LaRocca denigrated the role of African Americans in the creation of jazz, claiming, "My contention is that the negroes learned to play rhythm and blues from the whites. The negro did not play any kind of music equal to the white men at any time" (as quoted in the Ken Burns PBS documentary series *Jazz*). LaRocca declared himself "the creator of jazz" and "the Christopher Columbus of music." Many of his original letters have been preserved at Tulane University's Hogan Jazz Archive. For a cogent analysis of the LaRocca controversy, see Michael Patrick Welsh, "Jazz's Great White Hype," *Narratively*, August 14, 2014.

55 **LaRocca in Chicago:** Bruno, *The Story of the Original Dixieland Jazz Band*, 150–176.

55 **Original Dixieland Jass Band:** Bruno, *The Story of the Original Dixieland Jazz Band*.

58 **The end of Storyville:** Rose, *Storyville, New Orleans*, 166–181.

59 **Armstrong and the Streckfus Steamboat Line:** Armstrong, *Satchmo*, 187–192, 194, 209, 211.

60 **"The ofays were not used to seeing colored boys":** Armstrong, *Satchmo*, 189.

Chapter 3: Kansas City Stomp

63 **Thomas Joseph "T. J." Pendergast:** Diane Mutti Burke (ed.), *Wide Open Town: Kansas City in the Pendergast Era* (University Press of Kansas, 2018), 33, 37, 42–47, 165–166, 196–197, 281–282; English, *Paddy Whacked*, 213–224; Lawrence H. Larsen and Janice J. Huston, *Pendergast!*

(University of Missouri Press, 1997); William M. Reddig, *Tom's Town: Kansas City and the Pendergast Legend* (J. B. Lippincott, 1991).

64 **"I'm not bragging when I say":** Larsen and Huston, *Pendergast!*, 2.

65 **"One of them hesitated":** Larsen and Huston, *Pendergast!*, 6.

66 **"the wettest city in the Territories":** English, *Paddy Whacked*, 216–224; Frank R. Hayde, *The Mafia and the Machine* (Barricade Books, 2010), 1–84; Terence William O'Malley, *Black Hand/Strawman: The History of Organized Crime in Kansas City* (The Covington Group, 2011), 13–15.

67 **Felix H. Payne:** Nathan W. Pearson, *Goin' to Kansas City* (University of Illinois Press, 1994), 88–89, 97–98; Frank Driggs and Chuck Haddix, *Kansas City Jazz: From Ragtime to Bebop—A History* (Oxford University Press, 2006), 29, 130; Sydney Vigram, "African Americans in Tom's Town: Black Kansas City Negotiates the Pendergast Machine" (honors thesis in history), March 27, 2017.

68 **Piney Brown:** Pearson, *Goin' to Kansas City*, 97–98, 108; Shapiro and Hentoff, *Hear Me Talkin' to Ya*, 290–291.

69 **Johnny Lazia:** *United States of America v. John Lazia*, Western District of Missouri, Indictment No. 12287, September 16, 1933; Hayde, *The Mafia and the Machine*, 29–72; O'Malley, *Black Hand/Strawman*, 16–19, 48–59; William Ouseley, *Open City: The True Story of the KC Crime Family* (Leathers Publishing, 2012), 59, 70, 76–101, 119–133.

71 **Black Hand in Kansas City:** Hayde, *The Mafia and the Machine*, 79–84; Ouseley, *Open City*, 11–51; O'Malley, *Black Hand/Strawman*, 1–12.

71 **Killing of Officer Joseph Raimo:** Ouseley, *Open City*, 303–305; O'Malley, *Black Hand/Strawman*, 3–5.

74 **"The shows, also known to musicians as 'smokers'":** Stanley Crouch, *Kansas City Lightning: The Rise and Times of Charlie Parker* (Harper, 2013), 218–219.

74 **The Cuban Gardens:** *United States of America v. John Lazia*, Western District of Missouri, Bill of Exceptions No. 12028, May 7, 1934. This remarkable document, 291 pages, includes testimony from various witnesses regarding the Cuban Gardens, which had fallen into bankruptcy and litigation. The testimony offers a highly detailed look into the financing of the club and Lazia's role in it. Two months after these hearings, the mob boss was assassinated, suggesting that the fortunes of the

Cuban Gardens—Lazia's great dream and ultimately a grand failure—may have led directly to his death.

76 **"Andy was playing tuba":** Driggs and Haddix, *Kansas City Jazz*, 87.

77 **18th and Vine district:** Author interview, Geri Sanders (Director of Collections), American Jazz Museum, Kansas City, KS, February 27, 2020; Count Basie as told to Albert Murray, *Good Morning Blues: The Autobiography of Count Basie* (Random House, 1985), 107–155; Andy Kirk as told to Amy Lee, *Twenty Years on Wheels* (Bayou Press, 1989), 6, 44–48; Crouch, *Kansas City Lightning*, 59–62, 116–117, 122–125, 137–146; Linda Dahl, *Morning Glory: A Biography of Mary Lou Williams* (University of California Press, 1999), 69–72; Driggs and Haddix, *Kansas City Jazz*, 24–29, 33–34, 39, 225, 234; Leroy Astransky, *Jazz City: The Impact of Cities on the Development of Jazz* (Prentice-Hall, 1978), 153–172; Pearson, *Goin' to Kansas City*, 107–120; Ross Russel, *Jazz Styles in Kansas City and the Southwest* (Da Capo Press, 1973), 11–30; Shapiro and Hentoff, *Hear Me Talkin' to Ya*, 284–288, 291, 298–301.

77 **"Oh my, marvelous town":** Pearson, *Goin' to Kansas City*, 108. This quote originates from a 1968 television interview that Basie did with Ralph J. Gleason on *Jazz Casual*, a program on KQED in San Francisco.

78 **"Now, at that time":** Shapiro and Hentoff, *Hear Me Talkin' to Ya*, 107.

79 **Payne kidnapping:** Robert Trussell, "The Jazz Age: Journalism Wars of KC's Jazz Age: Feud Between 'American' and 'Call' Peaked with Kidnapping of Editor," *Kansas City Star*, February 20, 1990; Robert Trussell, "A Case of Black and White: The Night They Beat Up Cab Calloway and Gave Kansas City a Black Eye," *Kansas City Star*, February 28, 1988.

80 **"Everybody in Bennie Moten's band had guns":** Eddie Durham, oral history, Missouri Historical Society, February, 22, 1977.

80 **"Everybody carried a gun":** Count Basie, oral history, Missouri Historical Society, February 15, 1977.

81 **"I played at one place":** Ibid.

81 **"I'd had a problem in Kansas City with a police officer":** Ibid.

82 **"They would raid us occasionally":** Ibid.

82 **Bennie Moten:** Driggs and Haddix, *Kansas City Jazz*, 4, 33, 40, 42–45, 53, 94–97, 101–102, 107–111, 118–119, 121–122, 124–130; Pearson, *Goin' to Kansas City*, 121–134; Burke, *Wide Open Town*, 239–240, 244–245;



Armstrong House Museum, Queens, NY, Satchmo Collection, catalog No. 1995.25.2.

93 **Lincoln Gardens and Sunset Cafe:** Dempsey J. Travis, *An Autobiography of Black Jazz* (Academy Chicago Publications, 1983); Kenny, *Chicago Jazz*, 19–21, 24, 40, 50–51, 57, 103, 154.

95 **"Something you need to know about me":** "Joseph G. Glaser Is Dead; Booking Agent for Many Stars," *New York Times*, June 8, 1969.

95 **"All the young musicians in town":** Shapiro and Hentoff, *Hear Me Talkin' to Ya*, 115.

96 **Al Capone:** Herbert Asbury, *Gem of the Prairie: An Informal History of the Chicago Underworld* (later titled *The Gangs of Chicago*, originally published by Knopf, 1940), 62, 318–320, 323–324, 334–336, 344, 349–351, 353–369, 371–374; John Kobler, *Capone: The Life and World of Al Capone* (Putnam, 1971); Laurence Bergreen, *Capone: The Man and the Era* (Simon & Schuster, 1994); Gus Russo, *The Outfit: The Role of Chicago's Underworld in the Shaping of Modern America* (Bloomsbury USA, 2002), 2, 23–25, 27, 35–38, 43–44, 52, 59, 106–107, 214, 215, 340–341.

96 **Dean O'Banion murder:** English, *Paddy Whacked*, 147–148; Kobler, *Capone*, 98, 101–110, 124.

97 **"When one of Capone's Boys":** Armstrong, *Swing That Music*, 33.

101 **Attempted hit on Johnny Torrio:** Asbury, *Gem of the Prairie*, 347–351, 353–355; Bergreen, *Capone*, 143–146; Kobler, *Capone*, 207–208, 212, 301.

102 **Capone and jazz:** The gangster's affection for jazz is touched upon in all of the major Capone biographies, especially Bergreen's *Capone*, and in many Chicago-based jazz memoirs, such as Condon's *We Called It Music*.

103 **Fats Waller in Chicago:** Maurice Waller and Anthony Calabrese, *Fats Waller* (Schirmer Books, 1977).

104 **Joe E. Lewis:** Art Cohn, *The Joker Is Wild: The Story of Joe E. Lewis* (Random House, 1955).

109 **Sam "Momo" Giancana:** Sam Giancana and Chuck Giancana, *Double Cross: The Explosive Inside Story of the Mobster Who Controlled America* (Warner Books, 1992); Russo, *The Outfit*, 42, 179–183, 187, 301, 369–370, 374–378, 388–390, 398, 407–408, 413, 427, 448–449.

Chapter 5: Birth of the Hipster

113 **The Plantation Café:** Travis, *An Autobiography of Black Jazz*, 13, 27–28; Kenny, *Chicago Jazz*, 21–23, 26, 149–151.

113 **"Close those windows or I'll blow you off 35th Street":** Kenny, *Chicago Jazz*, 149.

113 **Attacks on Capone's establishments:** Kenny, *Chicago Jazz*, 150–151.

113 **The quotable Capone:** Kobler, *Capone*, 58, 112; Bergreen, *Capone*, 212–213, 239–240, 261–264, 268, 356–357, 369, 418, 436, 509. All of the biographies quote Capone from the various Chicago newspapers of the day.

114 **"Are you hip?":** Kenny, *Chicago Jazz*, 152.

115 **Milton "Mezz" Mezzrow:** Mezz Mezzrow with Bernard Wolfe, *Really the Blues* (Random House, 1946). Mezzrow is a legend in jazz history, partly because of his musicianship and his role as a prominent marijuana dealer, but mostly because of *Really the Blues*, which has achieved the status of a classic. Given Mezzrow's identification with Black culture, people tend to have strong feelings about his legacy. Laurence Bergreen, who wrote an otherwise excellent biography of Louis Armstrong (cited as a source for this book), sullies his work by going out of his way to scorn Mezzrow. Bergreen describes Mezzrow as "sinister" and *Really the Blues* as "a chilling self-portrait of an opportunistic junkie, and proto-hipster." Bergreen blames Mezzrow for getting Armstrong "habituated to the drug" when, in truth, Satchmo was more than capable of handling that himself.

116 **"Our whole jazz music was, in a way":** Mezzrow, *Really the Blues*, 182.

116 **"Only [musician] I ever heard of":** Shapiro and Hentoff, *Hear Me Talkin' to Ya*, 130–131.

117 **Jazz scene in Detroit:** Mezzrow, *Really the Blues*, 90–92; Lars Bjorn, *Before Motown: A History of Jazz in Detroit*, 1920–1960 (University of Michigan Press, 2001).

117 **The Purple Gang in Detroit:** Gregory A. Fornier, *The Elusive Purple Gang: Detroit's Kosher Nostra* (Wheatmark Inc, 1977); Mezzrow, *Really the Blues*, 92–101.

117 **"Soon I found myself hanging out with them":** Mezzrow, *Really the Blues*, 96.

119 **"The smell in that room was enough to knock you out":** Mezzrow, *Really the Blues*, 97.

120 **"Years later, when I was living in New York":** Mezzrow, *Really the Blues*, 101.

121 **"At one place we worked":** Shapiro and Hentoff, *Hear Me Talkin' to Ya*, 130.

121 **"The other customers left and the doors were closed":** Condon, *We Called It Music*, 125.

122 **Earl "Fatha" Hines:** Dance, *The World of Earl Hines*.

123 **"They told us no harm would come to us":** Dance, *The World of Earl Hines*, 118.

123 **Hines at the Grand Terrace:** Ibid.

125 **"I was in a music store a block away when the [massacre] occurred":** Dance, *The World of Earl Hines*, 123.

125 **Ebony magazine article:** Ben Burns, *Nitty Gritty: A White Editor in Black Journalism* (University Press of Mississippi, 1996); Earl Hines, "How Gangsters Ran the Band Business," *Ebony*, September 1948; "Hines Says Gangs Ruled Band 'Biz'," *Carolina Times*, August 20, 1949.

127 **Tommy Rockwell:** Bergreen, *Louis Armstrong*, 317, 329, 338–339, 348, 378; Teachout, *Pops*, 127–134, 136, 162–165.

127 **Glaser rape conviction:** Teachout, *Pops*, 205–207, 210; Ricky Riccardi, *Heart Full of Rhythm: The Big Band Years of Louis Armstrong* (Oxford University Press, 2020), 164–165, 167.

131 **Armstrong marijuana arrest in Los Angeles:** Bergreen, *Louis Armstrong*, 328–331; Teachout, *Pops*, 157–159, 302.

132 **Johnny Collins:** Bergreen, *Louis Armstrong*, 330, 335–336, 343, 347, 370–371; Teachout, *Pops*, 159–160, 162–165, 177, 181–190.

134 **Frankie Foster incident:** Bergreen, *Louis Armstrong*, 338, 340; Teachout, *Pops*, 162–165, 169.

Chapter 6: Friends in Dark Places

137 **The Hotsy Totsy Club:** Jimmy Durante and Jack Kofoed, *Night Clubs* (Knopf, 1931), 31, 163–169; Stanley Walker, *The Nightclub Era* (Frederick A. Stokes, 1983), 236–240; Robert Sylvester, *No Cover Charge:*

A Backward Look at the Nightclubs (Dial Press, 1956), 3–24; "Gives New Version of Café Murders; Doorman at Hotsy Totsy Club Says a Bartender Fled, Stuffing Pistol into Pocket," *New York Times*, February 8, 1930.

137 **Jack "Legs" Diamond:** Gary Levine, *Jack "Legs" Diamond: Anatomy of a Gangster* (Purple Mountain Press, 1995).

139 **Al Jolson and Walter Winchell:** Tristin Howard, *Winchell and Runyon: The Untold Story* (Hamilton Books, 2010), 134–135. This incident is part of New York City showbiz lore. In some accounts, Winchell's role is replaced by journalist (and future screenwriter) Mark Hellinger. It seems far more likely that Winchell would be in a position to exert this degree of influence over the likes of Legs Diamond.

141 **"One night a large party came in":** Condon, *We Called It Music*, 183–184.

141 **"One night Jack 'Legs' Diamond fell into the joint":** Mezzrow, *Really the Blues*, 178–179.

142 **Hotsy Totsy shooting and aftermath:** Levine, *Jack "Legs" Diamond*, 99–104, 111–113, 197; Walker, *The Nightclub Era*, 236–240; Sylvester, *No Cover Charge*, 11–24.

146 **"Gangdom is in control of the nightclubs":** Sylvester, *No Cover Charge*, 19.

147 **"I'd had a bellyful of gangsters":** Mezzrow, *Really the Blues*, 182.

147 **"A bunch of ugly-looking gangsters":** Mezzrow, *Really the Blues*, 183.

148 **Cutting sessions:** Rex Stewart, *Jazz Masters of the 30s* (New York: Macmillan, 1972), 143–150; Edward Kennedy Ellington, *Music Is My Mistress* (Doubleday, 1973); Shapiro and Hentoff, *Hear Me Talkin' to Ya*, 219–220. Many jazz autobiographies and histories touch on the subject of cutting sessions, as well as the rent parties, from the 1920s through the 1950s.

148 **Rent parties:** Ellington, *Music Is My Mistress*; Gioia, *History of Jazz*; Billie Holiday and William Dufty, *Lady Sings the Blues* (Doubleday, 1956); Leroi Jones, *Blues People: Negro Music in White America* (HarperCollins, 1963).

149 **"To a degree, all musicians, white or Black":** Stewart, *Jazz Masters of the 30s*, 143–144.

151 **Fats Waller:** Waller and Calabrese, *Fats Waller*.

152 **Arnold Rothstein:** Nick Tosches, *King of the Jews: The Greatest Mob Story Never Told* (Ecco, 2005).

152 **Andy Razaf:** Barr Singer, *Black and Blue: The Life and Lyrics of Andy Razaf* (Shirmer Books, 1992).

155 **Dutch Schultz:** Paul Sann, *Kill the Dutchman!: The Story of Dutch Schultz* (Arlington House, 1971).

155 **Razaf-Schultz relationship:** Singer, *Black and Blue*, 212, 216–219, 222, 267.

158 **Baron Wilkins:** James Haskins, *The Cotton Club: A Pictorial and Social History of the Most Famous Symbol of the Jazz Era* (Random House, 1977); "Barron Wilkins Slain in Harlem: 'Yellow Charleston,' Who Shot Noted Negro, Had Just Killed Another Man," *New York Times*, May 25, 1924.

159 **"For hours after Wilkins was killed":** "Popular Harlem Man Shot in Cold Blood; Killed When He Refused Money for Get-Away to Man Who Had Just Murdered Another Man About a Fifty Cent Loan," *New York Age*, May 31, 1924.

159 **Casper Holstein:** "Former 'Policy King' in Harlem Dies Broke; Casper Holstein of Harlem Had $500,000 at Peak of Career," *New York Times*, April 9, 1944.

160 **"We cannot enjoy half slavery and half freedom":** "Casper Holstein Gives $100 in Katy Ferguson Fund Drive for $16,000," *New York Age*, December 12, 1925.

161 **Holstein kidnapping by Mad Dog Coll:** "Kidnapped Negro Freed by Captors; Five Seized in Plot," *New York Times*, September 24, 1925.

Chapter 7: Down on the Plantation

163 **Mayor Jimmy Walker:** Gene Fowler, *Beau James: The Life and Times of Jimmy Walker* (Viking, 1949).

165 **The Jazz Age:** Herbert Asbury, *The Great Illusion: An Informal History of Prohibition* (Dodd, Mead, 1950); Gioia, *History of Jazz*, 53–88; Albert Murray, *Stomping the Blues* (McGraw-Hill, 1976); Haskins, *The Cotton Club*; Daniel Okrent, *Last Call: The Rise and Fall of Prohibition* (Scribner, 2011), 205–212; Walker, *The Nightclub Era*, 26–50, 77–102.

166 **Owney Madden youth and crime career:** English, *Paddy Whacked*, 115–119.

168 **Madden's bootlegging empire:** English, *Paddy Whacked*, 119–121, 123, 125–126; Graham Nown, *Arkansas Godfather: The Story of Owney Madden and How He Hijacked Middle America* (Butler Center for Arkansas Studies, 2013), 9, 34, 148–149, 205; David Hill, *The Vapors: A Southern Family, the New York Mob, and the Rise and Fall of Hot Springs, America's Forgotten Capital of Vice* (Farrar, Straus and Giroux, 2020), 31–32, 37, 84–86, 107, 145, 157, 206–210, 256.

169 **Origins of the Cotton Club:** Haskins, *The Cotton Club*; Malcolm Womack, "Harlem Holiday: The Cotton Club, 1925–1940," dissertation, doctorate degree in philosophy, University of Washington, 2013.

170 **"Owney Madden's club":** "Dry Padlocks Snapped on Nine Wet Doors; 'Owney' Madden's 'Club' Is One of Them," *New York Times*, June 23, 1925.

171 **"It was a real distinction":** Haskins, *The Cotton Club*, 43.

171 **"If you were a Black person":** Ibid.

171 **"White people began to come to Harlem in droves":** Langston Hughes, *The Big Sea: An Autobiography* (Knopf, 1940),134.

172 **Lena Horne:** Lena Horne and Richard Schickel, *Lena* (Doubleday, 1965); James Gavin, *Stormy Weather: The Life of Lena Horne* (Atria, 2009); Haskins, *The Cotton Club*, 65; Gerald Horne, *Jazz and Justice* (Monthly Review Press, 2019), 54.

173 **Duke Ellington:** Ellington, *Music Is My Mistress*; Terry Teachout, *Duke: A Life of Duke Ellington* (Avery, 2014); Haskins, *The Cotton Club*, 111; Crouch, *Considering Genius*, 133–153.

175 **"The music of my race":** Ellington, *Music Is My Mistress*, 78.

176 **"The episodes of the gangster era":** Ellington, *Music Is My Mistress*, 82.

176 **"I keep hearing about how bad":** Sonny Greer oral history interview (conducted by Stanley Crouch), Rutgers University, Institute of Jazz Studies.

177 **"[Madden] loved Duke":** Ibid.

177 **"There was this guy":** Teachout, *Duke*, 191.

177 **Cab Calloway:** Alyn Shipton, *Hi-de-ho: The Life of Cab Calloway* (Oxford University Press, 2013); Cab Calloway and Bryant Rollins, *Of Minnie the Moocher & Me* (Crowell, 1976), 66, 68; Haskins, *The Cotton Club*, 81.

177 **"Four guys were sitting there"**: Calloway and Rollins, *Of Minnie the Moocher & Me*, 112.

178 **"Any time we needed a quick buck"**: Sonny Greer oral history interview, Rutgers University, Institute of Jazz Studies.

179 **"These guys liked me"**: Calloway and Rollins: *Of Minnie the Moocher & Me*, 130–131.

181 **"The Plantation was [designed to be] a fine, fine place"**: Calloway and Rollins, *Of Minnie the Moocher & Me*, 82–83.

183 **Murder of Dutch Schultz**: Sann, *Kill the Dutchman!*, 3–20, 47–55.

184 **Armstrong reconnects with Glaser**: Anderson, *Storyville* magazine; Teachout, *Pops*, 363–365; Bergreen, *Louis Armstrong*, 372–388, 433–434; Riccardi, *Heart Full of Rhythm*, 161–179, 219.

185 **"When Louis came back from England"**: Bergreen, *Louis Armstrong*, 372.

185 **"I could see he was down and out"**: Anderson, *Storyville* magazine.

186 **"He was the most obscene"**: Max Gordon, *Live at the Village Vanguard* (St. Martin's, 1980), 79.

186 **"Joe was a professional tough guy"**: Bergreen, *Louis Armstrong*, 373.

186 **"Joe Glaser had the wonderful ability to lie"**: George Wein with Nate Chinen, *Myself Among Others: A Memoir* (Da Capo Press, 2003).

Chapter 8: The Crooner

189 **Early Frank Sinatra**: James Kaplan, *Frank: The Voice* (Doubleday, 2010), 5, 8–17, 21–25, 27–33, 467–468, 531–532; Kitty Kelley, *His Way: The Unauthorized Biography of Frank Sinatra* (Bantam, 1986); Pete Hamill, *Why Sinatra Matters* (Little Brown, 1998).

190 **Bing Crosby and Jack McGurn**: FBI file, Bing Crosby, #9-49113, memorandum to Clyde Tolson, November 1942; Michael Ellison, "FBI files lift lid on Big Crosby's links to the mob," *Guardian*, December 23, 1999; Tim Cronin, "When the Boys Play Through," *Chicago Golf*, April 2017; John Gault, "Going Bing's Way," *Maclean's*, October 1977; Russo, *The Outfit*, 123–124.

193 **The mafia in New Jersey**: Kaplan, *Frank*, 10–13, 161, 288–291; Hamill, *Why Sinatra Matters*; Jonathan Van Meter, *The Last Good Time: Skinny D'Amato, the Notorious 500 Club, & the Rise and Fall of Atlantic City*

(Crown, 2003), 34, 39, 44, 46–54, 58–59, 99, 151–152, 158, 182. See also Scott Deitche, *Garden State Gangland: The Rise of the Mob in New Jersey* (Rowan & Littlefield, 2017).

194 **Sinatra arrest:** Tom Kuntz and Phil Kuntz, *The Sinatra Files: The Secret FBI Dossier* (Three Rivers Press, 2000); Kaplan, *Frank*, 6–72; Kelley, *His Way*, 35–37, 41–42.

195 **Willie Moretti:** Kaplan, *Frank*, 10, 161, 183–184, 318–319, 498–499.

196 **Sinatra and the Dorsey band:** Kaplan, *Frank*, 90–92, 101, 107–108, 112–119, 127–128, 135–137; Kelley, *His Way*, 141–142, 161.

198 **"Buddy Rich Gets Face Bashed In":** Kaplan, *Frank*, 118.

199 **The Big Band era:** Gioia, *History of Jazz*, 127–184.

199 **Newark, New Jersey:** Barbara J. Kukla, *Swing City: Newark Night Life* (Temple University Press, 1991); Horne, *Jazz and Justice*, 80–81.

200 **Atlantic City:** Van Meter, *The Last Good Time*, 100–108. In his memoir, *Of Minnie the Moocher & Me*, Cab Calloway describes the Atlantic City of his young adulthood as "a big, fancy resort with a lot of jumping nightclubs."

201 **Skinny D'Amato and the 500 Club:** Van Meter, *The Last Good Time*, 73–78, 109–110, 117–118, 131–133, 148–149, 154–155, 228.

202 **Tampa and Ybor City:** Author interview with Scott Deitche, January 11, 2021. For the city's organized crime background, see Scott Deitche, *Cigar City Mafia: A Complete History of the Tampa Underworld* (Barricade Books, 2004).

203 **South Florida carpet joints:** Robert Lacey, *Little Man: Meyer Lansky and the Gangster Life* (Little Brown, 1991); T. J. English, *Havana Nocturne: How the Mob Owned Cuba . . . and Lost It to the Revolution* (William Morrow, 2008), 9, 56–57, 67, 78–80.

204 **Newport and Covington, Kentucky:** Jon Hendricks oral history interview, Museum of American History, Smithsonian, August 17–18, 1995; Nick Tosches, *Dino: Living High in the Dirty Business of Dreams* (Doubleday, 1992), 99–100.

205 **Hot Springs, Arkansas:** Philip Leigh, *The Devil's Town: Hot Springs during the Gangster Era* (Shotwell Publishing, 2018); Hill, *The Vapors*.

207 **St. Louis:** Dennis C. Owsley, *St Louis Jazz: A History* (History Press,

2015); Dizzy Gillespie and Al Fraser, *To Be or Not to Bop: Memoirs of Dizzy Gillespie* (Doubleday, 1979), 188–189.

208 **"Somebody insulted this lady"**: Clark Terry, oral history, June 15 and 19, 1999, National Museum of American History.

209 **"The Plantation Club was a white club"**: Gillespie and Fraser, *To Be or Not to Bop*, 188.

209 **Pittsburgh (Smoketown)**: Mark Whitaker, *Smoketown: The Untold Story of the Other Black Renaissance* (Simon & Schuster, 2019); Brian McKenna, "Gus Geenlee," The Society for American Baseball Research, SABR Digital Library; Ralph Carhart, "Rufus Jackson," The Society for American Baseball Research, SABR Digital Library.

211 **Denver**: Dick Kreck, *Smaldone: The Untold Story of an American Crime Family* (Fulcrum Publishing, 2010); Tom Lundin, "The Moonlight Ranch and Diamond Jack," *Historic Denver Nightlife*, Denver Public Library, July 14, 2017; Tom Lundin, "The Moonlight Ranch and Mike Rossi," *Historic Denver Nightlife*, Denver Public Library, May 25, 2017.

211 **"The Moonlight Ranch was pretty high class"**: Kirk, *Twenty Years on Wheels*, 38–40.

212 **"Rossi may have been tough"**: Ibid.

212 **"Here was this lady at the bar"**: Kreck, *Smaldone*, 41.

213 **Los Angeles (Central Avenue)**: Clora Bryant (ed.), *Central Avenue Sounds: Jazz in Los Angeles* (University of California Press, 1988); Cuddy Collette with Steven Louis Isoardi, *Jazz Generations: A Life in American Music and Society* (Continuum, 2000); Jeff Gold, *Sittin' In: Jazz Clubs of the 1940s and 1950s* (Harper Design, 2020). *Sittin' In* is a photo book that contains an impressive collection of photos from the era, many of them from Central Avenue in Los Angeles.

215 **"There was a lot of work over there"**: Bryant, *Central Avenue Sounds*, 73.

215 **Benjamin "Bugsy" Siegel**: Dean Jennings, *We Only Kill Each Other: The Life and Bad Times of Bugsy Siegel* (Prentice-Hall, 1967); John Buntin, *L.A. Noir: The Struggle for the Soul of America's Most Seductive City* (Crown, 2009), 3–4, 59–61, 64–67, 77–78, 82–84, 90–92, 102–103, 115, 116.

216 **Mickey Cohen**: Tere Tereba, *Mickey Cohen: The Life and Crimes of L.A.'s Notorious Mobster* (ECW Press, 2012); Mickey Cohen as told to John

Peer Nugent, *In My Own Words* (Prentice-Hall, 1975); Buntin, *L.A. Noir*, xiii, 4, 7–9, 46–50, 65–69, 71, 81, 83, 100, 103, 112–114, 145, 171–176, 245–247, 283–287.

217 **Buddy Colette's Mickey Cohen anecdote:** Colette with Isoardi, *Jazz Generations*, 112–113; Buddy Colette oral history interview (conducted by Steven Isoardi), Department of Special Collections, UCLA Library, Los Angles, 1989–1990.

Chapter 9: Swing Street

219 **The end of Prohibition:** Asbury, *The Great Illusion*; Okrent, *Last Call*, 328–330, 351–354.

220 **Meyer Lansky and the jukebox business:** Lacey, *Little Man*, 182–184.

221 **Testimony of Milton Hammergren:** Investigation of Improper Activities in the Labor or Management Field, Hearings Before the Senate Select Committee, September 1958–1959, transcript 742–827.

223 **Sinatra splits from Tommy Dorsey:** Kelley, *His Way*, 171–173, 176; Kaplan, *Frank*, 139–146, 181–185, 192, 200.

225 **"Frank told me years later":** Kaplan, *Frank*, 183.

225 **Joey D'Orazio's version of Dorsey incident:** J. Randy Taborrelli, *Sinatra: Behind the Legend* (Birch Lane Press, 1997), 89–90.

225 **"Three guys from New York City":** Ibid.

226 **"Don Corleone did this by putting a pistol to the forehead":** Mario Puzo, *The Godfather* (G. P. Putnam's Sons, 1968), 43.

227 **Decline of Harlem as jazz center:** Gioia, *History of Jazz*, 89–126; Leroy Ostransky, *Jazz City: Impact of Our Cites on the Development of Jazz* (Leathers, 2012), 188–197, 200–209, 218–219; see also Warren J. Halliburton with Ernest Kaiser, *Harlem: A History of Broken Dreams* (Zenith Books, 1974).

229 **Birth of 52nd Street (Swing Street):** Arnold Shaw, *52nd Street: The Street of Jazz* (Da Capo Press, 1971), ix–xiv, 9–14, 36–40; Patrick Burns, *Come In and Hear the Truth: Jazz and Race on 52nd Street* (University of Chicago Press, 2008), 13–32; Gioia, *History of Jazz*, 200–216.

232 **"All the Murder Inc guys":** Shaw, *52nd Street*, 198.

232 **"When we came back to the clubs":** Shaw, *52nd Street*, 333.

234 **Louis Prima on 52nd Street:** Boulard, *Just a Gigolo*, 118–119; Shaw, *52nd Street*, 45, 56, 88, 106–110, 114–116, 124–126, 145, 149; Burns, *Come In and Hear the Music*, 41–51.

235 **Louis "Pretty Boy" Amberg:** Shaw, *52nd Street*, 115.

236 **"Once Amberg showed Louis the picture":** Ibid.

238 **Charles "Lucky" Luciano:** Virgil Peterson, *The Mob: 200 Years of Organized Crime in New York* (Little Brown, 1952); Lacey, *Little Man*.

238 **Emergence of heroin:** Gerald H. Tolson, "Jazz and Substance Abuse: Road to creative genius or pathway to premature death," *International Journal of Law and Psychiatry*, 2007; Charles Winick, "The Use of Drugs by Jazz Musicians," *Society for the Study of Social Problems*, vol. 7, no. 3, Winter 1959–1960. Many musicians have written frankly and openly about the prevalence of heroin use in the jazz business, including Miles Davis in *Miles: The Autobiography*. In *The Last Interview and Other Conversations* (Melville House, 2019), Billie Holiday describes her condition from the hospital bed where she resided just days before her death from health complications related to her heroin addiction.

239 **Vito Genovese and dope:** Anthony M. DeStefano, *The Deadly Don: Vito Genovese, Mafia Boss* (Citadel Pres, 2021); Peterson, *The Mob*, 371–372.

241 **"Bird came in late":** Gillespie and Fraser, *To Be or Not to Bop*, 235.

242 **"There was a lot of dope around the music scene":** Miles Davis with Quincey Troup, *Miles: The Autobiography* (Simon & Schuster, 1989), 129–133.

243 **Dillard "Red" Morrison and Ellsworth "Bumpy" Johnson:** Zach O'Malley Greenburg, "The Musical Gangster: 'Red' Dillard Morrison," *Forbes*, June 2011; Mayme Johnson and Karen E. Quinones Miller, *Harlem Godfather: The Rap on My Husband, Ellsworth "Bumpy" Johnson* (Oshun Publishing, 2008), 127–130, 170–172.

244 **Bumpy Johnson's funeral:** Johnson and Quinones Miller, *Harlem Godfather*, 236–237.

Chapter 10: "Jazz Provides Background for Death"

245 **Whiteman orchestra in Havana:** Leonardo Acosta, *Cubano Be Cubano Bop: One Hundred Years of Jazz in Cuba* (Smithsonian Books, 2002), 18.

246 **Lansky and Batista:** English, *Havana Nocturne*, 20, 58–61, 74–75, 82, 92, 96, 100, 129, 164, 184, 198, 265–267, 285, 316; Lacey, *Little Man*, 245–246, 253, 259.

248 **Sinatra delivers cash to Luciano in Havana:** Kaplan, *Frank*, 316–320; English, *Havana Nocturne*, 39–43.

249 **Luciano deal with U.S. Naval Intelligence:** English, *Havana Nocturne*, 21–26. See also Rodney Campbell, *The Luciano Project: The Secret Wartime Collaboration of the Mafia and the U.S. Navy* (McGraw-Hill, 1977).

250 **Havana mob conference:** English, *Havana Nocturne*, 39–43.

252 **"I am puzzled as to why Frank Sinatra":** English, *Havana Nocturne*, 43.

253 **"The Street's reputation":** Shaw, *52nd Street*, 350.

254 **"The hoods who came as customers":** Ibid.

254 **Birdland:** Leo T. Sullivan, *Birdland, the Jazz Corner of the World: An Illustrated Tribute, 1949–1965* (Schiffer Publishing, 2018); Richard Carlin, *Morris Levy: Godfather of the Music Business* (University Press of Mississippi, 2016), 14–31, 89–97, 101.

255 **Morris "Mo" Levy:** Carlin, *Morris Levy*; Fredric Dannen, *Hit Men: Power Broker and Fast Money Inside the Music Business* (Vintage, 1991), 31–57; Teddy Reig with Edwrd Berger, *Reminiscing in Tempo: The Life and Times of a Jazz Hustler* (Scarecrow Press, 1995), 40, 45–46, 55–56, 66–67, 112, 116–117; Tommy James with Martin Fitzpatrick, *Me, the Mob, and the Music: One Helluva Ride with Tommy James and the Shondells* (Scribner, 2011). Tommy James was not a jazz musician; he was the lead singer of a popular psychedelic rock band. His group signed with Roulette Records at a time when the label was crossing over from jazz to rock and pop. James developed a toxic father-son relationship with Mo Levy that he chronicled with great insight in his book.

259 **"When Birdland opened its canopied doors":** "Florida's Color Bars Tumble," *Jet* magazine, December 31, 1953.

259 **Roulette Records:** Carlin, *Morris Levy*, 99, 107–108, 126–127, 129–132, 147–148, 153–154, 182–186; FBI file, Morris Levy.

259 **"If you want royalties":** Carlin, *Morris Levy*, viii.

260 **"A few minutes in the office corridors":** Bob Thiele, *What a Wonderful World: A Lifetime of Recordings* (Oxford University Press, 1995), 93–94.

261 **"Bob Krassnow lived in San Francisco":** Carlin, *Morris Levy*, 127.

261 **Count Basie's relationship with Levy:** Carlin, *Morris Levy*, 20–21, 37–38, 42, 75–77, 80–84, 101, 125, 182; Count Basie as told to Albert Murray, *Good Morning Blues: The Autobiography of Count Basie* (Random House, 1985), 299, 314, 316–317, 322, 327, 332.

262 **"Basie had lost his ass playing horses":** Carlin, *Morris Levy*, 80.

263 **"Basie was the worst gambler":** Doug Elfman, "Quincy Jones shares stories of old Vegas," *Las Vegas Journal-Review*, April 13, 2013.

263 **"Booze, Bribes, and Broads":** Carlin, *Morris Levy*, 101.

264 **The cabaret card:** Paul Chevigny, *Gigs: Jazz and the Cabaret Law in New York* (Routledge, 2004); Nate Chinen, "The Cabaret Card and Jazz: Nefarious nuisance or blessing in disguise?," *JazzTimes*, May 17, 2012; John Sibley, "Police Licensing of Clubs to End," *New York Times*, January 17, 1961.

267 **"For many years, I have denied myself the privilege":** Charles G. Bennett, "Cabaret Card Use Ended by Council," *New York Times*, September 15, 1967.

269 **The murder of Irving Levy:** Carlin, *Morris Levy*, 90–93; "Birdland Owner Stabbed to Death," UPI, January 28, 1959; Harney Aronson, "Cops Search Jazz Haunts for Slayer," *Newsday*, January 27, 1959; "Couple Accused in Birdland Case," *New York Times*, January 31, 1959.

Chapter 11: The Ghost of Chano Pozo

271 **"What's so bad about gambling?":** Lacey, *Little Man*, 197–198.

272 **Kefauver hearings:** Gilbert King, "The Senator and the Gangsters," *Smithsonian Magazine*, April 18, 2012; Thomas Doherty, "Frank Costello's Hands: Film, television and the Kefauver crime hearings," *Film History*, vol. 10, no. 3; Daniel J. Leab, *The Cold War and the Movies* (Indiana University Press, 1998), 359–374.

272 **"I almost fell off my chair":** Kaplan, *Frank*, 459.

274 **Sinatra's secret deposition:** Kaplan, *Frank*, 459–467.

280 **Mob exploitation of Havana:** English, *Havana Nocturne*.

281 **Emergence of Latin jazz:** Mario Bauza, oral history, December 13–14, 1978, Institute of Jazz Studies; Raul Fernandez, *Latin Jazz: The Perfect Combination* (Chronicle Books, 2002); Isabelle Leymarie, *Cuban Fire: The Story of Salsa and Latin Jazz* (Continuum, 2002).

281 **Chano Pozo:** Gillespie and Fraser, *To Be or Not to Bop*, 115, 319–320; Leonardo Paduro Fuentes, *The Sad Night of Chano Pozo* (AJUBELstudio, 2013); Max Salazar, "The Fast Life and Death of Chano Pozo," 1978, in vertical file on Chano Pozo, Institute of Jazz Studies.

283 **Nat King Cole in Havana:** Jean Stein, "All Havana Broke Loose: An Oral History of Tropicana," *Vanity Fair*, September 2011.

285 **The Tropicana nightclub:** Rosa Lowinger with Ofelia Fox, *Tropicana Nights: The Life and Times of the Legendary Cuban Nightclub* (Harcourt, 2005); Stein, "All Havana Broke Loose."

286 **"Tropicana was heaven":** Stein, "All Havana Broke Loose."

287 **Shanghai Theater in Havana:** English, *Havana Nocturne*, 147–148, 217–220.

288 **"What do our homeland's pain":** English, *Havana Nocturne*, 161.

289 **Assassination of Blanco Rico:** English, *Havana Nocturne*, 166.

290 **Bombing at the Tropicana:** Lowinger, *Tropicana Nights*, 314–317; Stein, "All Havana Broke Loose."

291 **The fall of Cuba to the revolution:** You could fill an entire room at your local library with books written about the Cuban Revolution from every conceivable angle. For the impact of the fall of Havana on the American mobsters, see English, *Havana Nocturne*, and also Lacey, *Little Man*.

294 **Miles Davis incident with abusive cop:** Miles with Troup, *Miles*, 238–240.

Chapter 12: Fear and Loathing at the Copacabana

297 **Mary Lou Williams:** Dahl, *Morning Glory*.

298 **"[One club owner] refused":** Dahl, *Morning Glory*, 117.

298 **"She was very attractive":** Dahl, *Morning Glory*, 80.

300 **"An evil person will cause":** Dahl, *Morning Glory*, 246.

301 **"He was very open in talking about":** James Kaplan, *Sinatra: The Chairman* (Doubleday, 2015), 36.

302 **Sinatra and Sam Giancana:** George Jacobs and William Stadiem, *Mr. S: My Life with Frank Sinatra* (HarperEntertainment, 2003), 101–104.

304 **Sinatra, Giancana, and JFK:** Giancana and Giancana, *Double Cross*.

306 **"You know, I like niggers":** Jacobs and Stadiem, *Mr. S*, 103–104.

306 **"Mr. Sam put a much nicer spin on it":** Ibid.

308 **"Lying [expletive]!":** Kaplan, *Sinatra*, 462.

310 **Levy and Sarah "Sassy" Vaughan:** Carlin, *Morris Levy*, 37, 63, 84–85, 87, 97, 125; Alaine M. Hayes, *Queen of Bebop: The Musical Lives of Sarah Vaughan* (Ecco, 2017), 100, 222, 248; FBI file, Morris Levy.

311 **Levy and Dick "Night Train" Lane:** Carlin, *Morris Levy*, 85–86.

312 **FBI investigation of Levy:** Carlin, *Morris Levy*, 62, 84, 91, 101, 109–110, 113–114, 118, 163–164, 197–199, 221–226, 236.

313 **Tommy Eboli:** FBI file, Morris Levy.

315 **The Copacabana nightclub:** Mickey Podell-Raber with Charles Pignone, *The Copa: Jules Podell and the Hottest Club North of Havana* (Harper, 2007); Tosches, *Dino*, 158–163.

315 **"Some of us thought it was a fad":** Author interview, Anthony Polameni, New York City, September 2000.

316 **Jules Podell:** Podell-Raber with Pignone, *The Copa*, 5, 22, 35–36, 60–61, 87, 113–114, 193–200; "Jules Podell, Showman, Dead; Owned Copacabana Since '40," *New York Times*, September 28, 1973.

316 **Nightclub investigations by Mayor La Guardia:** Anthony M. DeStefano, *Top Hoodlum: Frank Costello, Prime Minister of the Mafia* (Citadel, 2018), 168–169.

317 **"It was a freezing night":** Sammy Davis Jr. and Jane and Burt Boyar, *Yes I Can: The Story of Sammy Davis, Jr.* (Farrar, Straus and Giroux, 1965) 81–82.

318 **Copacabana and race:** Davis Jr. and Boyar and Boyar, *Yes I Can*.

319 **"Get off my stage, nigger":** Tosches, *Dino*, 161.

321 **Vic Damone:** Vic Damone, *Singing Was the Easy Part* (St. Martin's Press, 2009).

323 **Tony Bennett:** David Evanier, *All the Things You Are: The Life of Tony Bennet* (Wiley, 2011).

323 **"I felt I couldn't pass up on the chance":** Joe Jackson, "A boulevard of many artistic blessings," *Irish Independent*, August 11, 2002.

324 **Bobby Darin:** Podell-Raber with Pignone, *The Copa*, 40, 98, 137–140, 195; Don Heckman, "Bobby Darin Back in Song Program," *New York Times*, February 27, 1972.

Chapter 13: The Muck and the Mud

327 **The Sands Hotel and Casino:** David G. Schwartz, *At the Sands: The Casino That Shaped Classic Las Vegas, Brought the Rat Pack Together and Went Out With a Bang* (Winchester Books, 2020).

327 **Jack Entratter:** Schwartz, *At the Sands*, 20–21, 28, 33–34, 38–39, 42–44, 58–62, 95, 96, 98, 109–110, 151–153, 167–170; Podell-Raber with Pignone, *The Copa*, 7, 14, 31, 41–44; "Jack Entratter of Las Vegas, 57," *New York Times*, March 12, 1971.

328 **Evolution of Las Vegas:** Schwartz, *At the Sands*, 4–5, 9–12, 16–28, 62, 64–69, 71, 89–91, 183; Sally Denton and Roger Morris, *The Money and the Power: The Making of Las Vegas and Its Hold on America* (Knopf, 2001), 1–35; Nicholas Pileggi, *Casino: Love and Honor in Las Vegas* (Simon & Schuster, 1995), 4–5, 8–10, 83, 181.

331 **Racism and Vegas:** Davis Jr. and Boyar and Boyar, *Yes I Can*, 385–386, 412, 417; Daniel Mark Epstein, *Nat King Cole* (Farrar, Straus and Giroux, 1999), 232–233, 245–246, 320–321; Horne, *Jazz and Justice*, 162–166; Rosemary Pearce, "Fear and Motels in Las Vegas: Segregation and Celebrity on the Strip," USSO, U.S. Studies Online, October 14, 2020; "The March that Never Happened: Desegregating the Vegas Strip," *Nevada Law Journal*, vol. 5, no. 1, 2004.

332 **"Man, I love show business":** Epstein, *Nat King Cole*, 256.

332 **"A three- or four-year-old baby":** Davis Jr. and Boyar and Boyar, *Yes I Can*, 365–366.

333 **Sands changes its racial policies:** Schwartz, *At the Sands*, 101, 104–108, 178.

334 **The Westside agreement:** Alan Mattay, "The Moulin Rouge: A Symbol of Las Vegas' Civil Rights Struggle," *Intermountain Histories*, University of Nevada, February 17, 2017; Horne, *Jazz and Justice*, 162–166.

335 **Cole confrontation with Entratter:** Epstein, *Nat King Cole*, 232–233.

336 **"If you want to see what a million dollars":** Sammy Davis Jr. and Jane and Burt Boyar, *Why Me?: The Sammy Davis, Jr. Story* (Random House, 1992), 113.

336 **Jackie Mason and Sinatra:** Kaplan, *Sinatra*, 702–703, 714.

337 **Shecky Greene and Sinatra:** Kaplan, *Sinatra*, 704–705, 712–715.

339 **"I never got a bouquet of flowers"**: Samuel G. Freedman, "The Blues of Expatriate Paris: Recalling America's Jazz Exiles," *New York Times*, October 12, 1986.

340 **"That [album] is what put Debut on its feet"**: John F. Goodman, *Mingus Speaks* (University of California Press, 2013), 164.

341 **Mingus and Joey Gallo**: Goodman, *Mingus Speaks*, 197, 199, 201, 251, 275, 287.

342 **Max Roach and the *Freedom Now Suite***: Horne, *Jazz and Justice*, 257–259, 275, 282.

343 **"I'm jealous when I see ballet dancers"**: Abbey Lincoln oral history interview, Museum of American History, Smithsonian, August 17–18, 1996.

344 **Murder of Tommy Eboli**: "Mafia Chief Slain in Ambush," *Daily News*, July 17, 1972; Emanuel Perlmutter, "A Key Gang Figure Slain in Brooklyn," *New York Times*, July 17, 1972; FBI file, Morris Levy.

344 **Levy and Eboli in Europe**: FBI file, Morris Levy.

344 **"Levy said he knows of Eboli's reputation"**: Ibid.

345 **Levy incident outside Blue Angel nightclub**: Carlin, *Morris Levy*, 179–180.

345 **Vincent "the Chin" Gigante**: FBI file, Morris Levy; Carlin, *Morris Levy*, 157, 162–163, 167–169, 197–199, 208, 218–219, 221, 225–226.

347 **"Gigante controls by threats of force"**: FBI file, Morris Levy. Also, see George Anastasia, "Extortion Case Ties Music Industry Executive with Mob," *Philadelphia Inquirer*, June 25, 1987.

347 **Levy and Betty Carter**: William R. Baur, *Open the Door: The Life and Music of Betty Carter* (University of Michigan Press, 2003), 135–137, 141–142.

Chapter 14: Twilight of the Underworld

352 **"I found God in a little garden in Paris"**: Dahl, *Morning Glory*, 233.

352 **"Jazz is healing to the soul"**: Dahl, *Morning Glory*, 270.

353 **Mary Lou's Mass**: Dahl, *Morning Glory*, 306, 309–312, 317, 319, 321, 326–327, 360, 362, 376.

354 **"There were no complaints"**: Dahl, *Morning Glory*, 367.

355 **Satchmo and Glaser, the later years:** Teachout, *Pops*, 278–280, 317, 332–333, 337, 356, 365. Teachout also wrote a controversial play about the Satchmo-Glaser relationship titled *Satchmo at the Waldorf*, which debuted in Chicago at the Court Theatre in January 2016: Chris Jones, "Behind a great trumpeter, the notorious Joe Glaser," *Chicago Tribune*, January 29, 2016.

357 **"I'll bury you, you motherfucker":** Wein with Chinen, *Myself Among Others*, 299–300. Ricky Riccardi, esteemed director of the Louis Armstrong House Museum in Queens, New York, and author of *Heart Full of Rhythm*, a stellar Armstrong biography, takes issue with Wein's account of the Armstrong-Glaser relationship in its dying days. Riccardi suggests that Wein's deathbed anecdote is likely a fabrication, born of animus by Wein toward Glaser. Furthermore, Riccardi was critical of *Satchmo at the Waldorf*, Terry Teachout's play, which was influenced by Wein's memoir. Riccardi and Teachout hashed it out in a friendly though spirited debate on Riccardi's blog, *The Wonderful World of Louis Armstrong* (https://dippermouth.blogspot.com), commencing on June 6, 2015.

357 **Sinatra and the Nevada Gaming Control Board:** Bill Prochnau, "'Ol' Blue Eyes' Scores Big Hit with Nevada's Gaming Board," *Washington Post*, February 12, 1981.

359 **Westchester Premier Theater:** Matt Birkbeck, *Deconstructing Sammy: Music, Money, Madness, and the Mob* (HarperCollins, 2008), 179–182, 223; Kaplan, *Sinatra*, 860–861.

363 **Sal "Sal the Swindler" Pisello:** William Knoedelseder, *Stiffed: The True Story of MCA, the Music Business and the Mafia* (HarperCollins, 1993), 16–18, 29–39, 79–83, 115–116, 134–136, 236, 245–247, 291, 318, 346–349, 405–407.

363 **MCA's legacy in the music business:** Dannen, *Hit Men*, 53–56, 79, 89, 112, 137, 234–235; Knoedelseder, *Stiffed*, 10, 14, 21, 24, 26, 33, 35–36, 104, 106–107, 120, 135, 138, 160–161, 269–271, 300, 335–336, 348, 366, 435.

364 **Levy's cut-outs deal with LaMonte:** Dannen, *Hit Men*, 53–56, 282; Knoedelseder, *Stiffed*, 55–61, 156–236, 397–404; Carlin, *Morris Levy*, 209–220.

366 **Indictment of Levy:** William Knoedelseder, "Morris Levy: Big Clout in

the Record Industry: His Behind-the-Scenes Influence Is Felt Through-out the Industry," *Los Angles Times*, July 20, 1986.

367 **"MCA served me with a summons":** Carlin, *Morris Levy*, 218.

368 **"Let me tell you something about the mob":** Jim Schuh, "Record Heat: Morris Levy's Bad-Rap Rap," *Boston Phoenix*, October 7, 1986.

369 **Levy on trial in Los Angeles:** Carlin, *Morris Levy*, 225–237; Knoedel-seder, *Stiffed*, 107–108, 309–311, 313, 397–404, 420–425; "Sadly, No Tears for Morris Levy," *Billboard*, November 19, 1988.

370 **"He was still physically imposing":** Carlin, *Morris Levy*, 244.

Coda

372 **The decline of jazz as a commercial force:** Gioia, *History of Jazz*, 369–388; Thomas C. Horne, "The Decline of Jazz: From the Pit," *Harvard Crimson*, May 19, 1965; Ethan Dodd, "Is Jazz Dead?," *Yale News*, April 11, 2019. In 2014, Nielsen's Year End Report stated that jazz represented 1.4 percent of total U.S. music consumption. Even so, sales statistics do not reflect the cultural relevance of the music, which has persevered in the marketplace and culture longer than any other indigenous form of American music.

372 **Emergence of Wynton Marsalis:** Mary Campbell, "Wynton Marsalis: Boy Wonder of Jazz Has Been 'Discovered,'" AP, June 2, 1982; Peter Ap-plebome, "High Notes and Low: A Jazz Success Story with a Tinge of the Blues: At Lincoln Center, Designing the Canon Draws Fire," *New York Times*, September 22, 1998; Nate Chinen, "Wynton Marsalis: The Once and Future King of Jazz at Lincoln Center," *New York Times*, August 27, 2006.

373 **Jazz at Lincoln Center:** "History," Jazz at Lincoln Center official web-site (https://www.jazz.org/history/); Giovanni Russonello, "At 30, What Does Jazz at Lincoln Center Mean?," *New York Times*, September 13, 2017.

374 **The Village Vanguard:** Gordon, *Live at the Village Vanguard*.

375 **Cécille McLorin Salvant at the Vanguard:** The author attended the performance of Salvant at the club in September 2017. He can attest that the lines were long and the show was brilliant.

SOURCES

This book was based mostly on archival research. Given that many of the people who lived this history are no longer with us, I was dependent, to a large extent, on the public record. Of these sources, by far the most useful were the oral histories. Thankfully, a few prestigious institutions had the foresight to record interviews with many jazz musicians from throughout history. Some of these musicians were involved in the business of jazz almost from the beginning. The key oral history archives are housed at the Institute of Jazz Studies at Rutgers University; the National Museum of American History, part of the Smithsonian Institute; the Jazz Archive at Duke University; the Library of Congress; the Hogan Jazz Archive at Tulane University; and the Louis Armstrong House Museum.

Also helpful were the American Italian Museum in New Orleans, the New Orleans Historical Society, and the Jazz Museum of New Orleans. Any jazz research in the Crescent City also involves walking the streets of the French Quarter as well as what used to be the infamous jazz and bordello district of Storyville.

In Kansas City, I visited the American Jazz Museum and the Kansas City Public Library, and I familiarized myself with the historically essential 18th and Vine jazz district.

Research for this book began in early 2020, a few weeks before the Covid-19 pandemic set in. I was able to make research trips to New Orleans and Kansas City before everything shut down. Luckily, many of the other key locations—Chicago, Los Angeles, Las Vegas—are all cities I have either lived in or visited in the past. Anywhere I go, I make myself aware of the local jazz history and venues past and present.

It is astounding how much archival research is now available digitally online. Most of my research was conducted from my home base of New York City. Not only is New York a city with a long-standing association between jazz and the underworld, it contains various research institutions that were essential to this project, most notably the Schomburg Center for Research in Black Culture in Harlem, the New York Public Library in Midtown Manhattan, and the Louis Armstrong House Museum in the neighborhood of Hollis, Queens.

The importance of these institutions is that they lead you to other sources, most notably newspaper and magazine articles, academic journals, and documentary films that shed light on your subject from varying angles. Within the notes section of this book you will find reference to the many periodicals, articles, and essays that informed this study.

Also of importance were the many memoirs, biographies, and jazz and mob histories that have been written over the decades. A big part of the research for this book involved culling anecdotes from memoirs and biographies and cross-checking them with oral history interviews from the likes of Louis Armstrong, Duke Ellington, Sonny Greer, Count Basie, and many others. The relevant publications, both on the music and the organized crime sides of this story, are listed in the bibliography.

Finally, the most illuminating form of research is the music itself. Listen carefully to a song like "Doctor Jazz" by Jelly Roll Morton, or "Muggles" by Louis Armstrong, or "The Mooche" by Duke Ellington, or "The Damned Don't Cry" by John Coltrane, and you are likely to experience something of the connection between jazz and the underworld, which is a symbiosis entombed in history but also a living, breathing expression of liberation, aggression, and existential longing that is personified in the music. Jazz is a confluence of many elements, but one of those elements is most definitely its legacy of intermingling artistry and shadiness, an understanding that for the music to thrive as a commercial entity—especially when performed in nightclubs—it exists as a seduction for people from the upperworld as much as those who, accord-

ing to Langston Hughes, toil in "the primitive world, closer to the earth and much nearer to the stars."

Books

Acosta, Leonardo. *Cubano Be Cubano Bop: One Hundred Years of Jazz in Cuba*. Washington D.C.: Smithsonian Books, 2002.

Armstrong, Louis. *Satchmo: My Life in New Orleans*. New York: Prentice-Hall, 1954.

———. *Swing That Music*. New York: Da Capo Press, 1993 (originally published 1938).

Asbury, Herbert. *The French Quarter: An Informal History of the New Orleans Underworld*. New York: Alfred A. Knopf, 1936.

———. *Gem of the Prairie: An Informal History of the Chicago Underworld*. New York: Alfred A. Knopf, 1940.

———. *The Great Illusion: An Informal History of Prohibition*. New York: Dodd, Mead, 1950.

———. *Sucker's Progress: An Informal History of Gambling in America*. New York: Dodd, Mead, 1938.

Balliett, Whitney. *Such Sweet Thunder: 49 Pieces on Jazz*. New York: Bobbs-Merrill, 1966.

Basie, Count, as told to Albert Murray. *Good Morning Blues: The Autobiography of Count Basie*. New York: Random House, 1985.

Baur, William R. *Open the Door: The Life and Music of Betty Carter*. Ann Arbor: University of Michigan Press, 2003.

Bechet, Sidney. *Treat It Gentle: An Autobiography*. New York: Da Capo Press, 2002.

Bergreen, Laurence. *Capone: The Man and the Era*. New York: Simon & Schuster, 1994.

———. *Louis Armstrong: An Extravagant Life*. New York: Broadway Books, 1997.

Birkbeck, Matt. *Deconstructing Sammy: Music, Money, Madness, and the Mob*. New York: HarperCollins, 2008.

Bjorn, Lars. *Before Motown: A History of Jazz in Detroit, 1920–1960*. Ann Arbor: University of Michigan Press, 2001.

Boulard, Garry. *Just a Gigolo: The Life and Times of Louis Prima*. Lafayette, LA: Center for Louisiana Studies, University of Southwestern Louisiana, 1989.

Bruno, H. O. *The Story of the Original Dixieland Jazz Band*. Baton Rouge: Louisiana State University Press, 1960.

Bryant, Clora (ed.), et al. *Central Avenue Sounds: Jazz in Los Angeles*. Berkeley: University of California Press, 1998.

Buntin, John. *L.A. Noir: The Struggle for the Soul of America's Most Seductive City*. New York: Crown, 2009.

Burke, Diane Mutti (ed.), et al. *Wide Open Town: Kansas City in the Pendergast Era*. Lawrence: University Press of Kansas, 2018.

Burke, Patrick. *Come In and Hear the Truth: Jazz and Race on 52nd Street*. Chicago: University of Chicago Press, 2008.

Burns, Ben. *Nitty Gritty: A White Editor in Black Journalism*. Jackson: University Press of Mississippi, 1996.

Calloway, Cab, and Bryant Rollins. *Of Minnie the Moocher & Me*. New York: Crowell, 1976.

Carlin, Richard. *Morris Levy: Godfather of the Music Business*. Jackson: University Press of Mississippi, 2016.

Chevigny, Paul. *Gigs: Jazz and the Cabaret Law in New York City*. New York: Routledge, 2004.

Cohen, Mickey, as told to John Peer Nugent. *In My Own Words*. New York: Prentice-Hall, 1975.

Cohen, Rich. *Tough Jews: Fathers, Sons and Gangster Dreams*. New York: Simon & Schuster, 1998.

Cohn, Art. *The Joker Is Wild: The Story of Joe E. Lewis*. New York: Random House, 1955.

Collette, Buddy, with Steven Louis Isoardi. *Jazz Generations: A Life in American Music and Society*. New York: Continuum, 2000.

Condon, Eddie. *We Called It Music: A Generation of Jazz*. New York: H. Holt, 1947.

Crouch, Stanley. *Considering Genius: Writings on Jazz*. New York: Civitas Books, 2006.

———. *Kansas City Lightning: The Rise and Times of Charlie Parker*. New York: Harper, 2013.

Dahl, Linda. *Morning Glory: A Biography of Mary Lou Williams*. New York: Pantheon, 2000.

Damone, Vic, with David Chanoff. *Singing Was the Easy Part*. New York: St. Martin's Press, 2009.

Dance, Stanley. *The World of Earl Hines*. New York: Scribner, 1977.

Dannen, Fredric. *Hit Men: Power Brokers and Fast Money Inside the Music Business*. New York: Vintage, 1991.

Davis, Miles, with Quincy Troup. *Miles: The Autobiography*. New York: Simon & Schuster, 1989.

Davis, Sammy, Jr., and Jane and Burt Boyar. *Why Me?: The Sammy Davis, Jr. Story*. New York: Random House, 1992.

———. *Yes I Can: The Story of Sammy Davis, Jr.* New York: Farrar, Straus and Giroux, 1965.

Denton, Sally, and Roger Morris. *The Money and the Power: The Making of Las Vegas and Its Hold on America*. New York: Alfred A. Knopf, 2001.

DeStefano, Anthony M. *Top Hoodlum: Frank Costello, Prime Minister of the Mafia*. New York: Citadel, 2018.

Dray, Philip. *At the Hands of Persons Unknown: The Lynching of Black America*. New York: Random House, 2002.

Driggs, Frank, and Chuck Haddix. *Kansas City Jazz: From Ragtime to Bebop—A History*. New York: Oxford University Press, 2006.

Durante, Jimmy, and Jack Kofoed. *Night Clubs*. New York: Alfred A. Knopf, 1931.

Ellington, Edward Kennedy. *Music Is My Mistress*. New York: Doubleday, 1973.

English, T. J. *Havana Nocturne: How the Mob Owned Cuba . . . And Then Lost It to the Revolution*. New York: William Morrow, 2008.

———. *Paddy Whacked: The Untold Story of the Irish American Gangster*. New York: William Morrow, 2005.

Epstein, Daniel Mark. *Nat King Cole*. New York: Farrar, Straus and Giroux, 1999.

Evanier, David. *All the Things You Are: The Life of Tony Bennett*. New York: Wiley, 2011.

Fentress, James. *Eminent Gangsters: Immigrants and the Birth of Organized Crime in America*. New York: UPA, 2010.

Fernandez, Raul. *Latin Jazz: The Perfect Combination*. San Francisco: Chronicle Books, 2002.

Fornier, Gregory A. *The Elusive Purple Gang: Detroit's Kosher Nostra*. Tucson, AZ: Wheatmark, 2019.

Fowler, Gene. *Beau James: The Life and Times of Jimmy Walker*. New York: Viking, 1949.

Gambino, Richard. *Vendetta: The True Story of the Largest Lynching in U.S. History*. Garden City, NJ: Doubleday, 1977.

Gavin, James. *Stormy Weather: The Life of Lena Horne*. New York: Atria, 2009.

Genari, John. *Flavor and Soul: Italian America at Its African American Edge*. Chicago: University of Chicago Press, 2017.

Giancana, Sam, and Chuck Giancana. *Double Cross: The Explosive Inside Story of the Mobster Who Controlled America*. New York: Warner Books, 1992.

Gillespie, Dizzy, with Al Fraser. *To Be or Not to Bop: Memoirs of Dizzy Gillespie*. New York: Doubleday, 1979.

Gioia, Ted. *The History of Jazz*. New York: Oxford University Press, 2011.

Gleason, Toby (ed.). *Conversations in Jazz: The Ralph J. Gleason Interviews*. New Haven: Yale University Press, 2016.

Gold, Jeff. *Sittin' In: Jazz Clubs of the 1940s and 1950s*. New York: Harper Design, 2020.

Goodman, John F. *Mingus Speaks*. Berkeley: University of California Press, 2013.

Gordon, Max. *Live at the Village Vanguard*. New York: St. Martin's Press, 1980.

Hamill, Pete. *Why Sinatra Matters*. New York: Little, Brown, 1998.

Haskins, James. *The Cotton Club: A Pictorial and Social History of the Most Famous Symbol of the Jazz Era*. New York: Random House, 1977.

Hayde, Frank R. *The Mafia and the Machine: The Story of the Kansas City Mob*. Fort Lee, NJ: Barricade Books, 2010.

Hayes, Elaine M. *Queen of Bebop: The Musical Lives of Sarah Vaughan*. New York: Ecco, 2017.

Haygood, Wil. *In Black and White: The Life of Sammy Davis Jr.* New York: Alfred A. Knopf, 2003.

Hill, David. *The Vapors: A Southern Family, the New York Mob, and the Rise and Fall of Hot Springs, America's Forgotten Capital of Vice*. New York: Farrar, Straus and Giroux, 2020.

Holiday, Billie, with William Dufty. *Lady Sings the Blues*. New York: Doubleday, 1956.

Holiday, Billie, with an introduction by Khanya Mtshali. *The Last Interview and Other Conversations*. Brooklyn: Melville House, 2019.

Horne, Gerald. *Jazz and Justice: Racism and the Political Economy of the Music*. New York: Monthly Review Press, 2019.

Horne, Lena, and Richard Schickel. *Lena*. New York: Doubleday, 1965.

Hughes, Langston. *The Big Sea: An Autobiography*. New York: Alfred A. Knopf, 1940.

Hunt, Thomas. *Deep Water: Joseph P. Macheca and the Birth of the American Mafia*. iUniverse, Inc., 2007.

Jacobs, George, and William Stadiem. *Mr. S: My Life with Frank Sinatra*. New York: HarperEntertainment, 2003.

James, Tommy, with Martin Fitzpatrick. *Me, the Mob and the Music: One Helluva Ride with Tommy James and the Shondells*. New York: Scribner, 2011.

Jennings, Dean. *We Only Kill Each Other: The Life and Bad Times of Bugsy Siegel*. New York: Prentice-Hall, 1967.

Johnson, Mayme, and Karen E. Quinones Miller. *Harlem Godfather: The Rap on My Husband, Ellsworth "Bumpy" Johnson*. Philadelphia: Oshun Publishing, 2008.

Jones, Leroi (Amira Baraka). *Blues People: Negro Music in White America*. New York: HarperCollins, 1963.

Kaplan, James. *Frank: The Voice*. New York: Doubleday, 2010.

———. *Sinatra: The Chairman*. New York: Doubleday, 2015.

Kastas, Phil. *Dead Man Blues: Jelly Roll Morton Way Out West*. Berkeley: University of California Press, 2001.

Kelley, Kitty. *His Way: The Unauthorized Biography of Frank Sinatra*. New York: Bantam, 1986.

Kenny, William Howland. *Chicago Jazz: A Cultural History, 1904–1930*. New York: Oxford University Press, 1993.

Kirk, Andy, as told to Amy Lee. *Twenty Years on Wheels*. Oxford, U.K.: Bayou Press, 1989.

Knoedelseder, William. *Stiffed: A True Story of MCA, the Music Business and the Mafia*. New York: HarperCollins, 1993.

Kobler, John. *Capone: The Life and World of Al Capone*. New York: Putnam, 1971.

Kreck, Dick. *Smaldone: The Untold Story of an American Crime Family*. Golden, CO: Fulcrum Publishing, 2010.

Krist, Gary. *Empire of Sin: A Story of Sex, Jazz, Murder, and the Battle for Modern New Orleans*. New York: Crown, 2014.

Kukla, Barbara J. *Swing City: Newark Night Life, 1925–50*. Philadelphia: Temple University Press, 1991.

Kuntz, Tom, and Phil Kuntz. *The Sinatra Files: The Secret FBI Dossier*. New York: Three Rivers Press, 2000.

Lacey, Robert. *Little Man: Meyer Lansky and the Gangster Life*. New York: Little, Brown, 1991.

Larsen, Lawrence H., and Janice J. Huston. *Pendergast!* Columbia: University of Missouri Press, 1997.

Leigh, Philip. *The Devil's Town: Hot Springs During the Gangster Era*. Columbia, SC: Shotwell Publishing, 2018.

Levine, Gary. *Jack "Legs" Diamond: Anatomy of a Gangster*. Fleischmanns, NY: Purple Mountain Press, 1995.

Levy, John, with Devra Hall. *Men, Women and Girl Singers: My Life as a Musician Turned Talent Manager*. Silver Springs, MD: Beckham Publications Group, 2008.

Leymarie, Isabelle. *Cuban Fire: The Story of Salsa and Latin Jazz*. London: Continuum, 2002.

Lomax, Alan. *Mister Jelly Roll: The Fortunes of Jelly Roll Morton, New Orleans Creole and "Inventor of Jazz."* New York: Pantheon, 1993.

Lowinger, Rosa, and Ofelia Fox. *Tropicana Nights: The Life and Times of the Legendary Cuban Nightclub*. New York: Harcourt, 2005.

Margolick, David. *Strange Fruit: The Biography of a Song*. New York: Ecco, 2001.

Mezzrow, Mezz, with Bernard Wolfe. *Really the Blues*. New York: Random House, 1946.

Morris, Ronald L. *Wait Until Dark: Jazz and the Underworld, 1880–1940*. Bowling Green, KY: Bowling Green University Press, 1981.

Murray, Albert. *Stomping the Blues*. New York: McGraw-Hill, 1976.

Nelli, Humberto S. *The Business of Crime: Italians and Syndicate Crime in the United States*. New York: Oxford University Press, 1976.

Nown, Graham. *Arkansas Godfather: The Story of Owney Madden and How He Hijacked Middle America*. Little Rock: Butler Center for Arkansas Studies, 2013.

Okrent, Daniel. *Last Call: The Rise and Fall of Prohibition*. New York: Scribner, 2011.

O'Malley, Terence William. *Black Hand/Strawman: The History of Organized Crime in Kansas City*. Kansas City: The Covington Group, 2011.

Ostransky, Leroy. *Jazz City: The Impact of Our Cities on the Development of Jazz*. New York: Prentice-Hall, 1978.

Ouseley, William. *Open City: The True Story of the KC Crime Family*. Leawood, KS: Leathers Publishing, 2012.

Owsley, Dennis C. *St. Louis Jazz: A History*. West Columbia, SC: The History Press, 2015.

Paduro Fuentes, Leonardo. *The Sad Night of Chano Pozo*. Valencia, Spain: AJUBELstudio, 2013.

Pearson, Nathan W. *Goin' to Kansas City*. Chicago: University of Illinois Press, 1994.

Peterson, Virgil. *The Mob: 200 Years of Organized Crime in New York*. New York: Little, Brown, 1952.

Pileggi, Nicholas. *Casino: Love and Honor in Las Vegas*. New York: Simon & Schuster, 1995.

Podell-Raber, Mickey, with Charles Pignone. *The Copa: Jules Podell and the Hottest Club North of Havana*. New York: Harper, 2007.

Reddig, William M. *Tom's Town: Kansas City and the Pendergast Legend*. Philadelphia: J. B. Lippincott, 1991.

Reig, Teddy, with Edward Berger. *Reminiscing in Tempo: The Life and Times of a Jazz Hustler*. Lanham, MD: Scarecrow Press, 1995.

Riccardi, Ricky. *Heart Full of Rhythm: The Big Band Years of Louis Armstrong*. New York: Oxford University Press, 2020.

Rose, Al. *Storyville, New Orleans: Being an Authentic, Illustrated Account of the Notorious Red Light District*. Tuscaloosa: University of Alabama Press, 1974.

Russel, Ross. *Jazz Styles in Kansas City and the Southwest*. New York: Da Capo Press, 1973.

Russo, Gus. *The Outfit: The Role of Chicago's Underworld in the Shaping of Modern America*. New York: Bloomsbury USA, 2002.

———. *Supermob: How Sidney Korshak and His Criminal Associates Became America's Hidden Power Brokers*. New York: Bloomsbury USA, 2006.

Sann, Paul. *Kill the Dutchman!: The Story of Dutch Schultz*. New Rochelle, NY: Arlington House, 1971.

Schwartz, David G. *At the Sands: The Casino That Shaped Classic Las Vegas, Brought the Rat Pack Together and Went Out with a Bang*. Las Vegas, NV: Winchester Books, 2020.

Server, Lee. *Handsome Johnny: The Life and Death of Johnny Roselli:*

Gentleman Gangster, Hollywood Producer, CIA Assassin. New York: St. Martin's Griffin, 2019.

Shapiro, Nat, and Nat Hentoff. *Hear Me Talkin' to Ya: The Story of Jazz as Told by the Men Who Made It.* New York: Rinehart and Co., 1955.

Shaw, Arnold. *52nd Street: The Street of Jazz.* New York: Da Capo Press, 1971.

Shipton, Alyn. *Hi-de-ho: The Life of Cab Calloway.* New York: Oxford University Press, 2013.

Sidran, Ben. *Black Talk: How the Music of Black America Created a Radical Alternative to the Values of Western Literary Tradition.* New York: Da Capo Press, 1971.

Singer, Barr. *Black and Blue: The Life and Lyrics of Andy Razaf.* New York: Shirmer Books, 1992.

Spencer, Frederick J. *Jazz and Death: Medical Profiles of Jazz Greats.* Jackson: University Press of Mississippi, 2002.

Stewart, Rex. *Jazz Masters of the 30s.* New York: Macmillan, 1972.

Stoddard, Tom (as told to). *Pops Foster: The Autobiography of a New Orleans Jazzman.* Berkeley: University of California Press, 1977.

Sublette, Ned. *Cuba and Its Music: From the First Drums to the Mambo.* Chicago: Chicago Review Press, 2004.

———. *The World That Made New Orleans: From Spanish Silver to Congo Square.* Chicago: Chicago Review Press, 2008.

Sullivan, Leo T. *Birdland, the Jazz Corner of the World: An Illustrated Tribute, 1949–1965.* Atglen, PA: Schiffer Publishing, 2018.

Sylvester, Robert. *No Cover Charge: A Backward Look at the Nightclubs.* New York: The Dial Press, 1956.

Teachout, Terry. *Duke: A Life of Duke Ellington.* New York: Avery, 2014.

———. *Pops: A Life of Louis Armstrong.* Boston: Houghton Mifflin Harcourt, 2009.

Tereba, Tere. *Mickey Cohen: The Life and Crimes of L.A.'s Notorious Mobster.* New York: ECW Press, 2012.

Thiele, Bob. *What a Wonderful World: A Lifetime of Recordings*. New York: Oxford University Press, 1995.

Tosches, Nick. *Dino: Living High in the Dirty Business of Dreams*. New York: Doubleday, 1992.

———. *King of the Jews: The Greatest Mob Story Never Told*. New York: Ecco, 2005.

———. *Save the Last Dance for Satan*. New York: Kicks Books, 2011.

Travis, Dempsey J. *An Autobiography of Black Jazz*. Chicago: Chicago Academy Press, 1983.

Van Meter, Jonathan. *The Last Good Time: Skinny D'Amato, the Notorious 500 Club, & the Rise and Fall of Atlantic City*. New York: Crown, 2003.

Walker, Stanley. *The Nightclub Era*. New York: Frederick A. Stokes, 1983.

Waller, Maurice, and Anthony Calabrese. *Fats Waller*. New York: Schirmer Books, 1977.

Waters, Ethel, with Charles Samuels. *His Eye Is on the Sparrow: An Autobiography*. New York: Praeger, 1978.

Wein, George, with Nate Chinen. *Myself Among Others: A Memoir*. New York: Da Capo Press, 2003.

Wells, Dicky, as told to Stanley Dance. *The Night People: The Jazz Life of Dicky Wells*. London: Robert Hale Ltd., 1971.

Whitaker, Mark. *Smoketown: The Untold Story of the Other Great Black Renaissance*. New York: Simon & Schuster, 2019.

Wilkerson, W. R., III. *Hollywood Godfather: The Life and Crimes of Billy Wilkerson*. Chicago: Chicago Review Press, 2018.

INDEX

Moonlight Ranch, 211–13
Moré, Beny, 290
Moretti, Willie, 195–96, 224–25, 247,
 250, 301
 Kefauver hearings, 272, 274, 277–78
Morrison, Dillard "Red," 243–44
Morrow, Edward, 73
Mortimer, Lee, 273
Morton, Jelly Roll (Ferdinand Joseph
 LaMothe), 8, 30–35, 151
 assault on, 34–35
 in Chicago, 92
 early life of, 30–31
 lack of financial compensation, 362
 in Los Angeles, 214
 in New Orleans, 16, 30–33, 42
 nickname of, 31
Morton, Mabel, 34
Moten, Benjamin "Bennie," 78, 80,
 82–85
Moulin Rouge, 104
Mr. S (Jacobs), 306–7
Muscarella, Ray, 323–24
Music for Peace, 353
Musicians' Protective Union Local 627,
 84–85
Music Is My Mistress (Ellington), 176
Mussolini, Benito, 240
"My Buddy," 178, 212, 244

NAACP (National Association for
 the Advancement of Colored
 People), 307, 320, 333–34, 342
NARM (National Association of
 Recording Merchandisers), 365
Nash, Frank "Jelly," 86–88
Navy, U.S., 58, 160, 248–49, 268
Negro Baseball League, 67, 211
Nellis, Joseph, 272–77
Nevada Equal Rights Investigatory
 Commission, 333–34
Nevada Gaming Control Board, 357–61
Newark, 183, 199–200

New Orleans, 13–19, 23–29. *See also*
 Storyville
 mob in, 21–23, 41–52
 prostitution in, 15–16, 24–26, 28,
 35–36, 58–59
New Orleans Gang, 234–35
New Orleans lynchings of 1891, 49–51,
 52
New Orleans School for Creative Arts,
 373
Newport, Kentucky, 204, 272, 328
Newport Jazz Festival, 186, 356
New Rendezvous, 105–11
Newton, Wayne, 351
New York Age, 160–61
New York City, 137–62, 163–64, 227–34,
 253–59, 292–96. *See also* Harlem;
 and specific clubs
 cabaret card system, 264–67
 heroin in, 238–44
New York City Police Pension Fund, 265
New York Liquor Control Board, 266
New York Times, 159, 170, 177, 326
New York Yankees, 171, 315
"niggers," 52, 102
Night Clubs (Durante), 143–44
Nixon, Richard, 305
North End (Kansas City), 70–73
North Side Gang, 57, 96, 100–101, 125
Now It's My Turn, 348–49

O'Banion, Dean, 96, 100
O'Brien, Peter, 353, 354
O'Day, Anita, 227, 241
O'Farrill, Arturo "Chico," 281, 282
OKeh Records, Inc., 82, 127, 129, 132
Oliver, Joseph "King," 20–21, 35–36, 56,
 89, 90–93, 113, 127
Only the Lonely, 302
"on the take," 6
Onyx, the, 229–30, 231
opium, 118–20
"organized crime," 25